# The Editor's Toolkit

# The Editor's Toolkit

A Hands-On Guide to the Craft of Film and TV Editing

**Chris Wadsworth**

Focal Press
Taylor & Francis Group

NEW YORK AND LONDON

First published 2016
by Focal Press
711 Third Avenue, New York, NY 10017

and by Focal Press
2 Park Square, Milton Park, Abingdon, Oxon OX14 4RN

*Focal Press is an imprint of the Taylor & Francis Group, an informa business*

*Library of Congress Cataloging-in-Publication Data*
Wadsworth, Christopher.
  The editor's toolkit : a hands-on guide to the art of film editing / Christopher Wadsworth.
    pages cm
  Includes index.
  1. Motion pictures—Editing—Handbooks, manuals, etc.   I. Title.
  TR899.W33 2015
  777'.55—dc23
  2015012182

ISBN: 978-1-138-90337-1 (pbk)
ISBN: 978-1-315-67065-2 (ebk)

Typeset in DIN
by Apex CoVantage, LLC

Printed and bound in India by Replika Press Pvt. Ltd.

Written and Produced by
**Chris Wadsworth**

"I have had 40 years of experience in the editing world, making some of the BBC's most famous and iconic comedy and entertainment shows from the 1980s onwards . . . that might just help you."

... and introducing
**'Video Mickey'**

As drawn by his creator and fellow BBC Editor
**Dave Rixon**

# Contents

# A Foreword by Simon Ashcroft

What a great thing it is to be an editor. It's taking a seat in a comfy air-conditioned room from which you go looking down a telescope at the whole gamut of production processes that have brought a film or programme to *you*.

From the original spark of an idea to the delivery of words and pictures on camera, it is you, often working alone, that must weave a well-told story from the numerous strands of audio and visual media in your care. Everybody involved in a production, both in front of and behind the camera, will be depending on you to show off their work at its best, often making their work appear better than it ever was. If you do it well, nobody will even know you were there (except your closest colleagues), for the best edits are often completely invisible.

Chris's brilliantly designed and well-constructed book, along with a superb range of practical exercises, will teach you to walk and even run with this craft, but to truly dance with it, you will always need time and intrinsic talent. But what is that talent?

Well, I have always maintained that you can spot the potential for a great editor in the character of a person, regardless of his or her training—a good sense of timing, a musicality, a gift for storytelling, a creative spark, a communicative and emotional soul. To these intrinsic gifts, which are far from unique, anybody can now add the knowledge of this book and, garnished with a little experience, be ready to roll. You will be ready to make the magic that is film and television, taking real life or fiction and then compressing it and reshaping it into something that is as interesting and engaging as the subject can possibly allow, while it still feels totally believable, uncorrupted, natural, and 'just right.'

In the chapters to follow, Chris, who is without doubt one of the finest editors that the BBC ever produced, will bathe you in the knowledge of all his years of experience. He will share with you all there is to know about the instruments of editing, the protocols, the elephant traps, the tricks of the trade, the pleasures, and the frustrations. But only through doing it will you learn the depth of the craft, for editing is an art, just like playing the violin.

When Chris and I learnt to cut, we were lucky enough to be immersed in the talents of an exclusive club of experts at the BBC's Television Centre in West London. Now, at last, my dear old friend and colleague, Chris, the Yehudi Menuhin of his profession, has found a way to offer everybody, not just the lucky few, a set of master classes in this beautiful and engaging craft.

Simon Ashcroft
Film editor, studio director, and cameraman for BBC News and Current Affairs

## Acknowledgements

My grateful thanks go to the following people:
**Nicholas Gale** for his unending support.
**Dave Rixon** for the drawings.

**Francois Evans** for providing some music.
**Tom Wolsky** for his valuable suggestions.
**Simon Ashcroft** for the Foreword.
**Dominic Norton** for finding a publisher.

I would also like to thank the following people for their work on the video exercise material:
**John B. Hobbs**—Director (*Chocolates and Champagne* and *The Photograph*)
**Gorden Kaye**—Philip (*The Photograph*)
**Keith Drinkel**—Mark (*The Photograph*)
**Paul Taylor**—Tim (*Chocolates and Champagne*)
**Pippa Shepherd**—Helen (*Chocolates and Champagne*)
**Gemma Saunders**—Caroline (*Chocolates and Champagne*)
**Stuart McDonald**—The Voice of Ken Casey (*Chocolates and Champagne*)
**Curtis and Jackson Heighes**—Young Philip and Mark (*The Photograph*)
**Nigel Bradley**—DOP (*Chocolates and Champagne* and *The Photograph*)
**Steve Hubbard**—Sound (*Chocolates and Champagne* and *The Photograph*).
Finally, I would like to thank all of my friends and colleagues who were kind enough to offer a few thoughts about the craft of editing.

# Chapter 1
# What Is This All About?

I have lost count of how many times I've been asked, by runners and youngsters just starting out in film or TV, whether I had any shot material with which they might practice their editing skills. I usually let them have copies of some rushes of a scene or two, with the understanding that first, the material is strictly for their personal use, and second, that I would like to see what they do with it. This seemed to work incredibly well, as those aspiring editors were able to compare what they did with my version.

Editing your own films is okay up to a point, but it's not what you're going to be doing if you take up editing as a career. The trouble with editing your own stuff is that you know exactly how it should go together. Also, there are no limits: your cut can be any length, any style and there's no one around to say 'Hang on, what if we . . . ?' Sadly, the real editing world is very different, and it seems to me this is where some media courses fall short in their teaching.

This book intends to solve that problem. What's different here is that alongside the text there are exercises with clips of properly shot material for you to put together yourself, with some guidance if you want, and then I give you the chance to compare your version with what I did with the same material. Starting with examples as simple as joining pairs of shots together through to assembling chunks of real scenes, the exercises are carefully graded in complexity.

You will also be glad to know this book is not about software—well, not more than is necessary. This publication is the equivalent of showing you how to write a novel and not how to use a typewriter. With text explanations alongside the exercises, you will be able to explore all aspects of the craft of editing.

It was my ambition to write the text and design the exercises for all levels of experience. With luck, the combination of text explanations and practical exercises will take you—whether you're an absolute beginner, keen amateur, or just starting your career in the business—through to a level of professionalism that will impress any future client or employer. I would hope that even the most experienced of you will get something out of this; I know I did, during the preparation of this publication.

It's so magnificently rewarding to coax shots into sequences, sequences into scenes, and scenes into complete programmes or films that have the power to make us laugh, learn, cry, or fear.

Here's your chance to do some of the same.

## 1.1 A Brief Introduction

Throughout the book, I will use the titles of mainly British TV programmes and various films as cryptic paragraph title names. Some of these titles will mean nothing to you, but please feel free to Google them.

If the programme title is just acting as a paragraph title, it will look like this:

### 🎬 *Just a Film Title*—It's Only Acting as a Paragraph Title

And if the paragraph refers to a film or TV programme that you should search out and watch, it will look like this:

### 🎥 *A Film Worth Watching* (2015)—Give It a Watch Sometime!

I hope that is reasonably clear.

For a long time I resisted filling the book with movie or TV examples of technique, as I didn't want this publication falling into the trap of becoming too worthy about the 'art' of filmmaking. But I realised that movie clips provided us with marvellous examples of the techniques we will be examining here. And, given that so many of these clips are available on the Internet, it seemed silly to exclude such references. I also tried to make the film or TV examples as modern as I could, but very often it's the fact that a technique was being used for the first time that makes it worthy of comment.

### 🎬 *Cartoon Time*—A Little Bit of Light Entertainment

Helping us in this book is a character I bumped into at the BBC several years ago called Video Mickey.

He was (and is) drawn by a friend and fellow BBC editor, Dave Rixon, who kept us entertained with strip cartoons featuring Mickey and Claud the Cat, mixed in with some of the real personnel from the Television Recording Department of the BBC, or VT as it was known back then.

## 1.2 Do You Really Want to Be an Editor?

In order that you fully understand what you might be letting yourself in for, I'd better describe what an editor today actually does.

### 🎬 *Starter for Ten*—What Does an Editor Actually Do?

If asked, I would think most of the public would struggle to find an answer to the question of what an editor actually does. If any did

manage an answer, they would probably allude to only a single aspect of an editor's role. Yes, it's joining shots together; yes, it's selecting the best takes; and yes, it's taking the boring bits out of football matches, but this would still only be a fraction of what editors can be called on to do in the process of making a film or TV programme.

If you think about it, the fact that the public is ignorant about the exact nature of our role is exactly how it should be, because, for the most part, editors try to hide what we do and let script, performance, and content take all the credit. It's no wonder, therefore, that the question I posed at the beginning of this section is so difficult to answer.

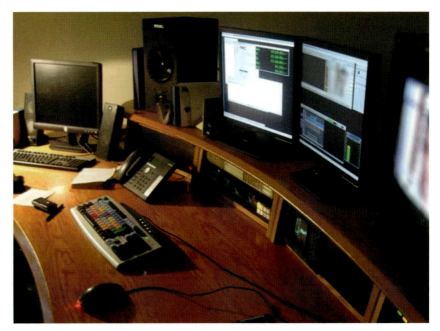

WHATEVER EDITORS DO, THEY DO IT IN A ROOM LIKE THIS.

### *On the Job*—What Editors Have to Do

Let me list my thoughts about an editor's role:

- **An editor uses a mixture of artistic and technical skills to assemble shots into a coherent whole.** I think that's how most of the public would answer the question about what an editor actually does. Remember though, a coherent whole is rarely conceived beforehand; rather, this usually evolves as the programme is put together. In other words, no one has a detailed architect's plan of the programme to be made that is handed to you with the words: 'Make that'.
- **An editor has a strong feeling for pace, rhythm, and storytelling.** I can't add to that!
- **An editor's skill determines the quality and delivery of the final product.** Yes, true, but you need good raw material in the form of script, performance, and photographed shots to achieve this.
- **An editor must work creatively with the layers of images, story, dialogue, and music.** Yes, and in doing so, an editor effectively remoulds these elements to produce a pleasing result that is greater than the sum of its parts.
- **An editor plays a dynamic role in the making of a film and is often involved with editorial and selection issues.** To a large extent this is up to you as an individual; however, I know of no director or producer who wants to be always in the driving seat. In fact, some really enjoy being a passenger after the stress of all that filming. The more your input is inventive and creative, the more you'll be appreciated, and the more you'll be left to get on with it. Bliss!
- **An editor reorders and tweaks content to ensure the logical sequencing and smooth running of a film or TV programme from whatever genre.** It's all true!
- **An editor acts as a fresh pair of eyes on shot material.** One of the best and most appreciated of our roles is to be truly objective and impartial with all programme material.

- **An editor has to adapt built-in skills to deal with a wide variety of different programme styles.** An editor is a Jack (or Jill) of all trades, and master of all trades as well.
- **An editor searches through tons of footage and puts together those clips that best tell a story that will hold a viewer's attention.** Yes, and this is especially true in the case of documentaries.
- **An editor experiments with styles and techniques, including the design of graphic elements.** That's the point! An element of experimentation is involved with every programme you work on, and solving a particular problem often requires a unique solution that was not previously thought of by the production team.
- **An editor quietly gets sequences to a high standard so that production (directors and producers mainly) can concentrate on wider issues and not get bogged down in the nitty-gritty.** Freeing up a director's time is also an important role for us.
- **An editor has to operate equipment that is sometimes complex and technical.** Yes, and we have to keep up to date with any changes in that technology. The typewriter is changed quite often, and the keys keep moving around and increasing in number.
- **An editor has to mix and balance sound.** A finished cut leaving your editing suite can still go straight 'on the air'.
- **An editor has to be creative with multiple layers of video.** Title sequences will call on every aspect of your creative input as well as your knowledge of the editing software.
- **An editor has to be able to manipulate music performance in many different styles.** Editing, mixing, and balancing music are all skills that are essential to acquire.

If that has not put you off, I would suggest you read on.

A SELFIE AT A *PARKINSON* EDIT IN 2008.

## 1.3 Why You Might Just Listen to Me

### 🎬 *The Apprentice*—That Was Me, Some Time Ago Now!

When I started at the BBC, editing was much more of a team effort, often involving the greenest of assistants. During that wonderful apprenticeship, all you had to do was to be part of it: watch, listen, and learn as the editors back then tackled a whole range of technical and editorial problems.

### 🎬 *The Today Programme*—Editing Today

Unfortunately, today, for the most part, we all work as individuals, and worse still, the process has become so fast and furious that even someone sitting alongside us would find it hard to decode

the keystrokes and mouse moves that turn creative thoughts and individual shots into a sequence.

As much as we all love the new technology, it has made it increasingly hard for those wanting to join the profession (that's you I hope) to pick up the skills and techniques which are necessary to become an editor.

### 🎬 *The Gadget Show*—Here Come the Toys!

Editing software is constantly improving, but the choice of software is not so important here from the point of view of what we are about to consider in this book. Remember, it's the novel that counts here, not the word processor.

## 1.4  My Background

### 🎬 *All Our Yesterdays*—Where It All Began for Me

When I was a youngster, video at home was unheard of. All we had was film—Standard 8, Super 8, and 16 mm for the kids with rich parents. Editing these formats in a domestic environment was somewhat unrewarding, as the results could hardly be described as good, and syncing sound was a real problem. But what we did have was 1/4" tape. Here, at least, with a splicing block and a cheap and cheerful audio mixer, you could produce reasonable-sounding results. Things like putting your favourite music tracks all mixed together on a reel of tape or producing sound effects for school plays could all be done at high quality at home.

That's how I started really, and when I was selected to do a vacation training course at the BBC Television Centre in 1975, in the telecine and videotape departments, I found that editors there were dealing with sound issues just as much as editing the pictures and I had done some of that sort of work myself. For example, I saw

that editing the vision from a freeze at the end of a slow-motion replay of a goal was simply a matter of deciding where that cut should happen, but sound mixing the roar of the crowd and a commentator talking as though his trousers were on fire to a quiet throw-in 10 minutes later took individual skill and technique.

My career decision was made. I joined the BBC (or the 'Beeb', as it was affectionately known) as a videotape engineer in 1976, and I was promoted to senior recording engineer in 1978. Right from the word go, I was assisting real edit sessions with various different editors for a huge range of programmes.

I was promoted to editor in 1980, and as a junior editor I was allocated all sorts of work like *Match of the Day, Top of the Pops, Play School,*

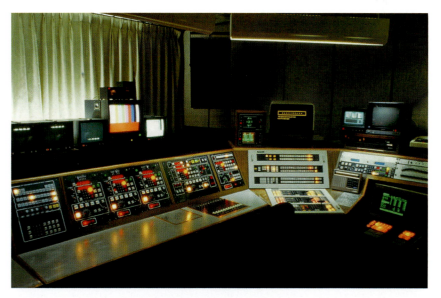

AN ONLINE EDITING SUITE FROM THE MID-1980s. ALONGSIDE THE BBC'S ELECTRA EDIT CONTROL SYSTEM, IT HAD VISION AND SOUND MONITORING, VISION AND SOUND MIXERS, A VIDEO EFFECTS GENERATOR, AN EDIT LOGGING COMPUTER, SOUND EQUALISATION AND OTHER SOUND EFFECTS GENERATORS, A CAPTION SCANNER AND GENERATOR, AN IDENT CLOCK, AND A VHS RECORDER. IT WAS DRIVEN BY AN EDITOR WITH AN ASSISTANT. TODAY, ALL THAT (AND MORE) IS CRAMMED INTO A SOFTWARE APPLICATION ON A LAPTOP OR TABLET. SHAME ABOUT THE ASSISTANT!

*Rugby Special, Film '80, Nationwide,* and a load of trails (or trailers) for BBC 1 and BBC 2. Within a year, I started to concentrate on 'light entertainment' programmes, as they used to be called back then.

The rest of my career details, in and out of the BBC, and a list of the programmes I have worked on, are in Appendix 3.

## 1.5 How to Use This Book and Its Data

### 🎬 *How!*—How to Get the Best Out of All This

I have a problem, and it's you. All of you. My problem is that I don't know how much you already know. I have to cover everything for those of you approaching the craft for the first time, but I do this at the risk of boring the clever clogs amongst you who have had a go at this editing lark already.

SCRIPTS FROM THE PAST AND PRESENT.

All I would say is that if any of you feels confident enough about a particular topic, especially those covered in the opening chapters, you should feel free to skip that section and move on. The last thing I want to do is bore you.

Each section has individual exercises associated with it, so once you're happy, move on! The main thing is, don't rush it! Packed into this book is the greater proportion of a lifetime of experience, so give yourself time to absorb it, or I fear you'll suffer from severe bouts of indigestion.

## 1.6 Let's Get Limbered Up—Material for the Exercises

### 🎬 *Starting Out*—An Introduction to the Exercises

Most of the exercises in this publication are taken from two dramas that I wrote a few years back. One is called *The Photograph* and the other *Chocolates and Champagne,* which was based on an original idea of a friend of mine, Nick Gale. Despite the fact they are both dramas, they will illustrate the editing techniques I want to show you perfectly.

Both films were shot in only four days and were directed by my friend and colleague John B. Hobbs who, in addition to directing numerous theatrical productions and the Chris Rea feature film *La Passione* (1996), has directed and produced many BBC situation comedies such as *'Allo 'Allo!, Bread, Mulberry, Down to Earth, Leaving,* and *Brush Strokes,* some of which I edited for him.

The director of photography (DOP) was Nigel Bradley, the sound recordist was Steve Hubbard, and production manager was Nick Gale. My sincere thanks go to all of them. It was quite a week I seem to remember!

DIRECTOR JOHN B. HOBBS CHECKING THE SCRIPT DURING THE FILMING OF *CHOCOLATES AND CHAMPAGNE.*

Here is a brief outline of the two plots, so that you will better understand the emotions involved when you start cutting the isolated excerpts.

*The Photograph* is about two brothers who, for whatever reason, have grown apart, but they are now forced to be together again on the day of their father's funeral.

Mark is a successful businessman, whereas his brother, Philip, is more downtrodden, having looked after their ailing father for several years. The trouble is, dad has always preferred Mark, despite the fact that he rarely came to see his father. The two brothers talk uncomfortably at first, but both try and make an effort. While reminiscing, some of dad's old home movies are remembered, and their flickering images bring back even more poignant memories for Mark. One event in particular Mark has long forgotten.

The actors here are Gorden Kaye (René in *'Allo 'Allo!*) and Keith Drinkel (Carter Brandon in *I Didn't Know You Cared*, Philip in *Family at War*, Maurice Gregory in *Coronation Street,* in addition to the Major in *Gandhi*).

I should say straight away that Gorden Kaye, who plays Philip, had very little time to learn the script, and he did marvellously to read and learn it as well as he did; my thanks to him for giving it a go. Some bits are sadly unusable, but in a strange way that has done me (and you) an enormous favour, as even greater editing skills are required to save as much of the performance as you can.

*Chocolates and Champagne* centres around a radio show dedication, sent in to the programme by Helen's husband, Joe, to celebrate their 10th wedding anniversary. Helen misses the live show, but her fussy neighbour Tim, who heard it, finds a way for Helen to listen to it again on the Internet. Later that day and quite by chance, Helen listens to a marital infidelity survey, which was featured later on in that same radio programme. As she listens, she slowly realises that her husband Joe's recent behaviour fits remarkably well with some of the points highlighted in the survey.

The next day she discusses the situation with Caroline, her best friend and fellow teacher at her nursery school, little realising that Caroline is part of the problem. Pennies begin to drop, and a later confrontation has tragic results.

The actors here are Paul Taylor who plays Tim, Pippa Shepherd as Helen, Gemma Saunders as Caroline, and a cameo role by yours truly as adulterer Joe, with the radio show host Ken Casey played by my director friend, Stuart McDonald.

## Ask the Family—A Few Words of Welcome from Some Friends and Colleagues

### Dewi Humphreys (Director)
Filming is like shopping for ingredients, while editing is cooking them into a palatable dish.

### Sir David Jason, OBE (Actor)
One of the most difficult genres to edit is comedy. If one wants to edit comedy, one has to have an innate sense of timing and, of course, a sense of humour. With these essential qualities, a comedy editor helps the director to stand aside for a moment or two and see the work with fresh eyes, which an experienced editor can bring. A good editor can work on his own, but works best together with a director, and as a team they can fine tune a performance. Conversely, whilst they can improve comic moments, they can also ruin them. I have learnt over the years as a performer to work closely with an editor, as they have a skill which can enhance the entire production.

### Neil Pittaway (Editor and Former Head of BBC Post-Production)
An editor is an arbiter, a new pair of eyes and ears, a solver of the impossible, a smoother of the ragged, a time- and finance-dependent project manager, an expert on the total production process, and quite often, a creator of a finished product way beyond the wildest dreams of the producer or their budget.

### Jon Plowman (Former Head of BBC Comedy)
A good editor is your production's best friend. He or she can make a good show look great and a great show look fantastic, but an editor's greatest trick is to make a bad show look passable, or even quite good. They can't change dross into gold; after all they're editors, not magicians!

### Brian Leveson and Paul Minett (Writers)
Every television production stands or falls by the quality of its editing. In sitcom particularly, it's vital that a comedic rhythm is maintained. It should be like a piece of music. It also helps to know about human nature. For instance, quite often the laugh is not going to be on the person cracking the gag, but on those reacting to the line. Great editors like Chris know this. Thanks for saving our scripts!

### Richard Boden (Producer, Director, and Director of Programmes at Delightful Industries)
Editing can be a strange way to spend the day, or several days, or several days and several evenings. You finish making a show and then find yourself in a small darkened room, usually with air

conditioning that either freezes you or leaves you falling into a heat-induced coma. So, you want to be sure you're working with an editor who is not only skilled at the technical side of the job [sort of a given, you hope!] but also someone who is creative, sensitive to the needs of the director as well as the writer—often the same person. As well, you rely on an editor to be able to be objective—be the viewers' eyes if you will. Having sweated over the show, you hope you've squeezed every drop there is to be squeezed to get the performance, but you're too close to the programme sometimes, and an editor who is brave enough to say that a moment isn't really working the way you've shot it and then adds 'but how about this' is so valuable.

Of course the editor who just tells you it isn't working but doesn't add the 'how about this' solution is pretty useless!

### John B. Hobbs (Producer and Director)

I had just finished filming a night shoot for 'Allo 'Allo! and was walking back to the unit base when Jeremy Lloyd, one of the series' writers, asked me whether I realised that that was the first time we've 'killed' any Germans on the show. I remember, after a little feeling of unease, replying to the effect that he had written the script, and indeed was alongside me when I filmed it. Despite this, I realised I had made a big mistake; 'Allo 'Allo! was, after all, a comedy. I assured Jeremy the next day, totally without any justification, that I could sort it out in the edit. That's what a good editor does—allows you to tell a white lie with complete confidence, that there is a solution, even though you have no idea of how to achieve it. Chris cleverly used matched bits of the grassy field to cover up the 'dead' bodies, and with a voiceover of 'Quick! Let's get out of here' from the fleeing and happily alive German soldiers that I had shot only with a camera. The sequence was saved, and with it, to a small extent, my reputation.

### Rob Gordon (Editor)

Any good director knows that allowing an editor the creative freedom to cut their pictures means they can get the best end result. A good editor will be sympathetic to a director's requirements, but present them in a way that maybe a director had not thought of. An experienced editor's visual cutting expertise can enhance the way a show is presented to the audience.

### Roy Gould (Comedy Director)

A director who has been working on a show from the script stage through rehearsals and into the studio can sometimes lose focus with what is important and what is not. A good editor who has not been involved with these other aspects of a production comes in with a fresh pair of eyes and ears and has not been tainted by everything else that has been going on beforehand, and will be able to help the director to sort out the wheat from the chaff.

### Chris Booth (Editor)

The editor is your first viewer; they carry with them an objectivity that you, the programme maker, doesn't have. They may well suggest things you abhor, simply because you have not seen that particular solution yourself. They bring a freshness of view that can contribute much to your programme, and they have the benefit of the experience of all the other programmes they have worked on.

Nowadays, editors are specialising in drama, in documentary, in light entertainment. Some say this is a good thing, but you lose the cross-fertilisation of ideas that can occur when, say, a light entertainment editor works on sport—the end result can win awards.

### Sydney Lotterby (Producer and Director)

I want an editor who I know wants to work on the sort of programmes I make. Ability and enthusiasm are the obvious principal attributes of a good editor, but hard on their heels is tact

and charm. An editor's skill is repairing by using the best retake, not necessarily the easiest, even sometimes using the sound from one take and vision from another—but that's where the skill lies.

The director is sometimes too close to the programme, and a good editor is often able to suggest time cuts if needed. All directors are possessive—it's their baby. When they are new, they want it cut their way; now's the time for an editor to be tactful—suggest but don't be dogmatic. Remember, once you've shown your skill and gained the director's confidence, you'll most likely be editing alone next time. Leaving a lot more time for the director to show his appreciation and buy you a drink!

### Gareth Gwenlan, OBE (Producer, Director, Former Head of Comedy at BBC Television, Managing Directory of Topcomedy Ltd)

A wise director will choose, as a matter of priority, an editor who is familiar and sympathetic to the style and expectations of the production.

A good editor will contribute editorially, lighten the load, and often inspire the director to make a better programme.

### David Hitchcock (Designer)

I hate editors; they cut out all the wide shots.

### John Bartlett (Producer)

Editing is a technical job, and an editor is a technician, assembling the writers', actors', and director's achievements into a preconceived whole. Genuinely top-class editing is all the foregoing, but then you have to add craft, artistry, a genuine and instinctive feel for the material, and the ability to transform what could be just a professionally produced programme into so much more.

### Ed Bye (Director)

A good editor can make your show better than you ever anticipated, often making the editing process the most enjoyable part of the production, and most times will get you out of the pooh.

### Nick Pitt (Editor)

My job as an editor is to give back more than I got; I aim to surprise the director (in a good way of course). My best work is done on my own, working at the rushes to give the best interpretation of the director's, producer's, and cast's intentions. This applies just as well in unscripted work, where the job is still to tell the story. Hopefully, when we get to the first viewing, the bulk of the work is already done.

### Nigel Bradley (Director of Photography)

As a DOP shooting on location, I see my role as providing the edit with the best kit of parts I possibly can, a bit like the components of a car. When I see the results on TV, a good editor will have miraculously transformed the footage into a Rolls Royce, always a pleasure to see!

### Paul Taylor (Tim in Chocolates and Champagne)

The care taken by everyone during the filming of Chocolates and Champagne to include as many options as possible for editing was remarkable. When we saw the finished film, I was amazed at the difference, even a slight change of shot made to the delivery of the dialogue.

### David Crossman (Director)

I was once accused of 'directing like an editor'. I regarded that as a compliment.

### Robyn Rogers (Editor)

Editors are key in shaping the all-important storyline in detail, whether it be documentary or drama; that's why they often make good producers or directors (Spielberg and Scorsese, for example, started in the cutting room).

### Penny Heighes (Editor)

We are there to be harsh with every frame, which has been lovingly shot and nurtured, but at the same time, we are there to ease the pain of casting it aside.

### Bernadette Darnell (Script Supervisor)

One of the first questions I ask is 'Who is the editor?'—you are SO important to my role!

### Andrew Marshall (Writer)

A great editor of a TV comedy is like a great orchestrator for a piece of music. Only they drink less.

### Julian Meers (Producer)

Editors don't just cut pictures, they require both creative and technical skills combined with huge patience, a degree in director psychology, greater aural than verbal senses, and a beady eye on the clock. Not much to ask really, but that's the gig.

### Barbara Hicks (Vision Mixer)

As a vision mixer, there is nothing worse than seeing random shots used from other cameras being slotted into a programme, however good the shots may be. A good editor is sympathetic to the style of the programme and takes over the baton from the studio vision mixer without trying to craft something different.

### Jon Bignold (Editor)

Editing works best when it is collaborative. A good editor can cast a fresh eye on a scene or an idea and see where its relevance or value lies, without the baggage of the effort which was required to bring it to fruition.

This is not just the negative business of throwing out stuff which no longer works; it can just as easily involve nurturing a fragile idea which the director may have dismissed as not working.

Editors are almost always heroic. Directors arrive with high hopes but have often had a difficult journey to get to the editing stage of the process. A good editor can help them to see how everything can work out in the end.

Editing can involve spending long hours in a dark room with the same person—perhaps for weeks or months on end. Not all personalities work well together under those circumstances. A good editor will find something other than film and TV to talk about. Working with an editor requires a certain amount of confidence and self-control. It involves giving them the space to be creative, whilst maintaining the sense that you care about it as much as they do. Editors somehow combine a fanatical approach to detail with a desire to go home on time.

### Dave Rixon (Editor and Creator of Video Mickey)

If an editor was not involved in the shoot, he or she is perhaps the best person to give the production team those valuable 'first impression' comments, for the viewer often sees the finished piece just once!

### Simon Frodsham (Managing Director of The Independent Post Company)

A good editor will always add to a programme, but what makes a good editor? The old adage that it's 20% about the kit and 80% about personality isn't that far from the truth. If you don't understand what the client wants to convey, all the technical ability in the world will not help you. It's that ability to match or exceed the client's vision that will ensure you are never without work. An ability to empathise with people is the first quality I look for in potential recruits to The Independent Post Company. Then comes technical ability, editorial judgement, and everything else.

### Lovett Bickford (Director)

Making a film or television programme is essentially a collective creative activity.

The director perhaps has the overall vision, then his production team go about realising that vision. Within that framework the editor is a crucial element, and many directors rely on them hugely. Many films (which will remain nameless—it's a fairly bitchy profession!) have been made in the editing suite. Indeed, many a director, not sure of what he wants, has shot scenes from every conceivable angle and shot size, and then left it to the editor to assemble and make the scene. Of course this is not always the case, but editors I would say are probably the key element in the finished product. A clever editor can very often get a director out of trouble if he has failed to cover a scene properly.

### Martin Baker (Editor)
The editor's role is valuable because they act as a bridge between the production team and the viewer. The editor is unlikely to be on the shoot and hopefully is not involved with any production politics, so they come to the footage with fresh eyes and bring a valuable independent perspective.

### Barry Stevens (Editor)
A video editor is a tailor, a chef, a carpenter, a shepherd, a nurse, a chemist, a memory bank, and many other things.

### Simon Hughes (Editor)
A good editor is like a good jazz drummer: he keeps time, determines the groove, and very occasionally there'll be a subtle solo. Most of the time, you won't know they're there.

### Paul Gartrell (Sound Supervisor)
An editor provides the conduit through which every technical, artistic, and creative shortfall is minimised.

### Shelly Fox (Bookings Manager, Suite TV, London)
The right editor is so important to the production and will make a very necessary contribution. From attending rehearsals, location and studio recordings, to understanding what the director and cast need to achieve. This is more than just pushing buttons, it's teamwork and making the director's vision come alive.

### Helen Lakey (Programme Compliance ITV)
It's all about two heads being better than one in achieving the desired end result. The key role of an editor, I believe, is to help a director make the good stuff look *amazing* and to be honest enough, as a friend, to suggest that the *so-so* stuff just isn't right for your final cut!

### David Colantuoni (Senior Director of Product Management at Avid)
Media Composer gives you the clearest career path to the top tier of the film and video industry, and we wish you every success on your journey.

## *Get Some In!*—Your Media Is Waiting

All that remains is to get the exercise clips into your editing software. It sounds so simple, doesn't it?

## *The Clip Show*—What the Exercise Clips Contain

All the media exercise clips come to you as a bunch of MOV files which are available for download with the purchase of this book from www.focalpress.com. A complete list of the MOVs appears in Appendix 2. They are named in accordance with the 52 exercises contained in the text. How you source the clips might change with time, but I am going to assume you now have them on (or near) your editing computer.

These MOV files are either rushes, exercise examples, or mix-downs of my versions of the individual editing exercises.

The numbers in parentheses are the source 'tape' numbers (01 to 16). These numbers, if allocated to your imported MOV files, will make the downloadable sequence timelines come alive if you drive an Avid. There is a complete list of instructions in Appendix 1.

The clips were originally shot at a resolution of DV 720 × 576, SD quality at 25 frames per second, with 48 kHz two-channel sound. Your editing software project settings should be set accordingly for their importation. In 'Avid speak' an import resolution of 4:1s produced good results with minimal loss of quality.

| Name | Length | Size | Subtitle | Bit rate |
|---|---|---|---|---|
| Ex 01-1 MCU M (12).mov | 00:00:10 | 37,777 KB | Chapter 1 Inserting a Shot | 1566kbps |
| Ex 01-2 MCU P (12).mov | 00:00:13 | 59,009 KB | Chapter 1 Inserting a Shot | 1592kbps |
| Ex 03-1 MCU T (04).mov | 00:00:09 | 35,407 KB | Chapter 2 Reaction Shots | 1631kbps |
| Ex 03-2 MCU H (04).mov | 00:00:08 | 33,186 KB | Chapter 2 Reaction Shots | 1529kbps |
| Ex 04-1 WS 2S (12).mov | 00:00:08 | 31,447 KB | Chapter 2 Cutaways 1 | 1628kbps |
| Ex 04-2 Trophies (12).mov | 00:00:06 | 22,224 KB | Chapter 2 Cutaways 1 | 1536kbps |
| Ex 05-1 M2S T & H (04).mov | 00:00:27 | 101,027 KB | Chapter 2 Cutaways 2 | 1551kbps |
| Ex 05-2 Laptop LS (05).mov | 00:00:16 | 57,802 KB | Chapter 2 Cutaways 2 | |
| Ex 05-3 Radio SW (05).mov | 00:00:02 | 10,967 KB | Chapter 2 Cutaways 2 | 1515kbps |
| Ex 05-4 Cursor (05).mov | 00:00:15 | 68,803 KB | Chapter 2 Cutaways 2 | 1609kbps |
| Ex 05-5 CU Play (05).mov | 00:00:15 | 57,478 KB | Chapter 2 Cutaways 2 | 1589kbps |
| Ex 05-6 Listen (05).mov | 00:00:07 | 37,993 KB | Chapter 2 Cutaways 2 | 1623kbps |
| Ex 05-7 Radio VO (16).mov | 00:00:25 | 4,755 KB | Chapter 2 Cutaways 2 | 1555kbps |
| Ex 06-1 WS H (02).mov | 00:00:22 | 84,141 KB | Chapter 2 Locked Off Shots | 1586kbps |
| Ex 08-1 MCU H (02).mov | 00:01:07 | 250,929 KB | Chapter 3 Crossing the Li... | 1553kbps |
| Ex 08-2 MCU C Flop (03).mov | 00:00:48 | 182,497 KB | Chapter 3 Crossing the Li... | 1538kbps |
| Ex 08-3 MCU C Norm (03).mov | 00:00:48 | 182,497 KB | Chapter 3 Crossing the Li... | 1538kbps |
| Ex 08-4 MS H OS C (02).mov | 00:00:35 | 130,715 KB | Chapter 3 Crossing the Li... | 1548kbps |
| Ex 08-5 MCU H OS C (02).mov | 00:00:46 | 175,239 KB | Chapter 3 Crossing the Li... | 1540kbps |
| Ex 10-1 The Photo (12).mov | 00:00:04 | 16,751 KB | Chapter 3 Repeated Action | 1735kbps |
| Ex 10-2 M & Photo (13).mov | 00:00:09 | 35,563 KB | Chapter 3 Repeated Action | 1638kbps |
| Ex 10-3 MCU P (12).mov | 00:00:07 | 36,013 KB | Chapter 3 Repeated Action | 1597kbps |
| Ex 10-4 MCU M (13).mov | 00:00:05 | 18,528 KB | Chapter 3 Repeated Action | 1536kbps |
| Ex 11-1 M & Photo (13).mov | 00:00:09 | 33,933 KB | Chapter 3 Movement 1 | 1563kbps |
| Ex 11-2 Sq 2S Sofa (12).mov | 00:00:09 | 33,637 KB | Chapter 3 Movement 1 | 1549kbps |
| Ex 11-3 W2S P up (13).mov | 00:00:10 | 39,555 KB | Chapter 3 Movement 1 | 1640kbps |

SOME 'RAW FOOTAGE' MOV CLIPS BEFORE IMPORTATION.

The latter are identified by 'CUT' in their file names. The rushes include raw camera footage, sound effects, or music.

The 52 exercises associated with this publication divide into two different types. The first type of exercise requires you only to look at some clips, which will illustrate the point I am explaining. The second type are real 'have a go' exercises, with raw footage for you to cut together yourself. As I promised, after you've had a go, you will be able to see what I did with those same clips to solve the problem of their assembly. Sometimes I also include alternative versions of the cut to illustrate how poor the material can look in the wrong hands.

All file names are made deliberately short, such that *Exercise 5, Shot 5 Close-Up Play Button (Tape 5) from Chapter 2* is abbreviated to *Ex 05-5 CU Play (05)*.

For the least technically minded, you can get started straight away by opening a new project, setting up a bin, and simply importing the MOV files into your editing software. Proceed to edit the source clips of the individual exercises and produce a sequence of your own. Once this is done, you can then look at the relevant MOV file for my cut version of the sequence ('CUT' in the file name) and see how I put the shots together.

In Appendix 1 you will find detailed instructions of how to get the MOV files into various editing software packages such as Avid Media Composer, Adobe Premiere Pro, and Final Cut Pro.

Because my sequences were cut on an Avid, importation into another Avid is easier. In order to get my cut sequences into

Premiere Pro or Final Cut Pro, you have to go via an edit decision list (EDL), a bunch of which I have provided. This will also work (I hope) if your editing software is not included in the previous list.

At the time of writing, Final Cut Pro X cannot import EDLs directly, but there is a workaround. Appendix 1 will explain more.

### 🎬 *Fresh Fields*—The First Exercise

Here is the first of the 52 exercises contained in this book. The format will become very familiar to you as you progress through the text.

Each exercise starts with a list of the *shots involved*, the contained *dialogue* and the *exercise aim*.

As I have already explained, the numbers in parentheses after the shot name are the source tape numbers. Appendix 1 has full details of their relevance.

Next there is a *questions* section about the exercise, which highlights points to consider as you start editing the footage. Finally, there is an *answers* section, where I go through some points of interest that are thrown up by the exercise and discuss the finer points of technique. Where appropriate, I will give you good and bad versions of the cut, so you can see the range of assembly possibilities.

Over to you! Have a go at this simple exercise, Exercise 1 Inserting a Shot.

# EXERCISE 1: INSERTING A SHOT

## Shots Involved:

1 MCU M (12)
2 MCU P (12)

## Dialogue:

*MARK:*

Perhaps, if Dad had seen us together more, happily grown up, perhaps it would have helped him to make the link between the filmed images of the past and the present.

## Exercise Aim:

Mark does all the talking here, but it would be boring to stay on him for all his speech without seeing Philip at all. The aim of this exercise is to insert a shot of Philip into Mark's speech, to show that Philip agrees with what Mark is putting forward.

Have a go and insert a reaction shot. We will discuss this and other techniques more fully later on, but I want you to just make a start and prove the system works.

## Questions:

When do you cut to Philip?
What bit of Philip's shot should you use?
When should you cut back to Mark?

## Answers:

How did you get on? Even with the simple insertion of a vision reaction there are many ways of getting it right, and even more ways of getting it wrong.

You have my *good* and *bad* versions of this sequence to consider. The main difference between them is that in the good version, Mark's remarks are clearly being taken in by Philip, as he is reacting more naturally and eye contact between the brothers is better maintained than in the bad version.

Have another look and you'll see what I mean. Don't worry if that was all a bit too much, too quickly; we will be considering this technique in more detail later on.

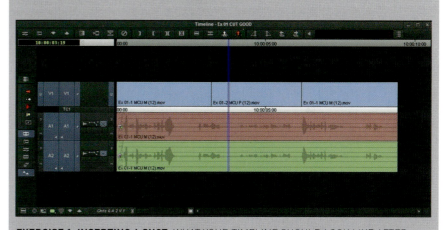

**EXERCISE 1: INSERTING A SHOT.** WHAT YOUR TIMELINE SHOULD LOOK LIKE AFTER YOU HAVE INSERTED PHILIP'S REACTION [2 MCU P (12)] INTO MARK'S SPEECH [1 MCU M (12)].

## 1.7 How to Join This Happy Band

🎬 *Tooled Up*—Get to Know the Tricks of the Craft

This book will build you a tool kit that will allow you to create, construct, or repair any programme material thrown at you. It will enable you to be more creative and valuable to an industry that recognises such talent with cash.

🎬 *MasterClass*—Compare Your Work with Mine

The ironic fact is, even though editing software is everywhere these days, even on mobile phones, there are now far fewer opportunities to inherit the skills and techniques from experienced editors, as I did. This is your opportunity to sit alongside me, as we both tackle real programme material.

**I will help you to:**
- Understand different types of shots, and start joining them together.
- Understand editing's 'dos and don'ts' and know when to break the rules.
- Start to transform shots into scenes that tell stories.
- Be creative with scene transitions.
- Create specialised montages, like dream and action sequences.
- Be clever when balancing sound, which will be both natural and realistic.
- Edit music and learn to cut Madonna, Coldplay, or Tchaikovsky down to size.
- Be inventive with video effects, which will make your edits sparkle.
- Create graphics and be stylish with titles, captions, and rollers (scrolls in the US).
- Understand editorial and compliance issues and learn about editorial responsibility.
- Start to think like a real editor.
- Make a better impression at your next interview.
- Create a CV, which might just be read or watched.

**At all stages you can:**
- Use professionally shot material to make real sequences.
- Learn at your own pace.
- Compare your work with what I did.
- See how the techniques we examine are used in the movies.

# Chapter 2
# Shots, Our Building Blocks

Before you tackle any job, you need to gather together the tools and raw materials that will enable you to do that job. Editing is no different. Our raw material (and sometimes it's very raw!) is in the form of photographed shots, and our tools are the skills with which we put those shots together.

First of all, let's have a look at the range of the types of shots which might be presented to us and how we might describe and categorise them.

This chapter is divided as follows:

- **2.1 Shot Sizes**—This describes the framing, or content, of individual shots, thus we talk of close-ups or wide shots.
- **2.2 How the Shot Moves**—This describes the way the shot develops from its start to its finish, such as tracking, panning, or tilting.
- **2.3 What the Shot Does**—This describes the shot's role when it is used as part of a sequence, for example, an establisher, a reaction shot, or a cutaway.
- **2.4 Special Shots**—Here, I look at shots designed for specific and unique occasions.

## 2.1  Shot Sizes

To start with, this section concentrates only on the framing, or content, of the shot and not its ultimate use in a sequence.

Let's start with the most common size of shots, especially if the content of the scene is dialogue.

🎬 *Who Framed Roger Rabbit?*—Introducing Shot Sizes

I will let Video Mickey model the different viewpoints.

face or object, and therefore they do not include much of the background. They are used to show a specific detail, such as misty, tearful eyes or a hint of a smile, that would otherwise go unnoticed in wider shots.

Close-ups are used more often in TV productions than in movies. This used to be to compensate for the lower resolution of a TV picture; however, with the advent of HD TV, the need for so many close-ups may decline, though I've not seen any evidence of this yet. Actually, quite the reverse seems to be happening, because it's the movies, now edited on small screens, which are piling in many more close-ups.

First, let's look at the shots that are most commonly used to photograph the human (sorry, rat-like) face and body.

 **Mid-Shots (MS)**

### Close-Up (CU)

A *close-up,* or CU, tightly frames a person's face (or an object) to fill the whole frame. Close-ups display the most detail in that

*Mid-shots* (MS) are generally framed down to the waist, and therefore not as good at showing facial expressions, but they work well to show body language.

### 🎬 Medium Close-Up (MCU)

A *medium close-up*, or MCU, frames the subject's head and shoulders; it's halfway between a mid-shot and a close-up. It is probably the most commonly used shot where spoken dialogue is involved.

### 🎬 Over-Shoulder Shot (OS)

You're not going to believe this, but an *over-shoulder shot* (OS) is a shot of someone, or something, taken from over the shoulder of another person. The back of a head, and perhaps part of a shoulder, are used to frame the image of whomever (or whatever) the camera is pointing towards. This type of shot is closest to the eyeline between two characters or groups of characters. Being so close to the eyeline, the shot allows more of the opposing face to be shown.

### 🎬 Long Shot (LS) or Full-Length Shot

A *long shot* (LS) is a slightly vague term. The question is, how long is long? A long shot of a person is a very different size of shot from a long shot of a building. Sometimes, this type of shot is more properly referred to as a *full-length shot*.

### 🎬 *Extreme Close-Up (ECU or XCU)*

*Extreme close-ups* (ECUs or XCUs) are framed so tightly that only a fraction of an object or face is the focus of attention, such as a person's eyes or mouth.

Actors are naturally nervous about this size of shot, because of the detail it can show, such as pimples, spots and fillings. Mickey seems to have no such reservations!

### 🎬 *Wide Shot (WS)*

Sometimes referred to as a full shot, a *wide shot,* or WS, typically shows the entire setting, with the intention of placing characters or objects in some relation to their surroundings.

Again, we have the problem of how wide is wide? The answer is that it depends on the shots in the sequence that surrounds the shot in question. A wide shot of the planet earth would be considered very wide indeed if the rest of the action is contained in a domestic environment, but it would be completely normal if our sequence was set in interstellar space.

Don't worry too much about this terminology; it will become second nature to use the term most appropriate for the situation.

## High-Angle Shot (HA)

A *high-angle shot*, or HA, is photographed with the camera located above head height, and thus the shot is angled downwards.

This shot is sometimes used in scenes of confrontation to show dominance over an opponent. The subject of a high-angle shot is made to look vulnerable or insignificant.

## Low-Angle Shot (LA)

A *low-angle shot*, or LA, is a shot from a camera positioned low on the vertical axis, often at knee height, looking up.

Again, like the high-angle shot, the shot is used in scenes of confrontation. In terms of objects, this type of shot exaggerates the importance, and certainly the size, of that person, object, or building.

### 🎬 Two-Shots, Three-Shots . . . (2S, 3S)

A *two-shot* or *three-shot* simply describes the number of people framed in the shot. It greatly simplifies shot description to define the shot by how many people are actually in it; thus we get the terms two-shots, three-shots, singles, and so forth.

You'll soon meet the phrase *two-shot favouring X or Y* (2S FAV X or Y). This simply means a shot that frames two people (X and Y) that is pointing more towards X than Y. This usually means it shows more of X's face compared with Y's.

I'll just leave that in the air for now, as you all must be getting fed up with all this schoolwork, especially now that algebra seems to be creeping into the lesson.

### 🎬 Reverse Angle Shot

Imagine two characters on a park bench. Most of the action is usually photographed from the front as they chat together. The scene might end with a shot from behind them, showing the backs of their heads and the view they have been enjoying. This is a *reverse angle* shot.

Here the camera is positioned behind the action and framed to contain the characters previously seen from the front (or vice versa). Thus, the camera has been repositioned by about 180° from its previous position, with respect to the subjects.

See also the discussion about 'crossing the line' in Chapter 3.

### 🎬 A Shot in the Dark—Shot Names

It's high time for an exercise. This time it's just a few clips for you to look at. It's called Exercise 2: Shot Names.

## EXERCISE 2: SHOT NAMES

For this exercise, search among the MOV files that accompany this publication and you will find four files named: Ex 2 Example 1, Ex 2 Example 2, Ex 2 Example 3, Ex 2 Example 4. These clips are exports of four sequences containing a variety of shots with their shot names (or descriptions) superimposed. Give them a watch and I'm sure the preceding (and slightly boring) list that you've just gone through will make more sense.

These clips also give a hint of what is to come, where a shot can also be categorised by what it is doing in the sequence.

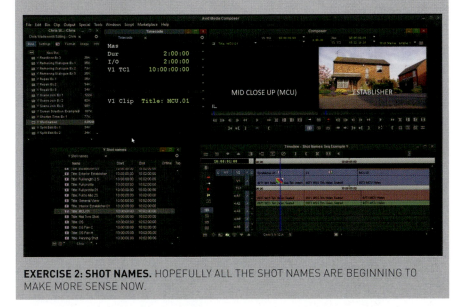

**EXERCISE 2: SHOT NAMES.** HOPEFULLY ALL THE SHOT NAMES ARE BEGINNING TO MAKE MORE SENSE NOW.

## 2.2  How the Shot Moves

Shots can also be categorised by how they move or develop. This usually involves describing how the camera was moved during the filming of that shot.

### *Movin' On*—A Tracking Shot

A *tracking shot*, also known as a *dolly shot*, is a shot taken from a camera mounted on a wheeled platform (or dolly) that is pushed on rails (or tracks). You can 'track in' on a stationary subject for emphasis or 'track out' to reveal more of any surroundings, or even track beside a moving object. Dollies with hydraulic arms can also smoothly 'boom' or 'jib' the camera up and down several feet on a vertical plane at the same time as any track.

### *Horizon*—Panning Shots

A *panning shot* is where the camera is moved in a predominately horizontal plane in either direction, hence the terms 'pan left' and 'pan right'.

The main problem with this shot (and you see this too often in material shot by amateurs) is that they are very difficult to shorten. Cutting while a camera is still in motion can look awkward, especially if all shots that surround the pan are still and framed for little movement.

### *Up North*—Tilting Shots

A *tilting shot* is where the camera is moved in a predominately vertical plane, generating terms like 'tilting up' or 'tilting down'.

### *Trigger-Happy TV*—Hand-Held Shots

A *hand-held shot*, just as the name suggests, is where the camera is off its mount and in the hands of the camera operator. There is a growing trend, especially in drama and documentary programmes,

to shoot more scenes this way. With the advent of Steadicam mounts (a sort of counterbalanced mount carried by the operator), these shots can look great, and you can now easily produce acceptable coverage of a conversation on the move, which would have meant, until quite recently, the laying of long lengths of track.

On the downside, I've seen some exaggerated hand-held coverage with absurdly intentional camera movements, which only serve as a distraction. Just look at the first series of the BBC's *This Life*, and you'll see what I mean.

### 🎬 *Bob the Builder*—A Crane Shot

A *crane shot* is a shot taken by a camera on a crane—no kidding! The crane, or 'cherry-picker', allows the camera to view the actors from above or to move up and away from them, producing a common, if not clichéd, way of ending a movie. Most cranes accommodate both camera and operator, but some can be operated by remote control.

The use of a crane on a golf tournament, for example, will allow each camera to cover the action on several holes.

### 🎬 *Bird's Eye View*—Aerial Shots

*Aerial shots* are usually shot with a camera attached to a special mount that can be installed in a helicopter, light aircraft, or airship in order to view wide landscapes. Today, remote-controlled drones can also provide such a filming platform. This sort of shot would clearly be restricted to exterior locations. Clever camera mounts can virtually eliminate the vibration associated with such shooting.

If the aerial shot is of a character or group of characters, it can make them seem insignificant or vulnerable. Alfred Hitchcock

loved using these shots, even at moments of high drama, thereby intentionally cutting away from the close action to see his characters reacting like ants to the situation. The escaping petrol catching fire in *The Birds* (1963) is a good example of his technique here.

Incidentally, talking of birds, the shot is often referred to as a *bird's-eye shot*.

## 2.3  What the Shot Does

I think you'll find the worst is over, and we'll soon be graduating from the classroom. Just before we do, we need to talk about what a particular shot does in relation to others which make up a sequence.

THE CANVAS WINDOW IN VERSION 6 OF FINAL CUT PRO. THAT'S ME ON THE TRAIN BY THE WAY!

## First Report—Establishing Shots

An *establishing shot* sets up a scene's location and its participants, or to put it academically, its 'spatial continuity' . . . yuck! Establishers enable subsequent closer shots to fit into the 'space' already created by the establisher . . . yuck again! For example, the use of an exterior shot of a building at night followed by an interior shot of people talking implies that the conversation is taking place inside that building and it's night-time. We, as viewers, are so easily convinced.

Where would those classic American TV series of the recent past, such as *Dallas*, *Ironside*, or *Dynasty*, be without a zoom in to a window of a building, followed by a cut inside to find J.R., Chief Ironside, or Alexis Carrington in full flow?

Typically, an establisher is placed at or near the beginning of a scene, indicating where, and sometimes when, the remainder of the scene takes place. The same shot can be used again at any time in the body of the scene to reestablish the geography. This might be necessary after a complex sequence of cuts and movements that may have disorientated the audience. The establisher's reappearance informs us of the new status quo.

An establishing shot may also establish a concept rather than a location, for example a time of the year, or Christmas, or simply a change in the weather.

As audiences grow ever more sophisticated, it is increasingly fashionable to skip the establishing shot at the start of a scene in order to move the story along more quickly and instead to drop it in later.

## Blott on the Landscape—General Views (GVs)

*General views*, or GVs, are shots of a general nature which can be used to set a scene or establish a location—establishers, in other words. Well, not quite. They distinguish themselves from establishers by the fact that they are shots taken during the filming process that might not have any specific use at the time of filming but are worth shooting anyway. They might end up in a montage, or some future title sequence, or act as breathers or segues between constructed scenes.

GVs are the type of shots that documentary filmmakers shoot all the time to allow a future edit to have as many options as possible. It's better to run off a few feet of this or that now rather than to have to go back and reshoot. The sad fact is, however

THE FRONT PANEL OF A SONY DIGIBETA TAPE MACHINE.

many GVs are shot at the time of filming, there will never be as many as you want in the edit suite. It's the same with cutaways, no editor has ever complained about there being too many.

### 🎬 *Wacko!*—Master Shots

A *master shot* is camera coverage of an entire scene or sequence of events from start to finish. It is photographed from an angle that keeps all or most of the action in view. It is, by its very nature, a wide shot, and it can sometimes perform a double function as an establishing shot . . . yes, that again!

Usually, the master shot is the first shot ticked-off during the shooting process, and it is the foundation of subsequent camera coverage. Alternative closer shots can (and will) produce better coverage of specific moments later in the scene.

### 🎬 *Money Box*—A Money Shot

A *money shot* (also called a *money-making shot*) is a provocative, sensational, or memorable sequence in a film. In other words, it is a shot on which the film's commercial success is expected to depend.

Borrowing the meaning from the pornographic film industry (yes, you've guessed it), the term is used to refer to a highly anticipated or satisfying climax . . . I will say no more!

Mainstream filmmakers generally use the term money shot as slang for the image that costs the most money to produce.

### 🎬 *The Golden Shot*—A Pack-Shot

A *pack-shot* is the shot in a commercial that shows a close-up of the product itself. A close-up lens is therefore sometimes called a pack-shot lens. Every advert or promotion has one of these; it's the 'ding' shot of the tube of toothpaste, or the ice going into the gin and tonic, or a cat licking its lips next to the new variety of cat food.

### 🎬 *Points of View*—A Point of View Shot (POV)

A *point of view shot* (POV) is a shot seen from the point of view of the actor. It's as though we, the viewers, are looking through the performer's eyes and seeing what he or she sees. Sometimes the POV can be taken from over the shoulder of the character whose viewpoint we are seeing.

Imagine coverage of a character walking up to a cliff edge. A shot swooping round the back of this character can still be considered a POV shot, as it achieves the same result of enabling us to see the character's viewpoint.

When an animal or alien is the featured character, the POV shot will usually be treated to look distorted and/or strangely coloured to match whatever the creature is seeing.

DALEK POV

The view through a Dalek's eyepiece in *Doctor Who* is a good example of this technique. Here, the shot is typically tinted, geometrically distorted, with a target sight and range-finding data superimposed, and it pans around to match the movement of the Dalek's eyepiece.

### 🎬 *Look Back in Anger*—A Reaction Shot

A *reaction shot* is a shot that cuts away from the main source of drama in a scene to show us an emotional response to that drama.

The framing of a reaction shot is most commonly a close-up, although a group of actors may also be shown reacting together. The reaction shot is generally bereft of any dialogue of its own, though this is not an absolute rule. Reaction shots are essential in comedy sequences, as the reaction of an actor (or actors) to a comedic incident provides a cue to the audience about how to respond to that incident. It makes it funnier, in other words. In some cases, the deliberate avoidance of showing reaction shots can be used by an editor to dramatic effect.

Reaction shots help keep the audience in contact with the ebbs and flows of the changing emotions of *all* the characters in a scene, whether speaking or not—the 'doers' and the 'done-to'. Reaction shots are in essence emotional multipliers, making the funny funnier, the sad sadder, and the scary scarier.

It's high time for an exercise after all that classroom stuff.

Now, as with all these exercises, you can cheat just by looking at my cut sequences, but I would encourage you to take the time and try to create a sequence of your own, and only then look at my version.

Have a go at Exercise 3: Reaction Shots.

## EXERCISE 3: REACTION SHOTS

**Shots Involved:**
```
1 MCU T (04)
2 MCU H (04)
```

**Dialogue:**

*TIM:*
Well, there can't be many 'Helen and Joe Hardings' living in Kingston, Surrey, can there? And this Joe is also trying to make amends for being away so often. It's you two!

**Exercise Aim:**
We need to see Helen be convinced and agree with what Tim has just said. The timing of this reaction shot must look totally natural.

**Questions:**
When do you cut to Helen?
What bit of Helen's shot should you use?
When do you cut back to Tim?
Can any improvements be made to the timing of Tim's speech?

**Answers:**
Helen doesn't give us much, but there is a moment when her face lights up, and it's this that has to be timed to Tim's line 'Can there?' This just begs for a reaction. The audience needs to know Helen has taken the point. At the same time, a trim can be made to Tim's next line. Also, in order to give Helen a little longer on screen, Tim's 'And' can be on Helen's face.

Incidentally, Tim gives a strange pause between 'living in' and 'Kingston Surrey', so if you cut early to Helen, this can be tightened up and put right.

I have included good and bad versions of this sequence for you to compare with your version.

### 🎬 *Don't Look Now*—Cutaway Shots

A *cutaway* is where a reaction shot, or at any rate a different shot, is inserted to enable a time-shortening edit to be achieved in the action or soundtrack.

The term cutaway is more commonly used in TV production rather than filmmaking. A cutaway is therefore used to allow an edit to be made in the dialogue track, during which we, the audience, can look either at the person receiving the information or, alternately, something else relating to their conversation.

For example, in a programme about antiques, say, many cutaways are shot in order to cut down the chat about an object, usually with the object in question acting as the source of the cutaways. This helps in two ways: first, to enable edits to be made in the dialogue, and second, to give the audience a better look at the priceless painting before it is sold.

Cutaways in TV news interviews are sometimes referred to as *noddies.* This is because the shot often photographs the reporter nodding away to what the interviewee has just said.

Careful choice of the best noddy is a skill you will have to acquire. It makes a huge difference to the naturalness of a piece to get this right.

I will take another look at noddies and the use of good cutaway techniques in Chapter 5, but for now, here is an exercise involving cutaways to start you off.

Exercise 4: Cutaways 1 awaits your attention.

## EXERCISE 4: CUTAWAYS 1

**Shots Involved:**

1 WS 2S (12)
2 Trophies (12)

**Dialogue:**

*MARK:*
Derek was Dad's old golfing partner, wasn't he?

*PHILIP:*
Look at all his trophies. I ought to have shares in 'Silvo' or 'Duraglit'.

**Exercise Aim:**

The aim of this exercise is to position the cutaway shot of the trophies in the best place with regard to the action in the wide shot.

**Questions:**

When is the best time to see the trophies?
How long do you stay on them?
At what point do you cut back to the wide two-shot?

**Answers:**

The important point here is to use the head turns the actors have given you. Wait for Mark to turn and then cut. We will know where, and at what, he is looking if you let him motivate the cut. Also, Mark makes an odd noise, a sort of an 'ah'. Personally, I think it sounds better without it. The great thing about cutaways is that as soon as you are on their vision, you can do what you like with the sound underneath.

**EXERCISE 4: CUTAWAYS 1.** THEY TURN, AND YOU CUT TO SEE AT WHAT THEY ARE LOOKING.

```
I come back to the two-shot to see Mark's head
turn back to Philip, as you really don't need
to stay on the trophies for too long. Also,
it's good to get back for the 'Silvo' line.

You again have good and bad versions to
look at.
```

### Look Who's Talking—More on Cutaways

Here's another exercise to demonstrate how to deal with cutaway vision that illustrates dialogue.

In this example, you have a variety of shots to punctuate Tim's verbal explanation of what he is doing with a computer. Sequences of this kind, where you are painting a dialogue track, can look very literal and plonky if you illustrate every single point with a visual cutaway. You have to create a balance between subject and object.

### The Frost Report (BBC TV) (1966)—The Lord Privy Seal Sketch

Just before you do the exercise, there was a great *Frost Report* sketch (BBC, 1966) called 'Lord Privy Seal' which illustrates my point about visual cutaways admirably.

Dig it out on the Internet and have a watch. I just love that second smiling shot of the then Prime Minister, Harold Wilson.

Now have a go at Exercise 5: Cutaways 2.

```
EXERCISE 5: CUTAWAYS 2

Shots Involved:
  1 M2S T & H (04)
  2 Laptop LS (05)
  3 Radio SW (05)
```

4 Cursor (05)
5 CU Play (05)
6 Listen (05)
7 Radio VO (16)

## Dialogue:

*TIM:*

Now, all you've got to do is select the 'Sunday Lovers Show', (PAUSE) then hit 'Listen Again'. Now, you were on just before the news; so if I fast forward to roughly here, we should be able to hear your bit.

WE HEAR KEN CASEY IN THE MIDDLE OF READING OUT JOE'S LETTER.

*TIM:*

Bull's-eye! Ken Casey reading Joe's letter out.

## Exercise Aim:

The aim here is to place the cutaways provided in the best place with regard to the dialogue.

## Questions:

What cutaway shots should you use?
What bits match the action most closely?
Do you need all of the cutaways?

## Answers:

You have only one shot that includes the dialogue, and the selection of what to illustrate is very much up to personal choice.

Once on a cutaway, you can of course tighten the sound that it covers. I lost Tim's word 'roughly', as it holds the action up too much, and the graphics aren't great at this point.

When Tim finally hits 'Play', never start any such voice over at the beginning of a sentence—it would never happen in real life, so take the opportunity of clipping the front of a word to give the impression of the random nature of the exercise.

**EXERCISE 5: CUTAWAYS 2.** THE CUTAWAY TO THE COMPUTER WILL SHOW US WHAT THEY ARE VIEWING, BUT AT THE EXPENSE OF NOT SEEING THEM.

## 2.4 Special Shots

### 🎬 *On the Move*—Locked-Off Shots

A *locked-off shot* is where the camera mount and pedestal are physically locked in one position. All adjustments to the camera's lens must be out of bounds when shooting such a shot. If they do have to be altered, then they must be returned to exactly the same setting; otherwise, what should be invisible in a future edit session will turn horribly visible and cost much more time and money to repair.

If the shot is successfully photographed, then invisible jump cuts can be performed anywhere in that fixed image. Magical appearance and disappearance effects can be created by the editor by jumping between characters present and absent in the locked-off shot. Ghostly half images, where a foreground character is seen to be semitransparent, can be created in a similar way by mixing or superimposing the shots with and without the character concerned in view.

Modern computer-driven mounts can allow the camera to perform shot adjustments in a totally repeatable way. With this feature, as you'd imagine, you can create magnificent multilayered shots without the need to resort to computer graphics. The drawback is such a mount is very expensive.

Here is an exercise, Exercise 6: Locked-Off Shots.

### EXERCISE 6: LOCKED-OFF SHOTS

**Shots Involved:**

1 WS H (02)

**Dialogue:**

None.

**Exercise Aim:**

Be creative! Just have fun.
Mix her in, jump her about. Fast then slow, anything you like.

**Questions:**

I suppose the question to ask is: What effect is most appropriate for your scene?

**Answers:**

All I did here is bring Helen in four times with some travelling wipes. Not very clever, I'll admit, but still quite funny. I like the repeated sound of the toy going back into the shed.
I am sure you did better.

**EXERCISE 6: LOCKED-OFF SHOTS.** AH! THE FUN YOU CAN HAVE WITH LOCKED-OFF SHOTS.

### 🎬 *The Fix*—Plate Shots

Occasionally, the machinery of film and TV production has to be contained within a shot alongside the actors purely because, for whatever reason, it has to be there. Boom poles and lights are possible examples of what I mean. A *plate shot* is a shot that doesn't contain any of this machinery or even performing actors; it is therefore a background shot.

A director will shoot a plate shot with the offending equipment removed, in order that in post-production, a wipe can be set up around the offending kit and a composite image produced that excludes such machinery. You've probably guessed it, but the camera would not be allowed to move between the shooting of the real action and the plate shot, unless of course the camera is on a computer-driven mount that ensures it tracks and moves in exactly the same way each time the shot is attempted.

### 🎬 *The Glass Ceiling*—Glass Shots

A *glass shot* is an economical, if not old-fashioned, method of producing elaborate-looking sets without actually building them.

A sheet of glass is painted with aspects of the set and scenery on it, usually at the extremities of the framed shot. This could be a ceiling that complements the rest of the photographed picture. The painted glass sheet is placed between the camera and the real set so that a composite picture is formed. Actors can perform freely, provided they don't stray into areas that are obscured by the paint. The technique can also be used to hide objects that are immoveable and unwanted in the shot.

Nowadays, you'd more probably turn to your friendly CGI operator rather than getting your paint brush out.

### 🎬 *Enough*—Phew!

You'll be glad to know that's it for shot descriptions. All we have to do now is glue some of them together.

Sadly, just as with self-assembly furniture, this can be a bit tricky to do. I hope the next chapter will help.

# Chapter 3
# Joining Shots Together

So far we have examined shots as individual jigsaw pieces; now let's put some of the puzzle together.

In this chapter, you'll see how individual shots can be made into simple sequences that tell stories, create moods, entertain, and inform us in an enhanced way, much more than individual shots could ever achieve on their own.

This chapter is divided as follows:

- **3.1 The Mechanics**
- **3.2 Joining Shots Together, the Don'ts**
- **3.3 Key Points—Joining Shots Together, the Don'ts**
- **3.4 Joining Shots Together, the Dos**
- **3.5 Key Points—Joining Shots Together, the Dos**

Let's start with the mechanics.

## 3.1  The Mechanics

This is going to get frighteningly near an editing software manual, but I will do my best to keep focused on technique.

### ▰ *Triangle*—An Introduction to Three-Point Editing

*Three-point editing* is fundamental to the concept of nonlinear editing and associated software packages. I will explain.

The simplest example of three-point editing is where you mark an 'in' and an 'out' on some source material and choose where it is to go in your sequence by marking another 'in' point. The section of the marked source clip (from in to out) will be placed in the sequence, starting from the marked 'in'.

You noticed I said 'will be placed' because I want to ignore, for the moment, the timeline functions of 'insert' or 'replace'.

So the rule is, in order to achieve a predictable edit, you have to set up three points that are shared in some way between the source clip and the sequence. These three points (a combination of ins and outs) can be allocated differently between the clip and the sequence, depending on what you want to do. Given that the software is obliged and programed to match first 'in' to 'in', or in this pair's absence, 'out' to 'out', then a predictable edit will result from just three marked points.

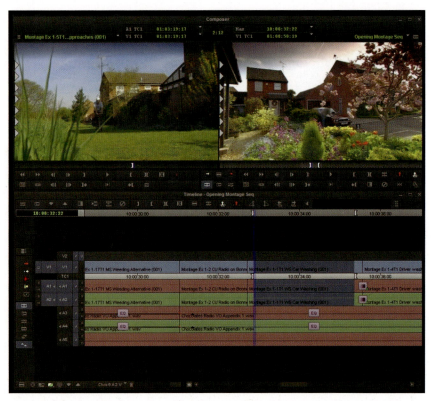

A SCREENSHOT OF AVID MEDIA COMPOSER SHOWING AN 'IN' ON A PICTURE SOURCE (LHS) AND AN 'IN' AND AN 'OUT' ON THE SEQUENCE (RHS). THE NEW PICTURE (V1), WITH ITS SOUND (A1, A2), WILL BE DROPPED IN OVER WHAT EXISTS AT PRESENT IN THE TIMELINE WITH THE TWO 'INS' SYNCHRONISED.

Of course, all of the above applies equally well to audio clips as well as video.

That's it, really. Ladies and gentlemen, I give you three-point editing.

## 3.2 Joining Shots Together, the Don'ts

If you get to know the rules now, you'll be more confident when you break them later on.

Here I examine some common *don'ts*, namely:

- Jump cuts
- Crossing the line
- Screen direction
- Jumping frame
- Two-shot to two-shot
- Repeated or double action

### Show Jumping from Hickstead—Jump Cuts . . . Nice or Nasty

If a cut is made in the middle of a moving shot and the resulting halves are joined together, this will create a *jump cut*. As a result, people and objects will jump across the join as what used to be continuous time passes in an instant.

A jump cut (or what looks like one) can also be produced if two sequential shots of the same subject are taken from camera positions that are too close together. As a rule, if the camera positions are separated by less than 30° and framing similar-sized shots, a viewer experiences the cut as a jump rather than as a change of viewpoint.

In real life, our brains turn the vision from our panning cameras (our eyes) into cuts by making us blink or by temporally blinding us to the image from our panning eyes and presenting a cut to our senses.

Jump cuts are considered against the rules of traditional continuity editing, which aims to give the appearance of continuous time and space. Jump cuts, by their very existence, will draw attention to the constructed nature of the shooting.

Even though I would caution against the use of this type of edit at the moment, it can be used to great effect to emphasise the discontinuity between two shots, or more often several shots, as jump cuts tend to work better in groups.

In many recent productions, jump cuts, or near jump cuts, are the house style, and this, combined with cutting while the often hand-held camera is still on the move, gives a greater sense of reality to the coverage. We, the audience, are made to experience the scene as though we were onlookers in the actual room and not remote viewers in the stalls or circle of a cinema.

## *What's My Line?*—Crossing the Line, or the 180° Rule

*Crossing the line*, or the *180° rule*, as it is known, states that two characters (or other elements) in the same scene should always maintain the same left/right screen relationship to each other until individual movement is seen to change this geographical relationship. In other words, what is on the left of frame stays on the left of frame (and vice versa), despite different camera viewpoints, until the movement of a person (or object) causes that situation to change.

But what does this have to do with crossing the line? To explain this, imagine two seated characters chatting together. Eye contact between these characters sets up what is known as an *eyeline*. Imagine now this straight line extended and stretched through and beyond these individuals as is necessary on both sides. If a camera passes over this imaginary line (the point at which there is a left/right reversal of the position of the photographed characters), it is called *crossing the line* or *crossing the line of action*.

DO NOT CROSS!

If crossed completely, the new shot (now photographed from the opposite side) is heading towards our old friend, the reverse angle. In most cases, reverse angles are quite acceptable when the geography is well established. Occasionally, a director will purposely cross the line in order to create disorientation.

The next exercise contains clips for you to view in which I have deliberately flopped some of our shots to show you how disturbing crossing the line can be.

Have a look at Exercise 7: Crossing the Line Examples 1–4.

## EXERCISE 7: CROSSING THE LINE EXAMPLES 1–4

Contained in the MOV files that accompany this publication, you will find four files named Ex 7-1, Ex 7-2, Ex 7-3, Ex 7-4, with correct and incorrect versions of each.

To produce the 'line cross', I deliberately flopped one of the shots horizontally and then used it to try to assemble the scene as normally as I could.

Give them a watch and I'm sure you will see how confusing the geography becomes in the incorrect versions. Even in Example 2, where it's only the computer screen, which is wrong with respect to Tim and Helen, it still looks very strange and causes the shots to be somewhat disconnected from the action.

What a relief to view the correct versions! Hopefully, this will prove how vital it is to get this right at the time of shooting.

In addition, here is another exercise, Exercise 8: Crossing the Line, which will attempt to prove how difficult it is to disguise these faulty shots.

## EXERCISE 8: CROSSING THE LINE

**Shots Involved:**

1 MCU H (02)
2 MCU C Flop (03) (I have flopped this picture)
3 MCU C Norm (03)
4 MS H OS C (02)
5 MCU H OS C (02)

**Exercise Aim:**

Caroline's shot has been intentionally flopped in order to create the effect of cutting across the line with respect to the other shots in the scene.

The aim of this exercise is to prove that whatever shots you use, either side of a shot that has been framed wrongly, you can't cure the geographical disorientation.

Generally, if it looks bad, it is bad.

**Questions:**

Can the problem, that Caroline's shot has been shot on the wrong side of the line, be mitigated in any way?
Is it possible to lessen the effect?

**Answers:**

Sadly, whatever you do here, it just looks bad. Both the two-shots and the singles don't cut to our rogue shot, despite the use of split edits and underlaying the dialogue.

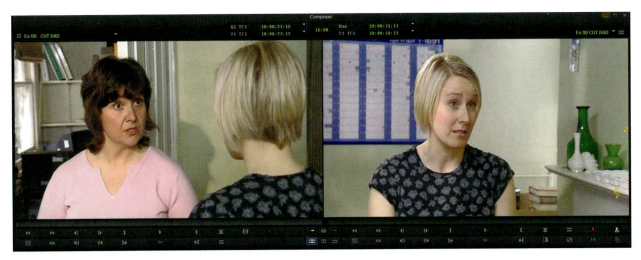

**EXERCISE 8: CROSSING THE LINE.** WHATEVER YOU DO, THESE SHOTS WILL NOT CUT TOGETHER COMFORTABLY.

Notice here that both sets of eyes are looking out of the frame to the right; this is a clear sign that something is wrong.

The only solution is not to use the offending shot, or keep its appearance to an absolute minimum. Sometimes, the inclusion of a wide shot might help a little.

You might consider flopping a real rogue shot, but remember, people look different the wrong way around. Also, that lapel button hole will change sides!

### Late Night Line-Up—Multiple Eyelines

The term *eyeline* keeps coming up, and it's simply the line along which any character is looking. If a character is looking predominately left in one shot, then that same character should continue to look left (to a lesser or greater extent) when the shot is changed to a different viewpoint. Making sure eyelines are matched over a cut is another way of making sure you have not crossed the line unintentionally.

This may seem slightly trivial given our example of two characters chatting with each other in isolation, but imagine this scene extended to a dinner table with eight people around it. Here, eyelines become much more complex and transitory, with all the characters around the table constantly engaging and disengaging with each other. For this reason, you'll find that a good director will run close-ups of key characters from both sides of their action to give you the maximum flexibility when you assemble the scene. This will also help if the scene has to be shortened in any way later on.

Wider shots, or establishers, are also vital here, not only to act as reminders of geography, but also to show changes of eyeline as conversational relationships come and go.

### 🎞️ *Twelve Angry Men* (1957)—Dealing with Multiple Eyelines

*Twelve Angry Men* (1957), which was directed by Sidney Lumet, edited by Carl Lerner, and starred Henry Fonda, is a superb example of how a director and editor deal with multiple eyelines in a 360° situation.

Find it on the Internet and look at the jury room scene, from 10:30 into the movie, for as long as you like.

See how the director photographs the different eye contacts between pairs of participants in the conversations. When a conversational pair is established (and that could be between one of the guys and any number of the rest of the group), then the eyes of each of the parties in the pairing will be framed to look out of opposite sides of the picture frame. Have a look, and you'll see what I mean.

Great scene, isn't it? It's hard to look at shot construction with dialogue and performances as good as that. But back to work!

Hopefully, you clearly saw that when a new eyeline is created, the director quickly establishes this by making sure we see either a head turn or at least a person's eyes flicking over to a new direction. In this way, a new eyeline is established, and subsequent shots are arranged accordingly.

Incidentally, look at the start of the film for an impressively choreographed single shot, lasting over six minutes, as the characters assemble in the jury room. I wonder how many takes it took to get that right.

### 🎬 Points West—Screen Direction and How to Maintain It

Crossing the line is linked to, and sometimes even called, *screen direction*. I think this is very confusing, as they are really quite different.

If an actor is shown walking from camera left to camera right, and then shown in a subsequent shot, to be moving from camera right to camera left, the audience will, in the absence of other geographical information, assume that the actor has changed direction. In order to prevent this, the screen direction must be maintained over successive shots.

The screen direction rule applies equally to moving objects. If an aircraft is seen taking off from right to left (pointing left, in other words), then any following in-flight shots (both exteriors and interiors) should also have the aircraft flying right to left, in order to avoid the impression of an unscheduled return flight.

So the rule to follow (or break) is: *out left-in right* and *out right-in left*, if that makes any sense at all.

### 🎞️ *It's Marty* (BBC TV) (1968–9)—'Just Putting the Cat Out, Dear'

There's a great sketch by Marty Feldman from one of his BBC shows *It's Marty* (1968–9), produced by Dennis Main Wilson and written by Marty Feldman and Barry Took, where, in trying to get away from his nagging wife sitting up in bed, the husband makes the excuse of putting out the cat, filling the bins, or making some cocoa, but each time he is visiting one of his many girlfriends from all parts of the world! It's a great sketch, and screen direction tells us exactly whether he is going out or coming back to his ever-nagging wife.

There are a couple of shots I might have flopped, but it wouldn't have made it any funnier. It is such a great use of stock footage.

### 🎬 *I Know Where I'm Going*—A Home-Grown Example

Look at Exercise 9: Screen Direction Example, where you'll find an example of what I am saying. There are good and bad versions.

## EXERCISE 9: SCREEN DIRECTION EXAMPLE

Have a look at a couple of MOV file clips called Ex 9-GOOD and Ex 9-BAD.
Again, to generate the bad clip, I have flopped one of our shots so that you can see the difference it makes to the start of the scene.

The first shot shows Helen walking into the school grounds; she is walking slightly left to right. The second is an interior as she enters the staff common room. In the bad version she seems to bump into herself, as I have made her enter the room from right to left.

You can clearly see the good version (and the way the shots were originally shot) is better.

Not a huge deal here, I know, and more a directorial responsibility, but worth knowing about.

### The Running, Jumping and Standing Still Film—What Is Jumping Frame?

Different shots that frame the same person or object in a similar size can cause that person or object to jump across the frame when they are cut together. When this happens it is called *jumping frame*. The effect is similar to a jump cut, and it can look and feel uncomfortable.

Imagine four people leaning on a gate or fence. The scene is shot in various ways, including a two-shot of the characters on the left (characters 1 and 2) and a three-shot of the characters on the right (character 2 alongside 3 and 4). If these shots are of similar sizes, then the cut between them can look ugly, as character 2, who is framed in both shots, will appear to jump frame. Remember that on location, many different viewpoints are taken of the same action, and some were never designed to cut together. Just be on the lookout for the jumping frame problem, which can, of course, include objects as well as people.

**EXERCISE 9: SCREEN DIRECTION EXAMPLE.** HELEN SEEMS TO BUMP INTO HERSELF IF YOU CUT THESE SHOTS TOGETHER.

### *Spot the Difference*—Cutting from a Two-Shot to Another Two-Shot Can Look Bad

As a rule, shots of a similar size that frame the same content don't cut well together; it's almost a jump cut again. Imagine we have those four people still leaning on that wretched fence. A square-on two-shot containing the left-hand pair does not generally cut well to a similar two-shot framing the right-hand pair, unless the size of the shots is substantially different. It's better to avoid this by cutting to a single first, or to a four-shot if available. The two-shot to two-shot problem is eased considerably by increasing the camera angle between the shots. If this is done, the photographed shots head towards the more comfortable 'over-shoulder' region.

When more characters are involved, the jump cut effect is not so much of a problem, as it is almost impossible to shoot a large group of characters without increasing the camera angle between individual shots, thus removing the possibility of the cut looking like a jump cut. In any case, a director would never arrange to have all such characters lined up so two-dimensionally unless they are all leaning on that fence as well!

### *Double or Drop*—Look for Repeated or Double Action

If a cut between two shots causes an actor's hand to move twice, or a person to get up from a chair twice, or a door to close twice, then an editor would be guilty of creating *double action*.

Of course, this may not only come from your primary action, but from a person or object in the background. It's just as well to check all characters and moving objects contained in the shots you wish to join for any repeated action.

If you end up in an either/or situation, then in my experience, it's better to jump time fractionally forward than to repeat any part of the action.

This being said, the intentional use of double action is increasingly used to enhance a movie action sequence where shots of car crashes, explosions, or attacking aliens can be shown more than once. The repeated action shots are often slowed down or from a different angle, but they are all designed to heighten the moment.

Let's get back to earth with an exercise. Have a go at Exercise 10: Repeated Action.

## EXERCISE 10: REPEATED ACTION

**Shots Involved:**

1 The Photo (12)
2 M & Photo (13)
3 MCU P (12)
4 MCU M (13)

**Dialogue:**

*MARK:*

Where's that drink?

MARK GETS UP, FINDS HIS UNFINISHED GLASS OF WINE AND NOTICES A FRAMED PHOTOGRAPH ON THE SAME SHELF.

*MARK:*

Oh no, that photograph of you and me.

**Exercise Aim:**

The aim is to get Mark up from the settee so that the rise is correctly timed between the various shots available.

**Questions:**

When should you cut wide?
Should we use Philip's shot as Mark gets up?

**Answers:**

As you've probably found out, it is better to jump time slightly forward than to make the action exact. Strange, but it works.

The shot of Philip looking slightly bemused as Mark gets up enables you to get him standing more quickly, so it's good to include this in your cut. It's also a reasonable reaction anyway, and it helps keep Philip in the story at this point.

Interestingly, there is a two-second time difference between my even worse cut and my good cut. All these seconds are valuable when they are added together.

Remember, cutting to an empty frame is a poor cut.

## 3.3 Key Points—Joining Shots Together, the Don'ts

- Jump cuts are produced by removing a portion of a shot and bolting the two remaining halves together.
- Jump cuts can be caused by camera positions being too close to each other (less than 30° difference) and their shot sizes being too similar.
- Jump cuts can look great when grouped together, especially if the camera is handheld.
- Crossing the line is where the camera is placed on the other side of an imaginary line between and beyond two characters.
- Shots taken from the other side of this line are effectively reverse shots.
- To avoid crossing the line, any character should continue to look out of the same side of the screen across adjoining shots, unless they are seen to move their position.
- Crossing the line can create wonderful disorientation.
- To imply a continuous journey, moving objects and people should face and travel in the same direction in sequential shots and thus maintain screen direction.
- If an object or person is seen to leave frame camera left, then it should enter frame camera right in the subsequent shot.
- Jumping frame is where an object or person jumps across the screen. It is caused by the shots being too closely matched in size and framing a common subject.
- Shots containing roughly the same shapes but different content (e.g. two different two-shots) can look bad when they are cut

together. Our eyes respond better to greater difference, so cutting two-shot to two-shot should be avoided.

- Check all elements (even background action) to ensure they do not repeat any movement over a cut; this would cause repeated or double action.
- It's better to jump time forward by a couple of frames than to repeat action.
- In certain situations, double action is a do rather than a don't, as in the climax of some action films.

## 3.4 Joining Shots Together, the Dos

Having seen what to avoid, let's now examine what usually works well.

Our top four *dos* are:

- Cutting on movement
- Maintaining eye contact
- Using split edits
- Including all changes of expression

### 🎬 *World in Action*—Cutting on Movement

*Cutting on movement* (or matching action) is probably the best technique you can adopt to achieve a satisfactory cut. Changes of camera viewpoint just disappear (if that's what you want) with a well-timed cut on movement. For example, it can be as simple as the correct timing of a cut to a wider shot as a character gets up from a chair.

At the same time as positioning such a cut, you have the opportunity of hiding any continuity problems between the two performances you are joining. It's the best 'get out of jail free card' I know to deal with those annoying little performance discrepancies.

The eye is attracted to movement; it's totally instinctive and there's nothing the viewer can do about it. This magnetic-like attraction to anything that moves is a human characteristic that an editor can use to great advantage. The viewer's eyes must go and check out this movement first and then, and only then, take in the rest of the shot. It's just the same as a magician doing conjuring tricks. A flick of the magician's right hand, and you don't see what has happened to the cards held in the left.

In our editing world, discrepancies in position, action, or timing can be minimised with a cut that immediately frames some movement, such as a flick of a dress, a hand gesture, or a passer-by. They all can act as marvellous eye-catching fly-paper. Again, you'll often find that a cut looks better if time is foreshortened slightly, even by just a frame or two.

This exercise might help; it's called Exercise 11: Movement 1.

**EXERCISE 11: MOVEMENT 1.** NOT VERY FLATTERING TO GORDEN KAYE (SORRY GORDEN), BUT A GOOD PLACE TO CUT TO THE WIDE SHOT.

# EXERCISE 11: MOVEMENT 1

## Shots Involved:

1 M & Photo (13)
2 Square 2S Sofa (12)
3 W2S P up (13)

## Dialogue:

*MARK:*
You don't have it to hand, do you?

*PHILIP:*
Yes, I think so. The tape's in dad's room; I'll go and get it.

PHILIP GETS UP TO FIND THE TAPE.

## Exercise Aim:

The aim of this exercise is to see how movement should dictate when to cut.

## Questions:

When should you cut to the wide shot for Philip's exit?

## Answers:

It just looks better to see the movement start in the close up and then continue this movement in the wide.

Included with this exercise are three sequences from me which demonstrate, in Goldilocks fashion, too early, too late, and just right versions.

Here, Philip's movement should motivate the cut. It makes a huge difference to get this right.

### *Not Going Out*—Movement Motivating the Cut

Here is another example of movement motivating the cut. Let the actor's movement here take you to the wide, and not before.

Have a go at Exercise 12: Movement 2.

## EXERCISE 12: MOVEMENT 2

**Shots Involved:**

1 H & C exit (02)
2 H OS C (02)
3 MCU C (03)

**Dialogue:**

*CAROLINE:*

Must go and tell the rest of the staff that you're a famous radio star.

*HELEN:*

Oh no, do you have to?
CAROLINE SMILES AND TURNS TO GO.

*CAROLINE:*

Catch you later.

**Exercise Aim:**

The aim of this exercise is to show again how movement should dictate when to cut.

**Questions:**

When should you cut to the wide shot for Caroline's exit?

**Answers:**

Yet again, it just looks better to see the movement start in the close-up and then continue this movement in the wide.

Cutting to the wide shot too early just looks weak and prematurely pulls us away from their facial expressions.

In this case, if we cut wide too early, we would be short-changed on Helen's 'Oh no' reaction to Caroline's suggestion about spreading the news of her mention on the radio around the school.

### *Eye to Eye*—The Importance of Eye-to-Eye Contact

I can't emphasise enough how important *eye contact* is between the characters in any scene. The eyes can often tell us more about how a character is truly feeling inside than the dialogue can.

As human beings, we are experts at recognising the slightest change of expression in another human face, and the eyes can reveal so much. It is vital for an editor to convey all this available emotional information to the audience.

You almost have to deal with eye contact as a separate layer for your attention that is equally as important as dialogue or action. So often, at the end of any speech, there's a very telling look that is worthy of inclusion; it can be the difference between a good cut and a perfect cut. Don't be frightened to open up the dialogue track by a small amount in order to preserve or enhance eye contact over a cut. Wow moments are made of this, and you, as an editor, have the power to make sure they hit the screen.

Have a go at Exercise 13: Eye Contact 1.

## EXERCISE 13: EYE CONTACT 1

**Shots Involved:**

1 Tk1 MCU M (12)
2 Tk2 MCU M (13)
3 MCU P (12)

**Dialogue:**

*MARK:*

Progress goes hand in hand with nostalgia; the one produces the other.

*PHILIP:*

He certainly thought the world had progressed too far and too fast for him. He couldn't keep up any more.

*MARK:*

I saw that a few years back with some of the guys in the publishing industry.

**Exercise Aim:**

The aim of this exercise is to demonstrate how important it is to maintain eye contact between a pair of characters.

**Questions:**

How do you keep eye contact going with these shots?

**Answers:**

If you've had a go, I hope you can see what a huge difference maintaining eye contact makes. Just by delaying or advancing your cut a few frames, you turn good into great.

Just have a look at the difference between my good and bad versions of this exercise. In the bad version, an unnecessarily early first cut from Mark leaves him with his eyes down and, at the same time, we cut to Philip who is looking into space. The cut back to Mark is too late, so Philip has already looked back down.

I hope you got near my good version.

Incidentally, at the same time as cutting early to Mark, we can make his reply red-hot on the back of Philip's outgoing words.

### Contact—Another Exercise in Eye Contact

Here is another example of the great importance of keeping your characters' eyes looking at each other.

Not surprisingly, it's called Exercise 14: Eye Contact 2.

# EXERCISE 14: EYE CONTACT 2

## Shots Involved:

1 CU H (02)
2 MCU C (03)

## Dialogue:

*HELEN:*

Caroline, I really need to talk. Are you around one evening this week?

*CAROLINE:*

I don't really see myself as a marriage councillor, but if there's a drink in it, or better still a meal, then I'm your man—so to speak.

## Exercise Aim:

Again, the aim is to demonstrate how important it is to keep the eyes of your characters in contact with each other.

## Questions:

Can you time the cuts between Caroline and Helen to maintain eye contact?

## Answers:

I wish we had a closer shot of Caroline, and then the shots would match a bit better. The cut to Caroline after Helen's speech 'Are you around one evening this week?' has to be sharp, as Helen's eyes duck down very quickly after her speech, thus reducing the impact. By the time they come up again, it makes the edit far too loose.

The cut back to Helen at the end of the section is a cheat of timing, to see Caroline's weak joke land.

The eyes can show when a person is lying, so you must give the viewer a chance to see this as well.

## 🎬 *Making Tracks*—Split Edits, How to Use Early and Late Vision

Imagine you're chatting with a group of friends; life would be very boring if we always had to look at the person who is actually talking at any particular moment. It doesn't happen in real life because, if you were a participant in such a discussion, you'd be

**EXERCISE 14: EYE CONTACT 2.** A CUT BETWEEN TWO CHARACTERS WILL LOOK BETTER IF YOU MAINTAIN EYE CONTACT.

constantly checking the effect the current conversation is having on the rest of the group. The same is true if this convivial chat between friends was photographed and subsequently edited. Straight sound and vision edits (straight AVs, as they are known) that only cut to the person talking would convey only a fraction of the emotional content available in such a scene.

When the vision and sound cuts are separated, even by a few frames, this is known as a *split edit* or *L-cut*. Huge benefits will result from cutting the sound and vision at slightly different times. The coverage becomes more interesting, and we begin to see reactions to dialogue that would otherwise have gone unseen. Thus, a mixture of split edits and reaction shots is the key to producing the best coverage of such dialogue-based scenes.

Scripted or not, the same techniques apply equally well to interviews, where split edits will give the viewer a better chance to see the interaction between interviewer and interviewee.

When I cut comedy, I prefer to hang on to the person who has just spoken for a moment rather than rushing over to the vision of the new speech. But I recognise that in dramas, the technique of cutting early to see the other person before the outgoing speech has ended can work just as well in some situations. Take another look at *Twelve Angry Men,* and you'll see numerous examples of this technique of cutting early.

Exercise 15: Split Edits 1 awaits your consideration.

## EXERCISE 15: SPLIT EDITS 1

### Shots Involved:

```
1 MCU P (12)
2 MCU M (12)
```

### Dialogue:

*MARK:*
Well, you did it yourself, when you said goodbye to Bob and Penny.

*PHILIP:*
What?

*MARK:*
You said, 'Dad would have appreciated it'.

### Exercise Aim:

The aim of this exercise is to show how a split edit helps a sequence of shots maintain flow.

### Questions:

When should you split a cut?
What are the less important words here that can be put out of vision?

### Answers:

Covering up Mark's words 'You said' helps in several ways. First, it increases the length of Philip's shot and extends the one word 'What?' shot to a more natural duration. Second, it allows us to see more of Philip's miscomprehension of Mark's remark. Third, it allows us to come back to Mark at the start of his important line, 'Dad would have appreciated it'.

Again, look at the difference between my with and without splits versions of this exercise, and you'll get the idea.

### *Separate Tables*—More about Split Edits

I think this technique of split edits is so important that it is worth giving you another example.

Here, you'll need to use split edits not only to make the coverage more interesting, but also to mitigate for the fact that Gorden Kaye, who plays Philip, is sometimes popping down to read the script. This will give you a good chance to show off how well you've mastered the technique of split edits.

Exercise 16: Split Edits 2 is up next.

## EXERCISE 16: SPLIT EDITS 2

### Shots Involved:
1 MCU M (12)
2 MCU P Tk 1 (12)
3 MCU P Tk 2 (12)

### Dialogue:

*PHILIP:*

Have your two seen any of dad's films?

*MARK:*

No, they haven't. They've seen photographs but not the film.

*PHILIP:*

You should show them sometime.

*MARK:*

Yes, I will. On the other hand, having your whole life catalogued and filed might not be an advantage. Might be better just to rely upon our memories.

*PHILIP:*

I don't think your two will have the choice.

### Exercise Aim:

The aim of this exercise is to show once again how a split edit helps a sequence maintain flow, and here it disguises the fact that one of your leading men is having to read the script.

### Questions:

Some of Philip's action in this exercise must be out of vision for obvious reasons, but what must we see of him?

### Answers:

I hope you were successful at script-reading removal.

**EXERCISE 16: SPLIT EDITS 2.** MY TIMELINE CLEARLY SHOWS SOUND AND VISION CUTS ARE SEPARATED IN TIME.

Despite having to stay on a shot for longer than you would normally do, the exercise proves you can stay on the receiver of information, rather than the giver, with no less dramatic results.

Again, you have my with and without splits versions to look at.

### 🎬 *The Banana Splits*—Even More about Split Edits

Here's another example of the technique of split edits. Have a go at Exercise 17: Split Edits 3.

## EXERCISE 17: SPLIT EDITS 3

### Shots Involved:
1 MCU H (04)
2 MCU T (04)

### Dialogue:

*HELEN:*

He must have done it for our anniversary . . . it's ten years this week!

*TIM:*

Yes, he said it was ten years in the letter.

### Exercise Aim:

I think you know the aim of this exercise by now!

### Questions:

Why haven't you finished this exercise yet?

### Answers:

Yet again, it is surprising how much improved the conversation feels with the vision cuts not happening at the same time as speech changes.

You have good and bad versions to look at, as usual.

### 🎬 *Face Off*—Get Those Changes of Expression on the Screen

The best and only way to keep the viewer in contact with all the changes of attitude, emotion, motivation, states of mind (the list is endless) is to put these changes into your sequence. This does not have to slow the pace of a scene down at all, as so often these changes of expression can be laid over dialogue, typically the actual dialogue which is the cause of that change of expression.

You have the solution already—split edits and reaction shots. The next exercise is called Exercise 18: Expressions 1.

PIPPA SHEPHERD AS HELEN IN *CHOCOLATES AND CHAMPAGNE*.

## EXERCISE 18: EXPRESSIONS 1

**Shots Involved:**

1 MLS H (05)
2 MCU H (05)
3-5 Laptop (05)
6 Radio VO (16)

**Dialogue:**

*RADIO VO:*

Here goes. No. 1 - Your partner starts to dress more smartly than he or she did for work, and starts buying more new clothes than they used to. No. 2 - Your partner starts to stay longer at work, using extra work as an excuse. No. 3 - Your partner goes away on weekend trips more often for whatever reason. No. 4 - Your partner suddenly goes on a diet, and joins a gym to get back in shape. No. 5 - Your partner suddenly starts using a cuddly nickname for a friend. No. 6 - Your partner sets up a second secret e-mail account on their computer.

**Exercise Aim:**

The aim is to show Helen's changes of expression as doubts of her husband's fidelity begin to surface.

**Questions:**

What bits of Helen's facial expressions best reflect the dialogue?
How do you show the audience what's going through her mind?

**Answers:**

There are lots of choices here. The important thing is to keep the interest going.

Frankly, there aren't enough shots to do this on their own without repetition, so I have put a move on the second time I used the computer speaker shot—it works well, I think. I also quite like the small smile Helen gives us on the 'gym' line.

In addition, the use of closer and closer shots helps to increase the concern in her face as she joins the dots up. A zoom in to Helen's face further emphasises her growing concern.

With a bit of equalisation to the voice and a good selection of shots, you should be there.

### Here's Looking at You—Another Expressions Exercise

As I think this aspect of editing is so important, here is another example of changing facial expressions, this time happening during a conversation.

The exercise is Exercise 19: Expressions 2.

# EXERCISE 19: EXPRESSIONS 2

**Shots Involved:**

1 MCU T (08)
2 MCU H (08)

**Dialogue:**

*HELEN:*

Is that the best excuse you could come up with —
to borrow some eggs? You'll have to do better
than that, Tim!

*TIM:*

I wanted to see how you were, especially after
reading the paper.

**Exercise Aim:**

The aim is to show how Helen's dialogue is
having an effect on Tim's frame of mind.

You've got just two MCUs to deal with here, but
careful timing of when we see either of these
shots is crucial.

**Questions:**

When should you cut to Tim?
How long should you stay on him?
What line of Helen's do you not need to see in
vision?

**Answers:**

Rather than go into lots of words, just look
at the difference between my good and bad
versions of this exercise. I hope you can see
that with careful shot selection, the changes
of expression of both characters here are fully
covered and conveyed to the audience.

A couple of points: First, after seeing Tim's head
go down, it is better to see him look up again
when we next cut to him. Second, I have opened up
the dialogue before Helen's second line, to give
me a bit more time on Tim and also to see Helen's
line in vision when I cut back to her.

## 🎥 *The Green Man* (1956)—A Great Example of Changing Facial Expressions

Alastair Sim, one of my favourite actors, gives a great example of changing facial expressions in a film called *The Green Man* (1956), directed by Robert Day and Basil Dearden and edited by Bernard Gribble. It is a Launder and Gilliat script, so you know it will be fun.

Sim plays an assassin called Hawkins who wants to blow up Sir Gregory Upshott (Raymond Huntley), who is staying at the Green Man hotel that night. The bomb (yes, this is a comedy) is packed into a duplicate radio, identical to the hotel's own, and Hawkins's plan is to blow up Sir Gregory while he listens to a speech he

gave earlier that is due to be broadcast that night. The trouble is, as Hawkins is taken into the hotel's lounge, a musical string trio bursts into life. His face fills with horror, as this will surely wreck his plan. With Hawkins's face looking like thunder, he reluctantly settles down in an armchair, staring at the three ladies playing away on a small stage. He soon realises that the only way to remove the ladies from the lounge is to woo them. His thunderous expression melts into joy, and a marvellous sequence ensues as the women are increasingly flattered by his attention, and obvious enthusiasm, as he rapidly becomes their number one fan. Search it out on the Internet.

Given the riches available here, it must have been hard for the film's editor to balance seeing all the changes of expression without extending the scene unnecessarily.

## 3.5  Key Points—Joining Shots Together, the Dos

- Cutting on movement is the simplest way to produce seamless edits.
- Time your cut so shots are joined by continuous movement.
- Hide continuity problems with a distracting and eye-catching piece of action.
- Treat eye contact between characters as a separate layer for your attention.
- Eyes can often reveal as much as spoken dialogue.

- Split edits enable you to easily include reactions to dialogue bombshells.
- Split edit coverage is much more interesting than simply cutting to the person who is speaking.
- Split edits with reaction shots are key techniques to produce interesting and varied coverage.
- Unspoken changes of expression and mood must be on the screen.
- Emotional journeys are as important as dialogue, often happening simultaneously, so don't hide them from your audience.

# Chapter 4
# Dealing with Dialogue

Dialogue forms the backbone of most movies and TV programmes. Here, I consider ways of dealing with dialogue from whatever source: script, interview, discussion, or actuality.

This chapter is divided as follows:

- **4.1 Fundamentals of Editing Speech**—Finding the best place for an edit within a word can be tricky.

- **4.2 Rhythm of the Spoken Word**—There is as much phrasing in the melodic line of speech as in music. You can do terrific harm to this hidden melodic line if you don't recognise it's there and respect it.
- **4.3 Editing Dialogue**—In this section, I examine the differences between two main sources of the spoken word coming into the edit suite: scripted dialogue and free-flowing speech.
- **4.4 Key Points—Dealing with Dialogue**

## 4.1  Fundamentals of Editing Speech

So often when you are editing speech, you are searching for that point where the audio join is invisible or, more accurately, inaudible.

### 🎬 *My Word*—Editing Vowels and Consonants

The best place to join two bits of dialogue together is in the gaps between words. Sometimes these gaps are very short or even nonexistent, and you'll have to place your edit on a word. Those of you who have tried this already know it is much easier to place a good-sounding cut on consonants rather than on vowels. Poppy sounds like Ps and Bs or hissy sounds like Ss and Cs are perfect for hiding sound edits. Vowels are difficult because they are tonal in nature and have an inbuilt pitch. Just try saying 'La' and stretch it out and you'll see what I mean; the sound you are making has

a fundamental frequency associated with it. Repeat the 'La' 10 minutes later, and it will probably be at a slightly different pitch, making a satisfactory edit between them difficult, if not impossible. It's much easier to find a nearby friendly P, B, C, or S sound.

Have a go at Exercise 20: Editing Dialogue Sounds.

## EXERCISE 20: EDITING DIALOGUE SOUNDS

**Shots Involved:**

1 MCU T (04)
2 Sq 2S T & H (04)

**Dialogue:**

*TIM:*

I'm always up first, and his idea of a good Sunday morning is to have a long lie-in. When he wakes, he calls me on the intercom, and demands tea to be served and brought up. I always answer the phone with 'Kitchen', and sign off with the pretend shout of 'Ruby' to an imaginary kitchen maid, á la Mrs. Bridges from 'Upstairs, Downstairs'. (HELEN SMIRKS) Well, it pleases him — (ALL OF A SUDDEN TIM GOES SHY) Just our little Sunday morning routine. He was a big fan you see.

**Exercise Aim:**

Here you have a wide shot and an MCU of the same dialogue. Try cutting between them in different places. Don't worry about the visual sense; this is a sound exercise. Cut where you like and as many times as you like.

**Questions:**

Where is the best-sounding place to cut between the words here?

**Answers:**

Editing during silences in the dialogue will obviously hide the fact you are going between different performances. If you have to cut in the middle of a word, then I hope this exercise has proved that consonants are far easier to deal with than vowels because vowels can be pitched so differently.

It's remarkable that Paul Taylor, who plays Tim here, pitches his two takes so accurately.

Have a look at my good and bad examples. You'll notice the software also has more trouble with the vowels and produces some annoying clicks and thumps. That's because it's trying to join purer sound waves together with fewer high frequencies in the waveform.

### Down Your Way—Move the Edit Around

For scripted dialogue in particular, we have already discovered it isn't necessary to put the sound edit on the same frame as the picture cut. Sometimes, superior sounding results can be achieved by moving the sound edit to the nearest synchronous consonant. Different performances of the same words usually keep in sync long enough for you to find an adjacent point to get across to the new sound.

Sometimes, with the use of over-shoulder and reaction shots, you are able to keep the same sound performance going over several changes of vision. If you are happy with a particular delivery, why make unnecessary work for yourself in the soundtrack?

### ▰ *Breathless*—Breaths and What to Do with Them

We all have to breathe, even actors, reporters, and presenters, but this is yet another problem with which an editor has to deal.

How and when we breathe during any speech depends completely on the content and tone of that conversation. When a person is shouting, he or she is barking out much more air than whispered speech. The shouter will have to breathe more heavily, and more often, while the rant goes on. Also, when an actor delivers a long sentence, he or she will usually delay the next intake of breath until the point is made and the sentence finished. This is generally followed by a large intake of breath to refill the lungs before the next paragraph continues.

You might be asking yourself what this has to do with editing. Well, the answer is quite a lot, because the clumsy removal of a breath in the process of editing unwanted dialogue can produce a poor result, with no obvious reason why, other than the fact that a breath is missing. Sometimes the removal of a breath will work, and it's only with practice that you'll know when you can get away with such a cut.

Some sound edits just can't be done because of inflexion problems, so don't be afraid to reject these as unworkable. However, an editor can't just sit back and declare impossibility, because your next words should be 'tell you what we can do. . . .'

It can be the case that the insertion of a breath from elsewhere in the dialogue track is able to correctly space a troublesome edit.

No chance for a breather now; Exercise 21: Breaths is waiting.

## EXERCISE 21: BREATHS

**Shots Involved:**
```
1 MLS H (07)
2 MCU H (07)
```

**Dialogue:**

*HELEN:*
Ooh, just felt the baby move again. (PAUSE) Okay, 'til seven.

**Exercise Aim:**

Helen takes a breath between her two lines.

The aim of the exercise is to examine ways of dealing with this breath.

**Questions:**

If you start on the MLS, when do you cut to the MCU: before or after Helen's intake of breath?

**Answers:**

The two good results here are either to have Helen's breath on the outgoing wider shot and cut to the MCU straight on the dialogue, or to lose the breath altogether.

What looks really bad is to cut to the MCU and then to have to wait while Helen takes a breath. This is poor cutting because an edit should power the scene on and not just cut to someone pausing in order to take a breath. The space for the breath, of course, gives the person on the other end of the phone a chance to reply, and this looks so much better in the wider shot. The cut, now placed after the breath, enables you to punch in to Helen's MCU right on the start of her next line.

## 4.2 Rhythm of the Spoken Word

An editor spends more of his or her time editing the spoken word than anything else. This is done with the intention of making such conversations (scripted or otherwise) more concise, understandable, and attractive, so that they can more accurately convey what was intended by the author or the participants. As you gain experience dealing with dialogue joins, you'll be able to hear in your own mind the results of many possible and different edits in the speech you are presented with without actually trying them out for real. With this skill, you'll instinctively concentrate on phrases that, when joined together, are more likely to achieve satisfactory results.

A TYPICAL EDIT SUITE LAYOUT USING TWO COMPUTER MONITORS AND HD PICTURE MONITOR.

### *Eyes Wide Shut*—Close Your Eyes and Listen

When you're editing tricky dialogue, the vision can often just get in the way. To solve the problem, I find it useful to look away from the pictures and get the sound right first, and then, only when this has been achieved, do I address the vision and adjust the pictures to suit the newly created soundtrack, frequently with a well-placed change of shot.

It's a sad and simple fact that whenever you make the slightest alteration to the timing of the soundtrack, you have to edit the pictures as well. Suddenly, working in radio seems very attractive.

### *Poetry Please*—The Rhythm of Dialogue

All dialogue has a rhythmic and tonal line just as complex as a musical melody; all you have to do as an editor is train your ears to hear it. Actors know this; after all, they are constantly timing themselves to their fellow performers as they fire perfectly intoned lines at each other . . . well, at least that's the theory. Directors also know this, as they tune individual performances towards a combined perfection.

Here comes the bad news: some of this natural rhythmic sense has to be already inside you in some form or another. Editing is called a craft for this very reason. You almost have to imagine yourself in the role of a conductor of an orchestra, calling in the strings, brass, or percussion at just the right moment to reflect what is written in the score . . . I mean script. What remains after any dialogue removal must not only make sense grammatically, but the new melodic and rhythmic line created by that edit must also make sense musically. This is called *intonation*.

Talking of orchestras, I can think of two examples where conversations are mimicked in music. First, the second movement of Beethoven's Piano Concerto No.4, where the piano obviously has a calming conversation with an angry orchestra, and second, the third movement from the Fantastic Symphony by Hector Berlioz, where two shepherds are calling to each other across a wide and open landscape, depicted by a cor anglais and offstage oboe, while a distant storm approaches. Both are well worth a listen.

Back to the plot with an exercise: Exercise 22: Dialogue Rhythm.

## EXERCISE 22: DIALOGUE RHYTHM

**Shots Involved:**

```
1 CU H   (06)
2 MCU H  (06)
3 MCU H  (06)
4 MCU T  (06)
5 W2S T & H (05)
```

**Dialogue:**

*HELEN:*

But let's have a look what the survey said; he scored at least five points. He *has* started dressing more smartly for work, he *does* go away for weekends more often, whether it's work or golf, they are weekends away, and now we've got Caroline, my oldest friend, knowing that he was away on a course and it was at Southampton. I'm positive I didn't tell her where the course was.

**Exercise Aim:**

The aim is to produce a decent cut of the scene, but at the same time to lose the dialogue in red. You have to produce a new dialogue rhythm, as perfect as if this was the one that was performed.

**Questions:**

How do you cut down the dialogue without causing damage?
What shots can you use to cover over the joins?

**Answers:**

When I cut words out, I usually say the new version of the speech to myself, and then try to create that timing in the cut.

It would be too easy (and the result awful) to use Tim's MCU as a cutaway on each and every occasion you make a trim.

Remember to be clever with the sizes of Helen's shots as well. There is nothing wrong with punching in to her CU, provided the continuity is acceptable.

Have a look at what I did.

P.S.: There is a trick in the long version on the two-shot about 13 seconds in, where I have put an invisible wipe down the frame, in order to change the timing of Tim's reaction with respect to Helen's speech. He was just too static in the original timing.

### 🎬 *Torn Curtain*—Repairing Dialogue

It sometimes happens that your best take has a fluff in it, which can be annoying if this is the only flaw in an otherwise perfect version of the action from all other points of view, such as camera, sound, lighting, and so forth. It would be a shame to throw this away and have to use a less good take just for the sake of a couple of fluffy words.

Well, the solution is to attempt a dialogue repair using as little as perhaps a single word from another take.

I think this is best demonstrated with an exercise, Exercise 23: Dialogue Repair, which is next.

## EXERCISE 23: DIALOGUE REPAIR

**Shots Involved:**

```
1 2S T&H Tk 1 (04)
2 2S T&H Tk 2 (04)
```

**Dialogue:**

*HELEN:*

I'm going to put a lock on that gate; or better still install a turn-style and start charging.

**Exercise Aim:**

The aim is to save the better take and repair the fluff. To start with, you have to decide which version is the better take and then repair away.

You have nothing else to cut to, so it all has to be done 'in vision'.

**Questions:**

Which take is better?
Can the fluff be repaired invisibly?

**Answers:**

Hopefully, you'll agree with me that take 1 is better, apart from the word 'install', which is slightly fluffed.

The trouble is, a fluffed word generally takes a longer time to splutter out than the

correct version. All you can do is to hope for a friendly vowel with which to stretch the soundtrack out. Alternatively, you could nibble a frame or two out of the vision.

Here, I've just put the word 'install' in from take 2, and it seems to work quite well. I had to alter the level of the word a bit to make it sit more comfortably in the other performance.

Intonation and pitch, in addition to level, will sometimes prevent the cleverest of repairs, but it's worth an attempt more often than not.

## 4.3 Editing Dialogue

An editor has to deal with two main sources of the spoken word: *scripted dialogue* in its many incarnations, such as acted lines, narration, and voiceovers, and *free-flowing speech,* which is more common in interviews, commentaries, or vox-pop situations. To preserve their individual characteristics, they have to be treated by an editor in slightly different ways.

### *An Actor's Life for Me*—Dealing with Scripted Dialogue

By the time scripted and filmed dialogue comes to you, it should be a fair likeness of what the director, the writers, and the actors intend to convey in terms of performance. If you are able to clearly hear the rhythmic and melodic line in spoken dialogue, you will be better able to preserve, and even enhance, this musical line through the necessary joins in performance that are required to produce an edited scene. But remember, especially in the case of performed drama, that those shots may have been filmed over a long period of time, often out of order and

sometimes in circumstances far removed from an environment where any actor can completely attend to the overall pace of a scene.

Here is where a good editor can make such a difference to the final product. This is because after the microscopic work of individual dialogue joins is over, you have to zoom out your attention and deal with the wider aspects of pace and tempo, starting with individual scenes and then to the complete piece.

During this process, you will reexamine the timing of individual cuts, or sections of cuts, to help improve the flow of the programme as a whole.

### *Any Answers?*—Dealing with Free-Flowing Speech

Free-flowing speech can be sourced in a variety of ways, such as interviews, live commentary, actuality, or just simple discussions. By its very nature, free-flowing speech is not rehearsed in any way, and thus it contains more of the individual speech characteristics of the participants.

Free-flowing speech contains many more delightful and individualistic conversational imperfections than scripted dialogue. All those frequent 'ums' and 'errs' we all insert into our natural speech are stressed and timed in a unique way to us as individuals. When you edit such dialogue and your subject is in vision, those individual speech characteristics must be preserved. Don't 'clean up' the dialogue too much around edit points, or they will only stick out as different. The only time I would clean-up dialogue is if the subject's words are being used as a voiceover to alternative pictures. In this situation, some conversational repeats and fluffs can be removed without doing any harm.

Normally, then, let that 'um' introduce a new idea, just as it did when it was alongside different dialogue. I say this because with free-flowing speech, an editor is required to 'cut and paste' to a far greater extent than is the case with scripted dialogue, and adopt more of an editorial role.

This editorial role will inevitably take you away from the microscopic world of individual sentences to the wider world of content. An editor in this new role has to be aware of many more factors, and I will examine some of these aspects later on when I talk more about interviews in Chapter 8, and also when the topic of editorial responsibility comes up in Chapter 13.

### *A Word in Edgeways*—Overlapping Dialogue

So often in real-life conversations, in our enthusiasm to get our point across, we will start our reply before the previous speaker has finished. This can sometimes be really annoying, but we all do it, especially when any discussion gets heated. To create this on the screen, some care has to be taken with the shooting of overlapping dialogue, or it will be impossible to edit together.

Actors have to overlap dialogue in shots where both or all participants are framed together, but they can be asked to separate the dialogue when individual singles are being shot. This can be off-putting for them, and many actors would feel this potentially ruins their performance, but the advantage is you have complete control of the timing of any overlap in the edit suite. Some directors share this view, that separating dialogue will potentially damage a performance, and see no reason to artificially make the edit easier. Even in close-ups, therefore, they will let the actors overlap as much as the script calls for and sort it out later. Well, not them themselves, you understand . . . it's more likely to be you! But don't panic, editing 'rat-a-tat-tat'

dialogue is often easier than you think, probably because vowel sounds are shorter, and the consonants are packed in more tightly.

When the overlap has to be created in the edit suite, all you have to do is to match what the actors gave you in the wider shots and maybe improve it! Split edits (yes, those again) come into their own here, allowing you to bounce to a different shot before or after the interruption.

Editing such overlapping dialogue, or creating an new overlap where one didn't exist, is great fun, and it can so improve the perception of reality that we all constantly strive for.

### Silent Witness—'Text-Speak' and How to Deal with It

Some conversations are silent. That may seem a strange concept, but we do it every day when we text someone using our mobiles. Producing dramatic coverage of a text conversation is mainly a problem for a director or a writer, as they will have to work out at an early stage how this information will get to the viewer.

As far as I can see, there are four main options:

- Show the phone screen.
- Subsequent spoken dialogue could convey the information that was contained in the text to the viewer.
- The text information could remain secret until a future plot revelation.
- Captions, perhaps in the style of phone text, could be superimposed on the picture as the message is typed or read.

I will discuss caption work later on in Chapter 12, but for now two points are worth mentioning. The first is to make sure the caption is large enough and up for long enough. Remember: *you* know what the caption says, whereas someone reading it for the first

time (often in poorer viewing conditions) will not. The second is to highlight this point in your sequence, as this section of vision will almost certainly need to be copied and kept clean of captions, not only to help a future grade (as they usually don't want to grade your caption work as well) but also for international sales, so that new captions in different languages can be superimposed at a later date on that saved 'clean' version.

## 4.4 Key Points—Dealing with Dialogue

- It is much easier to place successful audio edits on consonants rather than on vowels.
- All dialogue has a rhythm and tonal line, just as complex as a musical melody.
- Breaths in the wrong place can produce poor dialogue joins.
- Sometimes the insertion of a breath pause can cure a troublesome edit.
- If it helps, look away from the pictures when you are dealing with the sound, and once you are happy, adjust the pictures accordingly.
- Any edit must preserve the rhythmic nature of the speech, or create a new one which works equally well.
- Intonation and pitch will sometimes prevent the cleverest of repairs to a dialogue track, but they are worth an attempt most of the time.
- The timing between speeches is crucial to preserve and/or enhance what the participants have given you.
- An editor must provide and create consistency of performance, especially if the filming has taken place over a long period of time.
- Don't clean up free-flowing speech too much around edits, or it will stick out as different and usually awkward.

- Cleaning up free-flowing speech is more possible if the speech is being used to act as a voiceover for alternative shots.
- Editing free-flowing speech will cause you to adopt more of an editorial role, with all its associated responsibilities.
- Edits (editorial or otherwise) must be done according to an individual's speech patterns.

- When creating dialogue overlaps in the edit suite, match what the actors have given you and potentially improve it.
- Overlapping dialogue can enhance the impression of conversational reality.
- Any captions representing mobile text conversations must be large enough and up for long enough. Read the words twice, is the golden rule.

# Chapter 5
# Creating Sequences

We are in the process of zooming out, first from examining individual shots, then to joining those individual shots together as partners, and now I consider the wider picture, as those partners form groups of shots that start to tell a story.

This chapter is divided as follows:

- **5.1 Pace and Timing**—Taking a broader view, I show you how to be on the lookout for ways to control the pace and timing of a sequence.
- **5.2 Eliminating Unnecessary Pauses**—Learn how to spot and eliminate unnecessary pauses and delays.
- **5.3 Continuity**—Very often it's too late by the time poor continuity reaches the editor. I'll show you some ways you can deceive your audience and hide some of these problems.
- **5.4 Cutaways**—A necessary evil that, in the wrong hands, can make such a shot seem to scream 'I'm a cutaway!' I'll show you some tricks to avoid this.
- **5.5 Flow**—How additional sound can often help join shots together and create flow.
- **5.6 Time Jumps**—How to compress real time without letting the viewer know.
- **5.7 Editing without Dialogue**—How to create a sequence without the help of a dialogue track.
- **5.8 Key Points—Creating Sequences**

## 5.1  Pace and Timing

Pace and timing are hugely dependent on what you are cutting. The extremes of comedy and tragedy are paced, performed, and timed very differently but, as with every scene, an editor must include all available emotions, happy or sad, that affect the characters involved. This can only be done with the variety of shots provided for you, but the selection is very much up to you.

Even when you're dealing with a scene set at a funeral, an inherently slow and thoughtful process, you'll find there is still barely time in your cut to show how this sad occasion affects all of your participating characters. Remember, you are choosing what the viewer actually sees, so you'd better get this right . . . no pressure, then!

🎬 *Brain of Britain*—Be Clever with Your Material

I was always trained to constantly ask myself if any action I was working on could take place in a cleverer and quicker way. This has stood me in good stead for my chosen vocation of editing comedy. Here, every single frame has to justify its existence and fight for its survival, as so often you are up against the clock.

If you, as an editor, can offer clever ways in your cut to convey all the emotion, drama, and comedy of a scene, but in a shorter time and without this looking rushed in any way, then there is a good chance you'll be asked back.

Even in the slowest of scenes, the viewer, often unconsciously, expects to see a reason for every shot change straightaway. If they don't, they will have the sense, again often unconsciously, of being pulled away from an interesting outgoing shot, only to be forced to watch an unnecessary pause before the action gets going again. For this reason, dramatic pauses are better left on the outgoing shot, thus allowing the next shot change to propel the scene forward.

As you've probably gathered, there aren't many hard and fast rules connected with editing, but at last we have a rule that most would agree is good practice.

Our first editing rule is: Don't cut unless you have to, and if you do, make sure you have something just as interesting for the viewer to look at.

The next exercise is Ex 24 Keep It Moving.

## EXERCISE 24 KEEP IT MOVING

### Shots Involved:

```
1 MCU H (08)
2 MCU T (08)
```

### Dialogue:

```
The scenario is that Helen has had an affair,
which has had some tragic consequences. Tim,
her best friend, has, up to this point, known
nothing of this affair.
```

```
TIM:
I didn't know if I was still welcome,
especially after what happened. (PAUSE) I don't
understand, why didn't you tell me about John?

HELEN:
I didn't tell anyone.
```

### Exercise Aim:

```
This is a slow and thoughtful scene, but we still
need to keep it moving. You obviously need to use
some reaction shots, but the danger here is that
you could tighten all the emotion out of it.
```

### Questions:

```
When do you cut to Helen?
What bit of Helen's shot should you use?
When do you cut back to Tim?
Can any improvements be made to the timing of
Tim's speech?
```

### Answers:

```
For this exercise, I have offered three
sequences for your inspection.

As before, there is a too tight version, a too
loose version, and one I consider to be just
about right. This just about right version is
still tighter than the original performance,
but not so tight as to ruin the moment.

Helen can be red-hot after Tim's line, to
defend her reason for keeping him in the dark
about her affair.
```

### Dumb and Dumber—Be Objective—One of Our Strengths

An editor is marvellously ignorant of how difficult a shot or sequence was to film. Directors, writers, and producers are

often far too close to the material by the time it comes to the edit suite to be truly objective. This gives us as editors an amazing impartiality to include or reject on merit alone.

It's very often the case that shots that took the greatest time and effort to achieve on location are the most vulnerable when it comes to the cutting room. That fabulous sunrise, that expensive aerial shot, or that long and beautiful tracking shot are all at risk in the cutting room when the plot has to move on and, above all, fit into a timeslot. It is essential to make sure your director has no sharp objects at hand when you suggest losing such material.

### 🎬 *Between the Lines*—Use of Tension and Release

Achieving a good pace is not as simple as eliminating every pause; I'm sorry if I've given that impression. Just as in music, where the rests are equally as important as the notes, dramatic pauses are

the framework on which dialogue is played. Those little moments of tension and release are essential. They mostly originate from the script and the performance, but they can also be created or enhanced in the edit suite. That little glimmer of a smile as the outgoing line settles in the character's mind is so important to increase our comprehension of a narrative.

### 🎥 *Death in Venice* (1971)—Slow, Indulgent, or Simply Beautiful

Sometimes moments have to be enjoyed slowly, and *Death in Venice* (1971), directed by Luchino Visconti and starring Dirk Bogarde and Björn Andrésen, is a great example of this.

Set against a very slow performance of the Adagietto from Mahler's Symphony No. 5, the film sets a peaceful pace right from the off, with three minutes of credits against black before the ghostly image of a ferry, steaming across the frame, comes into view at the break of day. By six minutes into the film, all we have seen are the credits, the ferry, a couple of views of approaching Venice, bathed in the mist of an early dawn, and Aschenbach (Dirk Bogarde) on board that ferry, sitting in a wicker chair, wrapped up against the cold. The film takes its time, and yes, it's indulgent in places, but it's in no way less entertaining for that. You enter that world, bathe in its serenity, and enjoy the lush period detail.

The problem for all of us is, when do you let your piece breathe, and when do you tighten down the pauses?

## 5.2 Eliminating Unnecessary Pauses

### 🎬 *Space Patrol*—Dealing with Pauses and Silences

*Pauses* and *silences* get more notes and comments back from those who might look at an early cut than any other aspect of

editing I know. The problem is, an early cut is usually undubbed; in other words, the dialogue is present but as yet without any of the accompanying background sound, which will be added later. Despite frequent reminders that what they are watching is an undubbed cut, the comment about silence comes back time and time again, especially from those with little else to say. The only cure is to do a mini-dub on your material and shove on some background sound effects before these people view your cut. Pub atmos or a radio on, if appropriate, can help solve the problem.

## 🎬 *Pause for Thought*—Is That Pause Necessary?

Well, is the pause necessary? My only advice here is to judge every pause on its merits. Ask yourself the question, can I deal with the pause in a cleverer way? It may be possible to rearrange the shots and allow the pause to happen over a more interesting reaction.

Again, you may be disappointed that there are no hard and fast rules about which pause to shorten and which to leave alone; you'll just have to experiment with each of them in turn and see if you achieve improvement. All I would say is that I've rarely seen any sequence look worse for being tightened-up a little, even if this occurs at the fine-cutting stage, where the timing of any scene has already survived several previous viewings.

Have a go at Exercise 25: Pauses.

## EXERCISE 25: PAUSES

### Shots Involved:

```
1 MS P Tk 1 (13)
2 MS P Tk 2 (13)
3 MS M & Sofa (13)
```

### Dialogue:

The scenario is that Mark (seated) has just remembered that Philip (his brother) had a hand in saving his life when they got into trouble while swimming in the sea when they were boys.

Mark is clearly moved by this sudden recollection of the long-forgotten incident. He is visibly shaken. Philip reenters with a tray of tea and puts it down.

*PHILIP:*
You've just remembered that day we had on the beach, haven't you. (PAUSE) Come on, clear a space.

### Exercise Aim:

The aim is to investigate how long the pauses should be between the lines. This is very difficult to judge, and you'll have to go with your instincts.

### Questions:

How long do you give Mark before Philip comes in?
Should Philip speak immediately?
How long do you give Mark after Philip comes in?

### Answers:

This is mostly down to personal choice, but others will have to see your cut and think it's great as well!

There are a couple of takes of Philip to choose between. I am sure you'll see why these were both included. The 'beach' line is much better in take 2.

The crucial bit to have on the screen is Mark's gulp and his falling eyes while Philip stares at him.

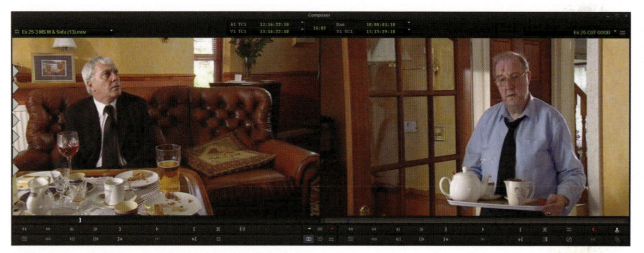

**EXERCISE 25: PAUSES.** A POIGNANT MOMENT FOR THE BROTHERS—HOW LONG DO YOU GIVE THEM?

Once more, you have three versions of the cut to consider here. Too tight, too loose, and what I consider to be just right.

I hope you like the temperature of my porridge!

## 5.3 Continuity

I suspect the majority of the population thinks that editors are primarily obsessed with continuity; this is far from being the case. As some sort of proof, here we are many pages into this book and I am only now seriously discussing continuity for the first time. I would put it at about 7 out of 10 in the grand scheme of things, for many reasons. After all, if there has been a really serious mistake in continuity, such as costume, set, or props, there is very little an editor can do about it, other than exclude.

The sitcom *My Family,* which starred Robert Lindsay and Zoë Wanamaker, was recorded in front of a live studio audience. Some scenes were shot in Robert's character's dental surgery, where there was a very large tank of ornamental fish.

At the end of a take, recordings were stopped, and then began a flurry of activity on the studio floor to get props and actors back to their starting positions before a second attempt could be made of the scene.

The one and only Bobby Bragg, who usually did the audience warm-up, was also employed to keep the audience entertained during such breaks in recording. If the delay was of a significant length, he would explain to the audience that the reason it was taking so long was that 'they', meaning us in the gallery, were waiting for the fish to get back into the right position.

deflect their eyes away from continuity trouble to a more innocent area of the screen by the simple use of a helpful and distracting bit of movement.

What power! Just try it; it works every time. If you know you have to make a less than perfect join, make sure your incoming shot has movement right on the cut, such as an arm or head turn, that will immediately distract the eye, so that any continuity discrepancy remains unobserved. Ask any magician!

For your next trick, try the technique in Exercise 26: Continuity.

**EXERCISE 26: CONTINUITY**

**Shots Involved:**

```
1 WS T & H (04)
2 MCU T (04)
3 MCU H (04)
```

**Dialogue:**

*HELEN:*
I've missed it for good, haven't I.

*TIM:*
Ah! Tell you what we could do. If we go back to my place, we could go on the Internet; go on the station's website and listen to it again.

**Exercise Aim:**

We have a continuity problem in that Tim says the line, 'Ah! Tell you what we could do' before he gets up in his MCU and as he gets up in the wide shot.

The aim is to solve the continuity problem and produce an acceptable result.

🎬 *Did You See?*—Solving Continuity Problems by Putting Movement on the Cut

As I have touched on before, an editor has many tools by which he or she can throw the viewer's eye away from minor discontinuities, which are inevitable between different takes of the same action.

The eye is attracted to movement, as we have seen; it's totally instinctive. This flaw in viewers' defences allows an editor to

**Questions:**

How can we use the wide shot as Tim gets up?
Can we cut to Helen to help us?
Is there a clever solution?

**Answers:**

If we use Tim's MCU, the wide is unusable until
Tim has finished his line. If we wait that long,
there will be a huge continuity problem with
his position as he gets up. Trouble is, taking
the line on the wide seems a shame, as it is
quite important to see this in close-up, and
the wide would give us a further problem with
the position of Helen's head.

How I solved it was to use some silence from
elsewhere in the soundtrack and cover over
Tim's words as he stands in the wide. The
pause sounds entirely real and natural, and,
as you can see, the movement distracts the eye
marvellously.

Incidentally, I cured Tim's fluff on the words,
'Tell you what we' with the other take. It
sounded a little like 'Tells you what we'.

### Sight and Sound in Concert—The Healing Powers of Sound

Sound also acts as amazing sticking plaster over indifferent
joins. I've always believed that sound carries the vision, and this
is yet further proof. In other words, if the sound is continuous,
overlapping, and correct, then you are able to get away with vision,
which may not be 100% perfect.

Have a go at the problem in this exercise, Exercise 27: Healing
Sound.

## EXERCISE 27: HEALING SOUND

**Shots Involved:**

1 WS 2S (12)
2 Sq 2S (12)
3 Sitting Fx (13)
4 Clock (16)

**Dialogue:**

*PHILIP:*
I ought to have shares in 'Silvo' or 'Duraglit'.

*THEY SIT.*

*MARK:*
It's a funny thing about funerals; the deceased
have no influence whatsoever in the events, even
though they are the reason for the gathering.

**Exercise Aim:**

There is no alternative; these shots must be
made to cut together. Try your best.

**Questions:**

How can the shots go together?
What point offers the least damage?

**Answers:**

Frames are missing here, so there is very
little an editor can do to invent those
missing frames. We are into damage limitation
territory, not perfection.

The join does not look pretty, however you
fiddle with it!

Well, as the exercise suggests, try placing
a useful sound effect over the troublesome

join and see what happens to the vision. Just put that chiming clock across the join, and suddenly life is not quite as bad.

Yes, I think a reshoot is still in order here, but if you have to make this cut work, then the addition of the clock helps immeasurably.

## 5.4 Cutaways

*Cutaways* is a name for added shots that allow an edit to be made in the soundtrack. They can look really obvious or virtually invisible, depending on their timing with respect to the neighbouring shots or action. They should look as natural as reaction shots; however, the reason they often don't is that you are sometimes forced into using one at a place where you'd never cut to a reaction shot.

The problem is caused by the fact that if an edit has to be made in the soundtrack, you have to do something with the vision to cover up what would otherwise be a jump cut.

It's time to get your editorial hat on with this next exercise, Exercise 28: Dialogue Removal.

Here, Helen's dialogue is flabby and longwinded. Decide what has to go and use, guess what, a cutaway.

### EXERCISE 28: DIALOGUE REMOVAL

**Shots Involved:**

1 MCU H (08)
2 MCU T (08)

**Dialogue:**

*TIM:*
I don't understand why you didn't tell me about John?

*HELEN:*
I didn't tell anyone. I mean, I wasn't sure myself and didn't know what the consequences would be. Our relationship happened so quickly, I decided not to tell anyone, well, until I had made up my mind. It was my affair after all, (PAUSE) literally.

*TIM:*
You're telling me!

**Exercise Aim:**
The aim here is to cut out the flab. Helen's explanation goes on far too long. Cut to the chase, using Tim as a cutaway.

**Questions:**
Which of Helen's lines should go? Which of Helen's lines are worth saving?
How can you make Tim's cutaway look good and natural?

**Answers:**
Well, how did you get on? We can argue about the merits of inclusion or exclusion of certain lines forever. It's one of the joys of fine-cutting a piece of writing, but I hope you got somewhere near my version.

One important point is that you have to allow Helen to get going with her answer for a reasonable time before you can cut away to a listening Tim. If you don't, you'll alert the edit-spotters to suspect something has happened here.

As you can see, I tend to cut to and from Tim on starts and ends of phrases. I think it just looks better.

## 🎬 *How to Look Good Naked*—Damage Limitation

I wouldn't bother preparing any BAFTA acceptance speech if you have to face too many of these *damage limitation* situations, but it is here that a good editor is even more valuable. This delicate repair work usually involves cutaways so that you can cover up any necessary reconstruction of the soundtrack.

If you can, try to place any cutaway at the end of a strong word or comment. At least this offers a plausible excuse for the forced change of viewpoint. Having made the cut, the choice of expression on the cutaway's face must be chosen to fit exactly with the mood of the outgoing words. Too often in interviews, I have seen the use of inappropriate reactions that are so obviously from a different part of the interview, and thus they stick out badly.

Care must also be taken to ensure that the subject of the cutaway hasn't changed position too much from the last time we saw them in the programme.

You've got a great exercise to attempt here! It will take all the skills you have acquired so far to get over the problems.

Have a go at Exercise 29: Damage Limitation 1.

## EXERCISE 29: DAMAGE LIMITATION 1

### Shots Involved:

```
1 MCU P (12)
2 MCU M (12)
```

### Dialogue:

*PHILIP:*

But he did miss you. So did I actually, if only just to help out with him occasionally. He was becoming quite difficult at times. He lived in the past you see. I think that was because it was only there, in the past, that he was able to be with his old friends again, where he was fit and healthy, and mum was still alive of course.

### Exercise Aim:

Do your best here to limit the damage and get something useable on the screen.

It's truly an editor's job to try to save this.

### Questions:

Yes, we can use Mark's listening picture, but for how long?
What bits of Philip's performance are useable?
What lines have to go?

### Answers:

How did you do?
Well, you can see my efforts and you might well disagree—that's fine. I lost several lines and tried to make the speech make sense in as short a time as possible.
Again, I have played a trick with the vision by editing a bit out of the middle of Mark's picture so that it fits better with the new dialogue.
As with other exercises, I have tried to maintain eye contact as much as possible. It really does allow you to hop over to the other person more easily and more invisibly.
I would love to get to Philip for his line 'fit and healthy', but it just looks too bad.
Good exercise, I think.

## 🎬 *Damages*—More on Damage Limitation

Here is another exercise involving damage limitation. Yet again, you have to try to save as much as you can from this section of the scene.

You'll find out that much of Philip's shot is unacceptable, but what can you do to mitigate the situation?

Have a go at Exercise 30: Damage Limitation 2.

### EXERCISE 30: DAMAGE LIMITATION 2

**Shots Involved:**

```
1 MS M & Mag (13)
2 MCU P (12)
3 MCU M (12)
```

**Dialogue:**

*PHILIP:*

They represented his world; yesterday's world. He hated today, he hated now, where he was on his own, in pain, increasingly out of touch and control.

*MARK:*

Progress always goes hand in hand with nostalgia; the one produces the other.

**Exercise Aim:**

The aim here, as the name of the exercise suggests, is once again damage limitation. You'll have to cut dialogue to make this work.

**Questions:**

Is any of Philip's shot saveable?
If no, how and when can we get to Mark's single?

**Answers:**

Sadly, in my view, none of Philip's single is acceptable. This leaves us with a problem getting off Mark's wider shot with the magazine to his single. Also, we can't stay on Mark's face for the whole of Philip's visually unusable speeches. The only answer is to adopt an editorial role and get rid of some of the dialogue. All we need is enough for Mark to say his line 'Progress goes hand in hand with nostalgia'.

Have a look at my rather brutally short version. Mark's blinks make the edit just about acceptable, but not that good. I think in a real-life situation, a pick-up of the flicking pages of the magazine would be the solution here.

## 🎬 *Noddy in Toyland*—How to Use Noddies

*Noddies*, as I have already mentioned, is just another term for a cutaway. The term is more usually applied to interview situations, and their use is worth considering separately just for a paragraph.

Don't be tempted to insert too many traditional-looking noddies. We don't sit listening to one another with our heads bobbling around like a toy dog on a dashboard or parcel shelf. Very often a blink or other slight change of expression is better than the more clichéd nod. To emphasise this, in some news organisations, the use of a traditional noddy is banned because it implies agreement with the point being made. What a cautious world we live in these days. Still, having gone away to the vision of the cutaway, don't be tempted to go back prematurely. Instead, stay a while and the change of shot will look much more intentional. One last point: try not to go back to the same size shot you left on. A two-shot

instead of a single (if such coverage is available and it fits) will further disguise the forced use of a cutaway.

Take a look at Exercise 31: Noddies.

```
The thing is not to make the reactions too short.

I used an invisible mix in Philip's second
reaction in order to shorten time and get
his head back up before the cut back to Mark
for his next line, 'wouldn't he have been
pleased'.

Sorry to keep banging on about it, but try to
keep the eyes up and looking at each other on
your cuts. In this way, TV and film can be made
to look better than what happens in real life.
```

### 🎬 *White Out*—More Stylistic Edits

I'm sure you have noticed a recent trend to dispose of cutaways altogether on certain types of programmes. More and more you'll see a quick mix or dip to white in place of the more traditional approach. I must say, this seems to be a more honest and straightforward technique, but I agree that it doesn't work in all circumstances. In other words, what would be appropriate for a news interview or a sport report would not be appropriate in *The Graham Norton Show* or *The Late Late Show* currently hosted by Brit James Corden.

## 5.5 Flow

What I mean by *flow* is best illustrated with an example.

### 🎬 *Noises Off*—Use of Sound Glue to Join Unrelated Pictures

Imagine a car draws up alongside a railway embankment. An occupant gets out and starts down an overgrown path alongside the embankment. In a wide establishing shot, a train is seen to pass with considerable noise. Subsequent close-ups of our

character walking down the path may have to be filmed in a different location, miles from any railway. There is a possibility these shots might not cut to the establisher that well. One solution that might do the trick would be to lay the sound of the train from the wide shot over these new shots. This is what I mean by *flow*. The cement joining the shots together is the sound of the passing train, even though the train is not seen in the close-up shots. One shot flows into the other, or others, because the audience now believes our path remains placed firmly alongside the railway line just by using the 'sound glue' of a passing train.

## Words and Music—Adding Music over Troublesome Pictures

Flow can also be created or enhanced by music that is either specially composed or from a commercial track. It's just another form of 'sound glue', but it's a *very* important one.

I will consider music and how it can help the editing process in greater detail in Chapter 10.

## Loose Ends—The Use of Sound Effects to Help Weld the Join

In the railway embankment scene described previously, the shots would have been designed and directed in a way to give the illusion of continuity of location, helped by the use of the train noise from the master shot and mixed over the subsequent closer shots. Sometimes extra glue, in the form of added sound effects, has to be offered in the edit suite in order to help the spatial continuity. Sounds like a dog barking, children playing nearby, or passing traffic can all help bond shots together and create flow. With such sound glue, you'll be surprised how many more liberties you'll be able to take with the timing and the content of the vision.

Imagine coverage of a person buying a railway ticket from a vending machine at a train station. The director will (hopefully) have given you a master wide and several close-ups: a wallet being opened, close-ups of the selection screen, fingers on a keypad, selections being made on the screen, and tickets being dispensed. You will be amazed how much easier it is to jump time within this sequence with, let's say, the added sound of an announcement from the station's PA system or the noise of a train arriving. These sounds will help disguise the small time jumps in the action that are necessary to shorten the otherwise boring sequence of buying a train ticket.

With the good use of a sound effect, you have shortened a dull sequence and created flow. Music will also perform this function superbly well, but it is not always appropriate in every case.

An exercise is next: Exercise 32: Shorten Time.

# EXERCISE 32: SHORTEN TIME

**Shots Involved:**

1 WS H's (03)
2 T at corner (03)
3 T at gate (03)
4 T Taps (03)
5 Aircraft (16)

**Dialogue:**

NONE.

**Exercise Aim:**

The aim here is to compare the ease with which you are able to shorten the action with and without the addition of the sound of a light aircraft passing overhead.

**Questions:**

What's the minimum shot length you can get away with?
Are all the shots necessary?

**Answers:**

I cut a long version to take Tim to the house in real time, and you can see how boring this is.

It should be clear that the noise of the light aircraft helps you cut down Tim's journey to the house with the result that even the really short version of the wide shot cutting directly to the shot through the garden gate is now completely acceptable.

I think the volume change of the noise of the aircraft on the cut to the gate shot is also a good idea.

In reality, this is a golden opportunity for a music cue, but the light aircraft sort of does the trick here.

Remember, silence is the worst option if you don't want to get those annoying edit notes.

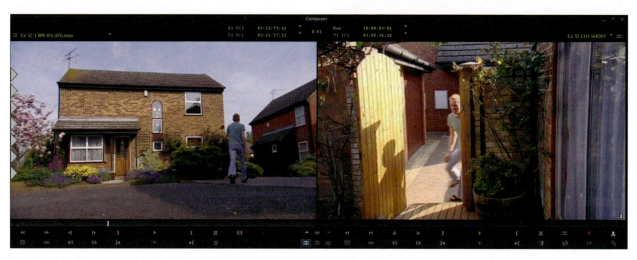

**EXERCISE 32: SHORTEN TIME.** HOW FAR CAN YOU JUMP TIM TO THE SIDE GATE WITHOUT IT LOOKING TOO RUSHED?

## 5.6 Time Jumps

I just thought it's worth spending a few moments examining some common techniques which are used to create or hide jumps in time.

### 🎬 *The Time Tunnel*—Putting the Clock Forward

*Time jumps* split into two main types, macro and micro, or if you like, long and short. Macro jumps are mostly given to you in the script or develop as the programme is assembled. This is especially true for documentaries.

Written scenes that stop when the participants go to bed and begin again with cocks crowing, milk bottles rattling in their crates, and toast projected vertically upwards from between red-hot heating elements have an inbuilt time jump. They are created by the pen, shot by the director, acted by the cast, and then timed to perfection by you. These jumps are fairly obvious, but in any film or TV programme, there are many more time jumps than you think. When you next watch a movie, count the number of times the clock has been moved on with respect to continuous time, however short those jumps are.

There are loads of examples in the language of film—a doorbell rings, a person reacts, and we cut straightaway to a hand going onto the latch; or a couple meet and greet on a city street and we cut to a waiter now serving some drinks to our couple, who are now seated at their favourite table near the window. In both these examples, elements of real life have been removed and deemed unnecessary to the story. Well, it would be ridiculous to watch a car driving even a relatively short distance, with all the traffic delays we expect these days on such a journey. In filmic terms, it is perfectly acceptable to show a car leaving a suburban house and a moment later arriving at terminal 3 to convey what is going on; the journey itself is edited out, either in the camera or in the edit suite. The clever part is making these joins work in terms of the sound and the vision.

### 🎥 *Citizen Kane* (1941)—An Example of Using Time Jumps from the Movies

Time jumps are used in a very creative way in the film *Citizen Kane* (1941), directed by Orson Welles and edited by Robert Wise. In the film, the central character, Charles Foster Kane, is seen at various stages throughout his life. These episodes are sometimes years apart, and Welles uses many great techniques, honed from his radio-producing days, to turn the pages of the calendar back and forth.

One particular junction starts at Christmas time when Kane is a boy. Walter Thatcher (George Coulouris), his guardian, offers the young Charles a gift with the words, 'Merry Christmas'. His sentence is finished 17 years later when Thatcher is dictating a letter and concludes with the words, 'and a Happy New Year'.

Only with the evidence that Thatcher looks older, and that he refers to Kane's 25th birthday, do we accept that all that time

has passed in an instant. As I said, it was probably Welles's background in radio (remember his sensational broadcast of *The War of the Worlds* [1937], which had America believing an alien invasion was actually happening) that hugely influenced his early filmmaking.

## 🎥 *The Theory of Everything* (2014)—A Great Time-Jumping Montage

At the end of the film *The Theory of Everything* (2014) about the life of Professor Stephen Hawking, which starred the 2015 BAFTA, Golden Globe, and Oscar-winning Eddie Redmayne and was directed by James Marsh and edited by Jinx Godfrey, there is a superb rewinding of time montage against Jóhann Jóhannsson's music to turn what was the end of the movie into the start.

Let me explain, and because most of us know about the life of Professor Stephen Hawking, I won't have to worry too much about spoilers. With his triumph of the publication of his book *A Brief History of Time,* you would think the film would end with this, but no. The music stirs and sends us on a superbly cut, rewinding montage of the key moments we've just seen from Stephen's life, this time run backwards—his family, his academic acclaim, his doctorate, the birth of his children, the onset of his illness, his university days at Cambridge, and eventually to that life-changing moment when he first saw his future wife Jane (Felicity Jones) at a party and in a Cambridge pub, all those years ago. Here the film ends as it began. So good!

## 🎥 *The Life and Death of Colonel Blimp* (1943)—One Superb Time Jump

I don't know how we've got so far in this publication without mentioning those great film makers Michael Powell and Emeric Pressburger, but they wound the clock back 40 years very cleverly on our hero, Clive Candy, played by Roger Livesey, in the film *The Life and Death of Colonel Blimp* (1943). The 40 years vanished from one end to the other of a bath in the steam room of a Turkish bath. He plunges in as Major-General Wynne-Candy in 1942 and emerges 40 years earlier in 1902 as Lieutenant Candy.

## 🎬 *Beat the Clock*—Back to Our Plot!

In a way these macro time jumps are easier to generate and deal with than the micro variety we constantly look for within the body of a scene. Micro jumps, used well, can drastically improve the impression of pace and urgency that are so necessary these days to hold the attention of an audience. Being clever with micro jumps, or *tightens,* is certainly one of the secrets of being a good editor.

## 🎬 *The Time Machine*—Micro Tightens

*Micro tightens* can only be achieved between different shots. Well, that's not strictly true, because time can sometimes be removed invisibly from within the same shot if the camera and your subject are both still enough; however, this is rare, especially because any tripod or mount is today, more often than not, gathering dust in a store cupboard. We're back to those fashionable jump cuts that we discussed earlier.

Given that, for the most part, we are looking to tighten time, it is sometimes necessary to generate a shot change in order to achieve this. It is always a good idea to be on the lookout for tightens. Once a sequence is assembled to a working version stage, ask yourself the question: Can it be made to happen more quickly without ruining performance or style? For example, maybe with the use of a close-up you can tuck under some incoming dialogue a few frames earlier and eliminate another pause. Once

again, our old friend movement will help give you the chance to jump time forward. Getting up from a chair, going through a door, or boarding a train are all examples that will give you the opportunity to cheat time forward slightly.

Along with movement, sound can also be used to push time forward—a door slam, a telephone ring, or the ping of an arriving text, and you can more easily jump to the next bit of action. Remember, even a few frames can make all the difference.

Thus, we have a second editing rule: Always look for nips and tucks.

### 🎥 The Great Gatsby (2013)—An Uncomfortable Ride?

In my opinion, a film where the removal of small amounts of time is taken to the extreme is *The Great Gatsby* (2013), starring Leonardo DiCaprio, directed by Baz Luhrmann, and edited by Jason Ballantine. Here, some of Luhrmann's time jumps turn into uncomfortable, distracting, and above all, unnecessary jump cuts.

### 🎬 A Time to Kill—Tightening Action

The next exercise is Exercise 33: Tighten Action. In this exercise I invite you to examine the possibilities of tightening dialogue, with the aim of making it both crisper and sharper. This does not mean you tighten everything in sight and start overlapping dialogue left, right, and centre. Consideration must, at all times, be given to the original performance; it should be improved by an edit but not changed out of recognition.

---

**EXERCISE 33: TIGHTEN ACTION**

**Shots Involved:**
```
1 MCU M (12)
2 MCU P (12)
```

---

**Dialogue:**

**Synopsis:** Philip has just reminded Mark that their mother died nearly 11 years ago. Mark remembers that this was the year he formed his company, 'Desktops'.

*MARK:*
I sold that last year you know; did very well out of it.

*PHILIP:*
Really, I think it was mum's funeral when you last stopped over here.

*MARK:*
Don't make me feel even more guilty.

**Exercise Aim:**
This is a simple exercise to drive home the point about tightens. It is up to you to make the cuts between the two characters and tighten the performances where appropriate.

**Questions:**
When do we cut to Philip?
Can you tighten the performance?
What about Mark's next line?

**Answers:**
It is pretty obvious that we should see both parties deliver their respective speeches. However, this shouldn't stop us from playing with the joins and doing some useful nips and tucks.

Philip gives a big pause between 'Really' and 'I think'. This is easily removed by staying on Mark's beaming face, which isn't a bad idea anyway. Also, you obviously have to use Mark's second attempt at his line, even though he is more wounded in the first take, but sadly this

## 5.7 Editing without Dialogue

Dialogue, by its very nature, offers you inbuilt cutting points as the conversation is batted back and forth between the participants. But what happens if there is no such dialogue to help you and you are left to control the pace of a sequence only by its content?

### *Keep on Running*—Try to Keep Things Moving

Take the example of a character walking up to a front door, ringing the bell, and waiting for an answer that is a long time in coming. The worst thing to do when trying to tell this story on screen is to replicate the wait as it happened in real life. A boring wait for the character in your story will inevitably turn into a boring wait for your audience. Ways have to be found to convey this long wait in a shorter time. A good director will provide you with a variety of shots that will enable you to achieve this, but it is your job to put them together in a sensible sequence.

To ensure your sequence isn't used as the latest cure for insomnia, you have to make sure each shot change moves the story on. I know a character waiting at a door is a challenge, but even here, changes of emotion (in this case the increasing frustration that the doorbell has still not been answered) can be assembled to form a reasonably interesting progression.

To make sure there is a progression, never return to the waiting character with exactly the same expression on his or her face as when it was last seen. It is far better to wind time on a fraction and display the next level of frustration as the wait continues. You know the kind of thing—a sigh, a look around, or even a look at a watch. Yes, I know the shots and the action have to be there in the first place, but you'd be surprised how, by putting even the slightest change of expression right at the start of the next shot, you can help push time on and keep your viewers awake. In reality, I'm sure a scene like this would be intercut with a parallel scene in order to keep the plot moving.

### *Tinker, Tailor, Soldier, Spy* (BBC TV) (1979)—A Scene without Dialogue

Without any doubt, *Tinker, Tailor, Soldier, Spy* (1979) is my favourite TV series of all time. From the book by John le Carré, it was directed by John Irvin, edited by Chris Wimble and Clare Douglas, and starred Alec Guinness as George Smiley. It starts with a superb cold opening which for two minutes contains no dialogue.

All the scene shows us is four men entering a room for a meeting. I know that sounds somewhat dull, but it is in fact quite the opposite. Each character reveals his persona to us both in his attitude to the forthcoming meeting and to the others, and all of this is played without any dialogue. First in is Toby Esterhase (Bernard Hepton), prim, proper, with his meeting file already prepared and now laid out perfectly on the desk in front of him. Next in is Roy Bland (Terence Rigby), dishevelled, smoking, and reading a document he probably should have read earlier. He's followed by Percy Alleline (Michael Aldridge) pompous, unsmiling, and entering the room as though he owns the place (which he does), and he sits down and gets his pen and pipe out ready to chair the meeting. Bill Haydon (Ian Richardson) is the last to arrive, and he enters balancing a saucer on top of a very full cup of tea. He tries to shut the door with his foot, but he fails. He sits

down and smiles at Toby, who, wanting everything to be just right, gets up and closes the door for Bill. We see a silent four-shot for another 10 seconds, until eventually Percy says, 'Right, we shall start'. A cut to the matryoshka dolls opening title sequence, complete with Geoffrey Burgon's marvellous music, and we indeed have started.

I wonder what TV drama today would be given the luxury of two minutes of a wordless cold opening consisting of four men entering a stuffy room for a meeting.

## 5.8 Key Points—Creating Sequences

- At last we have a first universal editing rule: *Don't cut unless you have to, and if you do, make sure you have something just as interesting for the viewer to look at.*
- Always look for ways for the action to take place in a cleverer and quicker way.
- Our second editing rule is: *Always look for nips and tucks.*
- Editors have an amazing impartiality to include (or reject) shots on merit alone and not the time and trouble it took to photograph them.
- Pauses can be left on the outgoing shot more comfortably than the incoming.
- Judge every pause on its merits.
- Be careful of leaving any gaps or silences in the soundtrack of an early undubbed cut, as they can cause a flurry of unnecessary edit notes. The solution is to dub some sound on, and you'll get away with that pause you want to keep.

- If you were being really devious, you could always leave some pauses in intentionally, so that your reviewers comment on these and might ignore or miss others.
- 'If in doubt, tighten' is not a bad attitude to adopt. Ninety-five percent of the time your sequence will look better.
- Continuity shouldn't rule an editor's life.
- If there is an unavoidable continuity problem, find ways to deflect the viewer's eye by cutting to an irresistible bit of movement somewhere else in the frame.
- Let perfect sound carry less than perfect vision.
- Cutaways should look as natural as reaction shots.
- Place the cutaway (if you can) at the end of a strong word or comment, which gives an excuse for the forced change of viewpoint.
- Try not to come back to the same size of shot after the cutaway.
- Sometimes it's better to be honest and dip to white, or something similar, to cover the join. This either works or it doesn't, according to the style of the programme concerned.
- Sound glue (sound or music that is spread over several different shots) can help the flow of a scene and hide small time jumps.
- Even sequences without dialogue must be made to flow. Never come back to a shot that tells the viewer nothing they don't know already.
- A boring wait for a character in your story can easily turn into a boring wait for your audience. Look for ways of editing time out of such a sequence whenever you can.

# Chapter 6
# Scene Construction

Once a few shots have been assembled, the scene, whatever it is, starts to take shape, and you're the first person to see it.

In this chapter, we widen our field of view even further as I concentrate on the overall shape of a scene rather than the individual elements of specific parts.

What I mean by this is that even though it is technically okay to cut a scene in an endless succession of MCUs as two people have a meal together, it would be mind-numbingly boring for a viewer (all right, unless you want to make a point).

Here I will suggest ways you might tackle the construction of a scene so that the end product will be enjoyable and not result in half of your audience seeing this as a good chance to reach for the remote and go and put the kettle on.

This chapter is divided as follows:

- **6.1 Where to Start?**
- **6.2 Scene Assembly Fundamentals**
- **6.3 Key Points—Scene Construction**

## 6.1  Where to Start?

Convention would decree that you should start a scene with an establisher. As we've discussed already, an exterior shot of a building followed by an interior shot of people talking implies that the conversation is taking place inside that building. Using an establisher to start a scene is a good, if not the best, way to give the viewer the essential geography in order to accept what an editor has to do to cover the rest of the scene properly, namely to concentrate on specific elements within that scene.

The problem is that as soon as you cut to a close-up of someone, you temporally ignore the other characters, incidentally forcing all your viewers to do the same. However, staying on an establisher,

or a wide shot, for the whole length of a scene is no solution either. There has to be a compromise.

###  *Making It*—Get That Canvas Dirty!

At first, I tend to put a scene together in a fairly conventional way: wide shot establisher, then over-shoulder or group shots, and then punching in to singles for the more important sections of dialogue. Having gone in shot-wise, it is often very difficult to break out to a wider shot again, because this cut very often looks weak by comparison. Luckily, most scenes have a moment where such a break-out can be achieved; a waiter bringing food, a passer-by, or some distracting noise are all good opportunities to go back to a wide shot and help the cut not to look weak. The advantage is that it will reconnect the viewer with the geography of the scene, especially if they need to see events happening nearby.

### *The Expert*—Now Make Good into Great

Having produced a workable framework, let us now look for ways of making the scene more visually interesting. This is where the magic comes in.

Let's look at some of the techniques.

## 6.2  Scene Assembly Fundamentals

### *Tiswas*—The Throwing of Custard Pies

Seeing the effect that dialogue or events have on all the characters in a scene is the key to correctly conveying all the available emotion, tension, and comedy in any piece of writing, performance, or even a simple discussion.

When you're dealing with comedy this is even more important, as you must see the funny line spoken in a reasonably close shot (staying long enough to capture the expression on the face that has just delivered this latest comedic gem) and then move straight over to see the reaction on the face of the victim.

I think of funny lines as verbal custard pies. If we consider the throwing of a custard pie, to get the maximum comedic effect, you must see the pie launched and then see it find its hapless victim. It's the same with funny lines.

This could be a third rule in this editing lark: See it launched, see it land—it works every time.

Frankly, 'see it launched, see it land' is not a bad rule to adopt even when your scene is far from funny.

### *Analysis*—Take a Look around Your Characters

With every new line you have to constantly ask yourself what character is most affected by this latest information, then check to see if that character gives a good enough reaction for inclusion in your cut. Revelations, important news, and disclosures

are all obvious examples of points where a reaction shot is a must. Remember, you've had the advantage, or sometimes the disadvantage, of seeing all the shots when you viewed the rushes, and therefore you already have a good idea of how all the characters are interacting in the scene. The viewer hasn't. You have to keep imagining that you are watching the scene for the first time and constantly ask yourself the question, what do I want to see next? All too often, the answer is several places at once, but you, as the editor, have to balance the 'for and against' arguments to achieve a final and varied selection.

One possible way of working here is to assemble a framework of cutting to the character who is speaking in whatever size shot is appropriate. Then, once you have this framework in place, look in turn at what reactions *all* your characters give to the dialogue and sprinkle the best and most important of these into your cut, and

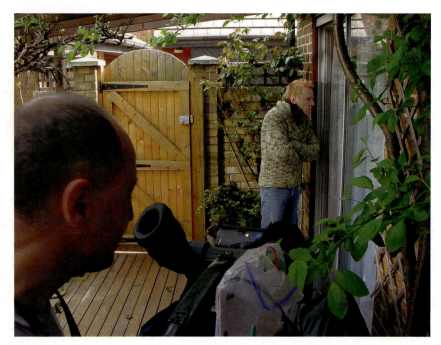

NIGEL BRADLEY AND PAUL TAYLOR FILMING *CHOCOLATES AND CHAMPAGNE.*

you'll quickly see the scene come to life. It is at this point that you should consider stretching the cut slightly in certain places to include extra reactions which would otherwise go unnoticed and unused.

### 🎬 *Out of Sight*—Or, More Accurately, Making Sure Your Characters Don't Do a Disappearing Act

Cutting out to a wider shot is trickier than you might have at first guessed. The reason for this is not only because of possible timing errors between different takes, but also, and more commonly, it is the choice of shots that must contain this action.

If there is a rule, it is to let any movement start in the shot that has best covered the current action, then release to a wider shot that will better continue and contain that new action. We are back to cutting *on* movement again (rather than *before*).

Our fourth editing rule is: Cut on movement, and not before.

If your cut to a wide shot is late, then the outgoing shot can often become messy or poorly framed, with a person too near camera as they get up, a half empty chair or sofa, or worse still, a half empty shot with important action going on outside the frame.

On the other hand, if your cut to a wide shot is early, it emphasises the weak nature of such a shot change because there is no immediate reason for its selection.

My good friend and director/producer colleague Sydney Lotterby described cutting to a wide shot too early as 'cutting out before the explosion'. If you cut too early, the audience will know something is going to happen, and therefore you potentially spoil the joke. You should cut on the explosion, and not before.

I think if you attempt the next exercise, Exercise 34: Out Wide 1, you'll see what I mean.

## EXERCISE 34: OUT WIDE 1

**Shots Involved:**

```
1 W2S to Desk (05)
2 OS Fav H (05)
3 MCU T (05)
```

**Dialogue:**

*HELEN:*

I suppose you're right. Go on, play that bit about us again on the computer.

*TIM:*

Yes, all right but first I want to show you something from earlier in the programme—it's one of those marital surveys.

**Exercise Aim:**

The aim of this exercise is to cover Helen and Tim's rise as they cross the room in the best way possible.

**Questions:**

From which shot is it best to cut to the wide shot? Do you simply jump back to the wide, or go via Tim's shot?

**Answers:**

Tim's shot allows you to cut to the wide and not to just jump back along the line.

Both versions look okay, and I can't really choose between them. I suppose with the inclusion of Tim's shot, you just catch his smile as Helen bursts into action.

The bad versions demonstrate that being late and early to the wide just looks odd.

## Take Two—Another Example of Out Wide

I thought that the technique of cutting out wide was important enough to give you another example, in order to illustrate what I am trying to say.

Have a go at this exercise, Exercise 35: Out Wide 2.

## EXERCISE 35: OUT WIDE 2

**Shots Involved:**

```
1 WS & Laptop (06)
2 2S OS Laptop (07)
```

**Dialogue:**

*TIM:*

Look, I really feel very uncomfortable doing this. You push the buttons and I'll tell you what to do.

THEY CHANGE PLACES.

*TIM:*

Right, just click on there.

**Exercise Aim:**

The aim of this exercise is to once again examine the best place to jump wide.

**Questions:**

This is a jump back almost along the line. Will that always look okay?

**Answers:**

The jump back works here because there is just enough difference of angle between the shots, and the movement contained within the two shots is

of a high standard of continuity. If you can get away with it and it looks good, do it.

Again, you have a good and two bad versions to look at. In the bad versions, the cut to the wide shot is either too early or too late.

PAUL TAYLOR AND PIPPA SHEPHERD AS TIM AND HELEN IN *CHOCOLATES AND CHAMPAGNE.*

## 🎬 *Wider Still and Wider*—Breaking Out Wide Again

In this exercise, there's a good example of what I meant when I talked about finding a piece of the action to break out to a wider shot, a transition which can sometimes look weak.

Have a go at this exercise, Exercise 36: Out Wide 3.

# EXERCISE 36: OUT WIDE 3

## Shots Involved:

1 MCU H (06)
2 MCU T (06)
3 W2S T & H (05)

## Dialogue:

*HELEN:*

Yes, there was something about another e-mail address? Have a look on his computer for me.

*TIM:*

Oh no! I'm not playing 'Burglar Bill' for you. Joey would kill me, if he knew.

## Exercise Aim:

The aim of this exercise is to once again find a good place to jump wide.

It should be fairly obvious, but I want you to see how effective this technique is in this example.

## Questions:

Where should you go wide?
Having done it, where should you cut next?

## Answers:

Helen's hand on Tim's knee is an ideal way to break the potential monotony of endless MCUs. The next cut should be easy, as you should go back to Tim for his blank refusal to cooperate. Again, you have good and bad versions to look at.

## 🎬 *Late Junction*—Look to Underlay Dialogue

We've touched on *underlaying dialogue* before, but it's worth mentioning it again to help you improve the appearance of a scene.

Always look for ways you can underlay dialogue so that you're not always trapped on the face giving the information. Weak incoming words like 'so' or an agreeing 'yes', or any dialogue repetition like 'I know, I know', will allow you to stay on the outgoing picture longer and stop you from falling into the trap of cutting to an actor just because he or she speaks.

Look for dialogue where, if it were written down, there would be a comma after the first word or group of words in that particular sentence.

We have a fifth editing rule: Cut on full stops and commas.

At the same time as doing this, always be on the look-out for trims of any sort.

The next exercise, Exercise 37: Underlaying Dialogue, will help illustrate this point better than words.

### EXERCISE 37: UNDERLAYING DIALOGUE

**Shots Involved:**
```
1 MCU H (08)
2 MCU T (08)
```

**Dialogue:**

*TIM:*
People speak to you when you've got a dog with you, don't they.

*HELEN:*
Yes, those 'good mornings' and 'hellos' from strangers, they sort of cheer you up a bit when you're feeling bad.

**Exercise Aim:**
The aim is to simply choose what words to underlay, and hopefully remove some of the pauses.

**Questions:**
What words can be safely put out of vision? Can you now tighten the dialogue?

**Answers:**
This is a simple exercise with a strong message. Helen gives us a massive pause between 'those' and '"good mornings" and "hellos"', and this can easily be cut out if you put her agreeing

**EXERCISE 37: UNDERLAYING DIALOGUE.** THIS TECHNIQUE WILL HELP THE CUT AND ALLOW YOU TO TIGHTEN UP ANY UNNECESSARY PAUSES.

'Yes' under Tim's outgoing shot. Also, I got rid of a funny 'snorty' laugh that Helen gives us.

It's amazing the difference these sorts of trims can make.

You should look to create overlaps and tucks at all times.

### 🎬 *Surprise, Surprise*—Dealing with the Unexpected

Imagine a scene with a couple talking in a bar. Would the line 'Darling, I've met someone else' look better in a close-up or from the other side of the pub? I hope the answer is obvious, but we have to make plans for that close-up so that the impact of the line is heightened by the coverage. Important story-changing lines like 'I'm pregnant', 'You're not my daughter', or 'He's been arrested' are the sorts of lines I mean. The trick is to make sure you are on mid-ish or wider shots coming up to one of these story bombshells, so that you can bang in to that all important close-up for the key line or reaction. It is amazing how much more powerful a line can be when it is accompanied by a sudden and dramatic close-up, especially after a series of wider shots.

After such revelations, the next cut is easy: straight across to see the tears welling up and buckets of custard cascading down the other character's face.

The exercise that follows, Exercise 38: Cutting In 1, provides an example of what I mean.

## EXERCISE 38: CUTTING IN 1

### Shots Involved:

```
1 CU H (07)
2 LS H & T (07)
```

### Dialogue:

> *HELEN:*
> Ha, that's why you wanted me to lie to him about where we were!
>
> HELEN PUSHES A BUTTON THEN LOOKS AT HER PHONE.
>
> *HELEN:*
> What? No, I don't want to re-record my message!

### Exercise Aim:

> The aim of this simple exercise is to find a place to jump into Helen's close-up for maximum effect.

### Questions:

> This is a simple cut from a wide shot to a close-up. The problem is, where should you do it?

### Answers:

> Talking to the phone, as if it were the phone's fault, would be difficult to see in the wide shot, and Helen's great turn to the phone gives us that perfect opportunity to jump in with ease.
>
> Generally, any action which is not clear enough in a wide shot should be seen in a closer version of that same action.

### 🎬 *The Invisible Man*—Now You See It!

While we are on the subject of wide shots verses mid or close shots, another rule that is worth adopting, is that any action which is not seen clearly enough in the shot you are using, should be shown to your audience in a closer version of that same action.

Thus we have a sixth editing rule: If you can't see any action clearly enough, use closer alternative coverage.

## 🎬 *A Close Shave*—Another Exercise on Cutting In

Here is another simple exercise that will drive my point home about when to cut in from a wider shot to a closer shot.

Have a go at Ex 39 Cutting In 2.

### EXERCISE 39 CUTTING IN 2

**Shots Involved:**

```
1 Sq 2S (13)
2 MCU M (13)
```

**Dialogue:**

*MARK:*

I can't remember how we managed to explain all the scratches that I had, but I suppose, at that age we were always getting into so many scrapes, it was forgotten. It was all so sudden, the wave simply swamped me.

**Exercise Aim:**

The aim of this exercise is simply to get off the two-shot and get to Mark's single at a point where it's good for the drama and Mark's continuity is acceptable.

**Questions:**

When can you make a cut to Mark's single off the two-shot?

**Answers:**

The thing is, once you have made your cut to Mark, you are forcing your audience to look only at Mark, and if you go in too early, you might make them miss seeing Philip's reaction to his speech. I know Philip doesn't give us much, but at least we will see that on the screen. With all this in mind, I went for the later line of 'It was all so sudden' to cut to his MCU. I like that timing, because Mark is in effect delivering that line to himself as he remembers the events of that near-tragic day on the beach. I don't think my bad version is truly bad, but I think it is better to hang on to the two-shot until Mark is in his own thought capsule.

KEITH DRINKEL AND GORDEN KAYE AS MARK AND PHILIP REMINISCING IN *THE PHOTOGRAPH*.

## Clone Zone—Don't Be Repetitive or Predictable

Changes of shot should, for the most part, be invisible and in no way individually distracting, so the less you adopt a repetitive or predictive style, the better (that is, unless you want to).

If you've been piling in reaction shot after reaction shot, I would give it a rest for a few shots, and then surprise the viewer with a smacker.

This exercise highlights the technique of varying the shot size. Have a go at Exercise 40: Vary Shot Sizes.

## EXERCISE 40: VARY SHOT SIZES

### Shots Involved:

```
1 M & Photo (13)
2 Sq 2S (12)
3 MCU M (13)
```

### Dialogue:

*MARK:*

Looks good doesn't it! Now, where was that?

*PHILIP:*

I think it's that swimming pool near the beach at Woolacombe, in Devon.

*MARK:*

Now, dad made some movie films out of that, didn't he, with that old 'Bel and Howell' thing that he had.

### Exercise Aim:

The aim of this exercise is to pick the size of shot most appropriate for the action and to make sure there is variation in your choice of shot.

### Questions:

What size of shot should you use for Mark's speeches?

### Answers:

I know the point about varying shot sizes comes into play more as the scene gets longer, but even with this short example, you can see that it is not good practice to come back to the relatively weak wide shot that has frankly done its job. We've seen Mark with the photograph and now surely we want to concentrate on his sudden keenness about his dad's films, which is better done in his MCU.

Even in the bad version, I corrected Mark's odd version of the word 'daaaaad' from the wide shot with his MCU sound, which I tucked under Philip's outgoing shot. You have my good and bad versions to look at.

In both versions, I waited for Mark to look at Philip before cutting to his shot, for reasons I don't need to restate.

## In Our Time—The Tempo of Cutting

As well as varying your shot sizes, you must try to vary the tempo of your cuts as well. Your cutting rate should reflect the tempo of the dialogue, and because that never remains the same for long, neither should your cutting rate. If the situation allows, why not stay on that wide shot for a few speeches, and then bang in some closer shots when the discussion gets more frantic? The tempo of the dialogue and the cutting rate will tend to help each other out. In other words, if an increase in the intensity of the dialogue within a scene is accompanied by a corresponding increase in your cutting rate, then that rise in dramatic tension will be enhanced.

## *Men Behaving Badly*—Breaking the Rules . . . It's Such Fun!

As a scene reaches perfection, I look for ways to break rules. For example, can I jump straight in on a close-up from a two-shot favouring the same character? Will the angle, size, and continuity allow such a cut?

Only experience will tell you what you can get away with and, therefore, what improves a cut rather than distracts. Movement, as it always does, will help here; a turn of the head, an intake of breath, a hunch of the shoulders, and in you go.

## *The Long View*—Considering Your Piece as a Whole

I know up to now we really have only considered scenes as individual areas of interest, but sooner or later they will be joined to neighbouring scenes to create a complete programme.

As we have just discussed, changes in the cutting rate reflect changes of mood within a scene, but varying the cutting rate can also be used to help shape the overall feel of a programme or film. An increase in the pace of cutting towards the end of a film is typically done with the obvious intention of heightening tensions in later scenes, in a probable attempt to combat the waning attention of a weary audience. Alternatively, as some films draw to a close, the mood might change to reflect the calm after the storm, and your cutting rate should be reduced to complement this change of mood.

Variations in cutting rate can also be used to reinforce the demeanour of different characters within the film. Long and slowly cut shots can emphasise the greater age or infirmity of a character, whereas quicker, sharper shot changes can reflect a more energetic and younger attitude.

## *Moulin Rouge* (2001)—Cut, Cut, Cut!

I can think of one example where constant fast cutting went too far for me, and this was in the film *Moulin Rouge (2001)* with Nicole Kidman and Ewan McGregor; it was directed by Baz Luhrmann and edited by Jill Bilcock. I'm desperately trying not to sound like an old fuddy-duddy, but sadly, I saw the cutting, not the movie.

## *My Way*—Unless You Want To!

'Unless you want to' is quite a phrase! You could include it after every piece of advice in this book. My role in writing this book is to merely show you convention. If you choose to be more stylistic and adopt a technique contrary to any of the advice offered here, that's fine.

I know, for much of the time, an editor has to follow the style the writer, designer, or director has conceived, but I would support convention only to say it is timeless. I have seen too many styles come and go, and the danger of this tidal flow in technique is that it could leave your piece high and dry in an area admired by only a few.

### 🎬 *Give Us a Break*—Once You're Done, Give the Scene a Rest!

When a scene is complete, it's high time for a rest . . . and I don't just mean you, give the scene a break as well. After the first assembly, I generally don't even look at the cut. I'd rather move on and tackle something different to clear my mind of the original scene's construction process, so when I eventually review it, even as late as the next day, I can do so with a more open mind.

After a break, you'll view a scene much more like a viewer at home or a member of a cinema audience will do, but unlike them, you'll be able change it and make it better. It's surprising what you'll find to change.

### 🎬 *Silent Movie*—Review the Sound and Vision Separately

Before you leave a scene, it's a good idea to turn off your picture monitor and listen to the soundtrack on its own. You'll find this very revealing, especially when it comes to pace and timing, and it can result in many small improvements which have so far remained undiscovered.

An equally good exercise is to do the opposite, and look at the scene without the sound. Again, it's surprising what you'll spot without those accompanying audio distractions. It's because you don't have any of that lovely 'sound glue' to help out your cuts, so some of the joins might now seem a bit wonky and worthy of improvement.

## 6.3 Key Points—Scene Construction

- Cut a scene conventionally to start with. Start with an establisher, then move to group shots, and then in tighter for more important lines.
- Establish a framework of cutting to the person delivering the lines in whatever size of shot seems appropriate. Then, search out important reactions from *all* those receiving the scene's information, and sprinkle them in.
- Use all the advantages of nonlinear editing software to store developing versions of a scene before you go on to construct more elaborate versions.
- Don't be scared of stretching out a dramatic moment in order to get an important reaction in the cut.
- Look for weak words or phrases that will allow you to create split edits and help you not to fall into the trap of always cutting to the person who is speaking.
- Find the moment in a speech to nip across to the recipient, and find out how any new information has gone down.
- Cutting to a wide shot after a series of close-ups can look like a weak cut. Search out moments in the scene that will allow you to do this for a good reason. A waiter passing by, new characters joining the group, or some adjacent action are all good ways to hop out to a wider shot.
- Any change of shot will allow you to tighten up the dialogue a fraction and help you control the overall flow.
- Funny lines are just like verbal custard pies.
- Our third editing rule is: *See it launched, see it land.*
- Our fourth editing rule is: *Cut on movement, not before.*
- Our fifth editing rule is: *Cut on commas and full stops.*
- Time your punch-ins to key moments in the drama. And afterwards, it's easy—straight to a reaction shot.
- Our sixth editing rule is: *If you can't see any action clearly enough, use closer alternative coverage.*

- Don't be repetitive or predictable with your choice of shots; in other words, don't just repeat, or predictably repeat, the shots you choose, because you would be repeating yourself in a predictable way.
- Vary your tempo of cutting to match and enhance the mood swings in the scene.
- Variations in the cutting rate can also be used to reinforce the demeanour of different characters within the film.
- Variations in the cutting rate can be used to shape the overall feel of a film.
- When you are editing, you can be as stylistic as you like. It is, after all, the essence of creativity, but remember, others will have to like your style as well.
- After completion, give the scene a break. After a rest, you'll view a scene much more like a viewer at home, but with the advantage of being able to change it.
- When you're happy with the scene, it's good practice to look at the vision and sound tracks separately. You'll be surprised what you'll find to change.

# Chapter 7
# Joining Scenes Together

In this chapter, I look at ways of joining scene to scene as we proceed further on our journey to producing a complete programme or film. Our polymer chain of individual edits gets longer and longer.

A change of scene usually accompanies a change of timescale. By how much time has jumped is generally made clear straight away to the viewer, whether it has been a few minutes or a few years.

### *Quartermaine's Terms* (1987)—Disguised Time Jumps

A favourite play of mine, dramatised by the BBC, that breaks this rule magnificently is *Quartermaine's Terms* (1987) by Simon Gray. It was directed by Bill Hays and starred Sir John Gielgud, Edward Fox, and Eleanor Bron. Here, cuts between scenes which were made to look like the next day turn out to be several weeks later, and only the forthcoming dialogue slowly reveals what has happened in the interim. As a viewer you keep saying to yourself, 'Oh, she's died', or 'Ah, they've split up', or 'He's in charge now', and so on. It's such good writing and well worth a watch. 'See you Monday'.

### *Scene*—Joining Scenes Offers You So Many Possibilities

A change of scene will offer you the widest range of possibilities as to the timing of such a join, much more so than anything we have looked at so far. The camera, when it filmed your incoming picture, will have been turning over for several seconds before the director's call for 'action'. Similarly, the last shot of the outgoing may hang on a few moments before the shout of 'cut' stopped the filming. Thus, highly charged moments that end a scene can be made to hang in the air before the bubble is burst by the arrival of the next scene.

This chapter is divided as follows:

- **7.1 Scene Transitions—A Look at the Range of Possibilities**
- **7.2 Repeated Transitions—Cross-Cutting (or Parallel Action)**
- **7.3 Key Points—Joining Scenes Together**

## 7.1 Scene Transitions—A Look at the Range of Possibilities

### *Place to Place*—The Simplest Scene Transition Is a Cut

By far the best way to join scene to scene is a cut. For the most part, a scene is a self-contained time bubble. Any tightens you make to increase pace within a scene are microscopic compared with time jumps that occur between complete scenes. Modern audiences are totally used to time jumps on cuts. Gone are the days

of wobbling the picture to imply we are going back in time to see a childhood experience from a character's life. A well-timed cut is the neatest, cleanest, and quickest way to jump from scene to scene.

### 🎥 *Lawrence of Arabia* (1962)—One of the Best Ever Scene Transitions Using a Simple Cut

One of the most famous cuts in all the movies comes from David Lean's *Lawrence of Arabia* (1962), starring Peter O'Toole. His Arabian adventure starts with the simple blowing out of a burning match. With the sound of the breath extinguishing the match, Lean cuts to a desert sun rising over a flat landscape over which that great tune, written by Maurice Jarre, also emerges out of the shadows of night. There follows a mix to a fantastic shot of rolling desert sands, and T.E. Lawrence and his guide appear as black dots over the crest of the dunes.

### 🎬 *In the Frame*—Good Cutting Techniques

Here are some good techniques to consider when you are cutting from one scene to another.

The eye is drawn to movement as we have discovered, so movement on a cut will help break the spell of the outgoing scene and introduce the new. Once again, it is better to leave the pause on the outgoing and let the first shot from the new scene move us on.

Look for something that wipes the frame on the cut. A passing car, a passer-by, or a hand gesture all act as marvellous screen wipes and can perfectly bring the outgoing scene to a close, just as a conductor of an orchestra brings the players to the end of a phrase with a swish of the hand.

The incoming shot can also be the source of movement for a screen wipe, such as a passer-by walking in front of the action, or a car moving in the shot, or maybe one of your main characters is revealed as he emerges from behind a pillar or lamp post. All of these snippets of movement act as screen wipes, or reveals, that neatly take you to the next part of the story.

Some such screen wipes are planned by the director (so use them, obviously), and the director will beam with pride as he or she says 'see what I do for you', but at least you have spotted them and included such superbly directed photography in your cut.

This technique applies equally well to documentaries, scripted drama, or comedy.

### 🎬 *The Early Music Show*—A Sound Cut

Very often, a sound can also shut a scene down perfectly—a door closes, a handbrake is applied, a telephone receiver is replaced on its hook (if they have those anymore). We hear the noise, see a head turn, and off we go to the next scene. The noise used to close a scene can alternately come from the incoming scene, like a doorbell, an alarm clock, or the explosion of fireworks. This technique is known as a *sound cut*.

Here, split edits come into their own as they generate very good scene transitions. These usually work best if the sound of the incoming scene is started over the outgoing vision. You'd almost certainly do this when music is involved and start the music before any associated picture change. Thus, the happiness of an outgoing scene can be easily undercut by sinister music before it ends, in order to prepare the audience for a new and more disturbing aspect of the story.

Over to you now! The first of three exercises in joining scenes is rather unimaginatively titled Exercise 41: Scene Join 1.

## EXERCISE 41: SCENE JOIN 1

### Shots Involved:
```
1 L2S H (02)
2 CU H (02)
3 WS H's (03)
4 W2S T & H (05)
5 MCU H (06)
6 MCU T (06)
7 Bell (16)
```

### Dialogue:

*HELEN: (TO HERSELF)*
How did she know he was at Southampton?

SHE GETS HER THINGS TOGETHER FOR HER NEXT CLASS.

NEXT SCENE: LATER THAT DAY.

*HELEN:*
I didn't tell her.

*TIM:*
She just assumed he was on a course.

(The scene goes on a bit further.)

### Exercise Aim:
The aim of this exercise is to join these two scenes together and maintain flow.

### Questions:
How can this scene join be done to give it some urgency?
Do you need the house establisher?
How much of the outgoing do you need?

### Answers:
First, the school bell is brilliant to say break-time has ended and it's time to move on, just as it does in real life. It also helps get me off Helen's close-up and back for a snatch of the wide shot to end the scene.

Second, the outside shot between the two scenes is useful; it gives you a visual break from all the interiors. Also, you can start the new scene's dialogue under this shot, so no time is wasted.

As you can see, I have come off the school scene quite quickly. The scene is over and the bell helps confirm this.

As usual, you have good and bad versions to examine.

### *The 39 Steps* (1935)—An Example of a Sound Cut

There is a great example of the technique of using sound on a cut in *The 39 Steps* (1935), directed by Alfred Hitchcock (his name will keep cropping up, and rightly so!) and edited by Derek N. Twist.

A murder has happened in Richard Hannay's flat (Robert Donat). Realising he would be a prime suspect, he grabs a map held in the victim's hand, decides to run, and sets off for Scotland by

train. While the train is heading north, the body of the woman is discovered by Hannay's housekeeper. She recoils and screams at the horror of her discovery, but instead of hearing her scream, we hear a train's whistle, followed by a shot of the train carrying the fleeing Hannay steaming north at top speed. Here, the early use of the incoming sound creates a great transition and heightens the tension, as the chase is on.

### 🎬 *From Darkness to Light*—Scene Transitions Using Fades and Dissolves

There is no doubt a *dissolve,* or a fade down and up, implies passage of time. If time is constantly changing in your piece, then continuously mixing back and forth can become tediously repetitive, and sometimes inadvertently give the impression of a slow pace. I would say dissolves used to join scenes is a technique that should be used sparingly. We are back to personal judgement again; however, remember the mid-point of the mix, where both pictures are superimposed on one another, must look attractive and intentional. The busier each of the individual shots is, the harder this is to achieve. You can cope with one of the shots being busy, but generally not both. A close-up of a face dissolving into a busy landscape may look good, but two busy landscapes mixing together will just look like an environmental mess.

### 🎥 *Apocalypse Now* (1979)—Some Good Looking Movie Mixes

No environmental mess here, other than the landscape which is being blown out of existence during the course of the Vietnam War. Just look at how well-crafted the mixes are in the opening scene from *Apocalypse Now* (1979), directed by Francis Ford Coppola

and edited by Lisa Fruchtman, Gerald B. Greenberg, and Walter Murch.

All the halfway points of the mixes in this opening scene look like photographic images in their own right.

Usually, it is very difficult to hold two (or more) images on the screen for any length of time unless they have been designed to complement each other by the director.

The mixes here are used to convey many aspects of the complex, hallucinating, and hard-drinking Captain Willard (Martin Sheen), where memories of the war are mixed with his own tense, drunk, and sleepless state. Captain Willard's shot is shown upside down, mixed over the wartime footage, which further confirms his troubled state of mind. Here, his memories of a wartime jungle terrain, helicopter blades, and napalm bombs are whirring around in his mind as he stares at a rotating ceiling fan.

The absence of the original sound informs us further that these are disturbing images of the past. The soundscape starts with slow single swishes of a synthesised helicopter rotor blade before we hear Jim Morrison and The Doors start performing 'The End'.

### 🎬 *Missing*—Scenes Have to Be Removed Sometimes

Problems can arise when a scene, or part of a scene, has to be removed for editorial reasons, leaving you with an unplanned and uncomfortable join where perhaps some of the same characters are involved in the identical location, but at a later time. Obviously, an exterior from your GV collection might get you out of trouble, but there could be a good reason why even this can't be used, so a dissolve, or a fade up and down, might be the only solution here.

I'm being a bit hard on dissolves, but don't be frightened of the long, slow dissolve. It can look great and help create a poignant, life-changing moment. A good director will have usually planned such shots in advance so that they can literally melt into one another with a nice slow mix.

Now have a go at Exercise 42: Scene Join 2.

**EXERCISE 42: SCENE JOIN 2.** WE HAVE TO GET THE BROTHERS OUT OF THE HOUSE, BUT HOW? THE MUSIC AND THE RIVER SHOTS WILL HELP.

**Dialogue:**

*PHILIP:*

I could do with some air. Shall we go for a walk by the river?

*MARK:*

Good idea.

NEXT SCENE: BY THE RIVER.

*MARK:*

How was dad towards the end?

*PHILIP:*

He was really quite frail. I often found him with his eyes shut, just smiling.

**Exercise Aim:**

The aim of this exercise is to join these two scenes together and maintain flow. You also have some music to play with.

**Questions:**

Can we do anything better than a straight cut here? It's quite poignant for the brothers to be chatting this easily.
Can the river shot take some of their dialogue?

**Answers:**

What great DOP work from Nigel Bradley to grab that unscripted water rippling shot. If it's offered, and it works, so use it.

I included some music, composed and donated by my friend Francois Evans, for you to experiment with.

What do you think of my version? I hope, especially now you've got some music to play with, you can see we're really getting somewhere with this editing lark.

You will have noticed I took a little nip out of the music to fit my river mixes a bit better. Without this snip in the music, I think we would linger too long.

### 🎬 *Tales of the Riverbank*—More on Scene Transitions

Here is another chance for you to show off your skills and join two scenes together from *Chocolates and Champagne*.

The scenario is that the brothers have realised, mainly from seeing their dad's films, that their parents had a hand in setting them up to compete all the time by dressing them alike when they were growing up, as though they were twins. They now understand how this has served only to push them apart in later life. The reconciliation is interrupted by a call from Mark's work.

Here is Exercise 43: Scene Join 3.

**EXERCISE 43: SCENE JOIN 3**

**Shots Involved:**
1 MCU M (12)
2 Sq 2S Bench (11)
3 WS get up (12)
4 WS Enter (13)
5 Music (16)

**Dialogue:**

*MARK: (ON HIS MOBILE)*

Okay, I'll be there but it won't be for a couple of hours. *(MARK HANGS UP)*. I have to

leave, I'm afraid. The office needs me to sign something that has to go out tonight. I might just make it if I leave now.

*PHILIP:*

Another big deal?

*MARK:*

Something like that.

NEXT SCENE: PHILIP'S HOUSE.

*PHILIP:*

Well, it was good to see you again. Shame it had to be under such sad circumstances. . . .

**Exercise Aim:**
The aim of this exercise is to join these two scenes together and maintain flow. You again have some music to play with.

**Questions:**
The moment has been shattered by the phone call. How can we reflect this in our cut? Does the music help?
If so, what bit can we use?

**Answers:**
As the phone call has interrupted their afternoon, it's best in my opinion to move on quite quickly. My choice is no long mixes here; instead, get straight to the next scene using the music, composed by Francois Evans, as the bridge. Again, I had a fiddle with it and chose a section that best fitted the mood. It was a little tricky to edit, but eventually successful I hope, and I managed to create a perfectly good music cue out of the piece.

I do love that walking away shot; it feels so right in the context of our pair having become slightly closer in the course of their chat, and that rising scale on the piano helps so much to say that life goes on.

### Light Fantastic—Quick Transitions Such as a Dip to Colour

Another dissolve-based transition that works well, although it is a little overused, is a quick up and down to a colour field (usually white). The software you are using will refer to this as a *dip to colour*, or something similar. This technique is often used as a flashback device, when a sudden thought of recent events strikes home on the face of a character.

A variation of this technique would be to use a video effect and briefly overexpose the outgoing and incoming shots over the join, producing a soft glow as the pictures burn and melt into one another.

Transitions of this kind can also be enhanced with some kind of sound effect. A whoosh, or something like it, can further increase the impact of this kind of transition.

Software improvements are constantly modifying what an editor can do with the pictures here, but the basic concept remains the same.

###  *The Weakest Link*—Weak Transitions

It is considered bad practice to cut from empty frame to empty frame. Usually, if your subject leaves frame in the outgoing shot, it is better to have something or someone already in vision in the incoming shot, and vice versa. This goes hand in hand with looking for ways of keeping the action going. There is no point seeing a moving car completely leave shot and then cutting to another empty frame with the same car eventually entering the incoming frame. It will look better to cut to the car already in the incoming shot, or alternately, pop in a shot of the driver for a moment. In this way, the action continues more neatly, and the dramatic flow is maintained.

For the same reason, an outgoing wide shot cutting to an incoming wide shot is often a very limp way of joining scene to scene. A better alternative is to bang in a close-up from the new scene as the first shot, then out wide to act as a reveal of where we are now.

As an example, you could imagine a tranquil summer scene of a sun-drenched river bank, but suddenly the mood is shattered as a shovel stabs at a mound of freshly driven snow before you cut to see a new landscape covered in ice and snow. Your audience will certainly understand the time jump which you have just illustrated.

### *A Shot in the Dark*—Smash Cut Transitions

Sometimes the very opposite of a mix works well—a smash cut. Here, one scene abruptly cuts to another, usually with the intention of startling the audience. To this end, the smash cut often occurs at a crucial moment in a scene where a cut would not be expected. To heighten the impact of a smash cut, there should be a considerable disparity in the content of the joining shots and their associated sounds.

An example of a clichéd smash cut is where a knife is raised, tightly held in a fist-like grip, and thrust down into the victim, but instead of seeing the impact and all the blood and guts, a smash cut is made to a more peaceful countryside location with birdsong or perhaps a boat slowly gliding down a river. Smash cuts can also be effective when a character wakes up from a nightmare, to simulate the jarring nature of that event.

An exercise, Exercise 44: Action Seq, follows.

# EXERCISE 44: ACTION SEQ

## Shots Involved:
1 MCU C (01)
2 MCU J (01)
3 Mobile falls (01)
4 MG-Tree (01)
5 Wheel Stopping (01)
6 Bonnet (02)
7 Headlight (01)
8 MG R to L (01)
& Various Sound Effects

## Dialogue:

*JOE: (ON PHONE, SHOUTING)*
Look, just switch it off!

*CAROLINE:*
You get it, I'm driving. It's gone down there.
(MORE SHUFFLING).

*JOE: (ON PHONE, SHOUTING)*
Look, you'll have us in that tree.

*CAROLINE & JOE:*
Nnnnoooo . . . Aaaaarrrrrrggggghhhhh.

WE HEAR A BRIEF SCREECH OF BRAKES THEN
SILENCE.

## Exercise Aim:
Have fun with this one!

## Questions:
How do you make this action look and sound
convincing?
How do you make that dreadful actor (me) look
fabulous?
How do you make the crash look real?

## Answers:

Bit of work to do here. The sound effects help a
lot (as always). I think the point here is, the
more you can make this happen quickly, the more
you'll generate the shock value it requires.

This is a good example of the smash cut to
black and what power it has. It sounds great to
have the horn stuck on and that fantastic sound
effect of a car crash.

Yes, we could have driven the car into the
tree, but I think we made the right decision
and got a better result, and I still had my
racing-green MG of course.

You never have to use every shot provided.
If they don't fit in, leave them out, but be
prepared to defend that decision with a better
looking alternative.

### 🎬 *Comedy Connections*—Smash Cut Transitions in Comedy

Smash cutting can also be used to great comedic effect. Reggie Perrin, as he thinks of his mother-in-law as a hippopotamus, comes to mind in *The Fall and Rise of Reggie Perrin*, as do many of those intercut nonsequiturs from *Monty Python's Flying Circus*.

Another common kind of smash cut technique in comedy is as a type of false censoring, allowing a character only to emit the first syllable of a swear word, for example.

I did a great one of these in 'Beer' from *Blackadder II*, the one where Miriam Margolyes plays Edmund's aunt, a puritanical and highly religious lady covered in wooden crucifixes. At the end, where Edmund begs to be allowed to continue his speech, he says 'and perhaps, finish with any luck.' Suddenly, from under the Queen's dress, his aunt emerges and says, 'Luck? Way-hey! Get it?' To which everyone says 'No?' The aunt then replies, 'Oh, come on, "Luck" . . . sounds almost exactly like F . . . !' We smash cut to the titles.

### 🎬 *Double Vision*—Partial Dissolve Transitions

I've recently seen a dissolve technique that works well in certain circumstances, and that's where you selectively dissolve away the least important portion of the outgoing shot to the incoming shot first, and only then allow the rest of the shot to follow. Photographed well, this can look very effective.

An example of this might be a shot of a person in a taxi having just completed a mobile phone conversation. The person ends the call, but continues to look at the phone. Photographed so that the character is on the left of frame, you can dissolve away the right-hand side of the screen (the taxi interior) and replace it with the incoming picture (with its primary content framed right), thus enabling you to have both pictures on the screen for longer than a conventional mix would allow. There is of course a soft-edged wipe between the two pictures while they are both on the screen.

It's sort of like pausing the mix halfway through, but, as I say, the pictures would have to be planned in advance for this technique to look good.

### 🎬 *Clockwise*—Wipes and Other Video Effect Transitions

Scene transitions can be produced in a huge range of styles and techniques. If you want to screw up the image of the outgoing picture like a piece of paper, force it into a wine bottle, and have the characters in the following scene pour it into their glasses, I can't stop you. Well, I can, when I grab the remote and see if *Newsnight* has started yet. Seriously, with modern software you can do just about anything you like; it's purely a matter of taste, time, and money.

All I would say is that if I see any of you putting a clock-wipe into a programme just to inform your audience that time has passed, I would regard this book to have failed utterly in what I've been trying to show you.

### 🎬 *Vive la Difference*—More on Smash Cut Transitions

Disparity in sound can also help create a good transition—loud to quiet, knife swish to birdsong, a nightmare soundscape to an alarm clock—there are many examples.

### 🎥 *Pennies from Heaven* (1979)—A Great Smash Cut

One of the best smash cuts I can remember is in the BBC version of Dennis Potter's *Pennies from Heaven* (1978) starring the late Bob Hoskins, directed by Piers Haggard and edited by David Martin and Howard Dell, a colleague of mine from whom I learnt so much. May I warn you, this next bit does contain 'spoilers'. The moment I refer to comes as Arthur (Bob Hoskins), our anti-hero, is about to be hanged for a murder he didn't commit. With the rope around his neck and with Arthur still protesting his innocence, he asks for his nose to be scratched. There is no reply from the execution party. Quickly follow shots of the noose, a hood being placed over his head, and his feet shuffling forward. Suddenly, the trap is released. There follows a fantastic cut to black and silence. We wait. Then some music is heard, in the form of the 1930s dance band hit 'In the Dark' by Roy Fox and His Band. A dot appears on the screen which starts to hop above the text of the lyrics of the song as the coda of the series starts. Brilliant! Give it a watch!

Actually, the whole series is well worth watching for its use of many clever transitions, which were mostly done on equipment where even a simple mix took three large two-inch videotape machines, each worth over £100,000 (the price of a substantial house then), and considerable skill to accomplish.

### 🎬 *Changing Faces*—Simple Wipe Transitions

Simple wipes and slides can work well, but they should be used with caution. The reason I say that is because they define a style that, with too frequent use, can become repetitive and predictable. The trouble is, they bring attention to themselves, probably unnecessarily, and therefore they can take away attention from the pictures you intend to join.

Apart from their use in sport coverage (which I examine more closely in a moment), another good use is when events have to be condensed into a very short timescale and the shots are somewhat repetitive, such as a fashion catwalk. Here, a variety

computer desktop than a TV picture. All you need to do is watch the box and look at recent news or sport coverage from the major broadcasters to see how different editorial teams multilayer their output to make it look as contemporary as possible. . . your palate is laid before you.

### 🎬 *We Are the Champions*—Sporting Transitions

Wipe-based transitions in sporting events can look great, especially if a graphic image is involved. Where would sport editors be if they didn't use a graphic and a wipe to get to the replay of a goal?

You've all seen the type of transitions I mean. The claret jug passes through frame and we are on a slow motion replay of the winning putt on the 18th at the Old Course at St. Andrew's; a cricket test side's team badge wipes through frame and we see how the last batsman was dismissed with a 'Yorker' at the Oval; a swish of a graphic-based tennis racket and we see the chalk dust fly as the ball just catches the line on the Centre Court at Wimbledon.

of wipes or video effect moves, such as slides or squashes, can work better than conventional cuts. After all, you are creating a montage (see Chapter 11).

### 🎥 *Batman* (1966)—Holy Scene Joins, Batman!

Sometimes, you want to bring attention to this sort of transition, as the original *Batman* ABC TV series from the 1960s ably demonstrates. Here, a spinning colourful picture with a zooming bat symbol was used over and over again as the scene join bumper. This brought the comic book originated nature of the story closer to the TV adaptation. *Thwak, Kepow! Zowie!*

### 🎬 *Picture Page*—Multiple Image Transitions

Wipes, picture in picture effects, and graphics can all be used to produce a modern Windows-like display that looks more like a

This is not as complicated as it sounds, as you will (more often than not) be provided with a kit of parts of these effects, elements of which will just simply drop onto your timeline.

## 7.2 Repeated Transitions—Cross-Cutting (or Parallel Action)

*Cross-cutting*, or intercutting, also sometimes called *parallel action,* is a technique that emphasises spatial discontinuity—one of those 'yuck' phrases from more worthy tomes on the subject of filmmaking. In English, what that means is that if you constantly switch from one location to another, you are emphasising the fact that simultaneous actions are happening in different locations and, at least to start with, are unconnected.

### *Up the Junction*—Scene Connection by Intercutting

An example of scene connection by intercutting might be a shot of a train hurtling down a track intercut with a car that has broken down on a level-crossing. To start with, the shots (or scenes) are totally unrelated—the train, the car, the train, the car, and so on. By cross-cutting the shots, the viewer will understand these events are happening at the same time but in two different locations. Eventually, a linking shot is seen which transforms the separate scenes into a single scene as the train approaches the stricken car. I won't spoil the end for you, in case you see the film one day, but you see what I mean.

### *Strangers on a Train* (1951)—A Movie Example of Cross-Cutting

If you want an example of cross-cutting from the movies, Alfred Hitchcock provides us with one in *Strangers on a Train* (1951), which was edited by William H. Ziegler.

Even before we meet the two protagonists in this murder plot, and crucially before they themselves meet, we only see two sets of feet, apparently walking toward each other, and, at least to start with, in different locations. They both get out of different taxis and start walking in what turns out to be the busy location of a railway station. No facial shots are used, and, despite the fact that these two sets of feet board a train, Hitchcock continues to imply approach by intercutting the two sets of walking feet, now in the same carriage of a moving train. They sit, still unidentified and still strangers to each other, until one of the characters accidentally kicks the other as he sits down, and at last the parallel action stops and a conversation ensues. To quote Louis Armstrong from *High Society* (1956), 'End of song, beginning of story'.

### *The Godfather* (1972)—Cross-Cutting Baptism and Murder

For another example of cross-cutting or parallel action, take a look at the baptism scene from *The Godfather* (1972), directed by Francis Ford Coppola and edited by William Reynolds and Peter Zinner.

Here, a church baptism service serves as the background to parallel scenes of murder, as Michael Corleone's men (Al Pacino) kill his enemies to establish Michael as the new head of the family. The continuous and calm eulogy from the priest and the faint cries of the baby hold this marvellous sequence together. The preparation for baptism matches and is played in parallel with the preparation for murder. The killing of Michael's enemies dramatically starts when Michael is asked about renouncing Satan, and ends in sync with the baptism as it draws to a close. You can't get more parallel than that.

To create such a sequence, an editor has to temporally come out of the shadows and reveal to the movie audience that he

or she actually exists. But even here, some attempt is made to camouflage the editors' existence, and thus the assembled nature of the scenes, by at least having the sound of the baptism service in the background throughout the parallel action of the assassination scenes.

### 🎬 *False Witness*—Laying False Trails with Cross-Cutting

Cross-cutting can also be used to create false trails in a murder mystery. For example, an innocent person can be brought into the viewer's list of suspects simply by cross-cutting his scenes with those around the time of the murder.

### 🎬 *Cracker*—Splitting Long Scenes

Cross-cutting can also be used to split long scenes and give a sense of pace without removing any actual running time. In these days of short attention spans, cross-cutting is used more and more in TV dramas (especially in soaps), where several storylines are running concurrently, and we happily dance between all of them at will. You might think the reason that directors and editors use this technique is to make the final product look more interesting than it actually is. Well, in the words of Francis Urquhart from the UK version of *House of Cards*, 'You might very well think that, but I couldn't possibly comment'.

### 🎬 *Pop Idol*—Music Video Secrets

Another form of cross-cutting that is very common is cutting between different takes of a music performance, such as in a music video. Here, the same song is performed in different locations and intercut to produce a visually interesting result. Thus, a public performance, a studio recording, and a rehearsal session of the same song can all be intercut together to produce

the final video. Add in a few general shots of the band at play, and you have the basis for the production of many pop videos.

## 7.3 Key Points—Joining Scenes Together

- A change of scene usually accompanies a change of timescale. This should be made clear to your audience.
- Cuts rule, okay! Modern audiences are completely used to transitional time jumps on cuts.
- Look for something to wipe the frame at the scene join. A car, a passer-by, or a reveal on the incoming. It makes for a great transition.
- A sound can either help end a scene (a door closes, a car moves off) or introduce a new scene (a telephone or doorbell), especially if you overlap the cut with this new sound. This is known as a *sound cut*.
- Music starting just before the end of the outgoing scene will also help introduce the new.
- Straightforward dissolves are a conventional way to imply time has passed.
- Dips to white and a whoosh on the sound, even if a little overused, can imply flashback.
- Smash cuts can really be effective to jump you out from one scene to another.
- Smash cuts can also be made to have great comedic effect.
- Cutting a wide shot to another wide shot can produce a weak scene join.
- For the same reason, an empty frame cutting to an empty frame is a weak transition.
- Wipes and other forms of picture manipulation are more common in sport and magazine programmes, producing a more 'computery' or 'graphicy' look.
- Cross-cutting scenes implies they are happening at the same time. This is also referred to as *parallel action*.

- Cross-cutting scenes can heighten tension and stop a long scene from dragging.
- Cross-cutting scenes can keep several storylines running simultaneously, as is very often the case in soap dramas.

- Music videos often use the technique of cross-cutting several performances of a song to produce a coherent, final sequence.
- Don't ever use a clock wipe to imply time has passed, not even for a joke.

# Chapter 8
# Different Programme Styles

Before going on, it's worth spending a moment considering how the scene assembly techniques that we have examined so far are modified when they are used in different programme genres.

In this chapter, I consider the stylistic differences between:

- **8.1 Comedy Shows**
- **8.2 Panel and Game Shows**
- **8.3 Interviews and Chat Shows**
- **8.4 Documentaries**
- **8.5 Trailers and Promotions**
- **8.6 Key Points—Different Programme Styles**

## 8.1  Comedy Shows

Comedy, even more than straight drama, relies on a series of actions and reactions. I have already talked about custard pies, but you can also think of these actions and reactions like a game of tennis, of repeating serves and returns, all of which have to be seen. Imagine how much less interesting it would be to watch a game of tennis where the director over-concentrated on just one of the two players.

### 🎥 *School for Scoundrels* (1960)—My Favourite Tennis Match

*School for Scoundrels* (1960), directed by Robert Hamer and edited by Richard Best, contains a brilliantly funny tennis match. It's between Henry Palfrey (Ian Carmichael) and Raymond 'Hard Cheese' Delauney (Terry-Thomas).

Palfrey stands no chance against Delauney, who uses every trick from his recently acquired 'Lifemanship' skills to win the match. The sequence is cut and timed to perfection, some of it with a musical underscore, and is a fine example of how to cut a comedy action sequence.

Notice that the film's editor, Richard Best, wasn't frightened to stay on a wide shot for a while to emphasise the fact that Palfrey is running about like a mad thing, trying to keep up with the game, while Delauney is strolling around the court almost with one hand in his pocket. The scene will certainly infect you, with the great put-down phrase of 'Hard Cheese'.

Happily, in the film, there is a return match where Palfrey does considerably better after he himself enrols in a course to acquire the same 'Lifemanship' skills.

### 🎬 *Comedy Connections*—Keeping Contact Going

In comedy, as a result of the requirement to keep the viewer in constant touch with all the participants in a scene, the number of cuts per minute is high because of all those launched and landing custard pies.

Where would we be without seeing Rodney's face fall in *Only Fools and Horses*, when Trigger calls him 'Dave' again; or the face of another poor unfortunate victim during an 'Am I bovvered?' tirade of abuse from Catherine Tate's schoolgirl character, Lauren; or Richard Wilson's face of horror in *One Foot in the Grave* before his catchphrase 'I don't believe it'?

EVERY FRAME COUNTS.

### ![] *I Love Lucy*—American Comedy Shows

To compensate for all these references to shows from the UK, I must give due credit to the great comedy shows from the US, and especially to those I grew up with. Shows like: *I Love Lucy, Bewitched, The Phil Silvers Show (Bilko), The Munsters*, and so on. They were usually shot on multiple 35 mm film cameras, and their slickness, as we look at them today, is a credit to the editors back

then. They still stand up very well to any microanalysis we can throw at them, sometimes over 60 years later.

### ![] *As Time Goes By* (1992–2005)—Home Territory for Me

Why do performances by some of our country's greatest comedy actors, such as Sir David Jason, Dawn French, Jennifer Saunders, or Rowan Atkinson need any editing in the first place? These people must be better than you at comedy timing. Surely Dame Judy Dench and Geoffrey Palmer, who star in *As Time Goes By*, written by the late Bob Larbey and directed by Sydney Lotterby, are at the top of their profession and could easily give *you* a lesson in delivering lines to a camera or audience.

*As Time Goes By,* like countless other comedies, is recorded in front of a live studio audience, and if you were in that audience watching the show being recorded, you would, more than likely, have been entirely happy with the pace of the performances. The trouble is an audience member just sees a permanent wide shot of the action and, in addition, has the personal freedom to look around the set, wherever they want, to get maximum enjoyment out of the scene.

When a scene is filmed, edited, and subsequently transmitted, we force the viewer to watch only what we choose. After a good laugh, if I cut to the actor who is next to speak and they are still waiting for the laugh to die down, it looks wrong, whereas to a member of the laughing audience, this is a perfectly natural piece of timing. Thus, the process of filming any action imposes its own artificial pace on the live performance, and this artificiality is purely the result of the fact that we are looking at the action through the lens of a camera and turning an audience member's permanent wide shot into a series of closer, more analytical shots.

### A Choice of Viewing—The Use of Isolated Camera Feeds (ISOs)

I can't imagine today how we managed to edit a five-camera studio audience comedy with only the main output recording to work with. Right up to the mid-1980s, no extra shots were available to the edit other than the ones the director and vision mixer chose and timed for us on the night. Vision mixers are known as technical directors in the states, but in the UK they seem to have much more of an artistic input. This can be a problem for American directors coming over to the UK, who have to deal with this additional layer of enthusiasm.

Thankfully, as recording machines are much cheaper today, several simultaneous recordings are made from the outputs of the various cameras alongside the main vision mixer coverage. Recently, even these recording machines have now disappeared, to be replaced by file servers. With the increased availability of these so-called

RECORDING SOFTWARE IN ACTION, ELIMINATING THE NEED FOR TAPE MACHINES.

isolated camera recordings (ISOs), a moment that proves to be much funnier than anybody had anticipated before the recording can be correctly covered from these alternative camera viewpoints.

Another advantage of having access to these simultaneous recordings is that it gives an editor many more opportunities to make those small tightens necessary to achieve the artificially high pace that television comedy demands.

Given the fact that these programmes are usually over-recorded by about 5 to 10 minutes, these ISOs can be used to good effect to manufacture extra shots in order to remove lines and successfully cut time out.

### Two Way Stretch—Stretching Time

For the most part, you try to tighten up action and line delivery. Sometimes the reverse is true, when you find yourself stretching time by doubling-up action from two or more angles in the hope of building up a comedy moment. Editing funny material that eventually will be shown to an audience and guessing the right amount of time to leave between a funny line (or action) and the next funny line (or action) is an art.

Stretching action is usually only possible with alternative coverage of that action, and thus you can dance around various alternative shots, mopping up every last drop of dripping custard in the hope a forthcoming audience playback will reward you by filling in your 'negatively edited' hole with laughter or applause.

The falling chandelier in *Only Fools and Horses* is a prime example of what I mean. It was shot on film and designed to be played to a live audience when the rest of the episode was recorded. It was edited by Mike Jackson with director Ray Butt. Ray and Mike put in every reaction shot they could think of after

I have always regarded this as a very odd and highly inaccurate use of the word *clean*. After all, the performers and the audience are in the same room and, as a result, no microphone placed on a performer or above an audience only picks up its intended source of sound to the exclusion of everything else.

Having to edit after a gag usually renders the laugh the gag got unusable, because it (the laugh) rarely would have finished before the commencement of the now-unwanted next line. In other words, you are not only editing the performers on stage, but you are also editing 300 of their friends at the same time.

The solution is clean laughs from your store cupboard, or elsewhere in the show, or even the audience warm-up. It's usually very wise to build up a collection of good and varied laughs, clean of overlapping dialogue, for use on these sorts of occasions.

## 8.3 Interviews and Chat Shows

An interview that has taken 20 minutes to record might have to be cut down to 5 minutes to fit a programme schedule. Producers of such an interview often do a paper cut, but as an editor, you are in charge of making such a paper cut work. Once a good working relationship has been established between you and the producer or director, an edit that causes trouble should be obvious to both of you straightaway so that no time is wasted pursuing the impossible dream. When I used to edit *Parkinson* with Sir Michael Parkinson's son, Mike Parkinson (how confusing is that), I only had to look across to Mike (the son that is) in a certain way to cause a flurry of paper work and for both of us to look for an alternative.

### Free Speech—Dealing with Unscripted Dialogue

Many of the same rules that applied to editing scripted dialogue are also just as relevant here, in the construction of an interview, except for the fact that the free-flowing dialogue from both interviewer and interviewee must be allowed to contain more of the individual spoken idiosyncrasies of the participants. It's akin to dealing with different comedy performances that I mentioned earlier.

### Face to Face—Dealing with Eye Contact

Eye contact is equally as important when you are cutting an interview as it is in a scene involving scripted dialogue. It is good practice to keep as much eye contact, or lack of it, in your cut as you can.

### Just a Minute—Hold On to the Outgoing

The best way of visually hiding edits in an interview is to hold on to the shot of the outgoing speaker as long as possible beyond the end of their answer, and then, underneath this vision extension, change the sound to a new and different question from the host. Only when this question is underway do you make the vision cut back to that of the host. Advanced students will recognise this technique straight away as the dear old split edit.

Within interviews, it's important that your edits not be predictive in any way. By that I mean, don't make early cuts to a yet-to-be-asked question. This is because an element of clairvoyance would have to be involved to know the next question was about to be delivered. In real life, you would never look at a telephone before it started to ring or a door until someone knocked on it. Vision lagging is the rule here, especially over weak words like 'um', 'well', or 'so'. After all, that's how a vision mixer has cut the rest of the show, so you might as well do the same—be reactive, not predictive.

### The Alternative View—The Use of Cutaways

We have already considered good techniques when you are dealing with cutaways, and it is just as vital to employ these in an interview

situation, or you might as well superimpose a flashing caption on the picture saying 'EDIT'.

As we have seen, try not to return to the same size of shot after the reaction cutaway. Thus, if you left on a single before your cutaway, it is better to come back to a two-shot or wide shot; this will make the edit look much more natural.

### 🎬 *I've Started, So I'll Finish!*—Let the Answer Get Going

One type of edit that's such a giveaway in an interview situation is to cut back to the host too quickly after the start of a new answer from the interviewee. There has to be a period of settlement while the audience listens to the start of the new answer uninterrupted. Cutting back to the host within the first few seconds of an answer in order to hide yet another audio join is a dead giveaway, and this has to be avoided if at all possible.

### 🎬 *Circus Boy*—Circuses to Funerals

Any edits you make in an interview shorten time, and this necessary shortening can sometimes lead to some conversational flow problems. A good interviewer will take time to introduce a more serious subject, especially after a period of uncontrolled jollity.

When a chunk of the interview is removed, you must be careful not to cause any change in the emotional content to happen too quickly by badly thought-out edits. I rather strangely call this the *circuses to funerals* problem. By that I mean that you can't cut directly between these two subjects of such contrasting content without producing an abrupt and uncomfortable emotional jump cut.

The circus has to leave town before the funeral procession can start to take its place. Faces must be allowed to change from laughter to tears at a natural pace, and in a chat show like *Parkinson,* where we never saw the audience, this change has to be included in the cut, whatever the duration problems this causes.

## 8.4 Documentaries

The term *documentaries* can cover a huge range of the television output, from the daytime house buying and selling programmes, to a documentary about the life and works of Alfred Schinttke.

### ▰ *If . . .*—Documentary Freedom—Is It Too Much Freedom?

I suppose the new variable in documentary editing that we have not considered so far is the programme order. For example, our invented documentary, *The Life and Works of Alfred Schinttke,* could start with his death and look back through his life, or alternatively start with his birth and work forward to his death. More usually of course, it's a mixture of both. This lifetime direction of travel can change mid-production when one of the team (writer, producer, director, or your good self as the editor) comes in one day and says 'I've got a great idea'. Be prepared for such drastic changes of mind by being scrupulously tidy with all your project elements. Here, nonlinear editing software comes into its own as old edits, thought to be dead and buried, can suddenly be brought back to life by such 'great ideas' as easily as the removal of a Transylvanian wooden stake from Count Dracula's heart.

Regardless of what happens in the middle, the most crucial aspects of any documentary are how to start and how to finish. You have to start with strong material to hook your viewers and end with something equally profound to keep them thinking and talking about it after the programme has ended.

### ▰ *New Faces*—The Perils of New Material

Another headache for documentary editors is that the source material can sometimes continue to arrive in the edit suite as researchers uncover some new and highly significant facts about your subject long after the programme has started to take shape. My advice is to 'Keep Calm and Carry on Editing', with the hope the 'great ideas' will eventually reduce in frequency.

Because the flow of a documentary cannot be judged until all the material is shot and placed in context, the arrival of this new material can itself cause the high rate of those 'great ideas'. These 'great ideas' can have a considerable effect on the order of individual sections, and maybe even the whole of the edited piece

GOOD ADVICE FOR DOCUMENTARY EDITORS.

so far. A late but crucial interview can easily negate the need for the inclusion of your best and most creative work which took so long to manufacture. When this happens, a preparation from a chemist might help you maintain your beautifully calm exterior and stop you from bursting into tears, or alternately you could just go down to the pub!

Eventually, with all the material in and the 'good ideas' only now serving to make the programme different and not necessarily better, it is time to stop and leave it alone. Your production might arrive at this steady state of conclusion considerably later than you do.

### Unfinished Business—Knowing When to STOP!

Knowing when to stop might be the hardest decision you and your production team will have to make. Sadly, all too often, the only whistle that is blown on this outpouring of 'creativity' is the fact that the programme is about to be transmitted. And this often comes after considerable time has been wasted moving the furniture around, without any obvious reason why, and without producing any significant improvement to the programme's content. All you can hope for is when that delivery date does arrive, you and your team are on one of those better ideas.

I'm so glad I have had a script beside me for most of my working life.

## 8.5 Trailers and Promotions

Some of the most inventive editing that is produced today on a day-to-day basis is in the making of trailers for cinema and TV. Very often, these trailers are created by a different editor and with the source material being used in a completely different way from the style that produced the programme or film in the first place.

There is a balancing act to do when you make a trailer, in that you must do your best to include the key points of the drama or narrative without giving away too much of the plot. Your trailer should therefore pose questions without necessarily answering them. The production team might have some good ideas about what is okay to give away plot-wise and what to hold back.

Shots in trailers or promotions have their durations counted in frames. Loads of quick cuts followed by snatches of dialogue are the order of the day, all designed to tempt the viewer to watch further. Even when you're promoting a slower, more romantic story, a pace has to be adopted that can contrast greatly with the original film. These promotions are great fun to do, as you can generate conversations that never occurred in the original film, where characters from one scene are answered by characters from another.

For the most part, cuts are still the best technique of assembly, allowing you to quickly intercut dialogue with dramatic snatches of action, such as flashes, explosions, or crashes. Cross-cutting like this will allow you to shave any dialogue down to the bare minimum and, at the same time, help create the sense that a lot is going on at one time.

Music will play an important role in any promotion. Hopefully, the film you are given to promote will have some music associated with it already, and this will undoubtedly help join the programme fragments together.

On a practical note, their music should have already been cleared for distribution or broadcast, and almost certainly this clearance

will include the production of promotional material as well, so you're covered. Worth checking though!

Just as with documentaries, it is vital to have two questions permanently in mind: how to start and how to finish. The bits in the middle will, to a large extent, look after themselves, but the start and finish are desperately important, first to grab the viewers' attention, and second, to leave a lasting memory that will encourage them to buy a cinema ticket or add the programme to a PVR schedule.

I know this advice is all a bit vague, but technique and content here can be so varied and contrasting that I can only talk in the most generalistic of terms. Techniques appropriate for promoting a light teen movie will be out of keeping if your film concentrates on atrocities such as genocide. The only common ground is that you have lots to say, but very little time in which to say it.

🎬 *The Hitchhiker's Guide to the Galaxy*—How to Make a Trailer

Here are some basic rules that might help you produce such a trailer or promotion. Remember, you are creating a montage that must:

- Start with very good material to hook your viewer.
- Show off the programme's creative talent (acting, writing, set design, special effects, and music) with your creative talent.
- Introduce the main characters.
- Let the audience see when and where the film is set and introduce the story.
- Not spoil any of the surprises in the plot.
- Let your trailer ask questions, rather than offering too many answers.
- If you are in any doubt, contact the programme makers about suitable material, especially with regard to plot revelations. They know the piece better than anybody.
- Display the range of emotions the film covers.
- Show off some of the programme's special effects and expensive shots.
- Leave the audience wanting more.
- And finally, tell the audience where and when it is to be shown.

All of this seems a bit obvious when you write it down, but it is worth examining all these points as you approach a final version to determine whether your trailer has more or less achieved this list of goals.

Like a commercial, a trailer must tick all the boxes, and it has to be packed into a very small space.

## 8.6 Key Points—Different Programme Styles

It would be a good idea to bring the key points that I have made in this chapter about different programme styles closer together, to enable an easier comparison.

**Comedy:**
- Cutting rates are high in comedy because of all the necessary actions and reactions.

- Always remember the rule—'see it launched, see it land'.
- Performances are generally fast, sharp and well-timed. Your edits must look the same.
- The process of filming any action can expose pauses which, even though they were acceptable in a live context, now only serve to slow things down.
- In a multi-camera environment, isolated camera recordings (ISOs), can make the funny . . . funnier, but these extra shots must always feel natural and not pull the viewer away from something that they were enjoying.
- Audience reaction will need just as much editing as the lines which caused that reaction.
- Editing comedy can sometimes involve stretching a moment out by using several shots from different viewpoints.
- If in doubt—tighten.

## Panel and Game Shows:
- The recorded show largely consists of one very long take.
- Few retakes are attempted. If a gag fails, it fails.
- Pace here is paramount. This is enhanced in the edit suite, often with music and graphics propelling the show forward.
- Survival of the fittest is the name of the game show.
- Once again, audience reaction, and how it is edited and mixed with the main dialogue, is one of the required skills.
- Rounds of applause and laughter are all generally shortened.
- You must contain the mechanics of the 'game' in as short a time as possible, without losing any of the fun it created.
- An editor here adopts more of a judgmental and editorial role.
- With different performers the golden rule is . . . if you alter their content, make sure you don't alter their performance style.
- Build up a quickly accessible stock of laughter and applause tails. You will need lots of these audio sticking plasters.
- Alternative sound tracks from the source recording will help you isolate specific sounds, for editing purposes.

## Interviews and Chat Shows:
- Just as with comedy, reaction shots are extremely important.
- Again, editorial judgement has to be added to the editor's role.
- Selection of the best material available must go hand in hand with a good assembly of those choices.
- Free-flowing dialogue, from both interviewer and interviewees, must be allowed to contain more of the individual spoken idiosyncrasies of the participants.
- Include as much eye contact, or lack of it, in your cut as you can.
- Don't make early cuts, to a yet to be asked question, for example.
- 'Sound then Vision' works well in any interview—be reactive, not predictive, with your shots.
- Never cut back to the host too quickly after the start of a new answer from the interviewee. Let your audience see that answer get going before you change the shot.
- Edits that require you to break the preceding point should only be considered if absolutely necessary.
- Be careful not to cause any change in the emotional content of an interview to happen too quickly, by badly thought-out edits.
- Continuing my strange analogy—the circus has to leave town before the funeral procession can start to take its place.

## Documentaries:
- The new variable in documentary editing is the programme order.
- The most crucial aspects of any documentary are . . . 'how to start' and 'how to finish'.
- Start with strong material to hook your viewers, and end with something equally profound.
- The phrase 'I've got a great idea' from any of the production team, including you, usually results in lots of work changing things around.

- Be careful to save and categorise old cut versions, as they might prove useful again as 'great ideas' come and inevitably go.
- Source material can continue to arrive in the edit suite, long after the programme has started to take shape.
- Knowing when to stop might be the hardest decision you, and your production team, will have to make.
- When the 'great ideas' only serve to make the programme different and not necessarily better, it is time to stop and leave it alone.

**Trailers and Promotions:**

- Just the same as documentaries . . . 'how to start' and 'how to finish' are crucial.

- A trailer should include the best bits of the programme or film without giving away too much of the plot. No spoilers, please!
- Contact the programme makers if you are in any doubt about the inclusion of certain material in your trailer.
- The programme makers will almost certainly have other 'clean' elements which would be useful in your trailer, such as music or graphics.
- Shots in trailers have their durations counted in frames— quick cuts followed by snatches of dialogue can say a lot in a short time.
- Cross-cutting scenes will allow you to shave any dialogue down to the bare minimum.
- Trailers must reflect the material they are trying to promote but can give it a different treatment.

# Chapter 9
# Sound Matters

In this chapter, I concentrate on one of the most important aspects of an editor's life, and it's strangely not the vision. Whereas the eye can be very forgiving about what it sees, the ear is always supercritical of what it hears, which means we just have to get the sound right.

Stranger still, you're about to find out that audio throws up many more fiddly, technical issues than video.

The reason for this is that video, including its levels, content, and technical range, is largely handled by the software. With audio you have the ability to mix different sources together that can sound absolutely dreadful, be technically untransmittable, or indeed just be downright bad, and the software doesn't give a damn and will happily let you get on with it!

It is for this reason that this chapter is very detailed and comprehensive.

The chapter is divided as follows:

- **9.1 Get the Room Right First**
- **9.2 Sound Levels**
- **9.3 Sound Monitoring**
- **9.4 Split Tracks**
- **9.5 Wild Tracks**
- **9.6 Sound Effects**
- **9.7 Sound Mixing**
- **9.8 Sub-Frame Editing**
- **9.9 Sound Processing**
- **9.10 More Specialised Sound Processing**
- **9.11 Additional Dialogue Recording**
- **9.12 Foley Sound Effects**
- **9.13 Key Points—Sound Matters**

## 9.1  Get the Room Right

Traditional nonlinear editing rooms, especially if they're primarily used for cutting offline material, are too often equipped with less

than perfect sound monitoring. It is essential before you start doing any serious alterations to the sound that you make sure your monitoring is set up to do the job.

You can do more harm than good if you start rebalancing sound using indifferent equipment. This could not only harm the programme, but it could also harm your reputation.

To start with, the room in which you are working should be sound-treated, at least with carpets, soft furnishings, and curtains, so that unwanted reflections and standing-wave effects are minimised.

Go on, insist on better speakers, get them onto a proper pair of stands, and put some curtains up!

### 🎬 *Neighbours*—Everybody Needs Good Neighbours (and Keeps Them!)

It is equally important that your room is sound-proofed to some extent so that you can not only be free from distracting external noises but also be able to turn the wick up without disturbing the neighbours. Computers, drives, and air conditioning are all sources of noise in an edit suite which ideally need to be minimised before serious sound balancing can be attempted.

Alternatively, you can use a pair of decent headphones, but be careful, as they can cause you to produce oddly balanced mixes on some material. Definitely stay clear of noise-cancelling

headphones, as they all have some form of inbuilt sound processing that could influence your mix strangely. If you have to use headphones, make sure that at some stage in the process you listen to your mix on decent monitoring loudspeakers. In good dubbing suites you will also find a pair of very ordinary speakers, so that the seven-channel mix can be listened to on the equivalent of TV speakers. Not a bad idea for the edit suite.

## 9.2  Sound Levels

Location sound recording is one of the most difficult things to get right on a shoot. Very often, the conditions for filming are perfect on one day, but too easily turn into a perfect storm the next. Even on the same day, shooting in different directions can produce wildly different sound backgrounds. Even an innocent bunch of trees gently blowing in the wind will produce different textures when recorded from different angles, and these differences will only reveal themselves when you attempt to cut between those shots in the edit suite. Some of these differences are simply down to level or volume and are easily corrected, but others are more difficult to cure.

### 🎬 *Peak Practice*—Adjusting Sound Levels within Limits

Never be frightened to push volume levels around. However, as you would expect, this cannot be done without limits. Sound, like vision, has to exist within certain electrical limits of level. This

used to be a voltage in the old analogue days, but now it's a 'bit' number.

In either case, if limits are exceeded, the result will be peak distortion. Here, the sound becomes hard-edged and painful to listen to. In the digital world, the binary word representing the analogue voltage is at a maximum of all 1s or all 0s so that an even higher input level will continue to produce the same all 1s or all 0s result. In these circumstances, the signal is said to be squared-off. The great feature of digital signals is that their levels are defined and aren't subject to the unwanted variations in gain or attenuation as suffered by their analogue equivalents when passing through the circuits of tape machines and other equipment in an edit suite of a few years ago.

SQUARED-OFF TONE PRODUCES DISTORTION.

In order that we all keep within the speed limit, a reference or line-up level is established. This reference, usually in the form of a burst of tone, is put, or should be put, at the start of any camera recording, whether on a file or on a tape.

## 🎬 *The Sound Barrier*—What Is a Decibel?

We were bound to get caught up in technicalities at some stage, and it's funny that the seemingly simple subject of sound brings these problems to our attention. To talk sound, we have to talk decibels (dBs). A decibel is a unit of a logarithmic scale used to describe voltage or power relationships. A logarithmic scale of volume is chosen to better match our hearing because our ears hear sound levels logarithmically.

In electrical terms, doubling the voltage of any analogue signal causes a gain increase of 6 dB.

Mathematically it is:

$$G_{dB} = 20 \log_{10} \left( \frac{V_1}{V_0} \right)$$

where $G_{dB}$ is the gain, $V_1$ is the new higher voltage, and $V_0$ is the original voltage.

I hope that wasn't too bad; just take away the fact that we describe sound in decibels with respect to an absolute maximum level.

As we have seen, the *absolute maximum* (all 1s or 0s) is dangerous or fatal to our signal quality. We therefore need a buffer zone to keep us from getting near this limit. To do this, a *working maximum* (or peak) is set up to be 10 dB lower than the absolute clipping maximum. In this way, a buffer zone is created (which is known as *headroom*) and allows for level transgressions that will not result in peak distortion and will therefore be capable of correction. It follows that no sound on your timeline should be louder than minus 10 dBFS (FS standing for full scale).

The reference level I referred to earlier in the previous section is usually defined as minus 18 decibels (–18dB) under the digital maximum level of all 1s. This reference level is more accurately described as: –18dBFS.

- The acceptable range of normal audio levels runs from: minus infinity dBFS (or silence) to a working maximum (or peak) of minus 10 dBFS.
- Line-up level is at minus 18 dBFS (or 8 dB under the working maximum).
- A headroom buffer is defined from minus 10 dBFS (the working maximum) up to 0 dBFS (the absolute maximum).
- To check that our levels are in the acceptable region, we need a meter of some kind.

## 9.3 Sound Monitoring

*See Hear*—Looking at Sound

The bar graph level meters available on much editing software are okay, but a good pair of PPMs (peak programme meters) really helps highlight any level problems.

Some manufacturers take this reference level to be at −20 dBFS (or even −12 dBFS), so make sure your software matches your friendly broadcaster's specification. Most editing software allows you to set this reference level to whatever you require.

I did warn you this would be comprehensive, didn't I? Pulling all this together:

The PPM scale is easier to read than most other meter types. On a PPM, the needle pointing straight up (PPM 4) represents the reference level, about which I have already spoken. This is variously called line-up level, zero level, or minus 18 dBFS. PPM 6 represents the peak level (minus 10 dBFS), so no sound in your cut should go over PPM 6.

Some really good meters can be switched to monitor the sum (left plus right) and difference signals (left minus right) of stereo sound.

Needle colours on such meters are: red for left (L), green for right (R) (the same as port and starboard), white for the sum (M), yellow for the difference (S).

Monitoring the sum and difference signals can also alert you to any part of your mix, which, if it is out of phase, would produce abnormally high S (or difference) signal levels.

It is very unusual to get 'out of phase' material any more, except maybe from microphones, but it is worth you being aware that this can still happen.

You'll generally find that studio-based material is much more accurately controlled, as far as level is concerned, than location material. Either way, a burst of tone placed before the programme material is so helpful when setting correct levels within your edit.

Most editing software can generate reference tone at whatever level and frequency you like. Normally, if this is set at 1 kHz and at a level of minus 18 dBFS (PPM 4), you won't go far wrong.

AUDIO WAVEFORMS IN FCP.

## See No Evil—Displaying Sound on Visual Displays

Stereo sound can also be displayed on a screen, whether that's an oscilloscope or computer monitor, as a two-dimensional waveform. This is done electronically by connecting the left signal to the horizontal direction on the display and the right signal to the vertical direction.

It follows that two signals of equal amplitude would generate a display that flickers on a line at 45° to the horizontal. This can be considered as a mono direction, or axis, and therefore equivalent to a sound that appears to come from the middle of the space between your two loudspeakers. Variations of amplitude and phase between the channels would take the trace (and your

STEREO TRACE WAVEFORMS CAN PRODUCE INTRIGUING PATTERNS AS WELL AS IDENTIFY FAULTS IN THE SOUND MIX.

loudspeaker image) away from that one-dimensional mono centre line to the stereo two-dimensional world.

This sort of display can offer you extra information about a stereo image that a pair of meters would not be capable of showing. Also, it can look very attractive, as the illustration demonstrates. Note that the top left plot represents a sound which is placed at the centre of the image and is offering roughly equal amplitude levels to both the left and the right outputs.

As displays and software sound processing techniques get more sophisticated, the range of what can be displayed also increases, but the principle remains the same.

## 9.4 Split Tracks

Location sound can be recorded with a combination of different microphones. Personal radio mics and a boom mic is a common example of a 'belt and braces' approach often used by sound recordists on location. These different versions of the sound will come to you either on different tracks on a tape (A1, A2, A3, A4), or incorporated with the vision file, or indeed as individual WAV files which you'll have to synchronise with the vision file yourself.

Modern WAV files (or BWAVs) have timecode information encoded with the audio data, so this synchronising operation can be performed with ease. Once married up to the vision, you can choose the best and most appropriate sound from the selection offered to you by the sound recordist.

Variations in editing software offer different solutions to this selection problem. To save you time, and especially if your

A SOUND MIXER WITH CONTROLS FOR PHASE, PAN, GAIN, LEVEL, AND BALANCE.

programme will be delivered to a dub when you have finished, you can retain the split nature of the various recordings in your timeline and simply mute selected tracks with any unwanted alternative sound. Any panned nature of the original material can also be ignored by putting those selected tracks in your timeline to 'mono', which means that audio on these tracks will come out equally loud from your two loudspeaker monitors.

Again, this is not as complicated as it sounds, I promise.

## 9.5 Wild Tracks

*Wild tracks* (sometimes referred to as *buzz tracks*) divide into two main types—background wild tracks and specific wild tracks.

### Noises Off—Background Wild Tracks

Background wild tracks are primarily recorded to help you get over the problems stated earlier about the variations in the quality of background sounds, which are caused by different microphone positions necessary during shooting. Trees in a breeze, a nearby road, or a children's playground can all sound different depending where the microphone, which is primarily picking up the actor's voice, is pointing. To get over this problem, a sound recordist on location will, with the crew and actors silent, record chunks of this background noise (or atmos) before the camera is moved to the next set-up. As it is impossible to remove atmos from speech once recorded, all you can do is bring the level of the quietest atmos up to match that of the loudest by adding some of the appropriate wild track to the mix at various points.

If your scene takes place in a noisy pub, the director will often shoot the scene in dead quiet, with all the extras miming the chatter, and once the dialogue is shot, get the sound recordist to record a wild track of that noisy pub, now clean of scripted dialogue, for later use. Keeping the dialogue separate in this way, will save you having to edit the noisy pub at the same time as editing your often less noisy actors. This technique only works if the actors are constantly reminded they are talking over the absent noise of the rest of the pub and that their speech and body language must reflect this.

### Making Tracks—Specific Wild Tracks

Examples of specific wild tracks are sounds like a car driving off, a baby crying, or a telephone ringing.

If recorded 'clean' on location, these wild tracks can often save a huge amount of time in an edit session or dub, as the sounds

recorded in this way are already in the right acoustic and will require very little fiddling around to make them sound perfect in the final mix. This is so much easier than finding an alternative sound effect from an effects library.

## 9.6  Sound Effects

The term *sound effects* does not only apply to specific additional sounds, but also, and rather confusingly, to the alteration of existing sounds with processes like equalisation or compression.

I will talk about these sound effects later on, but for now let's concentrate on sound effects. I hope that's clear!

Just like wild tracks, recorded sound effects can also be divided into two main categories: background effects and spot effects. Thus, in recreating the sound of a stormy night, the rain and wind would be background effects, and the thunder would be a spot effect.

### *Stormy Weather*—What Are Background Effects?

*Background effects* are sounds that don't have to synchronize with the picture but indicate the setting to the audience, such as a forest atmosphere, restaurant chatter, or traffic.

### *For Whom the Bell Tolls*—What Are Spot Effects?

*Spot effects* are sounds such as door slams, telephones ringing, and glass breaking. Some spot effects have to be specifically recorded, whereas others are manufactured. There is nothing to stop you from layering several sound effects together in order to create a new and more interesting sound out of two or three old ones.

### *On the Shelf*—Use of Effect Libraries

Large libraries of commercial sound effects are readily available on the Internet nowadays (in WAV or MP3 form), but on some projects, as we have seen, sound effects may be custom-recorded for the purpose.

In the early days of film and radio, library effects were held on analogue discs, sometimes even 78 rpm discs, and an expert technician could play several effects on separate turntables into a live broadcast in a matter of seconds. Today, with effects held in a digital format, it is easy to sequence as many effects as you like into a timeline, and therein lies the problem: it's far too easy to overdo things.

### *In the Night Garden*—Adding Sound Effects

I know the final soundtrack of most programmes is finished in a dub, but it can be the case that the soundtrack you produce in the edit suite goes on the air. A 'good ear' is required to produce a professional result, but no more so than when it comes to adding sound effects.

There is a huge danger here that you'll be tempted to plaster on added effects that are too loud; after all, you want the audience to hear the ticking clock effect you've just added, don't you? NO YOU DON'T! Remember, be subtle. No viewer should be made aware of the effects themselves, just what they do to enhance the realism of the drama.

In my opinion, many modern films are guilty of making the effects and music track too loud, and if you add this to the 'realism' of allowing your actors to mumble, the dialogue can become somewhat unintelligible.

There has recently been a flurry of viewer complaints about unintelligible dialogue in recent TV productions in the UK; *Quirke* (BBC) (2014), *Jamaica Inn* (BBC) (2014), and *Broadchurch* (ITV) (2015) have all come under fire recently for the poor quality of some of the dialogue.

## *I'm All Right Jack* (1959)—Funny Sound Effects

One of my favourite scenes in which sound effects were used to their comic best is in the film *I'm All Right Jack* (1959), directed and produced by John and Roy Boulting and edited by Anthony Harvey. The scene is set in a sweet factory.

Our hero, Stanley Windrush (Ian Carmichael), is being shown around the sweet-making machinery on the shop floor by the supervisor, played by Ronnie Stevens. Both the actors have to shout above the din of the machinery, which is whirring, bleeping, burping, wheezing, farting, and belching as the machines turn out vats of liquid cake mixtures and half-finished sweets. Windrush is, of course, asked to sample all the confectionary delights, with inevitable consequences.

It is a triumph for the sound department, where Chris Greenham is credited as the sound editor. Incidentally, the design department didn't do so badly either, with all the machines having face-like features with loads of flashing lights and moving parts. A siren sounds, a bell rings, the eyes light up, and the mouths vomit the next load of a sugary, gooey liquid into a duct for the next process.

Incidentally, the film contains one of the great lines of the movies, when Fred Kite, a left-wing union leader played by the great Peter Sellers, is asked whether he's ever been to Russia. Kite replies that he would like to visit one day, saying, 'Ah, Russia. All them cornfields, and ballet in the evening.'

## *Silent Movie*—Essential Sound Effects

There are certain sound effects that are used time and time again, such as mobile phones, cars starting, tick over, traffic and so on. The list can become very long, but with the advent of USB memory sticks, or even phone memories, it has become possible for an editor to carry these effects with them. Personally, I'm so pleased not to have to carry that heavy box of 78s around with me anymore. I would strongly advise you to build up a library of your own, which would contain your most commonly used effects. Very often, the wild tracks recorded on location and in the studio from your current production can be saved and used more than once to help other productions whose sound recordists were not so thorough in covering every option. It's so easy to keep a couple of phone rings to hand that, while they might not end up in the transmitted programme, they will allow you to time a cut properly.

## *Laughter in Paradise*—Save Your Laughs

In my line of work, it is essential to keep a store of laughs to act as sticking plaster over troublesome joins. While we all try to be honest, it sometimes becomes necessary to repair laughs that become unusable, for whatever reason, with laughs from another source. To clear my conscience, I always try to use laughs recorded in the same studio and, more importantly, from the same show. Replacement laughs have to be as nonspecific as possible, especially if they have to be used more than once in a programme. By nonspecific, I mean they must not contain any individual characteristic, such as a cough or a cackle, just a good, well-rounded laugh with a clean tail.

As a series progresses, I tend to save laughs that fit the above requirement and build up a library of suitable and varying laughs.

| Name | Bit rate | Date modified | Size | Type |
|---|---|---|---|---|
| Little Murmer.wav | 1536kbps | 28/11/2014 16:19 | 631 KB | VLC media file (.wav) |
| Long Laugh.wav | 1536kbps | 28/11/2014 16:19 | 1,696 KB | VLC media file (.wav) |
| Medium 2.wav | 1536kbps | 28/11/2014 16:19 | 436 KB | VLC media file (.wav) |
| Medium large.wav | 1536kbps | 28/11/2014 16:19 | 466 KB | VLC media file (.wav) |
| Medium.wav | 1536kbps | 28/11/2014 16:19 | 774 KB | VLC media file (.wav) |
| quite sharp.wav | 1536kbps | 28/11/2014 16:19 | 361 KB | VLC media file (.wav) |
| Shocked Laugh.wav | 1536kbps | 28/11/2014 16:19 | 1,389 KB | VLC media file (.wav) |
| Small medium sandwich Mixed.wav | 1536kbps | 28/11/2014 16:19 | 826 KB | VLC media file (.wav) |
| Small medium sandwich.wav | 1536kbps | 28/11/2014 16:19 | 826 KB | VLC media file (.wav) |
| Small medium with build.wav | 1536kbps | 28/11/2014 16:19 | 556 KB | VLC media file (.wav) |
| Small medium.wav | 1536kbps | 28/11/2014 16:19 | 564 KB | VLC media file (.wav) |
| Small.wav | 1536kbps | 28/11/2014 16:19 | 444 KB | VLC media file (.wav) |
| Very small.wav | 1536kbps | 28/11/2014 16:19 | 384 KB | VLC media file (.wav) |

If you find some really good laughs, you might be tempted to store them on a longer term basis, to help another series along.

When you are adding laughs, the golden rule is *less is more*, so don't become what I call 'laugh-happy'. If 300 people in the audience on the night have decided the line isn't funny, then there is a good chance the line really isn't funny. Over-egging these indifferent lines leaves you with nowhere to go when it comes to the genuinely funny ones. You'll never hear of a viewer complaint along the lines that they wished that the studio audience would laugh more; it's usually quite the opposite.

## 9.7  Sound Mixing

When you are mixing sound you can only go by what you hear; that's why good monitoring is essential. Just as you try to make shot changes not look awkward and clumsy, you must try to make the addition of extra sounds sound as natural as possible in order that no undue attention is brought to them individually.

### 🎬 *The Whisperers—Make It Believable*

An added phone ring must appear to come from the phone as used by your actor in the scene. If this has been sourced from a wild track recorded at the time of filming, it is much easier to balance this and make it feel totally natural, but if the effect comes from a commercially available recording, then some adjustment will have to be made to the ambience of that sound other than just getting the level right. The reason for this is that most commercially available effects are recorded at very close range and, as a result, are as dry as dust acoustically. To help with this problem, some form of sound processing is employed, such as equalisation or reverberation, to make these added effects sound believable.

The main thing is get the level right, and then turn it down a notch from there. Modern software offers what is called *rubber-banding*, where levels of individual tracks can be raised and lowered with the use of markers placed on that particular track in the timeline. Sometimes these levels can be set through a fader box (what luxury!) and altered in a 'fader live' mode . . . serious stuff.

A TIMELINE WITH RUBBER-BANDING MARKERS ON SOME TRACKS.

## <span>◼</span> *Mixed Blessings*—Adding Sound Effects

Here's an exercise involving mixing sound effects together; it's called Ex 46 Mixing Sound Fx.

You have several effects to play with here: a clock ticking, Philip making tea in the kitchen, a plane flying overhead, the projector noise, and the bleep of the VHS machine receiving the play command from a remote control. In addition, you have 'clean' footsteps from Philip, so that you can replace the footsteps on the actual shot, which are covered in dialogue, with the clean ones coming from another part of the scene.

It's quite an assembly job to start with, even before you add any of the effects. Remember, when Mark runs the film, we need to see his face come alive with wonder as he sees the flickering images of his childhood, but at the same time, give us a chance to see dad's film as well. You need to balance the POV shots of the film with Mark's face, certainly to start with, then the film can run in vision a bit more after that.

As to the effects, the results must be a subtle balance of realism and perceptibility. To best judge the levels of the individual sound effects you have just added, try listening to your mix at a wide range of volume levels and alter individual elements if necessary. Also, listen to the mix on headphones to give you an idea what your mix sounds like on different kinds of equipment.

A brief note here to those of you not working on Avid: because you had to import my timeline via an EDL, you will not get any of my track level adjustments (rubber-banding, in other words). However, you can still hear my final mix in the MOV file of my cut (in this case Ex 46-CUT.mov), which I have provided for you.

## EXERCISE 46: MIXING SOUND FX

### Shots Involved:

```
1 W2S P & M (13)
2-3 MCU M (13)
4-5 MS P & door (13)
6-9 Various TV Shots (15)
10-15 Sound Fx: clock ticking (16), making tea
(16), Philip's footsteps (13), plane overhead (16),
projector noise (15), bleep of VHS machine (16)
```

### Dialogue:

*PHILIP:*

I'll pop it on and make some more tea. That kettle's been on all afternoon. Sure you don't want a cup?

*MARK:*

No thanks. I'm fine with this.

*PHILIP:*

Woolacombe is about 10 minutes in. But it's from an earlier holiday than the photograph I think.

PHILIP LEAVES TO PUT THE KETTLE ON.

*MARK:*

I'll find it. (PAUSE) Oh God, my hair. Mum was never any good with dad's camera, was she. You can always tell the bits she shot; everybody had their heads chopped off. Look, there's you at a fair, on a merry-go-round. Least I think it's you; and all we can see are your legs going round and the horses.

*PHILIP:*

Wouldn't win any 'best photography' or 'best director' awards would it. I think the reels are a bit jumbled up.

## 9.8 Sub-Frame Editing

Sound edits in most video editing applications can only be achieved every 25th of a second, or 29.97th of a second with 60 Hz based material. Occasionally, there is a need to edit without this restriction, for example in the case of click removal. A click can be microscopic compared with the limit of 25th of a second (that's 40 ms), lasting as it does only a few audio samples. The removal of these individual samples is called *sub-frame editing*.

If your editing software does not include a sub-frame facility, a section of your 'clicky' waveform will have to be exported as a WAV file and imported into specialist sound editing programs like Sony's Soundforge or Audacity.

Here the waveform can be stretched out into individual peaks and troughs, and the click, when located, can be cut out and the waveform rejoined. In this way, because the WAV file is only shortened by a fraction (microseconds perhaps), no further action is necessary when this WAV file is inserted back into the edit, and it drops in perfectly. It's as though nothing has happened, but at least that annoying click has gone.

A SOUND WAVEFORM WITH A NASTY CLICK, AS DISPLAYED IN SOUNDFORGE.

Other forms of audio degradation, such as peak distortion, can be treated in the same way, and individual peaks that have been 'squared-off' can be surgically removed, leaving an unclipped but slightly shortened waveform. This can take a long time, but the results can be impressive.

## 9.9 Sound Processing

'Free' with much modern editing software are sound processing tools, often known as *digital signal processing (DSP)*, that will

help you tailor any aspect of the sound to meet the needs of your project. Yes, I know there might be a subsequent dub (am I repeating myself?), but some processing effects may have to be added in the edit suite. Another good reason for doing some of this work in the edit suite is that it is difficult to judge a cut, however well-crafted visually, with a soundtrack lacking in appropriate effects or full of inappropriate ones.

The range of processing effects and how they are applied are totally dependent on the software in use. Here are the most common, and therefore the most essential and powerful, sound processing effects.

### 🎬 *Acoustic Café*—A Look at Equalisation

*Equalisation* (EQ) is audio 'posh-speak' for bass and treble adjustment where different frequency bands are attenuated or boosted to produce some desired spectral characteristics.

THE AVID EQ TOOL.

Moderate use of equalisation can be used to fine-tune the tone quality of a recording. Extreme use of equalisation, such as heavily cutting a certain frequency or band of frequencies, can create more unusual effects (see parametric equalisation, coming up next).

A common use of equalisation is to transform a commercial track so that it might appear to be coming from a radio on the set, or to 'distance' wild tracks so that the tick-over of a waiting taxi doesn't appear to be coming from inside the room.

Both of these examples can be achieved, to a large extent, by attenuating the high and lows of the audio spectrum and adding a bit of reverb to create distance.

### 🎬 *Pick of the Week*—Filtering Sounds

*Parametric equalisation* is a more flexible form of equalisation, or in other words, equalisation with more knobs. In this mode, you are able to set the range of frequencies you wish to boost or cut and also set the sharpness of this adjustment, which is referred to as the Q.

My advice is to play around when you have a spare moment and listen to what you can do with speech and music when extreme and selective boosting or cutting is used on different frequency bands. Remember to store some of your favourite settings that might be most appropriate for your kind of work.

Parametric equalisation can also be used to repair a recording that has suffered from an external source of interference. Mains hum (50 Hz or 60 Hz), caused by induction from nearby electricity cables, for example, can be tuned into with a high-Q (or very selective) filter that is initially set to boost and then, once you're on top of the offending noise, switching that boost to cut, with the hope that the offending mains hum will disappear.

PARAGRAPHIC MANIPULATION WINDOW IN SOUNDFORGE.

Air-conditioning machines produce a range of frequencies of interfering noise, but the most troublesome frequencies are related to the motor speed, and these can be dealt with individually and removed. Beware though not to do too much damage to the rest of the audio spectrum you want to preserve.

I've probably gone into too much detail, but Brownie points are available here as you offer a solution to a distraught director worried about inaudibility in a noisy location.

### Open Spaces—Use of Echo and Reverberation

*Reverberation* (or reverb for short) is where one or several delayed signals is added to the original signal to simulate the reverberation effect of a large hall or cavern. Just clap your hands in a cathedral and count the number of seconds it takes for the sound to disappear, and you'll know what we are trying to achieve.

You might get up to four or five seconds in such an environment; this is known as the *reverberation time.* That's just one of the parameters available here in most DSP reverb applications. In addition, you are also able to adjust the quality (or EQ) of the reflected sound to allow for different surfaces in the room space whose sound characteristics you want to mimic. By adjusting this and other parameters, such as depth, attack, and release, you can create the 'sound' of many different environments.

### On the Ropes—Use of Audio Level Compression

*Level compression* is not to be confused with audio data rate compression. The audio compression here is primarily the reduction of the dynamic range of a sound or sounds, such that louder elements are reduced in level dynamically, to better match with lower level signals. Most sound reaching the cinema screen or TV is compressed in one way or another. This is done either as it is recorded or somewhere along the chain of processing from microphone to transmitter, which can include the edit suite.

The dynamic range of sounds in nature far exceeds a comfortable range we would expect to experience when we watch a film or TV programme at home or in the cinema. If the threshold of hearing anything at all is 0 dB SPL (sound pressure level) and the threshold of pain is 120 dB SPL, our ears are capable of hearing a dynamic range of 120 dB. Given that, first, listening environments are never totally quiet (typically they give values in the range 20 to 40 dB SPL), and second, we would not want to get near the pain threshold, any soundtrack content must be encouraged to fit into an acceptable range of levels from 40 to 90 dB SPL. This gives a dynamic range of only 50 dB, which is somewhat smaller than the range of sound levels that we can experience outside the cinema. It follows that some form of level compression is required in the chain from microphone to speaker; if this was not done, we would constantly be reaching for a volume control because it would be too loud or too soft all the time.

THE AUDIO MIXER TOOL IN AVID MEDIA COMPOSER VERSION 6.

Most studio-based sources of sound are compressed as they are recorded, so no further action is required by the editor or the dubbing mixer unless a specific problem arises, such as with the addition of some newly recorded dialogue that hasn't yet had this processing applied to it. Again, with most software, this is made easier with the ability to call on several presets within the compression parameters. As these are numerous and complex, it is good practice to remember and store the ones you like.

If your edit is going to a dub (oh no, not that again!), it is just as well to remove your processing effects prior to export, or at least let the dub have access to the original sound. The dub will almost certainly be able to call upon cleverer techniques which might well produce a better end result.

### 🎬 *Trouble in Store*—Keep Storing What You Like

The advantage of modern DSP applications is that you can store any processing effect you like, name it, and keep it forever. In this way, when you're asked to make the dialogue sound as though it was recorded in an empty 25,000 cubic metre oil tanker about 10 nautical miles off the coast of Newfoundland—*again*—you can look very smug and pull it immediately off your USB stick.

Seriously, it's good practice to store certain favourite effect parameters, as they tend to come up time and time again.

## 9.10  More Specialised Sound Processing

### 🎬 *Mixing It*—Flanging or Phasing Effects

*Flanging* (or *phasing*) is often used to create unusual sounds. Here, a delayed signal is added to a proportion of the original with

a continuously variable delay, usually shorter than 10 ms. This effect was originally created by playing the same recording on two almost-synchronized tape machines and then mixing the signals together. Filtering the delayed signal prior to mixing can produce a range of weird and wonderful effects. There are some Beatles and Beach Boys tracks of the 1960s that are good examples of this technique. Phasing can be used to give a synthesised or electronic effect to natural sounds, such as human speech.

Interestingly, the severe modulation of a sound wave that was necessary to produce the sound of a Dalek's voice was done in a circuit called a *ring modulator*. Today, what any hardware used to do can be replicated with DSP technology.

### 🎬 *The Choir*—Chorus Effects

*Chorus* is where a delayed signal is added to the original with a short and constant delay. If the delay is too short, it will interfere with the undelayed signal and create a phasing effect as above.

Chorusing can be used to good effect to make your 20 extras sound like 200 in a pub or club. However, a better way to achieve this might be to duplicate the wild track in the timeline (more than once if you wish), separate the copies in time by a few seconds, and apply different reverb effects to each layer, thus giving the impression of a much larger group of people.

### 🎬 *Tune-Up*—Pitch Shifting Effects

*Pitch shifting* shifts a signal up or down in pitch—yes, really. Here the frequencies within the wave are multiplied by an adjustable amount so that their pitch goes up or down but they occupy the same time scale. One cruel sound supervisor (namely Laurie Taylor) at the BBC always used to do this to the producer's audience warm-up speech

whenever the sound department was mentioned. The producer's voice kept swinging from a squeaky cartoon voice to a deep, deep bass. Well, it was very funny at the time, and the audience loved it!

One application of pitch shifting is pitch correction, the modern salvation of many indifferent singers. However, the result can sound strange, especially if you have to change the pitch too far.

### 🎬 *Time Bandits*—Time Stretching Effects

Another DSP effect available with most editing software is *time stretching*. This is the opposite of pitch shift because here the duration of an audio signal is changed without affecting its pitch. This is often used to fit and fine tune new dialogue from an additional dialogue recording session (discussed next) to better match the lip-sync of existing pictures.

## 9.11 Additional Dialogue Recording

For whatever reason, sometimes your actors have to be asked back to attend an *additional dialogue recording* (ADR) session so that dialogue that was impossible to use from the original recordings is re-recorded or new lines are added.

### 🎬 *The Chat Show*—Replacing Dialogue

ADR sessions are used for several reasons. They include:

- Changing or adding to the original scripted words.
- Altering the inflexion of a performance.
- Clarifying dialogue to make it more intelligible.
- Revoicing dialogue which was impossible to record at the time of filming because of, say, high background noise levels.
- Revoicing dialogue into a foreign language.

## 9.12 Foley Sound Effects

Just as dialogue is sometimes rerecorded in an ADR session, sound effects are also recreated in a specialised process called *Foley work*. Some movies are completely revoiced and Foleyed; none of the original sound is used at all, and it only serves as a guide for future rerecording.

In this way, all sounds, from a door squeak to the rustle of a newspaper, have to be recreated from scratch. This would be incredibly time consuming, if not impossible, to do from a sound effects library alone, so it's simpler to use the expertise of Foley artists to record appropriate sound effects in direct synchronism with the actions on screen. Thus, footsteps, the movement of hand props such as a teacup, and the rustling of cloth are common Foley effects.

A skilful Foley artist is able to put back all the emotion contained within the seemingly simple action of an actor walking.

### 🎬 *The World Service*—Preparing for International Sales

The advantage of the ADR and Foley approaches is that, in these days of international sales, the final soundtrack of a film can be distributed with the major elements of dialogue, music, and effects all completely separate. This will easily allow the dialogue to be revoiced into any language and then be remixed with the original and unchanged music and effects tracks. All can be processed separately to suit different outlets, such as Dolby 5.1 for cinema, HDTV, or Blu-ray release, and right back to ordinary two-channel stereo sound for analogue TV transmission.

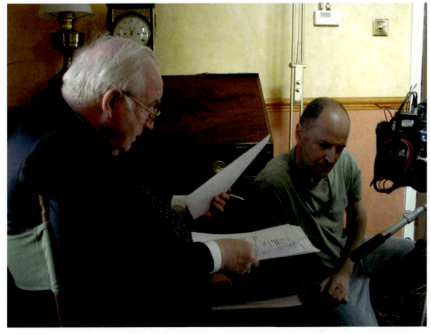

JOHN AND NIGEL CHECKING THE SCRIPT DURING THE FILMING OF *THE PHOTOGRAPH.*

## 9.13 Key Points—Sound Matters

- Get the room right first by treating it acoustically.
- Get decent loudspeakers and put them on stands.
- Sort your monitoring out with a good pair of PPMs.
- Make sure line-up levels match from all sources.
- Often, with multitrack location material, you have to choose the appropriate sound source for each of your characters' speeches. Once selected, pan it to the middle so that it comes equally from both speakers.
- Background wild tracks are primarily recorded to help you get over the problems of variations in the quality of background sounds caused by different recording positions.
- Specific wild tracks are sounds like a car driving off, a baby crying, or a telephone ringing. If recorded clean on location, these wild tracks can often save a huge amount of time in an edit session or dub.
- Build a library of the most commonly used sound effects, such as mobile phones, cars starting, an engine ticking-over, traffic noise, and so on. Encode them as good quality MP3s, or WMAs, or better still, straight WAVs, and carry them with you on a USB stick, flash memory, or your phone.
- Sub-frame editing offers you the ability to do microsurgery on a sound waveform. Even though it's not included with some editing platforms, it is available on more specialised sound editing programs.
- Digital sound processing (DSP) offers you a wide range of possibilities of tweaking sound.
- Equalisation (EQ) is audio posh-speak for bass and treble adjustment but is considerably more versatile.
- Filtering with a parametric equaliser is a more flexible form of EQ.
- Reverberation can help recreate the acoustic of any location, from a small room to a cathedral.
- Level compression (not to be confused with data rate compression) can make even a softly spoken commentary audible over an already full audio soundscape.
- Phasing/flanging can be used to give a synthesised or electronic effect to natural sounds, such as human speech.
- Chorus can be used to thicken sound.
- Pitch shift and time stretching can be used to repair or fit sounds to match the timing of their surroundings.
- Additional dialogue recording (ADR) allows dialogue, which was impossible to use from the original recordings, to be rerecorded.
- Foley sessions are used to recreate and add nondialogue sounds to a movie or TV programme.
- Some movies are completely revoiced and Foleyed with none of the original sound being used at all. This can make the creation of international versions a lot easier.

# Chapter 10
# Music, Music, Music

This chapter is divided as follows:

- **10.1 An Introduction to Music in the Movies**
- **10.2 A Brief History of Music in the Movies**
- **10.3 Back to Practicalities**
- **10.4 A Spoonful of Music Theory**
- **10.5 Key Points—Music, Music, Music**

Later in this chapter, I deal with some of the tricks you can use to cut music around without producing a crime scene. The musicians among you may have to stand-by and prepare to suck some eggs.

## 10.1  An Introduction to Music in the Movies

Before we get down to theory and technique, let's take a few moments to examine music and how it's been used so brilliantly in the movies and on TV.

*The Sound of Music*—When You Know the Notes to Sing. . . .

I've touched on the importance of 'sound glue' when I talked about flow, and I said such sound glue can be in the form of music. And what glue it can be sometimes. Take Leonard Bernstein's masterful score for *On the Waterfront* (1954), or Bernard Hermann's chilling music for Alfred Hitchcock's *Vertigo* (1958) or *Psycho* (1960), and not just in the shower scene, but also on that scary car journey through the driving rain with the windscreen wipers going full blast and the oncoming traffic's headlights blinding Marion Crane on her way to her fate at the Bates Motel.

Not to mention John Barry's music for *The Ipcress File* (1965), which turned Harry Palmer's (Sir Michael Caine) morning routine of dressing, reading the paper, and making coffee into an iconic opening credit sequence. Here, Barry's use of a cimbalom tells us that the Soviet Union is not that far away from Palmer's currently mundane lifestyle. Sorry to go on, but another favourite of mine would be Michael Nyman's busy and evocative accompaniment to *The Hours* (2002).

Not forgetting the TV world, I wonder where series like Gerry and Sylvia Anderson's *Fireball XL5*, *Stingray*, *Joe 90*, and of

course, *Thunderbirds,* would be without the brilliant themes and underscoring work of Barry Gray.

Before my list closes, I must mention Dennis Potter's use of 1930s dance band hits in *Pennies from Heaven* (1978), starring the late Bob Hoskins. Here, Potter was able to break the fourth wall and have his characters look directly at us as they launched into clever song and dance routines.

I'm not saying the programmes you might work on might be as well served by such musical greats as Nyman, Barry, Bernstein, Hermann, or Gray, but even with well-chosen commercial discs you can greatly enhance any cut sequence.

If you have any keyboard skills yourself, many modern keyboards can provide great sounds in a fraction of the time and effort it used to take (and no doubt cost). Sinister chords or echoed double basses breathing their bows across vibrating strings can greatly heighten the tension already present in your cut as an empty house is searched for the crazed gunman now on the loose. Equally, a tranquil melodic line will augment those long hot summer days walking in a field of hay. Well, that's before the crazed gunman, lurking in the woods, claims another gory victim.

## 10.2 A Brief History of Music in the Movies

Sadly, this publication cannot go into too much detail of film composers and their music, as it would become a huge list of talented people and great movies, but it's worth a small digression of a page or two to examine how music has been used in movie history.

### 🎥 *King Kong* (1933)—Music as a Mouthpiece

The first film to use a musical underscore was *King Kong* (1933), directed by Ernest Schoedsack. Up to then, incidental music was generally only used to start and finish a film. The music for *King Kong* was composed by Max Steiner, who used a symphony orchestra in a somewhat romantic and operatic way to enhance dialogue and action, especially the thoughts and feelings of the obviously wordless Kong, and convey them to the audience through music.

The 1930s and 40s saw the scoring of film soundtracks become a new and essential element of a film's production. Among the greats are Erich Korngold and his scores for *The Adventures of Robin Hood* (1938) and *The Sea Hawk* (1940); Max Steiner for *Gone with the Wind* (1939) and *Casablanca* (1942); classical composers such as Dimitri Shostakovich, who scored a total of 34 films, or Sir Arthur Bliss, who crafted one of the most original early soundtracks in the film *Things to Come* (1935). Scoring a musical soundtrack is still very much done today, but what has changed is the range of musical styles that are commonly used by composers and directors.

### 🎥 *A Street Car Named Desire* (1951)—Music Replacing Dialogue

The film *A Street Car Named Desire* (1951) boasted the first all-jazz score which was written by Alex North. The jazz riffs and motives used here, where notes are bent and flanged, were more able to reflect the attitudes and feelings of the characters than a traditional classical score. Here, the music itself starts to sound more personal, more human, and much more like real speech. In this way, the music was able to tell us more about a character's inner feelings than the visual evidence on the screen. Find the scene where Stanley (Marlon Brando) in his torn T-shirt calls Stella (Kim Hunter) to come outside and see him. It was certainly on the Internet when I last looked. Just listen to what the music does for the scene to heighten its sensuality.

It must be said that the music worked so well in this scene to imply a burning passionate desire that it was condemned by a moral defence group in the US, and the studio was forced to replace the lustful and 'saxy' music with strings! Happily, the less delicate audience of today is allowed to see and hear the original version.

## On the Record—Commercial Tracks versus Composed Music

I suppose it was from the 1960s onwards, with the rise of pop culture, that filmmakers started to turn away from having music especially composed for a film in favour of using contemporary tracks. Sometimes a song was commissioned for a film and it could stand alone commercially in the record shops long after the film had ceased playing in the cinemas. Take, for example, *Windmills of Your Mind,* which was composed by Michel Legrand and used in the film *The Thomas Crown Affair* (1968) or, more recently, James Bond's outing in *Skyfall* (2012). Here, the title song was composed and sung by Adele, and in the body of the movie there are additional songs by Charles Trenet and The Animals, amongst others. The rest of the original music was composed by Thomas Newman, paying regular homage to John Barry and Monty Norman, the originators of the Bond theme. The title song, like many of its predecessors for the Bond dynasty, was a huge hit, won an Academy Award, and undoubtedly helped promote and fund the movie.

Certain films like Richard Lester's *A Hard Day's Night* (1964) and *Help!* (1965), which featured The Beatles, actually threw the spotlight on the composers as performers. This was music for a new generation, including younger directors who knew how to use it.

###  *A Fistful of Dollars* (1964)—Music in Control

Sometimes the music acts as the controller of a scene, as in the famous shootout in the film *A Fistful of Dollars* (1964), directed by Sergio Leone with music by Ennio Morricone. Here, the characters are called into the arena in an almost operatic way by that great trumpet theme. They walk in step to its beat, they move in time to the music; in other words, the music is not only choreographing the drama, but also it has now replaced the dialogue.

###  *Bullitt* (1968)—Music in the Driver's Seat

This dialogue-replacing function of a musical score was further used in *Bullitt* (1968), where Lalo Schifrin's score said more than Frank Bullitt (Steve McQueen) did himself. We seem to have drifted back to the days of Korngold, Steiner, and Hermann where the music is composed specially for the movie.

### *Mean Streets* (1973)—Music on Record

However, with Martin Scorsese's *Mean Streets* (1973), we are back with a director wanting to use the music he grew up with to score his films. This was a low budget movie, funded independently of the big studios, so Scorsese couldn't afford a composer; instead, he was forced to use music familiar to him from his youth, which, as the film was set in New York in the early 1960s, made a perfect match. The use of 'Jumpin Jack Flash' by The Rolling Stones as Johnny Boy (Robert De Niro) comes to meet Charlie (Hervey Keitel), shot in slightly slow motion, works so well and tells us this character can only be trouble.

### 🎥 *Saturday Night Fever* (1977)—Music That Creates a Film

Occasionally, current trends in popular music have inspired the making of the movie itself. Take *Saturday Night Fever* (1977) set in Brooklyn, where disco, in the form of several hits written by the Bee Gees, is celebrated and forms the backdrop for Tony Manero (John Travolta) to become king of the disco floor. The soundtrack sold 15 million copies and encouraged a significant, if not permanent, relationship between the pop and movie industries.

Today, we are totally used to a CD or music download of the soundtrack of the latest movie release to be produced in parallel with that release. The soundtrack will, more often than not, contain a mixture of existing commercial tracks alongside new ones which were composed for the movie.

### 🎥 *Spellbound* (1945)—Music from Electronics

I suppose the modern ingredient for producing music for films is electronics, and more recently, the computer. This is not a new phenomenon, as movie makers have always been keen to exploit the latest technology. Take Hitchcock's *Spellbound* (1945), in which Miklós Rózsa used the sound of a Theremin, a monophonic electronic instrument, to imply the mental instability of the central character John Ballantyne (Gregory Peck).

### 🎥 *Thunderbirds* (1964–1966)—Music for Strings

In the TV world, even though *Thunderbirds* (1964–1966) was probably the most famous of the puppet adventure series produced by Gerry and Sylvia Anderson, Barry Gray composed the music for many other Anderson series, including the live-action *UFO* (1970) and *Space:1999* (1975). Gray had an interest in electronic music and used an Ondes Martenot (an early keyboard-based electronic instrument, which produced a somewhat similar sound to a Theremin) in several of the Gerry Anderson productions he scored, most notably in *Captain Scarlet and the Mysterons* (1967).

### 🎬 *The Score*—Music and Effects

As computer and synthesising programs got more and more sophisticated, the musical sound track was increasingly made up of a musical score, now integrated with complex multilayered sound effects. The production of such complex soundtracks today is in the hands of a composer alongside a sound editor or engineer. This can, of course, be one and the same person who will blend music and effects into a complete, composite soundscape.

### 🎥 *Doctor Who* (BBC TV) (1963)—Music from Technology

An early example of this synthesis between composer and technology from the TV world would be the collaboration of Ron Grainer with the BBC Radiophonic Workshop to produce the theme music for *Doctor Who* (1963–present). The Radiophonic Workshop provided the backbone for many BBC TV themes of the 1960s and 70s.

### 🎥 *Forbidden Planet* (1956)—Music from Another World

The first fully electronic score for a motion picture was Fred M. Wilcox's *Forbidden Planet* (1956). In the film, composers and sound engineers Bebe and Louis Barron produced, for the first time, an impression of sounds from another world. The futuristic effects are so neatly interwoven with any music, it's sometimes hard to tell one from the other.

### The Birds (1963)—Music, What Music?

The continuing advance in electronics enabled director Alfred Hitchcock to use synthesised bird calls and shrieks in his film *The Birds* (1963). These effects were created on an instrument called a Trautonium. He even used Bernard Hermann, his musical collaborator of many years, to select and position the artificial bird effects to best match the pictures. Incidentally, there isn't a single musical instrument in the film but there is still a score, as is clearly demonstrated by the result. As Hitchcock said, 'When you put music to a film, it's just another sound really'.

### A Clockwork Orange (1971)—Music from a Moog

I suppose one of the most memorable uses of synthesised music is Stanley Kubrick's *A Clockwork Orange* (1971). Walter Carlos, who had already produced the iconic album 'Switched on Bach' on a Moog synthesiser in 1968, heard that Kubrick was filming a futuristic movie about a guy obsessed with rape, ultra-violence, and Beethoven. Carlos, without asking, sent Kubrick a tape of a synthesised version of some Beethoven, and Kubrick saw that this had great potential and might work in the film alongside the more conventional orchestral arrangements of the same pieces.

The hard nature of the tones that Carlos was able to produce then suited *A Clockwork Orange* perfectly, but as synthesisers became more subtle, they were let loose on more conventional dramas, such as Hugh Hudson's *Chariots of Fire* (1981), which used the music of Vangelis.

### Apocalypse Now (1979)—Music in a Design

By the time we reach the 1970s, and accompanied by advances in sound recording and reproduction like stereo and quadraphonic sound, the idea of 'sound design' was born. With this new technological freedom, an editor, composer, sound engineer (call them what you will) could now layer many sounds on top of each other (including music), treat them acoustically, and place them in a three-dimensional space in such a way as to create a 'sound design'.

Once again, the opening of Francis Ford Coppola's *Apocalypse Now* (1979) is a case in point. Here, sound editor (sorry, designer) Walter Murch produced a soundscape as complex as an orchestral score.

In the film, even before the first image is seen, the synthesised sound of a single beating helicopter blade moves around the cinema and surrounds us, for this was one of the first films to be produced in a surround-sound format, with a world we are not going to forget in a hurry. But where are we? Eventually, we find out we are in Captain Benjamin Willard's (Martin Sheen) hotel bedroom and we are seeing his hallucinatic and drunken dream, influenced in no small measure by the rotating ceiling fan.

### Compact—Music for Today

Today, instead of the banks of hardware modules used in the synthesisers of the past, all these electronics, and more, can be sitting on your laptop, tablet, or mobile phone. There seems to be no limit to how many sound effects you can layer onto a sequence. And herein lies a problem—are we getting near the point of sound overload? Some would say yes, as a significant number of audience members are beginning to say, 'Great, but I couldn't hear what they said'.

The danger lies in the fact that these complex sound designs have to be produced on 'state of the art' kit, with their creators

in ideal surroundings. The problem is that we mere mortals don't often watch and listen to these movies in comparable surroundings, and care has to be taken by sound designers to pull back from the extreme and allow for less than perfect monitoring conditions.

## 10.3 Back to Practicalities

### Analysis—Back to Work!

It's about time we got back to our edit suite and the practical aspects of dealing with music in whatever form it arrives.

When a piece of music is used in a film or TV, it is referred to as a *cue*, regardless of the source. With commercial tracks, once you have chosen an appropriate track for your sequence you will, more often than not, have to alter the cutting rhythm of your sequence to match the music more closely. However, that shouldn't mean that you turn into a slave to the rhythm of the piece completely, but rather you should aim to match musical climax with dramatic climax and musical pause with dramatic pause. To achieve a good match with a commercial track, you will almost certainly have to cut the music around as well.

This timing adjustment is not usually necessary if you are having music composed for you. Here your cut sequence is king, and the composer will have to vary his or her tempi, along with rises and falls in the melodic line, to match the drama already created. A musician (unless you're Erich Korngold, for such was his power) will never ask you for a recut, thank goodness. Well, at least that's one person off the ever-growing list!

It would be impossible if they did—you'd never finish the wretched thing, with version after version being bashed forward and back in an endless reediting and recomposing tennis match—a scenario too horrible to contemplate.

### Cutting It—How to Start Cutting Music

Of course there's nothing to stop you from cutting music anywhere you like, the equivalent of the vision jump cut, but let's assume something more subtle is required. Music, just like speech, will only allow itself to be edited invisibly (okay, inaudibly) in certain places.

Back in the days when I was starting as an editor, a colleague of mine at the BBC would dub the piece of music to be edited to a ¼" tape, cut it long with splicing tape over the join, and proceed to shave slivers of tape off the join until perfection was reached. At the time this was considered to be slightly laborious, but we didn't know just how advanced he was, because this technique is exactly how you might edit a phrase out of some music today with nonlinear editing software—cut the chunk out roughly and trim it until it sounds good.

Music can't just be chopped around at will. It's the same as the clumsy removal of a word from a sentence which can, at the very least, disturb the rhythm of that sentence and, at worst, change the meaning completely.

Just as you have to know something about sentence construction before you can start mucking the words around, you have to understand some of the rudiments of musical construction before you are able to take similar liberties with the notes.

Musicians! Here come the eggs.

## 10.4 A Spoonful of Music Theory

### 🎬 *Music Time*—1-2-3-4, 1-2-3-4

Sorry, only a little bit of music theory, but it's necessary so that you'll be able to make an attempt at analysing any future piece of music that requires editing.

Most popular songs are in what musicians call 4/4 time; that is to say, four beats to the bar. Try counting a regular, 1-2-3-4, 1-2-3-4 to the next song you hear on the radio, and you'll see what I mean, the 1-2-3-4 making up one bar. Building out from here, songs are constructed in sections, the main sections being called verses, choruses, and bridge passages.

DAVE RIXON

### 🎬 *Discovering Music*—Examining Verses and Choruses

Verses and choruses are usually constructed in multiples of eight-bar lumps (that is 8 four-beat bars). Verses are the main story telling parts of the song in terms of lyrics, because these are usually different each time the verse appears. The chorus is also repeated, but here the lyrics, more often than not, are repeated word for word, and they usually contain the name of the song.

It is surprising how many pieces from modern rock-pop combos (sorry, I couldn't resist it) follow this verse/chorus structure. Even bands like the Sex Pistols, Rancid, or The Clash, wanting to smash the world and create anarchy, did so within an eight-bar verse/chorus structure.

Bridge passages (or middle eights), which are usually again in multiples of eight bars, offer a break from the verses and choruses heard so far and can also be identified as linking material. They can contain a new tune or idea that briefly takes us away and brings us back from the main verse/chorus sections. Beware they also can contain a key change (see later in this chapter).

### 🎬 *Songs of Praise*—A Look at Song Structures

Different songs have different structures, and you'll have to identify these in order to make successful edits within each song. This is simpler than you think, and the giveaway is repeats. Just plot the repeated tunes or lyrics, and the verse/chorus structure will be laid bare, waiting for attack.

My best advice is to play the song and mark the timecodes of such repeats, and these will inevitably turn into good edit points by which you can shorten the song successfully, which will not result in legal action from performer or composer. Do some maths and you can calculate the range of reductions in duration that are possible.

You'll certainly need to do some analysis of the five pieces I have for you in the Ex 47 Editing Music 1 example. The exercise requires you to cut each of the five pieces of music down to one minute exactly, but at the same time retain as much of the shape of the original compositions as possible. What I mean by that is that you can't just 'come in' later and offer the last minute of each piece; that would be cheating!

As always, you have my versions to listen to, after you've had a go.

Yet again, to those of you not working on Avid who have had to import my timelines via an EDL, you will not get any of my track level adjustments (rubber-banding, in other words). However, you can still hear my cut versions in the MOV files for this exercise, all five of which I have provided for you.

## EXERCISE 47: EDITING MUSIC 1

**Music Involved:**

```
1 Holidays (16)
2 Mermaid (16)
3 Death (16)
4 Burial (16)
5 Rejection (16)
```

**Exercise Aim:**

```
Here are five pieces of music composed by my
friend Francois Evans. My thanks to him for
letting me use them in this publication.

All you have to do is produce one minute
versions of all the five pieces.

Sounds easy, but these pieces don't have a
straightforward verse/chorus structure, as they
are more classical in their nature. The best
way to tackle this, I think, is to put markers
on the source clips to identify the sections,
```

```
and look for repeats (or near repeats) in each
section. Try to count the beats which will
identify the bars and you will find the four-
and two-bar phrases that will identify the best
places to try a cut. Good luck!
```

**Questions:**

```
How many beats in the bar does each piece have?
Is this the same throughout?
What are the correct bits to lose?
```

**Answers:**

```
Not very easy, was it? The easiest was 'Holidays'
and that was because of its repetitive nature;
the others were trickier. I tended to let the
music as written take us from section to section
and edit within these sections. What a chance of
good fortune that ascending harp figure is. You
can edit it to almost anything.

If you can see my timelines, you will notice that
I have put some of the music onto A3 and A4, so
that I can better construct an overlap, which
helps (with gain variations) to soften the blow
and slowly introduce a new texture. It was easy
enough to find a cut that was rhythmically correct,
but the orchestration was often totally different.

A lot of mixing was required.
```

### On the Beat—Marking Time in 'Play'

I find it more useful to mark potential musical edit points in 'play' rather than trying to position them manually. The reason for this could be my upbringing with linear editing methods, but I would urge you to try this technique here, in the nonlinear world. Simply mark the 'in' or 'out' points where you would tap your foot, and trim them in from there.

## 🎬 *Going for a Song*—Editing Song to Song

Sometimes, a montage of several songs or different pieces of music has to be made. Here, rather like a DJ in a club, my advice is to get the heartbeats of the two pieces in sync, and then look for a contained phrase or lyric which ends reasonably well and that will allow you to most easily get across to the next piece. In other words, it's important to get the bar lines matched up in order to preserve the 1-2-3-4, 1-2-3-4 structure over the join.

Luckily, music is rarely on its own on the soundtrack of a TV programme or film, so if you have to perform an uncomfortable join, all you need to do is bolster up other surrounding sounds to camouflage the musical crime.

Have a go yourself with Exercise 48: Editing Music 2. This uses the same music MOV files associated with Exercise 47. As usual, my version of the exercise is available for you once you've had a go (Ex 48-CUT All 5 Pieces.mov).

## EXERCISE 48: EDITING MUSIC 2

**Music Involved:**

```
1 Holidays  (16)
2 Mermaid   (16)
3 Death     (16)
4 Burial    (16)
5 Rejection (16)
```

**Exercise Aim:**

Here are those same pieces of music again.

The exercise this time is to produce a montage of all five pieces with an overall maximum duration of 1'40", and with each piece as close to the duration of 20 seconds as possible.

The montage must have a beginning and an end and contain what you consider to be a good representation of each of the individual pieces in the allotted 20 seconds. Have a go.

**Questions:**

What are the best bits of the five pieces?
Can you find good 20 second chunks?
Will they join together?

**Answers:**

Again, it was not very easy. 'Holidays' was especially difficult to get in and out of, given its totally different character.

If you are able to see my timeline, I have put lots of the music onto A3 and A4 to produce the overlaps necessary to soften the blow and slowly introduce the new piece.

That difficult join out of 'Holidays' is still not good, but I can find no better, given the timing limits of this exercise.

## 🎬 *In Tune*—Dealing with Key Changes

One word of caution is to watch out for key changes in the piece of music you are dealing with. They will render direct edits from before to after the key change impossible.

KEY CHANGES—E FLAT TO D.

If a cut-down version of a song containing a key change is required, you usually have to take the time out from the 'before' and 'after' sections totally separately, and include the key change as it was performed in the original song in your cut.

One of the most uneditable songs is Jerry Herman's 'I Am What I Am' from La Cage aux Folles, as there is a key change every verse!

###  *The Culture Show*—The Classical and Jazz Worlds

Searching for repeated passages and seeing if they'll edit together is just as valid to cut down classical and jazz pieces, and you can employ the same techniques which we have looked at so far to achieve edits in this genre. I'm sure you found that was the case in the recent exercise.

I know there are fewer repeats in classical music, and the repeats that are there are usually differently scored or in another key, so invisible edits are more difficult here, but they are by no means impossible.

ONLY 88 TO CHOOSE FROM.

###  *Twilight of the Gods*—Wagner's Five-Hour Music Drama in Three Acts

Right, it's about time for another exercise.

Musicians amongst you can now pay attention again, as we embark on a full analysis of the editing possibilities to take Siegfried out of Wagner's five-hour opera *Gotterdammerung (The Twilight of the Gods)*.

*. . . Only joking!*

## 10.5 Key Points—Music, Music, Music

- Music, either from commercial tracks or specially composed, can enhance any cut and give scene joins realflow.

- Most popular songs are written in a 4/4 time signature; that's four beats to the bar.
- Verses and choruses are usually multiples of eight-bar lumps.
- Verses have different words each time they come round.
- Choruses when they reappear they repeat the words as well, and these usually contain the name of the song.
- When you are looking for edits in a song, analyse it by marking the timecodes of the arrival of each section, verse or chorus. These will turn into future edit points.
- Edits in music usually work best between repeated sections.
- Beware of key changes; they will restrict editing possibilities to either side of the change and not across it.
- Mark potential 'in' or 'out' points in 'play', and trim them in from there.
- Classical music is not so formulaic as popular music, but you can still perform invisible joins—you've just got to try a little harder.
- Siegfried had better watch his back, especially in Act 3.

# Chapter 11
# Scenes of Style

In this chapter, I take a look at scenes of a more specialised nature or style. This chapter is divided as follows:

- **11.1 Flashbacks**
- **11.2 Flashbacks—Examples**
- **11.3 Dreams and Nightmares**
- **11.4 Dreams and Nightmares—Examples**
- **11.5 Action Sequences**
- **11.6 Action Sequences—Examples**
- **11.7 Montage with and without Music**
- **11.8 Montage—Examples**
- **11.9 Reconstructions**
- **11.10 Some Exercises for You to Try**

## 11.1  Flashbacks

A flashback is a reversal of time within a story or, more accurately, a window through which the viewer can see what has happened at a time before the story's present. A flashback creates its new time frame only through its content and in comparison with what's happened in the story so far. For example, if after seeing an old lady there is a cut to a young girl being addressed by the same name, the viewer can assume, with some visual evidence, that the new scene with the youngster depicts a time previous to the story's present. This would be a flashback.

🎬 *Words and Pictures—Give the Flashback a Different Texture*

Another common technique when dealing with flashbacks is to give those pictures an individual style by colouring or grading them differently from the rest of the material.

Slight mistiness, richer colours, softening around the edges, or motion-blurring are all ways of telling your audience they are looking at pictures from another time. You could even run the pictures at a slightly slower speed, if that helps and is appropriate.

### 🎬 *Look Back in Anger*—Different Flashback Styles

To a large extent, the style of flashbacks within a film or TV screenplay is preconceived in the writing, design, or direction. The question is, what should an editor do to help this transition to the past and create the illusion of time travel?

For the most part, we are back to our old friend the split edit, but used here in a more exaggerated form. If a character in a scene suddenly becomes emotionally reflective and starts to stare into the middle distance, and you stay long enough on this character's shot to allow children's voices to be heard, often distanced by reverberation, then the audience will believe the character is imagining these sounds from another time. If this is followed by a cut to some children playing, with the reverberation now gone (or reduced), hey presto, we are in the past when our character was a child.

If you reverse the role of pictures and sound, this can work just as well. In this case, you'd keep present day dialogue going over flashback pictures. For example, 'I remember when' over obvious shots of the past and we are instantly back when the character 'remembers when'.

## 11.2 Flashbacks—Examples

Here are a few famous examples of films which use flashbacks.

### 🎥 *Citizen Kane* (1941) —A Film in Flashback

One of the most famous examples of a nonchronological flashback film is the 1941 Orson Welles film *Citizen Kane,* edited by Robert Wise.

The central character, Charles Foster Kane, dies at the beginning of the film, uttering the word 'rosebud'. A group of reporters spend the rest of the film interviewing Kane's friends and associates in an effort to discover what Kane meant by uttering this word on his deathbed. As the interviews proceed, pieces of Kane's life unfold in flashback, but not always chronologically.

The opening is so creepy, with misty night-time shots of the decaying state of Kane's palace of Xanadu, complete with Bernard Hermann doing his Richard Wagner impression, as we slowly become aware of the single lit room in an otherwise deserted building.

Incidentally, it also contains one of the best track-ins in film history when, right at the end, we pan and track over Kane's vast collection of lifetime possessions, some now in huge packing crates, assembled at his palace of Xanadu. Eventually, we track in far enough to find out what Kane meant by 'rosebud'. Rosebud is only on the screen for a few moments, but the effect it has is amazing.

### 🎥 *JFK* (1991)—Time Jumps at Their Best

Oliver Stone's *JFK* (1991), edited by Joe Hutshing and Pietro Scalia, is another fantastic example where flashbacks are used very skilfully to tell another life story. The rhythm of the editing in and out of these flashbacks carries the whole film. Stone brought in a commercials editor, Hank Corwin, to help cut the film. To all accounts, his technique was, in some ways, completely alien to the other editors, but Stone appreciated his more stylised approach to cutting. You can certainly see his influence on the film, as the flashbacks are crafted

very much in the style of a commercial, with information packed into a very short time frame. Stone also employed extensive use of flashbacks within flashbacks, thus creating a multilayer effect of plot upon plot. As Stone said in an interview:

> I wanted to do the film on two or three levels—sound and picture would take us back, and we'd go from one flashback to another, and then that flashback would go inside another flashback. . . . I wanted multiple layers because reading the Warren Commission Report is like drowning.

As the film progresses, these layers are peeled away to get to the truth. Archive newsreel footage is also woven into the narrative in an amazingly skilful way, to act as another gateway to the past, a gateway through which the film passes time and time again without effort. That's the point: flashbacks handled well should look seamless; handled badly they can look awkward and clumsy.

Also look at Stone's later film *Nixon* (1995), starring Anthony Hopkins, to see another film where editing is at its best.

### The English Patient (1996)—Two Interwoven Stories

In complete contrast to *JFK* and *Citizen Kane,* I would encourage you to have a look at *The English Patient* (1996), directed by Anthony Minghella and edited by Walter Murch. It starred Ralph Fiennes and Juliette Binoche.

Here, two main storylines, which are set before and during World War II, are slowly unravelled to produce a fantastic tale of love, misunderstanding, and reconciliation. The film's present, in the last months of the war, finds Count László de Almásy (Ralph Fiennes) now badly burnt from a plane crash, being cared for by his French-Canadian nurse Hana (Juliette Binoche) at a deserted Italian villa. This 'present', in addition to providing numerous storylines of its own, is used by director Anthony Minghella and editor Walter Murch as backdrop for a series of flashbacks into the recent life of the Count, especially concerning his love affair with Katherine Clifton (Kristen Scott Thomas). Eventually, after the film's 40 time transitions, we understand how and why, the present has turned out the way it has. Yes, 40 time transitions, but you'd hardly notice, as the time jumps are handled with such variety, style, and delicacy.

The flashbacks occur mostly on cuts, usually with a music cue to help, but sometimes a dissolve is used to great effect. Take, for example, an aerial shot of the folded and crumpled desert landscape of North Africa visually mixing to the Count's folded and crumpled bed sheets. In addition to the cuts and mixes, there are fade down and ups mostly with sound overlaps and all individually selected to be most appropriate for the particular transition. At one point, the sounds of the past are played over the Count's face as he lies ill in bed, which gives the impression he is almost listening to his own memories as the next chapter of his life is revealed. It is truly a remarkable film made all the more remarkable in the cutting room.

## 11.3 Dreams and Nightmares

### Ramsay's Kitchen Nightmares—How to Make Dream Sequences

Dream sequences, and especially nightmares, are great fun to construct because you can do what you like. Every effect in the book can be hurled at such a sequence, often being utilised in an

exaggerated form. Your options here can include wild grading, resizing, rotation, defocus, distortion, reverse motion, motion judder, video howl round, in fact everything of which your software is capable. Shots can also be melded, one into another, to create fantastic distortions.

###  *In Your Dreams*—Various Dreams and Nightmare Styles

It's a strange fact, but you never see yourself in your own dreams. Yes, I never realised that, but it's true, isn't it. Because of this, many of the shots you should use to replicate dreams are POV shots. Wild camera movements (which can be wonderfully enhanced in the edit suite) can suggest the frantic movements of the dreamer's head as he or she looks around the strange and frightening environment. Walking, running,

and turning around can all be shown from the dreamer's own perspective. However, no director would stick to only POVs, which would be too literal.

DOPs have a ball shooting this kind of material, and so should you editing it. If you are able to separate an element such as a bird, animal, or even a post-box from one picture and superimpose it on the other, you can create wonderful abstract composite images, especially if you make the relocated element absurdly large with respect to the new background.

I would be very disappointed if I wasn't given a simultaneous 'track and zoom' shot to play with when constructing a dream sequence. These shots, done well, will alter the perspective of a foreground subject without changing its size. This will give the impression the background is moving with respect to the subject, a must inclusion in any dream or nightmare sequence.

### ▬ *I Dream of Jeannie*—The Sounds of Dreams and Nightmares

It's not only the vision you can play with in dream sequences, because the soundtrack can also be filled with extraordinary sounds which can further heighten the sense of unreality. Sounds played backwards can produce an incredible and unnerving soundscape. Just try a church bell or plucked string in reverse. Very often, it's better to strip any actuality sound off the pictures and replace it with exaggerated and isolated effects, which can of course be treated with some of the processing effects that we have discussed already, such as reverb, EQ, or phasing. If you've ever seen Jacques Tati's films, like *Mon Oncle* (1958) or *Monsieur Hulot's Holiday* (1953), you'll know what I mean. Tati created exactly this type of soundscape for comedy, but you'll more likely be asked to create weird, horror-filled worlds where loud heartbeats and

deep breathing will enhance the idea of terror. All you need to do is EQ and reverb these heartbeats, and you're well on your way.

 *Room 101—Prepare Yourself!*

As we have already discovered, ideas need to come thick and fast in an edit suite, where the meter is always running. This is fine when you are on your own, but it can be slightly intimidating with an audience. To avoid this scenario, it's wise to have thought about this kind of dream sequence in advance (well, you're doing it now by studying this book) so that you can quickly start to throw some preselected effects onto your current shots and not have to start from scratch.

Once you've done this preparation work, you'll realise what you like the look of and the range of effects your editing software is capable of delivering quickly and easily.

## 11.4 Dream and Nightmare—Examples

Here are a few famous examples of dreams or nightmare sequences from the movies.

### *Dead of Night* (1945)—A Series of Spooky Tales

In this example of a nightmare sequence from the movies, sound, or at least the absence of it, plays a vital role. It comes from the film *Dead of Night,* made by Michael Balcon's Ealing Studios in 1945. The film, edited by Charles Hasse, with several different famous Ealing directors, is a series of mysterious tales related by most of the characters in the film, who are gathered together at a private house in the country for an afternoon tea party.

One of the stories is told by a guy who has recently been involved in a motor racing accident. He tells the story of one particular night when he was recuperating in hospital; it was quite late, and he was lying there on his bed listening to the radio. In the film we see his bedside clock showing a quarter to 10. No one else is around. He is suddenly aware that the sounds of the wireless and the noises from the street outside are getting quieter and quieter, eventually disappearing altogether. The only sound that remains is his now overloud ticking bedside clock, when suddenly even this stops abruptly. He looks at the clock, which is now showing a quarter past four.

He can't understand what has happened. Has he been sleeping? Why is it suddenly so much later? He can't answer this, but he is strangely aware that the room feels different, drained as it is now of any sound whatsoever. He gets out of bed, walks across to the window in a fabulously lit, slightly low-angled shot, and pulls back the curtains to reveal the scene outside, which is in broad daylight, complete with accompanying birdsong. He looks down and sees a waiting horse-drawn hearse, complete with a driver and a coffin. The driver looks up to him with the words, 'Just room for one inside, sir'. He recoils at this invitation and turns to get back into bed, but he still cannot understand what is going on. Gradually, the sounds of normality return and he looks at his clock, which has started to tick again and whose hands are now pointing at the correct time of 10 minutes to 10.

It's such a simple and effective example of how a filmmaker can create tension just with silence—terrific!

Incidentally, later on in the same movie there is a great nightmare sequence, when all the told stories at that tea party come together in a terrifying climax. Not bad for 1945 and one of Stephen Spielberg's favourite films.

Sadly, this film, probably best known for the ventriloquist story which featured a young Michael Redgrave and his dummy Hugo,

is not very well known outside the UK, but despite this, it is well worth a watch.

## 🎥 *Spellbound* (1945)—That Man Again!

In *Spellbound* (1945), starring Gregory Peck and Ingrid Bergman, Alfred Hitchcock hired Salvador Dali to design a set for a dream sequence.

The dream is set in a series of three-dimensional versions of typical surrealistic Dali paintings, complete with misshapen wheels, huge eyes, and harsh shadows. Many objects are wildly out of scale and in the wrong perspective, like a huge pair of scissors or enormous playing cards. Bernard Hermann's music, using the wonderful sound of a Theremin, adds to our discomfort.

## 🎥 *Inception* (2010)—Dreams within Dreams

There are many scenes in Christopher Nolan's film *Inception* (2010), edited by Lee Smith and starring Leonardo DiCaprio and Ellen Page, which could be highlighted here, as the film is loaded with many dream sequences, sometimes dreams within dreams, all with a goodly sprinkling of impressive visual images. Nolan wisely did not rely totally on CGI, preferring to use as many in-camera tricks as he could.

## 🎥 *8½* (1963)—One Hell of a Traffic Jam

Love it or hate it, Federico Fellini's *8½* (1963), edited by Leo Cattozzo, is acknowledged by many as one of the greatest films ever made. For some it is pretentious, for others, a work of art; however the dream sequence, which starts the movie, is tremendous.

Set in a traffic jam in a city underpass, the driver, who we will learn to be the central character Guido (Marcello Mastroianni), is stared at by the other, largely motionless drivers and passengers who are also stuck in the jam. Suddenly, Guido's car starts to fill with steam or gas, and even his desperate attempts to try to get out have very little effect on the staring faces of the other drivers. Here, Fellini uses many imaginative shots to tell this fantastic tale, of which one of the most famous scenes is a bus full of seemingly headless passengers with their arms hanging out of the windows of the bus.

There is no point in describing the whole sequence, but it ends with Guido, now able to fly, being tethered to a rope like a kite above a beach. He unties the rope around his foot and falls from the sky. At this moment there is a smash cut and he wakes up. Quite a nightmare!

## 🎥 *A Matter of Life and Death* (1946)—'One Is Starved for Technicolor Up There'

*A Matter of Life and Death* (1946) (or *Stairway to Heaven* as it was called for release in the US) was written and directed by Michael Powell and Emeric Pressburger, edited by Reginald Mills, with brilliant cinematography by Jack Cardiff, and starred David Niven, Kim Hunter, Roger Livesey, and Marius Goring. This film has a dream-like fantasy quality throughout. You are left wondering if the whole film was indeed a dream, and therefore another 'dream within a dream' example, perhaps.

Squadron Leader Peter Carter (David Niven), the captain of a seriously damaged Lancaster bomber, is trying to return from a wartime raid on Nazi Germany. He has little chance of survival, as the aeroplane is so badly damaged and his parachute is shot-up and useless. He talks on the plane's radio to June (Kim Hunter), an American radio operator, and offers a 'goodbye' to life as he

explains to her that his cause is hopeless. Strangely enough, after he bails out to what should be certain death, he finds himself on the shores of a strange land. No one is around, save for a shepherd boy sitting in the dunes playing a pipe. Suddenly an RAF Mosquito flies overhead and he realises he has truly survived, and this is not a dream. He meets his June and the story gets going.

Shot in Technicolor, well at least the scenes on earth are, the film is breath-taking in its technique, and so far ahead of its time. The photographed images are stunning throughout, a huge staircase to the 'Other World' (for Heaven itself was never referred to in the movie, despite the American release title, which was forced on the makers), a galaxy turning into a truly Supreme Court, a frozen table-tennis match, the list is endless.

Yes, I know the story is somewhat corny and I know the film was commissioned to help improve the strained Anglo-American relations at that time just after the war, which gets slightly overplayed towards the end of the film, but this is of no consequence.

Not only is it a best film of all time, it also, in my opinion, offers the best reason why we are all in this business.

## 11.5  Action Sequences

I suppose if asked what kind of scenes the majority of movie goers like the best, I would think, for the most part, they would answer action sequences.

Here are some key aspects of the contained images that might define and distinguish an action sequence:

- There is a clash of the aims of the opposing characters or groups of characters.
- The sequence contains accelerated or accentuated movement of camera and subjects.
- The sequence tends to use shots of a shorter duration compared with gentler scenes.
- Action sequences rely on the technique of cross-cutting to keep the audience in touch with all the parties involved.
- Real time is truncated as the action is usually condensed on shot changes.
- There is little time for subtlety.
- The soundscape is thick with effects and probably music.
- Camera angles, high or low, can reflect the dominance or submission of the opposing forces.
- Decreasing shot durations can increase the intensity of the action as the clash reaches its climax.
- One side of the clash usually emerges victorious.

To achieve most, if not all, of these points, the audience must already understand the goals of the opposing parties, and therefore be hugely supportive of one over the other.

You might say that training for athletic success, for example, can also be made into a perfectly good action sequence without any obvious sign of any opposition. Well, I would say that the opposition here can be regarded as the physical limitations of the human body and how, during the training process, these limitations are overcome. In this way, an action sequence is not merely limited to a clash between those wearing white hats and those wearing black.

As you can see from the previous list, the action sequence uses some techniques which we have examined before and have already applied to less action-packed sequences. I suppose the most important technique to create a good action sequence would be to keep your audience in touch with the changing fortunes

of the opposing forces by cross-cutting their action. This, along with numerous POV and close-up reaction shots, will allow your audience to enjoy the excitement on offer to the full.

As you'd imagine this is quite a task, as the sequence might reflect a rollercoaster of changing fortunes before a winner is ultimately declared.

As for notable action sequences in the movies, you could look at the attack on the train in David Lean's *Lawrence of Arabia* (1962), or the 12-minute car chase in Peter Yates's *Bullitt* (1968), or the first 20 minutes of Stephen Spielberg's *Saving Private Ryan* (1998). Also, while I think about Spielberg, one of his first films, *Duel* (1971), with Dennis Weaver, is a masterpiece of action and suspense which virtually last the whole movie. Look at the cross-cutting, the POVs, and the reaction shots, which are interspersed with Hitchcockian wide shots, and you'll see what I mean.

Apparently, Spielberg 'auditioned' several trucks and chose the ugly brute he used in the film because it more resembled a menacing face. To this day, I can never look at an American truck of a similar design in the rear view mirror without getting a tinge of excitement. The power of the movies—and editing!

Incidentally, the action doesn't always have to result in death and destruction, as there are many comedic action sequences worthy of note. Blake Edwards's *The Great Race* (1965), or Ken Annakin's *Monte Carlo or Bust* (1969), or Buster Keaton's *The General* (1926), or David Zuker's *Naked Gun* (1988), *or* Jay Roach's *Austin Powers* (1997–2002), or Martin Brest's *Beverly Hill Cop* (1984), or Barry Sonnenfeld's *Men in Black* (1997) are good examples.

An impressive list, I'm sure you'll agree.

## 11.6 Action Sequence—Examples

Here come a couple of action sequence examples from the movies.

### *North by Northwest* (1959)—A Real-Time Action Sequence

*North by Northwest* (1959), directed by Alfred Hitchcock and edited by George Tomasini, which starred Cary Grant and Eva Marie Saint, contains the famous and brilliant crop-spraying scene. This scene actually breaks some of the rules I laid out earlier for an action sequence, but it is still packed with all the required tension of a chase.

Roger Thornhill (Cary Grant) has arranged a rendezvous with the mysterious George Kaplan, and, as instructed, he has taken a bus ride to the agreed meeting place. He steps off the bus in the middle of a flat, treeless prairie wilderness.

Just take the opening high wide angle. You could have joined this shot just as the bus pulls up at the stop. But no, Hitchcock (or his editor Tomasini) joins the shot with the bus having at least 500 yards to travel down the dead straight road before it eventually stops and lets Thornhill off. By doing this, Hitchcock gives us time to take in the open, featureless location, and we see Thornhill as a mere dot compared with the flat expanse of bare fields and barren landscape, which of course acts to emphasise his isolation and vulnerability. The second shot, as Thornhill stares at the departing bus, shows us the other direction, looking just as featureless as where he came from. Sound now plays its part in Thornhill's isolation because, after the departure of the bus, there is an arid silence, with nothing even for any wind to interact with, except the odd telegraph pole or fence post. This silence is only

broken by a passing car or truck and the distant sound of a crop-dusting biplane. To reinforce the silence, no music is used at all in this sequence until after the climax, with the clear intention of emphasising the idea of isolation.

The scene is set. I talked about rule-breaking earlier, and the rule which is most clearly broken here, apart from the one about sound, is that action sequences should be fast and furious, with many little time jumps on shot changes in order to heighten the impression of speed and content. I have looked at this scene several times, and to my judgement there are NO time jumps at all throughout its length; it's all real time.

I have already mentioned the opening shot, but a little later on, as Thornhill looks around the arid landscape, we see a series of POV shots of what he sees. Every time we return to see Thornhill, it's on exactly the same shot as when we last saw him. What's more, even on each of these cut backs, there is a pause before Thornhill turns and looks in a new direction. I get the impression Hitchcock is actually stretching time here and using the POVs to achieve this.

As another example of not using the technique of using shot changes to shorten time, take the sequence as a car emerges from behind a field of dried up maize. Hitchcock cuts several times between the approaching car and Thornhill, but on none of these cuts is time compressed at all. In fact, on a couple of occasions I think that the car should have been a little further forward in its progress from the field to the road. This delay adds to the threat which surely must come from something sometime soon. Eventually, the car stops and a man gets out. Is this Kaplan? No, because this proves to be a massive red herring.

The rest of the scene is superb, as the rendezvous with Kaplan turns out to be a trap when the crop-spraying plane starts to attack Thornhill. This sequence gave us one of the most iconic shots and stills in movie history, with Thornhill running for his life towards the camera with the plane just over his shoulder, coming in for yet another attempt to kill him.

The scene occupies 9½ minutes on the screen and contains 130 shots, which is very low for what we must still call an action sequence.

### 🎥 *The Matrix* (1999)—An Almost Balletic Shootout

*The Matrix* (1999), directed by Andy and Lana Wachowski, edited by Zach Staenberg, and starring Keanu Reeves, Laurence Fishburne, and Carrie-Anne Moss, provides us with a shootout with a difference. I must say straight away that most gunfights leave me cold, but this is different. Yes, we have goodies and baddies and lots of bullets flying around, but in addition we have an almost balletic and choreographed fight which is stunningly assembled to produce a terrific result.

The intensity of the battle contrasts with the use of slow motion as the team cartwheels through the spray of the bullets. The soundtrack, which of course is filled with the sound of gunfire, is also populated by metallic stings accompanied by rhythmic drums, which are soon joined by a bass guitar riff. Even after all that, not a single drop of blood is spilled—strange that!

Does anybody know a person who is good at retiling a lobby?

### 🎥 *The Cruel Sea* (1953)—A Tense Action Sequence

Convoy work in the North Atlantic during the Second War was for the most part uncomfortable and tedious. *The Cruel Sea* (1953), from the book by Nicholas Monserrat, captures that

mood perfectly. It was directed by Charles Frend, edited by Peter Tanner, and starred Jack Hawkins and Donald Sinden. Shot in black and white and accompanied by a melancholic soundtrack with the music composed by Alan Rawsthorne, the film creates a bleak atmosphere as the ship's company endures lengthy periods of uncomfortable boredom battling against a constant and ruthless enemy, the sea, interrupted only by rare glimpses of any human foe.

The most powerful and outstanding sequence in the film is where Captain Ericson (Jack Hawkins) is attempting to hunt down a suspected U-boat contact. The sonar signal is strong, and this convinces Sub-Lieutenant Lockhart, Ericson's number two (Donald Sinden), that they have made contact with a real U-boat submarine. With the help of the sonar echoes, Ericson steers his ship, the Compass Rose, closer and closer. Lockhart is certain it is a definite contact, but the trouble is there are some survivors from a recently torpedoed merchant ship on the surface of the sea awaiting rescue, right above where the U-Boat has been located. The close-up of Ericson's largely emotionless face as he weighs up the evidence is brilliantly enhanced as it is intercut with the men in the water and an increasingly confident Lockhart. Ericson decides to attack.

Tension turns to action. The director and the film's editor use a modest variety of shots, by today's standards, in a most remarkable way. The rushes bin contained: shots of the crew preparing to attack, some clearly questioning this decision, the men bobbing in the sea as they wait to be rescued, Lockhart operating the sonar with its insistent ping-ping-ping, the engines pounding at top speed, various sizes of Ericson's face, his POV of the men in the water, various sizes of the ship's bow cutting through the water, the men on the surface scattering as they realise Compass Rose is not on a rescue mission, various shots as the ship steams through the men, crew members unable to watch what is about to happen, depth charges launched and dropped into the sea, groups of the crew watching as the depth charges explode, and Ericson also watching the exploding depth charges.

The sequence ends with a crew member shouting 'bloody murderer' and Lockhart saying the fateful words 'Lost contact'.

I think what is so good about the sequence is that there is no clear resolution as to whether they got the U-boat or not.

This is truly an editor's sequence. In the three-minute scene from Ericson's cry of 'Attacking' to the end, there are 70 cuts. Notice how, as the ship gets closer to the men in the water, the shots of Ericson change in size from mid-shot, to close-up, to extreme close-up. Notice also, we never see any shots of the actual explosions of the depth charges; instead, all of this is played on the faces of a disbelieving and horror-struck crew.

Once again, the sound plays an important role, with the sonar pings constantly confirming to us there is a contact, and it's real and getting nearer. There is very little dialogue in the sequence, only the sound of the ship's engines, the men in the water, the ship cutting through the water, and the insistent sonar pings. I admire the fact that, once the depth charges are launched, the sonar pings disappear, which, at the same time as this offers us some relief, it reinforces the terrible silent wait before the charges explode.

Also, just like the crop-dusting scene in *North by Northwest,* music is not used until the attack, successful or not, is over. The scene settles on a shot of a now calm sea with a few floating lifejackets and other debris on the surface of the sea where the men used to be. Only now do we hear a mournful flute coda, as the picture fades to black.

## 11.7 Montage with and without Music

### ▪ *Danger Man*—Beware, We Are in Dangerous Territory

When you create a montage, you enter a world where the editing rulebook is thrown away. This might seem the answer to all our prayers to be able to edit without rules, but beware, you are in uncharted territory with danger signs all around.

### ▪ *Call My Bluff*—mon-tage: n. [mon-tahzh; *Fr.* mawn-tazh]

A dictionary definition of a *montage* might say: 'in a montage, shots rely on symbolic association between each other, rather than connecting physical action for their continuity'. Not extraordinarily helpful I think, certainly not if you're trying to create one. In order to help these 'symbolic associations' along, you'll need some sound or vision glue. Just as with dreams and nightmares, this glue can be music, some special soundscape, or some form of grading or texture applied to the pictures.

### ▪ *Time of Your Life*—Montages That Compress Time

Montages are hard to classify because they can either concentrate on a small element of the story or take us on a journey through time which will propel us to a later part of the story, jumping over the bits in between. In fact, this is probably the best and most common use of a montage, to move the story on, often fast-forwarding through time, allowing only glimpses at some relevant action.

### ▪ *Routine Break*—Montages That Act as a Break from Dialogue

Montages on the screen can act as a break from routine dialogue and, at the same time, allow more artistic freedom to cast and crew in the shooting process. A script might simply state that 'the two kids have a great time at a local fair'. It is hard for the director and DOP, with the help of the designer, not to shoot a barrage of fairground shots comprising many slates and handing them to you with the words 'Off you go!'

Within moments, you're supposed to produce a BAFTA-winning montage of that fairground evening which will live in the memory long after the film itself lies unrented on the video store's shelf.

I did say there was danger all around, didn't I?

You have three main options to consider when you construct a dialogue-free montage, and these are:

- Shot selection.
- Shot order.
- Shot duration.

With no dialogue to help you, shot order and duration become crucial to achieve a coherent, sequential whole. My advice here is to be quite mean with the duration of the shots and, above all, never come back to a shot that tells the viewer nothing they don't know already.

Shot duration, of course, is mainly governed by the action the shot contains, but as we have already seen, an editor should always be on the lookout for ways of shortening such action by the clever use of all the shots that are available. A close-up of the same action already shown in a wide shot will allow you to cut down the time taken by that action and, incidentally, make it more interesting visually.

If music is to ultimately augment the shots in such a sequence, my advice would be not to put it on straight away, but instead make the shots work on their own first. Once you are happy with the

sequence, add the music and tweak to suit. You will be amazed at how much of it naturally fits, but do allow the music to adjust the timing of your cuts so that the fit is made even better.

### 🎬 *Looks Familiar*—Different Picture Styles in Montages

As I have already commented, the pictures in montages are often made to look different in some way. There are many options here. You could 'filmise' them (removing the shot's interlacing) or apply colour correction, slow motion, or some form of defocusing vignette. Difference can also be generated by using footage from an alternative source. It can be the case that your sporting tournament is also being covered by hand-held roving cameras, as well as the main coverage. These roving cameras, and their operators, are often given more artistic freedom to collect different looking and perhaps more interesting shots.

This alternative coverage will give you those fantastic crash zooms that, with a bit of slow motion, can look so good in compilation montages.

### 🎬 *The Epilogue*—End of Series Montages

Some of the best examples of sequences cut to music—yes, they are montages as well—are to be seen at the end of the day, or at the end of the tournament, at big sporting events such as the Olympics, the World Cup, or the Six Nations Rugby Tournament.

Here, set against a good choice of a musical bed, and with a good selection of shots between action, quotes from the players, and the crowd's appreciation (might they be called reaction shots?), you can create magic that will bring a tear to the eye of even the most hardened of sports fans as their favourite tournament draws to a close for yet another year.

### 🎬 *Top of the Pops*—Pop Videos and Other Sequences Cut to Music

I have talked a little about this aspect of editing already in the chapter about music, and I have specifically discussed the production of music videos, but I wanted to go back and talk a little more about the techniques involved and give some examples of well-cut musical sequences from TV and the movies.

When cutting a sequence to a predominantly musical bed, it is too easy to settle into a cutting rhythm so closely tied to that of the music that your cutting becomes repetitive and boring.

The trick is to vary your cutting so that you follow individual beats or rhythms for a patch, then go against this by staying on an interesting shot much longer. Maybe also, take the advantage of a slower section in the music to slow your cutting rate down before bashing in a few short shots, which will wake-up an audience marvellously.

## 11.8 Montage—Examples

There are many examples of well-edited montages in the movies and on TV. Here are some worthy of your attention.

### 🎥 *Babel* (2006)—Some Beautifully Edited Montages

Especially in the Tokyo section from *Babel* (2006), directed by Alejandro González Iñárritu and edited by Douglas Crise and Stephen Mirrione, you'll find some brilliantly edited montages where actuality sound has been stripped away and replaced with music. The scene where Chieko, a young, deaf, mute girl living in Tokyo, played by Rinko Kikuchi, takes drugs and heads for a night club with her new drug-dealing boyfriend is a marvellous example of a great cinematic montage.

With constant silent reminders of how Chieko herself is experiencing the night's events, the montage takes us through her 'high' to ultimate disappointment and rejection as she sees one of her girlfriends making out with the boy she liked. When she leaves the nightclub and returns to those silent streets alone, the effect is incredibly poignant and sad, and it was mostly created in the editing suite rather than the camera.

### 🎥 *The Lavender Hill Mob* (1951)—The Eiffel Tower Sequence

*The Lavender Hill Mob* (1951) provides a great montage example. It was one of the classic Ealing comedies and starred Alec Guinness, Stanley Holloway, and Sidney James. It was directed by Charles Crichton and edited by Seth Holt.

The montage occurs when our bullion-robbing heroes, Holland and Pendlebury, are in Paris and find out that their solid-gold Eiffel tower statues are now being sold by mistake to a group of English schoolgirls from a souvenir shop at the top of the Eiffel tower itself. They get most of the statues back from the girls and replace them with the correct souvenir versions, but a couple of the girls head off into a descending lift with a pair of the gold statues. There now follows a dizzy set of *Vertigo*-like shots as Holland and Pendlebury run down the huge number of steps of an emergency access spiral staircase to beat the lift to the ground in order to get the statues back. The choice and variety of shots used here, as they get drunk and dizzy from spinning around and around, makes for a very funny montage. They emerge at the bottom, unable to stop spinning, just in time to see the girls with their statues get into a car and drive off.

### 🎥 *2001: A Space Odyssey* (1969)—The Journey to Jupiter

Another great example of filmic montage is the sequence Jupiter and Beyond the Infinite in Stanley Kubrick's film *2001:*

*A Space Odyssey*, released in 1969. This is truly montage at its best.

Starting off in a relatively simple narrative form of shooting, a series of approaching and passing colourful light shapes starts to disorientate us as they are intercut with our hero, Dave, in his spacecraft. Reflections of these lights on his helmet show us that this is what he is experiencing. The glue for the montage is György Ligeti's music, starting with a chorus of voices crying out in a more and more anguished way as the images increase in intensity, thus heightening our disorientation. On his journey to infinity through alien solar systems, Dave's image is shaken violently to imply high speeds of travel. Views of deep space are intercut with extreme close-ups of his facial features. We see his eye is highly tinted to reflect his colourful surroundings. He blinks and we see exploding nebula, blazing skies with wildly and weirdly colourful landscapes.

At the end of this 10-minute sequence there is silence; time has vanished, as cuts from POV to POV reveal that Dave is reborn.

I saw this when it came out in 1969 (I was 13) on a huge screen in proper cinemascope. It made a big impression.

The rulebook has well and truly been thrown away—*but stop*: this is not the time to add this particular publication to your recycling bin just yet. There are a few more old and enjoyable rules left for us to examine.

### 🎥 *Notting Hill* (1999)—A Montage to Move the Clock Forward

*Notting Hill* (1999) provides a perfect example of a montage being used to move time on. The film was directed by Roger Mitchell, edited by Nick Moore, and written by my *Blackadder* colleague Richard Curtis. In the montage, William Thacker (Hugh Grant)

walks down the Portobello Road in Notting Hill as the seasons change from summer, to autumn, to winter, through Christmas, to spring, and back to summer.

Even though we are cleverly only on one shot as far as the walking William Thacker is concerned, I would still categorise this as a montage, as the market backgrounds are clearly changing, however invisibly, if that makes any sense at all, to represent the passing year. The song 'Ain't No Sunshine' by Bill Withers adds perfectly to the impressively cut visuals.

### 🎞 *The Prisoner* (1967)—One of the Great Title Sequences

I must not forget TV, and my favourite titles montage comes from *The Prisoner* (1967), which starred Patrick McGoohan. Here, the story of 'how he got to the village' is perfectly told in pictures against Ron Grainer's compelling music and a few well-written lines of dialogue.

Everything is so right—good shots of his car driving around Westminster in London, his footsteps is sync with the music as he goes to see his boss, thunder replacing a 'frank exchange of views' when he resigns, his photograph ID being over-typed with a series of capital Xs, futuristic machinery then filing his ID card as 'Resigned', a hearse following his car back to his London home, his abduction and ultimately waking-up in a replica of his flat in the village, when the dialogue with the new Number Two begins: 'Where am I?' . . . 'In the village' . . . and so on.

I must have seen this sequence hundreds of times, but it still thrills and sets you up perfectly for what is to come in that episode and, at the same time, introduces the new Number Two.

BE SEEING YOU.

### 🎞 *Last Night of the Proms* (2014)—A Fantastic Opportunity to Be Inventive

It's not only sporting events that allow such montage opportunities. As an example, the 2014 BBC Proms closed with a fantastic highlights package which contained brave and thrilling musical edits, including some fantastic musical smash cuts, which really brought the season to a close in a most memorable way.

Given that the range of music now featured in the BBC Proms is so huge, it gave the editor here a fantastic opportunity to cut from Richard Strauss, to a 1940s swing number, to Ravel, to Cole Porter, to Sibelius, to Verdi, to John Tavener, back to Richard Strauss, to Mozart, and even a Wilfred Owen World War I poem. Clever shots of conductors and performers made this into a stunning piece of work. Again, last time I looked, the BBC still had a link to this sequence.

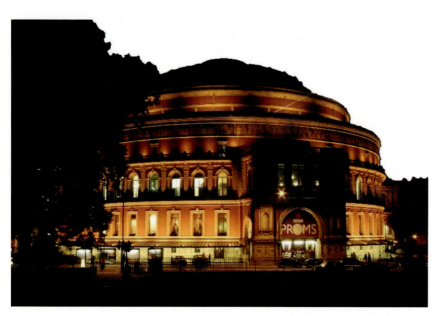

THE ALBERT HALL IN LONDON, THE HOME OF THE BBC PROMS EVERY SUMMER.

### 🎥 *'I Just Wanna Dance'* (2004)—My Favourite Music Compilation

For me, no holiday to Gran Canaria would be complete without a beer in my hand and several viewings of this video compilation of clips from film musicals cut to 'I Just Wanna Dance' from *Jerry Springer the Opera*, written by Richard Thomas and Stewart Lee and sung by Alison Jiear. It plays in one of the bars out there on a regular basis.

The video, which was made by Manny Patel in 2004, is a lesson in how to punctuate a music track with well-selected clips.

The line 'things are looking bad for me' over a pregnant Barbra Streisand from *Funny Lady* makes me smile every time I watch it. What makes the compilation so good is that the original film clips are cut in such a way that the characters are now dancing and singing to 'the beat of a different drum'. This is done so skilfully that you're almost convinced, at times, that the original performers are actually singing the new words.

## 11.9  Reconstructions

Either because not enough actual footage is available, or because there was none in the first place, an editor's skills can be used to great effect when creating reconstructions.

### 🎬 *Crimewatch*—Criminal Reconstructions

Let's look at one specific area, commonly used on TV, and that is *criminal reconstructions*.

For the reconstruction of a crime, the last moments of a victim's journey are often reenacted to help jog people's memories as to whether they can give any more information about the actual crime to the police.

When you construct this sort of sequence, you must make it absolutely clear to the viewer at all times what is actual real-life footage and what is reconstructed. This probably means the repetitive use of captions, but it is part of broadcasting regulations (certainly in the UK) that this is made absolutely clear.

Today, with the extensive use of CCTV cameras, much of a person's last known journey is available to the programme maker once it's been released by any police investigation. This CCTV footage can now be intercut with new specially shot material relating to the incident. Using look-alikes, the shots of these actors are photographed in a much more stylised way than would be normal, which is mainly done to avoid seeing the actors' faces.

Because of this, the conventional shots of facial expressions are out. Instead, the camera is made to hang back or go in close to shoot specific parts of the body like hands, feet, clothing, handbags, umbrellas, and so forth. Recent photographs of the real victim can be inserted over the action to remind us of what he or she actually looked like. Remember, you are creating a montage.

Cross-cutting scenes (like the train and the car on the level-crossing) can heighten tension as victim and criminal get closer geographically. Many filler shots are used, such as pavements passing under walking feet, railings and walls going by, or passing traffic—the list is endless. These shots are there mainly to fill time and to allow voiceovers to inform us further about the known facts of the actual incident. Added captions will also help to clearly identify time and place.

### 🎬 *We the Accused*—A Look at Picture and Sound Techniques in Reconstructions

The different attitudes of victim and criminal can be represented by different styles of POV shots. If the criminal is high on drugs or alcohol, then their POV shots could, with some justification, be shot to reflect this. An editor can help here by treating these shots with focus variations or creating a tunnel-vision effect (if that's what's wanted) by distorting the edges of the frame. We are back in the territory of dreams and nightmares, and some of the treatments we applied to the POV shots there are equally applicable here.

What about sound? Well, if the crime was recent and the criminal is still on the run, then the sound, for the most part, is played very straight, so heavy breathing or rapid heartbeats would not

be appropriate here. Some music can be used, but this is rare; it completely depends on the programme's style. If the crimes were committed a few years ago and the criminal's trial is over, then more audio embellishments, like elaborate and suspenseful soundscapes complete with music, can be used more freely.

I know this is mostly directorial stuff, but I am telling you all this so that you can understand why the item was shot the way it was.

Add some intercuts to interviews with the victim's relatives and the investigating officers, and the reconstruction can be made to look really interesting, with the hope it will throw some light on the crime.

ALEXANDRA PALACE, NORTH LONDON, WHERE IT ALL BEGAN FOR TELEVISION IN 1936.

### Time Tunnel—Other Reconstructions

I know that in this section I have concentrated on criminal reconstructions, and I am fully aware that there are many different types of reconstruction, such as historical, social, wartime, or scientific. However, these can be filmed and put together in so many different ways, it would be impossible for me to lay out any ground rules here as to their individual construction.

I would hope that, given what you have seen and learnt up to now in this publication, you will be able to adapt such knowledge to suit.

## 11.10 Some Exercises for You to Try

### In Loving Memory—Different Flashback Styles

After all that chat, it's high time for an exercise.

I've got a dream sequence for you to generate for yourself now in Exercise 49: Dream Seqs.

I hope you enjoy my version after you have had a go.

---

**EXERCISE 49: DREAM SEQS**

**Shots Involved:**

```
1 MCU M (13)
2 TV Shots (14)
3-7 Rough Sea (14)
8 WT Boys (16)
```

**Dialogue:**

**SCENARIO:** The older Mark remembers a near tragic day on a beach with his brother.

*YOUNG PHILIP & MARK:*

Ad lib cries of help both requested and offered.

**Exercise Aim:**

The aim of this exercise is to try to create a memory of the day Mark's brother had a hand in getting him out of trouble in the sea.

You have a free hand to conjure up the near tragedy of that day.

**Questions:**

How can the wave shots be used to the full advantage, while at the same time we see the pain of the memory on the face of the older Mark?

**Answers:**

I think my superimposition idea works reasonably well. It needs better sound maybe, with the possible addition of some threatening music.

I do love that return to silence; that does work well.

You have probably noticed the lack of 'good' and 'bad' versions in recent exercises. The reason is, the more we advance in technique, different cuts become just different and less definable as good or bad. This exercise was a case in point.

My thanks go to Curtis and Jackson Heighes for playing young Philip and Mark.

## *The Photograph*—A Closing Sequence Is Required

This next exercise, Exercise 50: Montage 1, is not quite as dramatic in nature as some of the recent examples from the movies I have just discussed, but we need to end *The Photograph* in a poignant and stylish way.

You have to do everything here. Choose the shots, choose the font for the credits, and make the music fit a credit duration of 45 seconds.

Your cut-down version of Music Example 5 in Exercise 47: Editing Music 1 might just help here.

GO ON, DO BETTER!

## EXERCISE 50: MONTAGE 1

**Shots Involved:**

1 MCU P Sits (13)
2 WS M exit (13)
3 TV & Cups (14)
4 TV Clips (14)
5 Film Clips (15)
6 Proj Fx (16)
7 Music (16)

**Dialogue:**

*PHILIP:*

Goodbye.

*MARK:*

Look, I'll let myself out; your tea is getting cold. Bye.

PHILIP SITS.

*PHILIP:*

Oh yes, that's another thing, only one cup and saucer from now on.

**Exercise Aim:**

The aim of this exercise is to produce a closing montage with credits of a suitable design. The credits must not be longer than 45 seconds.

Hint: the music will have to be edited to suit.
The credits to be included are:
Philip: Gorden Kaye
Mark: Keith Drinkel
Two Boys in the Film: Chris & Nigel Wadsworth

Sound: Steve Hubbard
Director of Photography: Nigel Bradley
Production Manager: Nicholas Gale

Director: John B. Hobbs

**Questions:**

What shots should you use?
What font should you use?
How should you pace the graphics?
Will the music fit?

**Answers:**

Philip is now alone again with his memories. Not exactly a joyous prospect for him, hence the choice of reflective music. I pulled away from the 'cup and saucer' shot quite quickly, with the aim of going full frame to the film reasonably early on. I underlayed the music on Philip's last line, and that seems to work well to lead us into the closing credits. I always prefer music to end and not just fade out, so a crafty nip in the middle of the track achieved this.

### 🎬 *Sunday, Bloody Sunday*—More on Montage

Here's another montage to create: It's Sunday morning and *Chocolates and Champagne* requires an opening montage. Your job is to make an opening title sequence, complete with graphics, to open the programme. It needs to last the duration of Ken Casey's announcement on his radio show, which most people in this suburban setting seem to be listening to as they get on with Sunday morning chores.

Have a go at this one: Exercise 51: Montage 2.

THE KEN CASEY SHOW IS ON THE RADIO! WHO WILL WIN HIS *CHOCOLATES AND CHAMPAGNE*?

## EXERCISE 51: MONTAGE 2

**Shots Involved:**

1-18 Various Sunday morning activity
shots (01)
19 H Reading (01)
20 Birds Fx (16)
21 & 22 Radio VO (16)

**Dialogue:**

*RADIO VO:*

And if you've just joined us, a big welcome
to the 'Sunday Lovers Show' with me Ken
Casey, your very own Sunday Lover, on 'Radio
SW' 99.3 FM. Where have you been? It's
another fine Sunday morning and I hope you
are enjoying the sunshine, or just having a
really good lie-in.

We've some fabulous tracks still to come
on the show, so stay tuned and relax to
some of the greatest love songs ever.
Remember, coming up very soon we will be
selecting this week's lucky couple, who
will win my 'Chocolates and Champagne'.
Who will it be? Well, we'll find out right
after this.

**Exercise Aim:**

The aim of this exercise is to produce an
opening montage with credits of a suitable
design. After you've finished, you could mix in
some music of your own.
The credits to be included are:
Chocolates and Champagne written by Chris
Wadsworth & Nicholas Gale
Helen: Pippa Shepherd
Tim: Paul Taylor
Caroline: Jemma Saunders
Voice of Ken Casey: Stuart McDonald
Directed by: John B. Hobbs

**Questions:**

What shots should you use?
What font should you use?
How should you pace the graphics?

**Answers:**

Again, I hope you didn't feel you had to use every shot. If you felt the Radio VO was too long for the shots available, you should have considered cutting it down.

All I can say is that I hope you like my version. But that's the point about montage—there is no right or wrong, except for the fact that it has to be liked by others.

I wonder if any of you tried to multi-frame some of the images; if so, I'd love to see the results.

I think my font is a bit thin!

# Chapter 12
# Video Manipulation

Talking about Kubrick's *2001* in the last chapter leads us on very well to consider the topic of video manipulation, full as the film is of many visual and video effects.

## ▬ *Box of Delights*—It's Playtime, Guys!

Let me first define the difference between *visual* and *video* effects. *Visual effects* (commonly shortened to Vid FX or VFX) are basically special effects that can be created in front of the camera and therefore include stuff like explosions, crashes, fire, water, rain, snow, and so on. *Video effects* (also commonly shortened to Vid FX or VFX, hence the confusion) include all forms of video manipulation performed on the video signal outside the context of a live-action shoot, and therefore after the camera has stopped turning. That phrase 'outside the context of a live-action shoot' almost certainly means you and your edit suite. The terms *visual* and *video* are becoming increasingly interchangeable today as more and more effects involve the integration of live-action footage (or visual effects) with computer-generated imagery (or video effects) in order to create composite images which would simply be impossible to photograph directly. I think I have confused myself now!

## ▬ *The Name of the Game*—Let's Get the Terminology Right First

Let's make a start on the area that most concerns us—video effects. Video effects have become increasingly common (if a little over-relied on) in many recent movies. With the introduction of affordable animation and compositing software, even the more complex of these techniques has become accessible to the amateur filmmaker. However, these are increasingly specialised areas of filmmaking and are somewhat outside the remit of this book.

Instead, we will concentrate on simpler effects that you will regularly need in your editing work.

This chapter is divided as follows:

- **12.1 Motion Effects**
- **12.2 Keying**
- **12.3 Types of Key: Luminance, Chroma, and Matte**
- **12.4 Graphics**
- **12.5 Multiple Images**
- **12.6 Multilayer Video Sticking Plaster**

## 12.1 Motion Effects

*The Fast Show*—Speeding Pictures Up

The technique of *speeding pictures up* is most often seen in daytime or children's programmes where it's commonly used to make the programme more 'cool' and perhaps more visually interesting than it really is. Constantly changing the speed of a sequence is a lazy way of editing, and it is usually forced on you by the absence of cutaways. However, I do accept that, because of the nature of the material, the more conventional way of editing such footage is out of the question. I suppose a smarter alternative would be jump cuts.

Although I am not a huge fan, because a quick-cut montage can look so much better than simply using the accelerator pedal, I can see speeding pictures up is a useful (and certainly easier) technique in some productions.

*House of Cards* (2013)—Sometimes It Works!

I've been a bit hard on fast forward, but all that changed when I saw the opening titles of the American version of *House of Cards* (2013), starring Kevin Spacey. That is indeed the way to do it! To be fair, I suppose this technique is more accurately described as 'time-lapse' photography, rather than the more crude description of just speeding the pictures up. The huge contrast between the fast images of clouds, traffic, and trains zooming by and the slow movements of the camera and the sun's shadows works very well.

*It's Marty* (BBC TV) (1968–9)—Everybody Back on the Coach!

I'm rapidly losing my argument about speeding pictures up with another example of just how well they can work sometimes— here to create laughter. Take a look at Marty Feldman in 'The Lightening Coach Tour' from his BBC series *It's Marty* (1968–9).

I remember seeing this sketch when I was still at school and all of us raving about it the next day. The speeded-up chatter of the coach party with Marty's repeated cries of 'Wait for me' as they tear around the countryside to the seaside and back is hilarious. After they've been to the pub for lunch, the repeated roadside 'reliefs' is a gem of a sequence. You can clearly see the influence of Feldman's hero, Buster Keaton, in this sketch.

The series was produced by the great Dennis Main Wilson, who I was fortunate enough to work with (however briefly), and it was

written by Marty Feldman and Barry Took. The coach tour operator was played by John Junkin.

### 🎬 *The Benny Hill Show*—Okay, I Give In!

Right from the days of the Keystone Kops, comedy performers and directors have used the technique of undercranking the camera to produce 'funnier' speeded-up pictures. As an example, where would Benny Hill be without a speeded-up closing sequence of him being chased by several scantily clad young ladies? Ah! The innocent (or guilty!) days of the 70s. Every technique has its use, I suppose.

I think this must be every editor's blind spot, given that we see speeded-up pictures every day while searching for that next perfect shot, we don't find them at all funny anymore.

### 🎬 *The Day the Earth Stood Still*—Slowing Pictures Down

*Slowing pictures down* is done for many more stylistic reasons and will certainly produce much more creative results. Where would sport coverage be without several slow motions of different viewpoints of a just-scored goal?

When I started at the BBC, there was only one machine capable of slow motion. Made by the Ampex Corporation, it was a magnetic disc-based machine that was only able to capture and process a total of 36 seconds of material. On a 'Match of the Day' football night, all the editors working on the programme would queue up (myself included) to offer our normal-speed material to 'the disc' and one by one would insert the now slowed-down material back into a prepared 'hole' in the match edit. The joys of linear editing! The commentators at the match that afternoon had to commentate blind over an imaginary replay and we would, now

several hours later, have to try to fit a slow motion of the action to match these words. But hey, in the words of the coal-eating Monty Python sketch, 'We were happy!'

Today, with high scan rate cameras, slow motion footage of sporting moments can look stunning as individual blades of grass part when an 8-iron swishes by or beads of sweat fall from clashing heads in the penalty area.

Slow motion can also be used in a less analytical mode and instead create a romantic or suspenseful atmosphere in order to punctuate a moment in time. Used well, you can create a depth to pictures which was never present in the same shots played at normal speed.

I have to say that slowing down pictures shot at only 25 FPS can have disappointing results; it just depends on their content. Software and the computer's ability to 'invent' frames in between the scanned ones is always improving, but just beware of the technique's limitations.

### 🎥 *Blackadder Goes Forth* (1989)—Over the Top

Allow me to join Kubrick, Stone, and Welles, if only for a moment, in an example of my own here with the closing sequence from *Blackadder Goes Forth* (1989), where our heroes emerge from their trenches for the final time. Slow motion and long dissolves turned what was, to all accounts, an undershot scene into a heart-stopping moment rarely found in audience sitcoms. Alongside me in the edit suite that morning were Richard Boden (director), John Lloyd (producer), and Nial Brown (my assistant at the time). We had barely 10 seconds of useable material to fill 40 seconds of Howard Goodall's music, which was designed to close the series. Slow motion was an obvious choice, I grant you, but what we didn't

expect was that suddenly, with extreme slow motion (about 6–10 FPS) the majesty and horror of such an event came to life (sorry, a strange choice of words, but you'll forgive me). Explosions that at full speed looked like typical studio visual effects, spraying polystyrene in all directions, started to look like the real thing—dangerous, frightening, and capable of doing real harm—and our heroes were in the thick of it.

With the colour drained out, long and slow vision mixes joined the now slowed-down action together and got us to a shot of no-man's land, hauntingly empty after the battle. Actually, even this shot was not used as intended, as I grabbed it from before the actors were cued into action. A visit by Nial to the BBC stills library produced several shots of a countryside covered in poppies. When I tried one of them, the hairs on the back of my neck literally stood up as our studio shot of the desolation of trench warfare in 1917 just seemed to melt into modern day tranquillity—the choice had been made. A drift back to colour to reveal the blood-red poppies, and with faint birdsong added after the end of the music, we were there.

In those four hours, we created a sequence that has become iconic and much talked about for all the right reasons. The edit suite used back then, comprised of four timecode-controlled, one-inch Ampex analogue videotape machines, was capable of slow motion (obviously), but in this mode the timing of the slow motion was unprogrammable and unpredictable, the speed being controlled manually by crude linear faders. Chinagraph markings and many hands (yes, even the production team) on the BBC's Electra editing panels brought the sequence to life. Because of the unpredictability of the slow motion and the generational restrictions of analogue machines, it had to work, to a large extent, in one pass, using all four machines carrying the different pictures, each being cued and run in turn.

A PERSONAL CONNECTION FOR ME TO THE FIRST WORLD WAR. HERE IS THE GRAVE OF MY GREAT-UNCLE, VERNON C. WADSWORTH, WHO DIED WHEN HE WAS 18, LYING WITH HIS FALLEN COMRADES FROM 1916 IN FLEURBAIX, NORTHERN FRANCE.

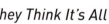 *They Think It's All Over!*—**Knowing When to Stop!**

This brings us to a very important point that I can't stress enough. It could be the most important point in this book!

The technology that we used to create the closing sequence of *Blackadder Goes Forth* had naturally imposed a point at which we were forced to stop. Nowadays, there is no such technological limit, and modern software will allow you to build layer upon layer, effect upon effect, with no limit whatsoever. It is totally up to you to know when to stop.

Just as an artist or composer has to eventually walk away from the work he or she is creating, so an editor has to know when to leave a sequence alone.

The key point is that today we might have easily ruined that *Blackadder* sequence for the crass and simple reason that we *could*.

BBC'S ELECTRA EDITING PANEL, SIMILAR TO THE ONE ON WHICH THE CLOSING SEQUENCE OF *BLACKADDER GOES FORTH* WAS EDITED.

### 🎥 *The Cruel Sea* (1953)—A Nice Bit of Movie Trivia

Before we leave motion effects, I rather like this bit of movie trivia which shows that, even when there has been a mistake and a shot has been missed or incorrectly filmed, there is sometimes a solution in the edit suite.

We have already looked at this sequence from *The Cruel Sea* (1953) when I was examining movie examples of action sequences, but I recently saw a clip of Peter Tanner, the film's editor, talking about this incident, and I think its retelling is worthy of inclusion.

In the aftermath of the depth charge attack, there is a harrowing shot, apparently taken from the stern of Compass Rose, and all you see are the remains of some life jackets and other debris floating on the now calm surface of the sea, nothing else.

Tanner relates that after the filming had been completed, it was discovered that Charles Frend's directions for this shot, for he had not been with the unit, had been misunderstood. The shot was mistakenly taken from the filming ship's bow, with the camera looking forward and therefore heading toward the debris, thereby totally destroying the poignant intention of the shot. A reshoot was not feasible, given it had to perfectly match with what was already filmed. Luckily, the problem was solved in the cutting room by running the film backwards.

Brilliant! Tanner's solution had worked! However, if you look carefully at the shot in the movie, you can see that the seagulls are flying backwards.

## 12.2 Keying

Here I look at the ways multiple video layers are used to create captions, graphics, and title sequences.

More bad news I'm afraid, just as before when we looked at sequences we first had to study individual shots, here we have to get a few technical definitions out of the way before we get to the fun.

### ▪ *Through the Keyhole*—Video Used as a Switch or Key

A *key* is a video signal that acts as a controlling switch between other video sources.

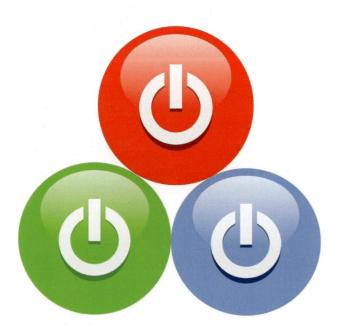

Thus, the key, or foreground picture, can be made to cut a hole in a background picture.

The source of the key can simply be the level of the foreground signal itself; this is known as *luminance keying*. Alternately, you can use a colour contained in that foreground picture, and this is (not surprisingly) known as *chroma keying*.

Sometimes the controlling key is a separate source of video, and this is referred to as an *external key* or *matte*.

Let's look at all these types of key in turn.

## 12.3 Types of Key—Luminance, Chroma, and Matte

### ▪ *Cutting Edge*—Luminance Keying

Often used in simple caption work, luminance keying only uses two video layers in your timeline. Here, the caption or title graphic (placed on layer 2 or V2) uses itself, or more precisely the video level of itself, to cut a hole in the background picture (placed on layer 1 or V1) and fills that hole with itself or a colour.

The key can have a border (simply cut a bigger hole), or coloured border (fill the enlarged hole with a colour), or shadow (cut a bigger hole and offset it slightly), or soft edges (mix between the hole edges and the background), or opacity (mix between the filled hole and the background).

An effect that was once popular, mainly because it was one of the very limited camera-based effects in the early days of TV, is creating and using a 'negative' version of a picture which is then mixed, or luminance keyed, with the original. This can easily add a weird and frightening look to a shot or scene.

In this way, keying pictures with themselves can produce wonderful effects, especially if some adjustment to the size of

the picture is made, thus creating a video howl-round not unlike pointing a camera at a monitor, à la the original *Doctor Who* titles of 1963.

## 🎬 *The Green, Green Grass*—Chroma Keying or Green Screen

Chroma keying or *green screen* is a technique where a colour, or a small range of colours, is removed from a foreground image and these regions replaced with an alternative image. Here, the colour contained in the primary image acts as our switch (or key) to display a secondary image. This technique is also known as *colour separation overlay* (CSO) primarily by the BBC, but even they are coming round to the near universal terms of *chroma key* or *green screen*. Strangely, the term green screen is still used even if green is not the colour controlling the key.

Why green? Well, it's the colour furthest away, in spectral terms, from any hue contained in the average human face. Blue and sometimes yellow can also be used depending on costume requirements because, if the actor wears green clothes and green is the keying colour, then his clothes will also be replaced with the

background picture. Modern software is very good at being selective between 'green screen' green and other greens in the foreground, but to be on the safe side, the colour controlling the key is usually chosen to be different from any other foreground colour.

The problem editing green screen sequences is that an older computer's speed can slow down as it processes that second stream of video. If you are on older equipment, edit the foreground action first with all that green, and when you are happy with the sequence, put in the intended backgrounds, adjust the key, hit render, and go for lunch. Come back after lunch, and change everything.

Here's an exercise to prove you can do it: Exercise 52: Chroma Key.

**EXERCISE 52: CHROMA KEY**

**Shots Involved:**
 1 WS 2S (12)
 2 WS H's House (03)
 3 W2S rise (12)
 4 Green TVs (16)

**Dialogue:**
 NONE.

**Exercise Aim:**
 The aim of this exercise is to put the three pictures into the three TVs.

 Hint: TVs with green screens go on V4 and the three other pictures on V3, V2, and V1.

 Then use 'Picture in Picture' to create a composite of V1, V2 and V3, which is presented to the V4 keying layer.

 Don't bother too much about aspect ratios and cropping, just get the pictures keying well.

**Questions:**

How did you get on?

**Answers:**

It's a software thing really, but it will give you practice arranging the timeline in the correct manner before you are called upon to do this for real.

You can of course stretch this exercise out and make the pictures in the TVs turn off, one by one, to a bright line across the middle and then go to a dot as they used to. Ask your grandparents.

No, I didn't bother either!

### *Outside Edge*—External or Matte Keying

When an external key or matte is used, three layers (or streams) of video are involved—the background on V1, the fill (or foreground) on V2, and the key, switch, or matte on V3. Matte keying is more commonly used in higher end graphic sequences where a separate key or matte is provided to cut a hole in addition to a foreground that fills it.

An example of this in its simplest form might be a shaped strap, filled with a graphic, over which a name super can be written.

There is not much I can say about the technique of editing these sorts of effects together, other than to say they have to deserve their inclusion like everything else. Graphics can often cost the production a great deal of money, but this shouldn't cloud any judgement on their final removal, if that becomes necessary.

Right, we are out of the classroom again, you'll be glad to hear.

THE AVID EFFECTS PALATE.

## 12.4 Graphics

Having talked about keying, let me say a few words about graphics. Today in TV, I would say 90% of all graphics work is done in the edit

suite, and an editor is more and more called upon to write, type, design, and animate graphics as few programme budgets can afford a specialist graphics person any more, and certainly not for any length of time. The style may have been chosen elsewhere, but 'you know who' will have to make it work. As with other aspects of editing, it's wise for you to have a few favourite styles up your sleeve so that you can quickly call on one of these when the question of captions or graphics arises.

## ◼ *Look and Read*—Dealing with Captions

For most of the time, caption work is limited to adding a few name supers or maybe a closing roller. Easy stuff, I know, and not particularly creative, especially if you're on programme 11 of series 4. Occasionally, you'll have to be more inventive, particularly when you ask your production about the graphics for the programme, and you get that 'Ooh, we've not thought about that' look!

Well, now's your chance. Simple static superimpositions can be improved dramatically if you build in some subtle movement either

to the size and position of the whole caption or to the spacing of individual letters. By altering the letter spacing, the spread of the caption can be seen to settle in frame, which can look very stylish.

## ◼ *True to Type*—Choosing A Font

Font choice is also an important factor that can give your captions great individual style on the screen, but the choice should always reflect the mood of the programme concerned. Hopefully, none of you would put a fancy handwritten font on a hard-hitting programme about prison violence!

Try using coloured lines to underline words; it's quick to do, and it can also look very smart. However, these lines should not be too thin to cause vertical jitter on interlaced pictures. You also might consider making the caption write itself on the screen like a typewriter, or animate the letters one by one, or just simply focus the caption up as it settles into position.

THE BORIS TEXT APPLICATION WITHIN FCP.

Your choice of software will help or hinder here. Some title software is very easy and intuitive to use, and some just too complex for occasional use. The problem is, if the software is too complex, you'll forget how to drive it between uses and probably go back to a simple title tool and do your best.

Font choice is largely a matter of personal taste, but get to know what you like, especially if you've not considered the choice of graphic styles before. Once you know what you like, you'll be better able to defend or modify your design when the inevitable doubts from the production team arise.

### Head to Head—HD versus SD

This point about HD versus SD is slightly out of date today, with most productions shooting in HD (or higher), but it's still worth mentioning in passing.

When graphics are provided for you, there is the possibility of a clash between the low-res interlaced TV world and the high-res graphics world. Sadly, some graphics originated on high-end, high-res machines don't always look as good on an SD TV screen. Good designers know this and work around the restriction accordingly. However, sometimes stuff comes to you that looks really dreadful when you put the artwork on your TV monitor, and all eyes look at you as if you were to blame. The remedy is to get involved in the design process as soon as possible so that a prototype version can be inserted into the programme to reveal any limitations the TV system imposes on the artwork at an early stage.

The advent of HDTV has eased the problems, but remember, some people are still looking at the broadcast output on standard definition CRT TVs, so for the moment, you have to satisfy both worlds.

### The Front Page— raphic Safe Ar

Many broadcasters put limitations on where graphics can be placed on the screen. A programme made today for an aspect ratio of 16:9 may still have a 4:3 caption safe area limitation, and that's way in! See Mickey's test cards in Chapter 15. Safe area charts are provided by the broadcasters, and these images can be imported into your project and used as guiding templates for caption insertion. Different broadcasters, software, and TV manufacturers have varying ideas of what 'safe' actually is, so beware. Generally, your broadcaster is right, especially if they are the ones that have to technically pass your programme.

You might very well have to resize imported graphics in order to comply with these broadcasting limits. The trouble is that as you reduce the graphics in size, you might render small-sized fonts unreadable. We are back to the HD/SD clash again. Always check the rules concerning caption insertion with your friendly individual broadcaster.

### 20/20 Vision—Graphic Readability

The golden rule when dealing with graphic readability is for you to slowly read out every word of a completed caption *twice* and *aloud*. The reason for this is that you know exactly what the caption says, as you presumably have just typed it in, but the viewer does not.

When you add graphics to your timeline, it is good practice to time the arrival and departure of your caption to significant moments in your cut. This can be the vision or the sound. For example, listen to the speech over which there is to be a name super, and hear in your mind the ideal place for a 'fade-up' and a 'fade-down'. This is best done at play speed, marking the 'up' and 'down' points with your 'in' and 'out' markers. A good starting point for the duration

Whether you should put up a caption immediately after the appearance of the person concerned or wait a couple of seconds is totally up to you, but whatever you decide, be consistent with this timing throughout the programme.

It's important never to put a caption or graphic over a person's mouth; it just looks bad and might prevent those viewers who are hard of hearing and good at lip-reading from picking up what is being said. Also, try not to have to place the caption over several shot changes; however, I do understand this may be unavoidable in many circumstances.

### Sign Zone—Keep Your Backgrounds Clean

of any name super is between three and five seconds, depending on how many words are superimposed with the person's name—a job title, for example.

As a quick note while we are talking about graphics, a practice I started, and since then has been claimed by most broadcasters

as their own idea, is to put the clean backgrounds over which you have superimposed captions or title work at the end of your master tape or delivered file. This way, when the inevitable 'spellink mistoke' is discovered, you can easily correct it and not have to go searching through dozens of original recordings to find the background concerned.

Sadly, 'spellink mistokes' are all too often discovered once the nonlinear material is gone or has been superseded by a graded version, and if that's the case, you'll be so grateful you spent those extra seconds putting the clean graded material on the back end of the delivered programme.

Most broadcasters want you to leave a minute of black and silence after a programme ends for emergencies, so put your clean elements on after that.

## 12.5  Multiple Images

The use of multiple images on the screen can work very well without making the viewer suspect that mutton is being dressed up as lamb. Contestant profiles in game shows which provide information about the individuals can easily be built up from multiple images, or multiple versions of the same image.

I saw a good example of this in the BBC's recent coverage of the Leeds International Piano Competition. Here the pianists' profiles consisted of an enlarged version of the mid-shot of the individual, which was graded blue, slowed down and defocused, and over which was superimposed the original mid-shot footage of the smiling contestant along with some stats about his or her career—it looked very good.

*A Point of View*—Images Turned in to Windows.

Multiple images can make TV programmes look much more like a Windows-based display on a computer. Different views of the same subject can be made to run simultaneously in separate areas of the screen; a frontal mid-shot can be paired alongside a profile mid-shot or long shot, which can also provide the background. Done with nonlinear software this is very easy, as the different pictures are put on different layers in the timeline and reduced in size using 'picture in picture' (or something similar) to form a composite picture.

## Flog It!—Stretching Out Limited Resources

Some low budget documentaries spend the first half of the programme telling you what's coming up later, and then when it is later, reminds you of what happened in the first half when they were telling you what was coming up later! The net gain is nearly zero. This situation is more common if the programme spans advert breaks, where part one ends with a trailer for part two (to keep you watching), and part two starts with a massive recap of part one.

An editor on this type of production will be asked to come up with interesting ways to disguise the fact that material may have to be stretched and used more than once.

Here are some examples of what you might consider.

Imagine you only have two photographs of a couple of people or objects. Even with only two stills, it is surprising how you can stretch these photos into an interesting sequence by manipulating the images in various ways.

Try some, or all, of the following on those photographs:

- Reduce the size of the images, put them against a colour or a graphic, and move them around the screen.
- Reveal the images by turning them about an axis, X or Y.
- Use gentle zooms to highlight some individual feature or features.
- Cut out the principal foreground and separate it from the background and treat them differently with regard to focus, grading, or size. In this way, a zoom into the shot can be made to look three dimensional. I grant you this does take time to achieve properly, but it can look good.

- Reveal the images by flying them in like rolls of paper, or darts, or pages in a book. There are many possibilities with a little programing effort.
- Put various sizes of the same image on the screen at once against a colour or a graphic.
- Crop out details from the image, separate them, and make a collage.
- Reveal the images by wiping them individually onto the screen.
- Put flashes of white between different sizes of the same image as they appear and disappear on the screen.
- Colour or tint the images differently (Warhol like?) and place these different versions on the screen together.
- Defocus one image and use it as a coloured background for the untreated version of that same image, to be layered above.
- Defocus one image and bring the other into focus as the first disappears.
- Slide the images along in the style of an old slide projector.

## Please Sir—In Conclusion

The list above can go on and on, but I hope I've given you some idea of the possibilities. For extra inspiration, all I would do is look at the examples that are used on the box today. If there is anything you like, adapt the style for your current or future project.

## 12.6 Multilayer Video Sticking Plaster

## U.F.O.—The Removal of Unwanted Flying Objects

As much of my source material is still recorded with boom microphones, I probably have to deal with these low-flying objects more than most. Happily, techniques to remove these booms can be applied to all such uninvited flying objects (UFOs) that enter frame from time to time.

The techniques for removing these UFOs fall into three main categories:

- Resize.
- Wipe.
- Picture in picture.

### Supersize Me—Resizing Images

With *resizing*, the overall picture is simply enlarged to exclude the offending object. This is very easy to do, but with standard definition (SD) pictures you are limited to a size increase of between 5% and 10%, depending on the source material. Beyond the 10% barrier, the picture becomes too soft and the line structure too visible. You can hide this a bit if you are able to introduce this resize gradually over the course of a shot, and especially if you can piggyback on the natural movement of a camera's framing. Release from such a resize can and should be done in a similar way, or on a shot change.

HD pictures can cope with a larger amount of zoom but even they, beyond about 20%, start to break up.

### Total Wipeout—Wiping Out UFOs

For the *wipe out* technique to work, it is essential for the offending object to get out of the way at some point and reveal the background it temporarily obscured, preferably without any adjustment of the camera's framing. If this is the case, you are able to freeze the picture before (or after) the invasion of the UFO and use this freeze on a second timeline video layer to repair the problem. A shaped wipe is placed around the affected area, and you can simply cut out this area of UFO invasion and replace it with a frozen clean background.

A couple of points: first, the freeze should be a true 'freeze frame', in other words, using both fields of an interlaced image; and second, this technique only works well if the camera is stationary while the boom is in shot.

If the camera moves during the shot with the offending boom, then the frozen element will have to be moved and tracked to match the movement of the camera.

Good camera operators will know not to adjust their framing to get rid of the dipping boom and rather let it get out of the way on its own, because they know if they move the camera it will ruin the potential repair.

The advantage of this technique is that both pictures, sticking plaster and original, move in sync with each other geographically. The disadvantage is that correction can only cope with a small range of camera repositions. At this stage you might decide to try resizing as described previously, or look at another take.

Coming to our rescue here is cleverer drawing and compositing software, with even cleverer operators, who can work wonders when the problem lies beyond the capabilities of either edit suite software or us!

## 12.7 Colour Correction

I have called this section *colour correction* rather than grading as I feel there is a huge difference between the two operations. As an editor, I would say that, unless you specialise, you will be colour correcting pictures rather than grading them. In starting to talk about colour correction, it is worth asking yourself if you have perfect colour vision. If you haven't been checked, do so. Those of you who suffer from severe colour blindness would be advised to leave the more complex aspects of colour correction to others. Level adjustment is okay, like making a shot appear darker to match its neighbours, but that's it.

**The Colour Receiver Installation Film—Some Colour Fundamentals**

As you probably know, colour TV uses only three colours: red, green, and blue (RGB). The eye is effectively fooled to see a range of colours by mixing together different proportions of these three primary colours. TV white is made up of red, green, and blue light in the proportion: 0.3 red + 0.59 green + 0.11 blue. So green does

**You've Been Framed—The 'Picture in Picture' Technique**

If the movement of the camera is too great to replace the UFO with a freeze wipe, it might be possible to use another bit of the picture to cover up the offending object, and this is what I refer to as the *picture in picture* technique. For example, if the boom comes over some curtains, it might be possible to duplicate a lower section of the curtains and move it up, to act as sticking plaster, and remove the boom. Here again, a second layer of vision is created on the timeline. This video layer carries the sticking plaster, now moved to suit the repair. Draw around the UFO and turn this into a soft-edged wipe, which will restrict the correction layer to be visible only where you want it.

THIS MAY NOT WORK AS WELL WITH THE PRINTED COLOURS IN THIS BOOK, BUT YOU SHOULD SEE THAT THE TWO YELLOW BARS HAVE DIFFERENT TINTS.

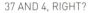 37 AND 4, RIGHT?

most of the work when a monitor displays a white raster. Thus, with old CRT monitors and TVs, it was always the green gun that wore out first, because it was taking more beam current than the other two over its lifetime.

### 🎬 *Being Human*—You Can't Believe Your Eyes

Another problem with human beings is that our eyes, or more accurately the signal processing in our brains, don't see absolute colours, but rather see colour in relation to the colours that surround. If you don't believe me, just try duplicating and moving the yellow colour bar from a standard set of colour bars to the other end (near the blue bar) and you'll see two completely different yellows on display, even though they are electrically exactly the same. One yellow will appear more of a lemon-yellow compared with its duplicate. Go on, try it—colour bars on two video layers, 'picture in picture' applied to the top layer. Crop the yellow bar and move it along to where I said, and you'll be amazed, it will actually change colour as you move it across.

### 🎬 *The Black and White Minstrel Show*—Don't Colour My World

Because our eyes are capable of playing tricks on us, professional grading rooms are painted to be completely colour neutral, and in addition, they have a source of true 'grey' white light to act as a reference. It's the same problem we had monitoring sound properly, in that the room and monitor must be as perfect as possible. The 'grey' reference acts as a palate cleaner to reset the grader's eyes in case the programme starts to drift off in a particular spectral direction.

You've all experienced the effect that, after staring at a single colour for a while, when that colour is removed from your view everything looks strangely coloured until your eyes have had a chance to settle down again. I am not suggesting you get a paintbrush out to your edit suite, but that orange wallpaper has to go before you start to seriously grade your pictures.

## Chuckle Vision—Lies, Dammed Lies, and What Monitors Display

Monitors are capable of telling lies. They effectively have colour correction built in to them, and this must be lined up to reproduce accurate monochrome pictures before you can use them to alter the colour content of your pictures.

It is essential that your picture monitor be checked for what engineers call *grey-scale tracking*.

A GREY-SCALE CAMERA LINE-UP CHART AND, ON THE RIGHT, PICTURE LINE-UP GENERATING EQUIPMENT (PLUGE).

| Auto Color Balance(Hex) | |
|---|---|
| **Auto-RGB** | |
| Source | MAIN |
| Red Offset1 | 0FD |
| Green Offset1 | 111 |
| Blue Offset1 | 116 |
| Red Offset2 | 00 |
| Green Offset2 | 59 |
| Blue Offset2 | 5D |
| Red Gain | 05F |
| Green Gain | 05F |
| Blue Gain | 060 |
| Reset | ▶ To Set |
| AV | OK |
| Component | OK |
| RGB | OK |

A MONITOR MENU WITH RGB ADJUSTMENTS.

Here, the monitor is balanced (RGB gain and RGB backgrounds) to match a grey-scale light box. Once set, most modern monitors will stay grey. So gone are the days of waiting an hour or so (I'm not kidding) for valved monitors to warm up and stop drifting.

Along with your picture monitor, the computer display should also be checked because, if white here is being displayed slightly pink, for example, then this will ruin the neutral surroundings we are trying to create.

## Do Not Adjust Your Set—Hands Off the Menus

I hope I've made you realise that it might be better to leave all this to those who know.

All of the above should serve as a huge warning, and that's to only attempt any colour correction for real when you know what you're doing.

Generally, programmes are professionally graded before transmission, but this is by no means universal. Some colour correction work will have to be done in the edit suite, but hopefully this will be limited to getting pictures to match a little better for a viewing, rather than starting from scratch and grading the whole programme prior to transmission.

### 🎬 *It Ain't Half Hot Mum*—There Are Limits You Know!

Colour correction controls are, for the most part, intuitive. RGB adjustments are usually represented graphically, and the response of each colour is individually controlled from dark to light. The best thing to do is to try it all out.

Rather boringly, the result you'll produce, especially if you are livening things up, will usually be totally untransmittable. We're back to level limitations, I'm afraid, similar to those we dealt with in connection with sound. Thankfully, most software can be set to warn or limit such transgressions so that you don't produce illegal colours. Yes, it's that bad; and you'll find that there are plenty of police around to check that you stay on the level. Technical reviews and quality assessment reviews (QARs) are ruthless and will gladly fail (for thus it seems) any level transgression.

I say all this so that you're armed and ready; it can get pretty rough out there.

### 🎬 *Sorry*—I Have a Confession

I have a serious confession to make, and that is the colour blindness numbers a few pages back of course should have been 62 and 3.

### 🎬 *Edge of Darkness*—Colour Correction: Terms of Engagement

For the most part, an editor will only be required to smooth over and match one picture to another, but here's a list of some of the parameters available in colour correction software.

- *Saturation*—Any area of colour is increased or reduced. Turning this right down will produce a black and white image.
- *Lift/brightness/set-up*—With this control you can black crush darker elements to render them invisible, or lift them out of the gloom.
- *Gain/level*—Same as contrast on a TV. Blacks are unchanged (mostly), but lighter elements are amplified or attenuated. The limit of such amplification is peak white (0.7 volts above black).
- *Gamma*—This alters the otherwise linear response from black to white, and is more commonly used to enhance or reduce subtleties near black. Gamma can be altered for each colour separately, so very quickly your pictures can start to look somewhat impressionistic, and worthy of inclusion in a Tate Modern art exhibition.
- *Hue*—A hangover from the NTSC colour system, which could introduce hue errors (red changing from magenta to green), and this control corrected such errors. The control can change the feel of the colour content without affecting the rest of the image. It can be selective to the level of the signal it affects, that is the shadows, middles, or highlights. Try it.
- *Clip high*—Means what it says, it puts a limit on the whitest white or the reddest red and so on.
- *Clip low*—I'll leave that to your imagination.

###  *South Pacific* (1968)—Fantasy Grading

We need an example of using creative grading from the movies, and the Rodgers and Hammerstein musical *South Pacific* (1958) provides a good one. It was directed by Joshua Logan and starred Rossano Brazzi and Mitzi Gaynor, and it was edited by Robert L. Simpson.

During Bloody Mary's song 'Bali Hai', the pictures are graded in a more and more extreme way in order to reinforce the effect her song, about the mysterious powers of the island of Bali Hai, is having on Lt. Cable (John Kerr).

The images start off by having their saturation increased, with, at the same time, an overall decrease in their detail, but this may be due to the extra optical filmic processing the images had to go through to produce the colour effects in the first place. Intense golden colours give way to more extreme reds and blues, sometimes changing in vision and varying in hue across the screen. In addition, a misty, out-of-focus vignette is used to soften the edges of the frame. I must say the effect works best here to heighten the mystery of Bali Hai, but works less well with other songs in the movie. Indeed, when we visit Bali Hai, all the pictures are treated for saturation and hue, which becomes somewhat tiresome over the length of the scene. What have I said about overusing an effect just because you can?

### 🎬 *Pennies from Heaven* (BBC TV) (1978) and *The Singing Detective* (BBC TV) (1986)—Shall We Dance?

From the TV world, *Pennies from Heaven* (1978) and *The Singing Detective* (1986), both written by Dennis Potter, offer excellent examples of pictures being graded and lit differently, again when a song was called for.

There's a scene in episode two of *Pennies from Heaven* where Arthur (Bob Hoskins) is pleading for a loan from his stuffy bank manager (Peter Cellier), and it must be said negotiations are not exactly going well, when suddenly the song 'Without That Certain Thing' by Roy Fox and His Band is heard, and the bank manager's office is transformed into a theatre set, complete with footlights.

Lighting and the balance of the cameras are altered to increase the effect of the change. Both Bob Hoskins and Peter Cellier do well in this impromptu dance routine. I know this was before the days of post-production grading as such, but it serves as an example of the technique of picture manipulation to suit or generate a mood.

You could also search for the scene from episode one where Joan (Gemma Craven) is at home entertaining girlfriends Irene (Jenny Logan) and Betty (Tessa Dunne), and they suddenly start performing 'You Rascal You' by the Blue Lyres.

As an example from *The Singing Detective,* search for 'Dry Bones' for another marvellous fourth wall–breaking song and dance routine.

You forget how good these series were!

### Play Misty for Me—Making Your Pictures Just Look Better

Let's assume you're nearly finished editing, and you and your director now have important clients to impress, and your pictures could do with some smartening up. Generally, pictures from a location will be shot to sit in the middle of the available range of levels, so you could try applying a global 'lift down, gain up,

saturation up' colour correction to your timeline and tweak the shots that now look worse.

If you were really keen, a very slight edge vignette could help give depth to some exteriors, especially those with flat featureless skies. It is amazing how this can improve the look of some shots. It can also be used to bring out your foreground characters from their backgrounds, but be careful you are nearly grading the show now.

## 12.8 Effects—Those You Should Carry with You

From time to time, I have mentioned settings and effects that you should have up your sleeve if things turn nasty. Here again the same is true. For a start, keep a copy of the settings of your favourite effects on your USB stick in the form of a folder or a bin. This can be easily copied from project to project and will give you a head start with any new effects.

In addition to these software settings, there isn't much I'd carry with me picture wise, except for things like that old favourite, the scratched film loop. I can't remember how many times I have had to degrade modern video footage to make it look as though it had been on a cutting room floor for weeks. When you find a good bit of scratched leader or a film countdown, make a QuickTime movie of it and keep it.

Incidentally, I did this for the square-bashing titles for *Blackadder Goes Forth.* After the series was transmitted, the production got a letter from a member of the public saying that he was pleased to see that the BBC was, at last, running these archive films at the correct speed! I don't know what he thought Rowan Atkinson was doing there in that footage. Still, one happy customer at least, we didn't have the heart to tell him.

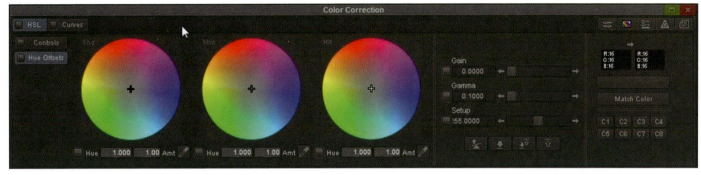

THE AVID MEDIA COMPOSER COLOUR CORRECTOR WINDOW.

Other regularly used video effects include the 'record' viewfinder graticule, with line corners and a 'REC' graphic superimposed, or a binocular effect over a long shot. Both of these, once generated, are bound to be called on again and again, so you might as well pop them onto your USB stick.

### *The Sky at Night*—Adding Weather to Shots

Things like a rain loop, snow, clouds, or a shot of the moon can be useful to store as JPEGS or QuickTimes, and you'll get loads of Brownie points when you add the moon to that already fabulous night exterior, which will justify some of the light used in the filming.

You'll soon build up a library of such material most appropriate for your kind of work.

## 12.9  Key Points—Video Manipulation

- *Visual effects* (commonly shortened to Vid FX or VFX) are special effects that can be created in front of the camera, such as explosions, crashes, fire, water, rain, and snow.

- *Video effects* (also commonly shortened to Vid FX or VFX) include all forms of video manipulation performed on the video signal outside the context of a live-action shoot.
- Changing the speed of a sequence is a lazy way of editing, and it is usually forced on you by the absence of shot cutaways.
- Comedy performers and directors have used the technique of undercranking the camera to produce 'funnier' speeded-up pictures.
- Slowing pictures down can produce attractive and creative results.
- A *key* is a video signal that acts as a controlling switch between other video sources.
- The source of the key can simply be the level of the foreground signal itself; this is known as *luminance keying*.
- If a colour contained in that foreground picture is used as the key, this is known as *chroma keying*.
- If the controlling key is a separate source of video, then this is referred to as an *external key* or *matte*.
- Some graphics originated on high-end, high-res machines don't always look as good on an SD TV screen.
- Different broadcasters, software, and TV manufacturers have varying ideas of what 'caption safe' actually is, so beware.

- You might have to resize imported graphics in order to comply with broadcasting limits.
- The golden rule when dealing with captions is for you to slowly read out every word of a completed caption *twice* and *aloud*.
- Never put a caption or graphic over a person's mouth; it just looks bad, and it might prevent those viewers who are hard of hearing and good at lip-reading from picking up what is being said.
- Put clean backgrounds over which you have superimposed captions or title work at the end of your master tape or delivered file.
- Contestant profiles in game shows and the like, which provide information about the individuals, can be built up from multiple images or multiple versions of the same image.
- Zooming in on SD pictures is limited to between 5% and 10%, depending on the source material. With HD pictures you can't go much beyond 20%.
- Before you start seriously grading your pictures, the room and your monitors have to be perfect and telling the truth.
- Quality assessment reviews (QARs) are ruthless and will gladly fail any video level transgression.
- Copy the settings of your most used video effects onto your USB stick. These can include colour corrections, vignettes, fonts, caption styles, or layouts for multiple images.
- Collect useful video elements like scratched film leaders, rain, the moon, or a 'REC' viewfinder graphic.

# Chapter 13
# Editorial Responsibility

Modern editing techniques and the speed of the operation, as the sheer volume of the output on all channels increases, has made editorial responsibility issues much more important.

This chapter is divided as follows:

- **13.1 Editorial Responsibility—An Introduction**
- **13.2 Taste and Decency**
- **13.3 The Range of Compliance Categories**
- **13.4 Other Compliance Issues**
- **13.5 A Look at Copyright**
- **13.6 Key Points—Editorial Responsibility**

## 13.1 Editorial Responsibility—An Introduction

### *A Year with the Queen* (2007)—Where It All Went Wrong!

Ever since 'Queen-gate', and perhaps a little late, the BBC and other broadcasters remind us regularly of our editorial responsibilities. 'Queen-gate' was where the Queen, in a trailer for a documentary series called *A Year with the Queen* (2007), was made to look as though she was angry at a remark made by photographer Annie Leibovitz when she asked the Queen to look 'less dressy and remove her crown'. In the trailer, the Queen was seemingly seen

to storm off in a huff, complaining to an aide, 'I'm not changing anything, I've done enough dressing like this, thank you very much!' The trouble was, the footage of a complaining Queen Elizabeth was filmed on her way in to see Leibovitz, not after the meeting. The trailer had completely misrepresented what had actually happened.

### *Rough Justice*—The Truth, the Whole Truth, and Nothing but the Truth

The basic rule is, *tell the truth,* as simple as that. Keep events in the order they happened in real life unless it is safe for you to move them about. I know the chronological order of an interview is often changed to improve the flow and join thought processes together more logically, but this must never result in any change of the sense of what was said. This would be misrepresentation, and that's crime number one.

Recent exposures in the UK involving seemingly untouchable programmes, like *Blue Peter* and *This Morning*, have warned us all of the consequences of getting it wrong.

### *The Royale Family*—Only Joking, Ma'am!

As part of the team that produced an internal BBC 'Christmas Tape' in 1978, we got into trouble when we removed the word

'discrimination' from sport presenter David Coleman's innocent question, 'Have you ever experienced any sex *discrimination*?' The trouble was that his interviewee was Princess Anne. We used her actual reply which was, 'I don't know . . . maybe once or twice'. With a broad grin, Coleman asked his next question: 'What about Mark Phillips?' to which Her Royal Highness answered, 'There's no one he'd rather be beaten by than me'. Good old university undergrad stuff, and luckily the BBC saw it that way too. The trouble was it got onto the front page of the *Sunday People* newspaper on New Year's Eve with the headline, 'ANNE TELE SPOOF, SHOCK FOR BBC'.

I still have the newspaper and the T-shirt.

I digress, I know, but it's an example of how an innocent joke was made a potential subject for national debate. More seriously, great harm can be done to individuals who are the victims of such misrepresentation.

### ▣ *Order, Order*—Making Sure Cuts Don't Change the Meaning

In the edit suite, just make sure that if you do have to swap events around or take a phrase out of context, the sense remains unaltered. Don't shorten any sentence that changes the sentence's meaning; for example 'Chris Wadsworth doesn't edit well if he's tired' down to 'Chris Wadsworth doesn't edit well'. You see what I mean; a phrase taken out of context can completely change the meaning of what was said originally.

### ▣ *Screen Test*—Passing the Test

Before doing any work for the BBC today, producers, directors, and editors have to take an online course where, by means of various examples of editorial dilemmas, you have to choose the best solution to the editorial problems presented to you. I found it a surprisingly useful exercise, even though I still mostly edit scripted dramas where we have fewer controversial editorial issues.

All the major UK broadcasters (BBC, ITV, Channel 4, and SKY) have this information on their websites. It's worth a read, when you have a moment, and is bound to be more up to date than this publication.

The BBC itself has a lot of information on its website: www.bbc.co.uk/editorialguidelines.

Have a browse when you have a spare hour or two.

## 13.2  Taste and Decency

In these days of increasing concern about sex and bad language in broadcast material, let alone 'political correctness' or religious sensitivities, an editor, along with the production team, has to be more and more a custodian of a nation's morals.

### ▣ *Blue Peter*—Keep It Clean!

Every programme broadcast on the main channels in the UK has associated with it a compliance form which lists all the words

contained in the programme that could possibly be considered as bad language, and the programme is classified accordingly. In addition to bad language, any nudity, violence (sexual or otherwise), and religious references are also noted down alongside the timecode at which they occur. The acceptable limit of such content varies according to the broadcasting channel and the time of transmission. What is considered okay for BBC3 might not be suitable for a BBC1 audience, unless it is shown at a later time. In addition, a show populated with bad language or significant violence will almost certainly have a verbal warning transmitted before it goes out.

🎬 *The Moral Maze*—**Misrepresentation of the Distasteful**

You might say that if a person actually speaks with obscenities left, right, and centre, then it would be a misrepresentation to

tone down such dialogue. Yes, you're right, but if the reduction in the frequency of such bad language is the only way to get your programme on the air, then I can't see why not.

In any case, the reduction in the frequency of the bad language is so much better than 'bleeping', which in my opinion is as crude as the word it tries to cover. However, I know many regard bleeping as a more honest solution to the problem.

## 13.3  The Range of Compliance Categories

As an example of how well documented programme content is, here is a list of the topics covered on a typical compliance form.

Programmes are analysed for any of the following:

- Offensive language or gesture.
- Sex—Sexual content, sexual innuendo/reference, nudity.
- Violence—Real life, fictional, involving children, sexual violence.
- Imitative behaviour—Drug/solvent abuse, suicide, self-harm, hanging, other potentially dangerous behaviour, use of alcohol, smoking.
- Portrayal—Disabilities, religious, minorities, cultural sensitivities.
- Disturbing content—Disturbing images/sounds, disasters, accidents, kidnappings, terrorist acts, exorcism, occult, paranormal, horror.
- Impartiality and diversity of opinion—Personal view, authored, major controversial subjects/issues; Does it require a balancing programme?
- Accuracy—Reconstructions, anonymity issues.
- Fairness—Portrayal of real people in drama.
- Privacy—Secret recording, footage of suffering and distress, door stepping.

- Crime and antisocial behaviour—Interviews with criminals, demonstration of illegal activity.
- Editorial integrity and independence—Commercial, sponsor, or brand references; branded products featured; conflicts of interest: presenters, guests, production team.
- Politics—Opinion polls/surveys, interviews, appearance of party leaders.
- Other issues affecting transmission—Public figures as contributors, reference to public figures, sensitive content issues, restrictions on reuse.
- Interactivity—Competitions, audience voting, premium rate telephony, non-premium rate telephony.

As you can see, it's a very comprehensive list. Phew, it's a wonder how we are able to make anything anymore. But seriously, it's worth knowing the categories of concern, and, along with your production team, to be aware of their implications.

## 13.4 Other Compliance Issues

🎬 *Light Fantastic*—Dealing with Flickering Images

Flickering images and certain types of repetitive visual patterns can cause problems for some viewers who have photosensitive epilepsy. Television is by nature a flickering medium (because of the 50 Hz (or 60 Hz) refresh rate of interlaced scanning and the 25 Hz (or 30 Hz) frame replacement rate), so it is therefore not possible to completely eliminate the risk of television itself causing problems with some viewers, regardless of the content. An HD picture with higher line and scan rates reduces the perception of this type of flicker.

🎬 *The Light Programme*—'Harding' and Other Compliance Tests

Back in 1993, the transmission of an advert in the UK for 'Pot Noodles' induced seizures in three people. This incident led the Independent Television Commission to introduce new guidelines to avoid a repetition of the problem. In Japan, four years later, it was reported that an episode of *Pokémon* led to over 750 hospital admissions, mostly due to seizures. Today, the content of all programmes, including advertisements and trailers, prior to transmission in various countries including Japan and the UK, has to go through and pass what is called a *Harding Test.* The test is based on research done by Professor Graham Harding into the problem of photosensitive epilepsy. The test is able to identify sections of a programme where the intensity and frequency of changing light or colour levels might trigger a person with photosensitive epilepsy to have problems.

The source of these changing light levels might be strobe lighting, flash photography, or just a shot of the sun through passing trees.

If a sequence has failed in this way, the cure is to grade down the severity or frequency of the flashes until they pass through Harding without setting off any alarms. In some cases where repair is impossible, it means the removal of a shot altogether. Obviously such drastic action, if it happens after a dub and grade, can cause problems both of a technical nature and to the programme's budget. It is good practice, therefore, to put a locked *offline* cut through Harding to act as a check that everything is within limits, or at least to highlight problem areas early enough so a solution is found while all the decision makers are still present or near the edit suite.

In certain cases, if the removal of such shots damages the reason for transmission, like flash photography at an important news event, a verbal warning is given instead: 'This report does contain some flash photography'. I'm sure you've all heard something similar.

Here are some aspects about flashing images that are worth considering:

- Bright and rapidly flickering images should be avoided. It seems around 9 Hz is the worst.
- If the source of the flickering is restricted to a smaller area of the screen (25% say), then the effect will be less harmful and will, more often than not, pass through Harding.
- Flickering nearer the centre of the screen carries with it a weighting factor, as the effect on a sensitive viewer of such flickering is greater nearer the centre of the image as compared with the periphery.
- The range of brightness change in a flickering image is a crucial factor, and anything you can do to grade down such transitions can help greatly. A luminance key might help here to clip peak whites down a little.

- Changes in colour aren't so serious unless they affect the red channel substantially, which seems to cause the most problems.
- Prominent and regular patterns that cover a large proportion of the picture area should be avoided, especially if they represent bars, spirals, or dartboard patterns.
- Moving or flickering regular patterns are particularly hazardous, so no close-ups of your Vertigo LPs going round on your turntable, please.
- Care also needs to be taken with computer-generated images, which, if sufficiently detailed, can cause a high degree of interference flicker between the two scanning rates.

## 13.5  A Look at Copyright

*The Price Is Right*—Copyright and Other Issues

It is normally forbidden to reproduce picture, sound, or text media without the permission of the owners or creators of that media, who hold the copyright. In granting permission, a payment is usually made to the owners of the copyright. This permission can be time or location limited, thus we talk of UK or world rights to show and distribute material.

In the UK, the term of copyright of a musical composition is limited to the life of the author plus 70 years, while the term of copyright of a sound recording is limited to 50 years from the date of recording; for example all compositions composed by a songwriter who died in 1940 came out of copyright on 1 January 2011, or a sound recording made on 3 October 1960 entered the public domain on the same date of 1 January 2011.

Any archive footage (or music, for that matter) reproduced in a new programme has to be accounted for, to the second. For this

reason, deals are usually done between the production company and the copyright holder to cover the use of many such clips over a wide range of programmes in order to save on admin, time, and money. Remember, copyright issues can extend to include posters on walls in the back of shot, so beware.

I know this is more of a production issue, but you should be aware of the restrictions these rules impose on your production, and thus on you.

Back in the edit suite, any music you find for your programme will have to be paid for at some stage, so it's better to find out the cost of it early on, and certainly before you fall in love with the piece and set your complicated, multilayered montage to it.

## 13.6 Key Points—Editorial Responsibility

- It's safer to keep events in the order they happened in real life.
- If you move material about, make sure the sense remains unaltered.
- An editor, along with the production team, has to be more and more a custodian of a nation's morals.
- Some broadcasts insist that key personnel complete an online course about editorial dilemmas.
- Every programme broadcast on the main channels in the UK has associated with it a compliance form.
- Flickering images and certain types of repetitive visual patterns can cause problems for some viewers who have photosensitive epilepsy.
- In certain countries, programmes are tested for flickering images and strobe lighting in what is known as a Harding Test.
- It is normally forbidden to reproduce picture, sound, or text media without the permission of the owners or creators of that media, who hold the copyright.
- Any archive footage (or music, for that matter) reproduced in a new programme has to be accounted for to the second.
- Copyright issues can extend to include posters on walls in the back of shot.

# Chapter 14
# Timescales

In none of our previous discussions have I mentioned anything about time. No, I'm not about to tread on Professor Stephen Hawking's toes, but rather I will talk about how long it takes (or more realistically, how long you are allowed to take) to make a programme or series these days.

This chapter is divided as follows:

- **14.1 Past and Present**
- **14.2 An Editing Schedule for *Still Open Hours* (2014)**
- **14.3 An Editing Schedule for *Rock n' Chips* (2010)**

## 14.1  Past and Present

### *Does the Team Think?*—Everybody's a Critic

Budgets are constantly being adjusted downwards, which means increased pressure on those of us who are paid to make artistic decisions, which we all know can take time. The new technology has made the editing process quicker, but at the same time, it has opened the gates for the world and his wife to have a view on any cut. I have sometimes, and rather cheekily, referred to them as the 'grown-ups'; however, be warned, their numbers are growing fast. Gone are the days of a cut just having to satisfy you and your producer or director.

### *The Good Old Days*—Oh No! Here He Goes Again

I can tell you that when I started editing programmes like *Only Fools and Horses, Just Good Friends,* and *Terry and June* that they were assembled in not much more than six hours, and that was it—no grade, no dub, only reviewed (on another machine) and on the air.

It is true that these programmes contained previously edited filmed inserts and that this material only required slight adjustment after the audience had seen it. In addition, recorded takes were much longer (and there were no ISO feeds), with far fewer retakes than would be attempted these days; as a result, there was much less you could do to the show. Had we known they would still be regularly on the air over 30 years later, providing the backbone for stations like UK Gold, maybe we should have spent more time on them. The good thing is, even looking at them today over 30 years later, they still aren't at all bad. Yes, they're a little flabby in places, but generally that flabbiness is part of their charm.

Well, that's quite enough wallowing in the past for one page; let me show you how much time I spend these days on an actual series. For this I will use real figures from two recent projects.

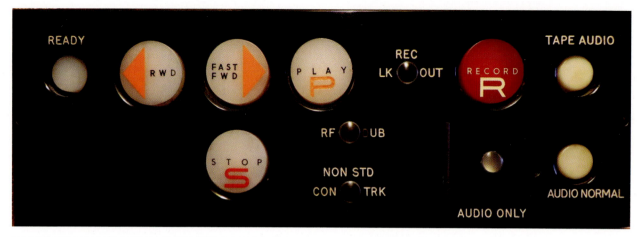

TRANSPORT CONTROLS OF AN AMPEX-TWO INCH VR2000 QUADRUPLEX VIDEOTAPE MACHINE FROM THE 1970S.

## 14.2  An Editing Schedule for *Still Open All Hours* (2014)

*Still Open All Hours* (Series 1)—A series of six half-hour comedies for BBC Comedy (transmitted January 2015) and written by Roy Clarke, the shooting of which was a mixture of location and multicamera studio days. It was directed by Dewi Humphreys and produced by Alex Walsh-Taylor.

### 🎬 *Still Open All Hours* (2014)—First the Location Material

*Still Open All Hours* was shot on location in Doncaster for two weeks. The unit would send the rushes, in file format, down to London to a company called Outpost at Pinewood Studios, where the material was copied and transcoded into an Avid. I was given nine days to get the material together before spending two days with Dewi doing some fine tuning before the audience was to see the material as part of each episode's recording.

### 🎬 *This Week—Still Open All Hours*: The Studio Shoot

A *Still Open All Hours* studio week had two main recording days, one without an audience (a *pre-rec* day, as it is known) designed to record scenes in 'guest' sets or getting complicated scenes which would be impossible to shoot in front of an audience out of the way. A pre-rec day usually produced about 12 minutes of cut material. The rushes were ingested overnight so that they were ready for me to assemble the next day. Dewi would only get about a half hour with me during his 'lunch break' to look at what I had done. The programme inserts (complete with location scenes as well) had to be ready for a dress run of the episode at about 4:00 p.m. prior to an audience record at 7:30 p.m. The audience sees the show in dramatic order, but has to cope with scene repetition and retakes—but it's free.

More ingesting of this new audience material is done overnight and the complete programme recording (laughs and all) is ready

for me the following morning. I work with it from 9:00 a.m. until about 4:00 p.m. (about seven hours), by which time I get Dewi to come and see it, and we look through the cut with the intention, by the end of the day, of producing a 29-minute first cut for distribution to the writers, the producer, and BBC executives. This is not by any means a rough cut. How very dare you! Dewi and I pride ourselves to cut the show down to the delivery duration (here of 29 minutes) because if we didn't, the fine cutting process would take much longer and be considerably more chaotic. It is all too easy for someone to say, 'Ooh, I missed that bit', but much harder to decide what 'other bit' should be cut to allow a reinstatement.

Handing the production team a 'to time' cut makes the arithmetic simple—whatever goes back in causes something else to be cut.

### The Final Cut—*Still Open All Hours:* The Editing Schedule

We go round this track five more times and generate six 29-minute shows with a bunch of notes from our first cut recipients, their partners, their children, their cleaners, clever pets, and close friends. All right, only joking! Six further days of fine cuts with close liaison with the writer and BBC execs, and we walk away with six really smart, locked shows.

### *S and V Satis—Still Open All Hours:* After the Cut Is Over

Further processes outside the edit suite include: two day prep dub (per show), one day dub (per show) with a dubbing mixer to finalise the sound, and a half-day (per show) with a colour grader.

All shows come back to me, this time in an online suite, for the insertion of graphics, rollers (or scrolls), bars, and tone and ident clocks. At this stage, I make sure clean elements are placed at the end of the tape or file, ready for delivery. This takes two days, as I can easily 'top and tail' (as it's called) three shows in a day.

### *Final Score—Still Open All Hours:* The Scores on the Doors

So our results board is as follows:

- 11 days editing the location material.
- 6 days (1 day per show) editing the pre-recs.
- 6 days (1 day per show) to produce a first cut.
- 6 days (1 day per show) to do the fine cuts.
- 2 days 'top and tail' (adding graphics, a leader, and clean elements).

A total of 31 days in an edit suite to produce six 29-minute shows for BBC1, giving an editing average of 5'37" per day.

And outside of the edit suite:

- 3 days (a half day per show) with a colour grader.
- 18 days in a dubbing suite.

For the dubbing suite we get 9'40" per day's use, and the grading suite where 58 minutes is produced per day. As you can appreciate, the edit suite with its driver accounts for a sizeable part of the programme's budget.

## 14.3  An Editing Schedule for *Rock n' Chips* (2010)

*Rock n' Chips*—A 90-minute comedy drama written by the much-missed John Sullivan (transmitted January 2010) that took the characters from *Only Fools and Horses* back to 1960 to find Del, Trigger, Boycie, and the rest just leaving school. Again, it was directed by Dewi Humphreys and produced by Gareth Gwenlan.

###  *Rock n' Chips* (2010)—The Editing Schedule

Turning to *Rock n' Chips,* this was an all location shoot with no audience recordings to deal with and, consequently, the editing process was much more straightforward. The totals were:

- 21 days editing to a first workable cut.
- 5 days fine-cutting.
- 1 day 'top and tail' (adding graphics, a leader, and the clean elements).

Therefore, we spent a total of 27 days to produce a 90-minute programme, giving an editing average of 3'33" per day.

Grading took three days and dubbing (including prep dubs) took seven days.

Having written all that out, I'm not sure what I'm trying to prove, other than providing a possible benchmark for you.

Here is a spreadsheet of one month of the studio/rehearsal/ editing schedule of *Still Open All Hours.*

## NOVEMBER 2014

| | SAT | SUN | MON | TUE | WED | THU | FRI |
|---|---|---|---|---|---|---|---|
| 44 | 01-Nov | 02-Nov | 03-Nov | 04-Nov | 05-Nov | 06-Nov | 07-Nov |
| | Deliver Ep 1 & 2 | | Table Read/ Rehearsal Ep4 | Rehearsal Ep4 | Rechearsal/ Tech Run Ep4 | Studio Pre-Record Ep4 | Studio Audience Record Ep4 |
| | | | | | | | Conform Ep3 |
| | | | 2nd Cut Ep3 | Tech Review Ep1&2 | | Pic Lock Ep3 | Edit Pre-Rec Ep4 |
| 45 | 08-Nov | 09-Nov | 10-Nov | 11-Nov | 12-Nov | 13-Nov | 14-Nov |
| | | | Table Read/ Rehearsal Ep5 | Rehearsal Ep5 | Rechearsal/ Tech Run Ep5 | Studio Pre-Record Ep5 | Studio Audience Record Ep5 |
| | Upload Ep4 | | 1st Cut Ep4 | Audio Prep Ep3 | Audio Prep Ep3 | 2nd Cut Ep4 | Edit Pre-Rec Ep5 |
| 46 TX EP1 | 15-Nov | 16-Nov | 17-Nov | 18-Nov | 19-Nov | 20-Nov | 21-Nov |
| | | | Table Read/ Rehearsal Ep6 | Rehearsal Ep6 | Rechearsal/ Tech Run Ep6 | Studio Pre-Record Ep6 | Studio Audience Record Ep6 |
| | | | | | | Audio Prep Ep4 | Audio Prep Ep4 |
| | Upload Ep5 | | 1st Cut Ep5 | Pic Lock Ep4 | Conform Ep4 | 2nd Cut Ep5 | Edit Pre-Rec Ep6 |
| 47 TX EP2 | 22-Nov | 23-Nov | 24-Nov | 25-Nov | 26-Nov | 27-Nov | 28-Nov |
| | | | | | On-line Ep 3 & 4 | | (AM) Pic Lock Ep5 then Conform Ep5 (early PM) then 2nd Cut Ep6 |
| | Upload Ep6 | | 1st Cut Ep6 | Grade Ep3 & 4 | Dub & Layback Ep3 | Dub & Layback Ep4 | |

A STUDIO/REHEARSAL/EDITING SCHEDULE FROM *STILL OPEN ALL HOURS*, NOVEMBER 2014.

# Chapter 15
# Projects—Crossing Ts and Dotting Is

Here I'll tie up some loose ends as I look at:

- **15.1 Bin Management**
- **15.2 Media Management**
- **15.3 Timeline Management**
- **15.4 Your Assistant and You**
- **15.5 Capturing Multicamera Material**
- **15.6 Labelling Clips Sensibly**
- **15.7 Keeping a Copy**
- **15.8 Clock Information**
- **15.9 Top and Tails: Leaders, Titles, and Clean Elements**
- **15.10 Scripts**
- **15.11 Panning and Scanning**
- **15.12 Offline and Online**
- **15.13 Tapeless**
- **15.14 Key Points—Projects—Crossing Is and Dotting Ts**

A TYPICAL PROJECT WINDOW.

## 15.1  Bin Management

Most editing projects start off relatively simply. Sadly, they don't stay like that for long. Luckily, or not so luckily, editing software allows you to organise your project in any way you like.

### 🎬 *The Dustbin Men*—A Look at Bin Management

Crucial to project management is *bin management*. Bins, or folders, or collections, or whatever your software chooses to

call them, can hold references to everything from clips and title graphics to sequences. It is good practice to use different bins to group different aspects of the project together. In this way you can give music, sound effects, colour corrections, source clips, and sequences their own space. Keeping bins in a tidy state is vital, with their contents having clear and concise labels. It's so easy to lose an old version of a cut in your desire to proceed quickly. Set your bin column headings to best suit your type of work. Yet again, getting this sorted now can save you time and heartache later on. These bin settings are saved with your general settings.

Here are a few tips:

- When you start a new project, it is worth setting up your bin/folder structure for the material you expect right from the first day. This will not only help you, but also it will help those who have to load newly captured or ingested material into your project.
- Folders tend to hide things, so label them clearly in order that they help rather than hinder the location of project elements.
- Footage is much easier to find if it is grouped in a useful and specific way, such as by scene, section, or subject.
- It is good practice to keep sequences separate from original captured material. Sequences are special and crucial, and they become increasingly so as the project progresses.
- Always name bins with unique bin names, and don't use generic names like 'edits' or 'studio Rx', because everybody else will do the same. If your project information is centrally stored along with many other projects, then there could be dozens of bins labelled as 'edits', which is fine until something terrible happens. Remember also, with central storage, you are not the only person who has access to your project and media. If I was working again on programmes like *My Family* or

AN AVID BIN FULL OF CLIPS.

*The Green, Green Grass* or *Birds of a Feather,* I would be using bin names like: 'MF RX6 Edits', 'GGG Show 3 Edits' or 'BOAF Graphics'. The result is your bins will be more identifiable if ever they go walkabout.

- Remember, forces of well-intentioned evil are never far away. In most post-production houses, projects are open to everybody (and have to be) to allow new material to be ingested and logged in. In the dead of night, while you are happily dreaming away, new material and bins are created in your project and named in a style unique to the person in charge of ingesting that new material. Without a previous conversation, this new media can be hidden away in the most curious of locations within your project and, consequently, can be very hard to find in the morning.

- When new material has been captured or ingested for you, it is worth spending a short time sorting and renaming the new clips in the style that you prefer, and thereby matching the rest of your project's cataloguing system.

- The use of colour can help you to differentiate between groups of clips. Editing software tackles this problem in different ways, but it's worth investigating what's possible.

- If bins get too big, they tend to hide information from you by their sheer bulk. If this happens, create a new bin and subdivide the clips. It's much better to have smaller bins than constantly scrolling up and down masses of entries in a vain attempt to find that missing clip.

- Keep different kinds of project elements in separate bins—all the effects in one bin, captions in another, music in another, and so on.

- Design your cataloguing system of bin names so that it is obvious and logical. This will also help those who need access to your project from time to time.

- Whatever you do, keep saving your project. How often you do this is totally up to you. 'Autosave' can be set to regularly save the project when you forget. I would set this for about 10 minutes, as it's better to be safe than sorry. Also, just get into the habit of saving the project before you tackle something strange or tricky. You know what software can be like!

- However tired you are, always tidy up your project at the end of each day. Spending two minutes doing this every day could save huge embarrassment later on.

## 15.2 Media Management

### *Drive Safely*—How to Manage Your Media

*Media management* is obviously very important, but more often than not, the management of such media, including its back-up, is in the hands of the facility house at which you are working. They will usually allocate you a drive space for your project and name it accordingly. This is fine for most offline work, but if you are working online and your media is not wanted from one week to the

NOT A PRETTY SIGHT!

next, there is a strong desire from the facility house to clear out such temporary media on a weekly basis. They can be ruthless.

However, there will be some media (titles, in and out of break stings, caption rollers etc.) that will be wanted for the whole of the run of the series. In this case, I would ask the facility house to set you up a second drive allocation which could hold this more generic material and, therefore, operate separately from the drives holding the weekly stuff. This'll keep your generic material safe from overzealous housekeeping and allow the facility house to safely free up drive space by deleting only truly unwanted media.

Transferring media that is wanted for the series between the two (or more) drive locations does not take much time, and it will certainly prevent the wrong media from going offline again.

## 15.3  Timeline Management

It's worth a few words from me about timelines.

### ▦ *Off the Beaten Track*—The Track Assignment of Media Clips

Media clips on a timeline can become very messy if some form of *timeline management* is not employed. I try to allocate media to individual tracks in a systematic way, especially at first, but as a sequence gets more and more complicated, this state of order can rapidly disappear.

Vision tends to look after itself, provided you start with V1 and work up the layers from there with captions and effects. It is also helped by the fact that the software allows you to group different vision streams together easily. Wouldn't that be great if it was as easy with sound. For some reason, most software manufacturers don't allow us to group sound tracks in a similar way. As a result, sound can be more trouble, especially if you use a scattergun approach.

I find the best way to maintain order in the sound department is to allocate different tracks for different types of sound, such as sync sound, effects, music, audience, commentary, and so forth.

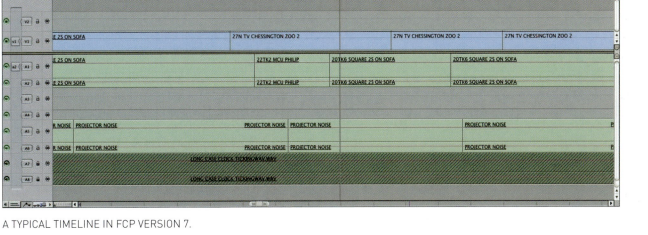

A TYPICAL TIMELINE IN FCP VERSION 7.

With this in mind, the timeline track allocation might be as follows:

> A1 A2: for sync dialogue and sync effects.
> A3 A4: also for sync dialogue and sync effects to allow for
> overlaps and sound underlay operations.
> A5 A6: for audience reaction.
> A7 A8: for music.
> A9 A10: for effects or wild tracks.

I know this can be extensively modified depending on your programme content, but try to stick to something ordered and logical.

With your clips labelled correctly, life will be much easier.

A different approach is taken in Apple's Final Cut Pro X where they have designed what is called a 'magnetic timeline'. Here clips are drawn to a central home line, and only spreading out when several clips are layered together. It took some getting used to, but I could clearly see some advantages.

AN AVID TRACK PANEL WITH ALL THE SYNC LOCKS ON.

### Will Shakespeare—Tracks: To Sync or Not to Sync?

Each track in a timeline can be individually *sync-locked* to its neighbours. In other words, clips on that locked track can only move sideways, provided they take all adjacent locked clips with them. This ensures that sound never leaves the vision with which it was captured and that nonsync sound clips you have added (like music and effects) remain locked in the place where you set them. It is this condition, with all tracks locked, that I prefer to work in most of the time. I know some editors like to work with all the sync-locks off, but that's just too scary for me; it's your choice, though.

However, there is a middle way that might suit some of you. Quite often, when you start assembling a sequence with a music bed, you don't want to have to keep paying attention to the sync of this music track at the same time as shuffling shots around in the layers above. You really want to let the music look after itself while you 'create' on higher video and audio levels. The solution to this, which I find very useful, is to allocate two tracks at the bottom of my timeline that aren't sync-locked to the rest of the tracks and temporally move the music concerned down onto these tracks, in order that the software can ignore the sync relationship between this music and all other timeline media. When you have finished shuffling vision and sound around on the tracks above, move the music back to adjacent locked tracks, and the music will return to a locked relationship with your newly created vision and sound.

This also works with any sound whose sync you temporally don't care about while you move other media elements around.

## 15.4 Your Assistant and You

It is important, in order to avoid the problem of searching into which corner of your project that vital new ingested material has gone this time, to set up a good working relationship with your assistant, or the person who ingests for you, as quickly as possible.

### Friends—Set Up a Working Arrangement with Your Assistant

Assistants do a fantastic job, sometimes at very antisocial hours, but they'll do it even better if you give them a few hints of where new material should go and be filed within your project.

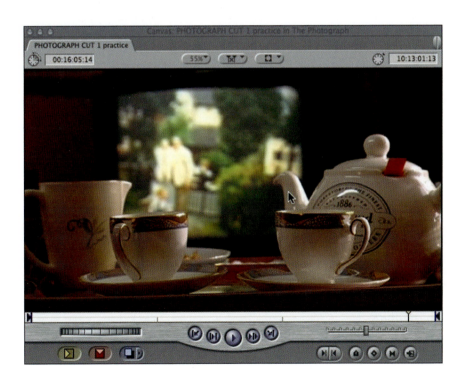

Multicam material can produce a real headache for the person in charge of the ingesting process, and a real mess for you the following morning, if you don't take some active interest in it.

I once walked into an edit of an awards ceremony which had been so badly captured, with stops and starts all over the place between the MAIN and various ISO recordings, it was impossible to group up any of this material into decent length chunks. This seriously hampered our progress throughout the day (and incidentally, the following night).

## 15.5 Capturing Multicamera Material

I nearly took this section out entirely because of the increasing dominance of file capture over tape, and thus the method of dealing with multicam material described here is rapidly becoming incredibly old fashioned.

All I will say is that, at the time, it worked well and used to offer me synchronous groups of MAIN and ISO recordings, all starting and finishing at the same matching timecodes, and with the MAIN recording at the top of the group—bliss!

I will very briefly outline the procedure.

Multicam material used to come to you on four or five tapes, all with coincident timecodes, and it was this fact that the method exploited. The trick on an Avid was to ingest the MAIN recording accurately, and name the clips according to production notes. The clips were then duplicated within the bin, one set for each of the ISOs that were recorded with the MAIN. Next, the media was unlinked from these duplicates and new reel numbers were allocated to the clips. All that was left to do was to batch digitise the ISO recording tapes in automatically.

THE AVID CAPTURE TOOL.

ultimately in the timeline), but this is made more difficult if studios just keep recording between takes and even between scene changes.

'LOG AND CAPTURE' IN ADOBE PREMIERE PRO.

The assistant was now able to go and make a cup of tea and put their feet up while the recordings went in. After capture, the clips were easily grouped, as all related clips had the same start and stop timecodes. Provided you only edited with these groups, you'd carry all your ISOs with you on your timeline, without you even noticing.

### 🎬 *The Longest Day*—Will They Ever Push Stop?

While we are on the subject of ingesting studio-based material, a problem has recently appeared now that tape is used less and less, in favour of file production.

The problem is that studios have become very reluctant to stop recording! I want each take to be separately identified in a bin (and

What's so wrong with stopping the recordings occasionally? Stop, then immediately start is all that's needed, and I would get the separate files in my bin of source clips automatically. It would save me so much time creating endless subclips from these huge and very long files. The problem is that the cost of storage is not significant these days.

To those in charge of studio-based recordings, I'm not asking now, I'm begging:

PLEASE PUSH THAT STOP BUTTON MORE OFTEN.

## 15.6 Labelling Clips Sensibly

🎬 *Get Smart*—Labelling Clips Sensibly

Files ingested into editing software from a camera source, for example, are not usually given friendly names, just a date and a very long reference number are often all you get. This may help the computer, but it certainly is of no benefit to you. I know it's a slightly laborious job, but it is hugely beneficial to rename the clips according to production notes. My advice is that the renaming process should use as few characters as possible, because when clip names are superimposed on a timeline, they are truncated from the right with densely packed edits, so put the important information in a condensed form at the start of the clip name, for example: 137/4 instead of Programme 3 Shot 137 Take 4; and SC4 TK2, or even 4/2, instead of Episode 2 Scene 4 Take 2. The great thing is the timecode is welded to the shot, so when all else

A BIN IN ADOBE PREMIERE PRO.

fails and a clip is temporally lost, if you know the timecode, you're halfway there.

## 15.7 Keeping a Copy

Whatever you do, always take a copy of your project home with you at night. It's so easy to do this with a USB stick, or your mobile phone memory, and it could save a vast amount of time reediting a lost cut. Media is relatively easy to recapture, but the loss of a project is a huge problem.

🎬 *Lost*—Well It Played Okay Yesterday!

You might say the project is already stored in the editing computer and on the media discs, so that's safe enough, but I have to say I once had an Avid computer, complete with its discs, stolen over a weekend from the post-production house at which I was working. The thieves cut the leads and stole the computer, along with a digibeta machine and all the media drives. Luckily, I had taken a floppy-disc copy and was able to carry on with minimum disruption, once of course the post-production house had bought a new computer.

It is said that data is only safe if there are three individual copies that are all stored geographically separate from each other.

## 15.8 Clock Information

Editing software has been strangely slow at realising that a countdown clock might occasionally be required in an edit.

I have long since given up with software designers, and I carry a QuickTime movie of a simple countdown clock on my USB stick and import this into a 'Bits and Pieces' project bin.

### 🎬 *At the Third Stroke . . .* —What to Put On the Clock

Following is an example of transmission clock information for *My Family* from a few years back. This typically included:

| | |
|---|---|
| LLV A445K/71 | (BBC programme number) |
| My Family | (programme title) |
| Series 11 TX3 | |
| (Rx 5 DLT1106) | (transmission and recording information) |
| 'Bill and Ben' | (subtitle) |
| Dur: 29'03" | (duration) |
| Stereo mix (A1, A2) | (sound information) |
| 16:9 | (video format) |

Sometimes, a production contact number was included, but this was rare.

This having been said, there is a recent move to put very little information on clocks, and the reason is the easier production of new versions of that programme. Thus, if you convert the aspect ratio of a completed programme from 16:9 to 4:3, the old clock information becomes wrong and would have to be changed on the 4:3 version. It is for this reason that clock information is restricted nowadays to information that won't change with the creation of a new version. This might leave only the title and episode name, because even the duration would change if an extra worldwide distribution logo was added at the end of the original programme.

Watch this space, as the goalposts don't stay in one place for very long.

## 15.9 Top and Tails: Leaders, Titles, and Clean Elements

### 🎬 *The Ten Commandments*—Well, a Few of Them Anyway

In the UK, all programmes must start at timecode 10:00:00:00, so a tape leader (if there is still a tape) must start at the latest at 09:57:45:00 to allow space for a 'bars and tone' test signal, and a clock which starts at 09:59:30:00, with 'black and silence' at 09:59:57:00 for three seconds before the start of the programme at exactly 10:00:00:00. I believe it's more common in the US to start at 01:00:00:00; you do the maths!

With the UK starting programmes at 10 o'clock and the US at 1 o'clock, you may very well say why not start at 00:00:00:00? Well, if you are to attach a leader onto this tape, then this would effectively be represented by timecodes from the previous day! If

To illustrate this, from about series 5 onwards, you are listening to a stereo copy of my own of the opening and closing music to *Only Fools and Horses*, and again in the recent *2014 Sport Relief* sketch with David Beckham, as the BBC's version of the music had been lost long ago.

## Feedback—The Recording Report Form and Other Paperwork

The *recording report form* (RRF), which is separate from any compliance form, contains details of the programme's technical format, content, and review status. However, with more and more deliveries in a file format, the RRF is becoming slightly redundant.

you did this, some equipment that uses this timecode information might have trouble dealing with this.

## Closedown—How It All Should End

At the end of the programme, the final shot must be held for at least 10 seconds (I tend to leave it longer), then go to black. After about a minute, and at the next round figure of timecode, I put any clean elements (captionless backgrounds) that I want to keep. All this information must be clearly stated on a recording report form (RRF) which accompanies the file or tape.

In addition to the clean elements specific to an episode, I sometimes (at least once a series) put a clean copy of the titles and title music at the end of a programme. From bitter experience, I know this is the most likely element of the programme to be lost, from series to series.

A RECORDING REPORT CARD FROM THE 1970S. HOW TIMES CHANGE . . . SO MANY OF THE BOXES ARE TOTALLY IRRELEVANT NOW.

The facility house at which you are working usually completes such forms after a technical review or QAR and sends them to the appropriate people, such as the production company and broadcaster.

With the advent of file delivery this has become a vague area, and no one is quite certain, at the time of writing, how to replace the RRF and, more importantly, how the information it used to contain is attached to the file which is delivered for broadcast. Watch this space again!

## 15.10 Scripts

### 🎬 *A Good Read*—Tram-Lined Scripts

Editing from a well-marked-up script is such a joy. Most dramas and comedies use a tram-lined script, as it's by far and away the best way of conveying shooting information to the editor. Here different takes are represented by vertical lines covering the dialogue involved as printed in the script, looking not unlike tram tracks in an urban street.

A different line (with a timecode start time) is used for each attempt at lines or action. Colour can help here and highlight a way through the maze of choices available to us.

The advantage of a tram-lined script is that you can see exactly how many versions of a particular line the director has offered you from which to construct the scene.

Even with less script-based shows, you can still mark-up best attempts at certain sequences and good shots that must be used in this way.

I know some editors, more from the documentary and news side of things, who start by piling in these 'good shots' and build a sequence around them by adding sync clips in between.

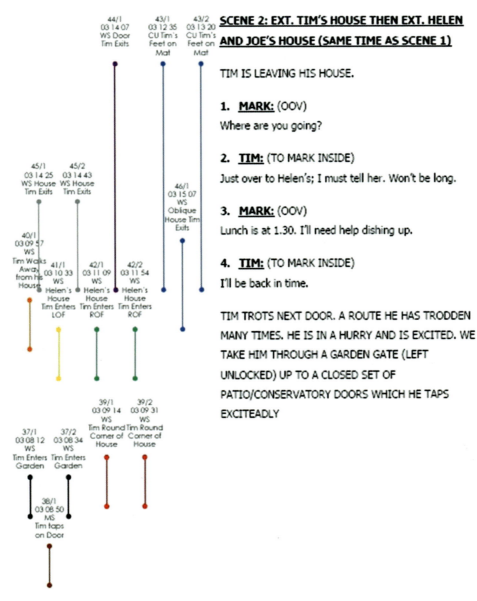

**SCENE 2: EXT. TIM'S HOUSE THEN EXT. HELEN AND JOE'S HOUSE (SAME TIME AS SCENE 1)**

TIM IS LEAVING HIS HOUSE.

1. **MARK:** (OOV)
Where are you going?

2. **TIM:** (TO MARK INSIDE)
Just over to Helen's; I must tell her. Won't be long.

3. **MARK:** (OOV)
Lunch is at 1.30. I'll need help dishing up.

4. **TIM:** (TO MARK INSIDE)
I'll be back in time.

TIM TROTS NEXT DOOR. A ROUTE HE HAS TRODDEN MANY TIMES. HE IS IN A HURRY AND IS EXCITED. WE TAKE HIM THROUGH A GARDEN GATE (LEFT UNLOCKED) UP TO A CLOSED SET OF PATIO/CONSERVATORY DOORS WHICH HE TAPS EXCITEADLY

NOT CHEKHOV I KNOW, BUT A WELL TRAM-LINED SCRIPT.

## 15.11 Panning and Scanning

### 🎬 *It's a Square World*—A Look at Aspect Ratios

If a 16:9 originated programme is sold abroad, there may still be a requirement for a 4:3 (or centre-cut) version to be generated, though thankfully this is becoming much rarer. The process creates a problem, as the new 4:3 framing must exclude picture information from the left and the right of the original 16:9 frame. In some cases, an actor could be rendered invisible and yet still audible on the soundtrack . . . this ain't good.

Modern editing software makes the cure very easy. The process is roughly this: apply the 16:9 to 4:3 *pan and scan* effect to the chosen vision track. This cuts an equal amount of the picture from left and right, leaving you with the bit in the middle, or centre-cut version, which is geometrically 4 wide by 3 high. Incidentally, in this mode, nothing is lost from either the top or bottom of the frame.

SEE WHAT I MEAN!

'NORMAL' WIDESCREEN 16:9 TEST CARD.

WHAT'S LEFT, AFTER BEING CROPPED TO A RATIO OF 4:3.

END OF AN ERA . . . MY FINAL DAY AT BBC TELEVISION CENTRE - BOTH OFFLINE AND ONLINE.

If you now view the complete programme on a 4:3 monitor, you'll see this 'middle slice' is not always appropriate for every shot, and some adjustment to the left/right pan will better frame the action on that particular shot. Simply apply 'add edit' to the start and finish of the shot, to which a more appropriate pan and scan setting is to be applied.

These pan settings can be altered during a shot, but I would only do this if I were forced to, and even then, try to 'piggy-back' on an existing camera move.

This pan and scan process usually happens when the programme is essentially finished, and certainly after the grade and dub.

One final point worth mentioning is that the process of producing a centre-cut version can play havoc with the original timing of the cut. Remember, when you chose the original 'in' point, it was on 16:9 framed pictures. After a pan and scan conversion, the extreme left and right of the frame do not exist anymore and, as a result, a differently timed 'in' might now be more appropriate for some shot changes. A reedit is clearly out of the question, so you could find yourself panning and scanning away in order to justify the original timing of the shot changes. At some stage you'll begin to think that life is too short, and I have to say I would tend to agree.

## 15.12 Offline and Online

The historical reasons for the division between offline and online working were cost of storage and the technical ability of the personnel involved.

### ⬛ *Streets Apart*—Quantity versus Quality

Even a few years ago, media storage was relatively expensive on a medium to long-term basis. The workaround was to reduce the storage requirement for a project by reducing the quality of the pictures while decisions about the programme's content were being made. Only when all factions, great and small, were satisfied were the pictures conformed back up to full quality. A subsequent and purely online session would see a leader and captions added after a grade.

### ⬛ *Just Good Friends*—Offline ♥ Online

A clear demarcation developed between off and online working, including the personnel that operated such equipment.

If you restricted yourself to editing offline material only, you were able to get away with knowing less about the technical aspects of sound and vision processing and leave this to your online colleagues. Today, as storage is cheaper, the demarcation is disappearing, and most of us now have to embrace the technical requirements of delivering a programme to a broadcaster.

Having said that, the HD quality goalposts are constantly shifting, and, with the advent of 4K and 5K high resolution formats which require not only huge amounts of memory but also very fast RAID storage, I can see the offline and online ways of working being with us for some time to come.

## 15.13 Tapeless

### ⬛ *Sex, Lies and Videotape*—A Tapeless Environment

As file-based workflows are becoming the norm, it's worth a quick look at the *tapeless environment,* where media files get sent from camera card, to back-up drive, to editing machine, to sound dub, to grade, to broadcaster, to the air, all without the use of a tape-based medium.

There are clear benefits from going tapeless, for example the ingest process into the edit computer at offline and online resolutions is much quicker than tape, as the operation can be performed at greater than real time. This speed benefit comes at all stages when moving media from one computer to another as it hops from camera, to edit, to dub, to grade, to broadcaster.

This benefit aside, the media can be more vulnerable to poor handling procedures and a clumsy workflow. A tape, being physical in nature, is more easily stored and catalogued, and any way, we're used to them. Files, on the other hand, need a new way of working. This has created a new member of the crew, namely a digital imaging technician (DIT) whose role is to look after this data as it travels from camera cards (or the like) to the editing computer and back-up drives. In the US they are referred

to as 'data wranglers'. Memory cards are not cheap, so there is a strong desire to reuse them. Once the media is safely off the cards, they are cleaned and ready for reuse. 'Cleaned' means wiped, so any old data is checked and backed-up rigorously before the card is made available for reuse. The DIT will also be in charge of labelling the files and creating clear and logical metadata, so that any media is easily findable by all in the post-production chain.

One area of confusion is that formats vary from camera to camera and are not always compatible. AVCHD, H.264, XDCAM, DVCProHD, ArriRAW, RED, and DNxHD are some of the bewildering array of formats used at the time of writing.

Handling this ever-growing library of digital media data is a new headache for post-production houses. This tsunami of media has the ability to overwhelm companies not so well prepared, but systems like AVID ISIS, Editshare, or Facilis Terrablock can help with this problem.

Yet again, this area of the editing process is in a state of flux, so it's wise to check the latest work flow arrangements.

## 15.14 Key Points—Projects—Crossing Ts and Dotting Is

- When you start a new project, it is worth setting up your bin/folder structure for the material you expect right from the first day.
- Use different bins to group different aspects of the project together.
- It is good practice to keep sequences separate from original captured material.

- Design your cataloguing system of bin names so that it is obvious and logical.
- However tired you are, always tidy up your project at the end of each day.
- Guard your genetic material from unscheduled wiping by setting up a second 'do not wipe' drive allocation on any central storage system.
- On a timeline, allocate different tracks for different types of sound, such as sync sound, effects, music, audience, and commentary.
- Sounds that you temporally don't want to keep in sync with other media can be moved down to unlocked tracks in your timeline and moved back when you are happy.
- Clip names superimposed on a timeline are truncated from the right with densely packed edits, so start each clip name with the most important information in a condensed form.
- Always take a copy of your project home with you at night.
- Today, clock information is normally restricted to information that won't change with the creation of a new programme version.
- In addition to the clean elements specific to an episode, put a clean copy of the titles and title music at the end of your cut at least once a series, as this is the most likely element of the programme to be lost from series to series.
- A tram-lined script is the best way of conveying shooting information to the editor.
- 'Pan and scan' is used to convert between different aspect ratio formats.
- The process of producing a centre-cut, or 4:3 version, of your programme can play havoc with the original timing of your cuts.
- The historical reasons for the division between offline and online working were cost of storage and the technical ability of the personnel involved.

- In the tapeless environment a digital imaging technician's (DIT) role is to look after media data as it travels from camera cards (or the like) to the editing computer and back-up drives. In the US they are referred to as 'data wranglers'.

- Handling the ever-growing tsunami of digital media data is a new headache for post-production houses, and your media is caught up in the ever-increasing tide.

# Chapter 16
# The Final Days

You have to let go of a project one day. All too soon, others will get their greedy paws on your baby, but this is only right and proper. Sometimes, if the experience has not been quite the most enjoyable event in your life, you'll be all too delighted to pass the wretched thing on. Here are a few thoughts on the handover process.

This chapter is divided as follows:

- **16.1 Handover**
- **16.2 Elements That Are Worth Keeping**

## 16.1 Handover

Whether the programme is going to a dub, grade, or online, there are a few things you have to do to make this handover process as painless as possible.

### No Frills—Leave Your Locked Sequence as Dubbers Would Wish to Find It

If the programme is heading for a grade, then remove all colour corrections you have introduced in the course of the editing process. It's much easier for graders to start from the original pictures than to readjust half-corrected pictures.

AN EDL FROM AVID . . . STILL USEFUL FOR THE GRADE SOMETIMES.

You might decide to keep a copy of your colour-corrected pictures at the end of the programme, to give an idea to the grade of what you and the director had in mind visually for any sequence.

### 🎬 *The Sound Barrier*—You Say OMF, I Say AAF, and We Can't Call the Whole Thing Off!

The dub will not want all the audio media associated with your project; it just wants the bits you've used, along with a handle of a couple of seconds on each side of your edit points. To export this selection, someone has to prepare either OMF (open media format) or AAF (advanced authoring format) files of the timeline soundtracks for import into Pro Tools, which is the software commonly found in dubbing suites. You should consult the dubbing mixer to ascertain his or her exact requirements.

Just as I warned you about editing software constantly changing, this is just as true for software used in a dubbing suite, so check for the latest specifications. The AAF format appears to be the favourite at the moment and seems to cause fewer problems during this export process. These AAFs (about 130 MB big for every 30 minutes of average source material) are usually delivered to the dub using fast file transfer networks. You could also burn a data DVD disc and deliver the files that way.

### 🎬 *Vision On*—Dubs Need to See the Pictures as Well

Video mix-downs are also essential for a dub; after all, they have to see the pictures as well! The trouble is, with long programmes, this can result in very large files, and some older operating systems still have a problem with this. In addition, FAT32 formatted drives (USB sticks and other portable drives) have a file size limit of about 4 GB. If this is the case, your options are limited to either divide the edit down into 15-minute lumps and mix-down these sections separately, or reduce the overall quality of the mix-down itself. With either route, the resulting mix-down is exported in an AAF format.

### 🎬 *A Very Peculiar Practice*—Things for the Grade

Grades still sometimes ask for EDLs (edit decision lists). These used to be the only way of transferring your offline edit information to linear kit for conforming. We thought we'd left them well behind, but they seem to be the simplest way of giving a grade your cut points.

The grade simply imports the EDL (vision only) and instantly the cuts appear in their kit's timeline, just as they were in your edit. From this point, it's easy to change the grading settings on different shots and not have to search for the shot changes manually. The format for EDLs is usually a CMX 3600, which is available as an option in the EDL generating window of most editing software.

## 16.2  Elements That Are Worth Keeping

### 🎬 *Take Your Pick*—What Should You Keep for Next Time?

As you close the door on your edit suite for the last time on a particular project, what should you take with you? No, I'm not talking about the 55" 4k LED panel, but rather what elements of the project you should copy onto your USB stick, in the hope you might be involved with a second series?

Here are some of the elements I would want to keep.

### 🎬 *Project X*—Gather Your Project Information Together

Set up an archive folder on your USB stick, clearly named in an umbrella folder like 'Finished Projects'. The first and most important file, or set of files, you must put there is the final version of your project. This will naturally include all the bins, the most important of which will be the ones that include the final

sequences, now finished with captions and leaders. These will be very useful when a new series or episode is started, as even having a copy of the closing roller, for example, will save you typing the whole thing in again for series two.

When I used to do *Parkinson* every week, all I did was duplicate last week's locked sequence and simply copy it into a new project. It didn't matter that most of last week's media had been deleted; the basic structure was there, including titles, clocks, and advert break stings. All I had to do was to change its name and insert the new, as yet unedited, media into the old timeline and start editing. It sounds so simple now!

### 🎬 *Quote . . . Unquote*—Yes, Even the Words and How They Are Writ

Sometimes, and especially if the font is unique to your project, it is useful to keep the font or fonts that were used in your programme. Given that a future series will be some months away, it will almost certainly be edited on a new (or newly cleaned out) computer, where the fonts will have gone back to the standard ones issued with a fresh Windows or Mac installation.

It's therefore good practice to export the fonts and add then to your archive folder on your USB stick.

### 🎬 *Keeping Up Appearances*—Save, Save, Save

Although captions, rollers (I know, scrolls!), effects, and so on are stored separately within the project in numerous bins, it is sometimes of great benefit at the end of a series or programme to assemble all this generic information and copy it into a new single bin which you can more easily carry through to the next year. To differentiate it, I would call the new bin something like 'Series 1 Bits and Pieces'. This could contain settings for effects, colour corrections, captions, clocks, rollers, credits, in fact anything that might get used again.

I know the bin itself doesn't contain media, but captions are easily recreated at some future date.

To have all this information in one place will save you the frustration of searching around in an old project when you have long forgotten exactly where you had filed everything.

### 🎬 *The Last Song*—Save the Titles

Last, keep a copy of the titles and any generic music which could be used for a future series, as this can so easily go astray when production staff move offices and do other work in the interim.

USB sticks are of substantial size now and can easily take much of this kind of material, both sound and vision, in an uncompressed format.

# Chapter 17
# My Last Bits of Advice

This chapter is divided as follows:

- **17.1 The Day-to-Day Use of the Edit Suite**
- **17.2 Is That All Right?**
- **17.3 You're the Host**
- **17.4 Attitude**
- **17.5 CVs**

SEEING THIS MENU MEANS YOU'RE NEARING THE FINISHING LINE.

## 17.1 The Day-to-Day Use of the Edit Suite

🎬 *Survival*—The Laws of the Jungle

Editors can spend many of our waking hours in front of a computer, so it's worth ensuring these enforced periods of physical inactivity do not harm you in any way.

Here are a few tips for damage limitation.

🎬 *Listen with Mother*—Are You Sitting Comfortably?

A good chair with correct lumbar support is essential. It should be adjusted, along with your desk (some edit suites are equipped with variable height desks) so that your wrists are flat on the keyboard or mouse, your feet are touching the floor, and you are looking at the monitors straight on, or just down a little.

### ◼ *Walk on the Wild Side*—Get Out of That Chair Sometimes

Get up and walk around as much as possible during the day. What I do is leave scripts and shot notes on the other side of the suite so that I regularly have to get up and fetch this information. If you don't, you can find that the greater part of three hours has passed and you haven't moved out of your chair.

### ◼ *Danger Mouse*—Hands Off the Mouse!

Use the mouse sparingly. Instead, use the keyboard for as many operations as possible, preferably the ones you perform most often; for example, in and out of trim and all the associated trim functions, jumping along the timeline, and 'loop-play' around edits would all be keyboard functions for me.

Holding your hand on the mouse all day can become uncomfortable, and I know some people who have developed repetitive strain injury (RSI) problems with their wrists because of excessive and continual use of the mouse. Alternatively, you can use a pen and tablet, which is much better, and I know that mouse-heavy programs like Final Cut Pro and Adobe Premiere

Pro can be operated more efficiently from a tablet. Just ask for one; most post-production houses will have them.

It is vital to investigate the keyboard shortcuts your editing software will allow. I guarantee time spent here will help you so much in the future, in that you will be really fluent with the software. Also, get all the function keys filled with your most often used software features, including menu operations.

My Avid keyboard is illustrated here. The main points about its layout are that I have duplicated and grouped the *source* and *trim* operations together onto the function keys, and I have put the *fast forward* and *rewind* buttons, which help me tab forwards and backwards in the timeline, on the keyboard's up/down keys to match the immoveable FCP ones, with the most important *play-loop* key alongside. The arrangement ensures that both hands are well occupied throughout the day, to help balance the load.

### ◼ *The Upper Hand*—20 Tiny Fingers . . . Use Them All!

Use two hands as much as possible. Frighteningly, I have seen some people operate the keyboard with the left hand only and the right permanently glued to the mouse; this is not good.

### ▐ *From Here to Eternity*—Well, at Least from Here to Infinity

You must exercise your eyes as well. If your edit suite has a window, use it as often as you like to focus on the world outside. This will also remind your eyes that they should blink occasionally. Eyes don't like being stuck at a fixed focal length all the day, and this exercise will help remind them what it feels like to focus on infinity.

### ▐ *Working Lunch*—Take a Break

Now that fewer of us smoke, or are allowed to smoke, these days, five-minute breaks have to be scheduled into your day. Take the natural opportunities of rendering, capturing, importing, or exporting to get out and walk around. It's so much better than watching a blue bar count the percentages up to 100.

### ▐ *Time Gentlemen Please*—Go Home Occasionally . . . It Helps!

Even though you think you are achieving so much by working on and on, it's so often the case that when you come to review such material in the cold light of the next day, it's usually rubbish.

UNDRUNK CUPS OF COFFEE

BOX OF EDITING TRICKS

—DAVE RIXON—

## 17.2 Is That All Right?

I do prefer to work alone as long as I can, but sooner or later you'll have visitors. Eventually, you'll have to work alongside your director, producer, or writer . . . or all three!

### *Careless Talk*—Zip It!

There is a danger, especially when you are working with someone for the first time, that you give away psychological power, which will be very hard to regain. 'Is that all right?' is a question that should never leave an editor's lips; just never say it!

If any edit is not 'all right', simply adjust it until it is. That's the deal. That's what you're paid for.

### *The X Factor*—Don't Set Yourself Up to Be Marked All the Time

None of the directors and producers I have ever worked with has wanted to act as permanent judge over every edit . . . that's your job. They have every opportunity to chip in with suggestions at any stage, but don't offer up everything you do to be 'marked'. This will put you in an impossible position from which it is hard to escape.

I understand this requires confidence, but that's exactly what this book, and the associated exercises, have been designed to give you.

## 17.3 You're the Host

You're the host in the edit suite; this is your room, your office, so make sure you entertain your guests and that everybody is comfortable.

### *Come Dine with Me*—It's Your Party

Remember also that there are people behind you in the suite, so do make eye contact with them occasionally, as there is such a danger that all they will see of you is this figure, hunched over the keyboard for most of the day, facing away from them.

## 17.4 Attitude

It's a sad fact that you can be the most brilliant and accomplished editor technically, but with a poor attitude, you might end up with no work.

### *Top of the Form*—How to Stay In the Running

The trouble is, as individuals we are the last ones to recognise that something is wrong, and it just might be our own attitude that is the reason why the phone has stopped ringing.

### *Opportunity Knocks*—On the Wanted List

Strong client-facing skills are essential, so a confident attitude should always be presented to your client to assure them that they are in good hands.

The client obviously needs to be involved in the creative process, it's their project after all, but not so much that you become a slave, implementing only *their* creative vision.

Communicating your own ideas and suggestions in a succinct and coherent way is hugely important to reinforce their confidence in your ability to do the job.

## 17.5 CVs

### Double Your Money—Without Any Hitch

CVs are a thorny issue, and it's worth considering what you should do to best promote yourself on your CV showreel before we close.

- As editing is supposed to be invisible, it is very difficult for anybody watching a clip to judge your input on the evidence of the sequence itself. You have to tell them what you did!
- Keep any video showreel material short, 5 to 10 minutes at the most, and include caption information over the chosen clips, as this will give those watching an indication of your influence on the project.
- Don't make the presentation flashier than the material contained within. I have seen too many CV showreels that overuse video effects with no sense of any taste or decency. A prospective director might go away with the impression that their next project might end up looking like your CV presentation.
- Allow time for anyone watching your presentation to jot down some notes. This is essential, as it is unlikely that your CV will be watched a second time. To do this, keep any important, fact-giving captions up just a fraction longer than you normally would.

- Include name checks of directors and producers you have recently worked with. We live in such a small community that there's a reasonable chance that your next prospective employer already knows the personnel with whom you've just worked.
- If you are sending a DVD, include a few business cards printed with all your contact information.
- As DVDs themselves are slowly heading for the format cemetery, you could put your showreel online, or on your website, or on Vimeo, or even on YouTube, but beware of copyright restrictions.
- As USB sticks are almost as cheap as greetings cards, why not get a few of these printed with your contact details and give them out with your CVs? Make them a useable size (greater than 8 GB) and they'll be kept in the pocket for longer. Even if the director gives the USB stick to his or her children, your name will still be on it.
- If you have a website, keep it up to date and include on it any recommendations from any directors and producers with whom you have recently worked.
- Include a photograph with your CV and maybe some snaps of you with your last production team.
- Keep all nonrelevant material as short as possible. Sadly, no one is interested in when you passed your cycling proficiency test, or when you first swam a length, or that you like travelling and meeting old people.

# Chapter 18
# In Conclusion

## 🎬 *The Good Life*—Oh Yes!

Is editing the best job in TV and films? Yes, by a mile, but I'm rather biased. As I said at the start of all this, I can't think of any other job where you try to hide what you do and how you do it.

The good life, oh yes, and I hope I've encouraged some of you to share some of the thrills of this marvellous craft.

## 🎬 *You Can't See the Join*—Or Can You?

How a programme or film is put together should be invisible to the viewer. The only time I start to see the structure of a film is if I'm bored with it and start to play the 'What's the next shot going to be?' game. If a viewer starts to be aware of how a programme or film was assembled, then there must be something wrong. The viewer should enjoy the programme, not the editing. It's the same with a musical performance; the audience should enjoy the concerto, not the piano.

## 🎬 *Britain's Got Talent*—Awards for Hiding What We Do!

Given that we try to hide the fact that we exist at all, and we let script, performance, direction, and design take all the credit, it seems a strange concept to award a statue or mask to something that should remain invisible. In addition, by the time a film or TV programme hits the screen, large or small, it is very difficult to tell who did what to influence the result. Poor direction saved in the edit suite or great direction not fully realised can produce the same overall result.

It is for this reason that popular and successful films tend to win editing awards, even if the editing that went into them was not necessarily the best that year. Sadly, a film that was totally rescued in the edit suite by brilliant and inventive work will never be acknowledged properly, simply because it wasn't as popular as the film of the moment.

## 🎬 *Goodnight and Good Luck*—And It's Goodnight from Him

The craft of editing is knowing exactly where and when to change the picture or sound so that the audience in cinemas, living rooms, kitchens, hotel bedrooms, offices, schools, trains, boats, and planes gain the maximum impact from that choice.

I'm really sorry that this aspect of the craft cannot be taught; this has to come from somewhere already within you. You've instinctively got to know what is right. The cut shouldn't be there, but *THERE*!

If you have that instinct, and I think you'll know if you do, I hope this book has helped extend your skills and given you increased confidence.

Whatever is the case, I wish you well.

# Appendix 1
# Loading the Exercise Media

As promised, here are detailed instructions to get the MOV exercise files associated with this publication into your editing software. As software is constantly evolving, the most up to date loading instructions can be found on the editor's toolkit website: www.editors-toolkit.com.

**▣ *Scary Movie*—For Those of You Who Like to Live Dangerously**

For those using AVID Media Composer, Final Cut Pro, or Adobe Premiere Pro, and who like a challenge, you can try the following methods to get my actual 'cut' sequence timelines, complete with media, active in your software. If you succeed, you'll be able to push my sequence timelines around and maybe find improvements. I offer no guarantee, apart from the fact that, after a bit of fiddling, even I managed to move timelines from Media Composer to FCP and Premiere Pro by transferring the MOV files and applying the methods outlined below.

**▣ *The Great Composers*—Getting the Media into AVID**

Let me first deal with the AVID Media Composer route:

I am assuming you have copied the MOV files to a local drive.

1. Open a new 25i PAL project.

2. Copy the 'Exercises Timelines' bin into your project. This bin contains sequence timelines but as yet without any media.

3. Create a new bin in your project and call it 'Imported Clips' (or something like that) and import all the MOV files into this bin using a suitable resolution. The material was originally DV 25 420, so if you have enough space on your drive, this will be a good resolution to choose. This will bring in the original clip timecode information as well. I know it's strange, but true. Check that these clips play okay.

4. If you sort the clips alphabetically (CTL+E on the file name heading), you'll see there are several clips associated with each exercise. Some of these MOV imports are source clips which are your raw material for the exercises, and some are 'cut' clips, which are my finished versions of the exercises, and these all start with 10 o'clock timecodes.

5. Find the 'Start' column heading within this bin, and sort all the clips with respect to timecode (again, CTL+E on 'Start'). This will sort the clips with respect to hours, minutes, and seconds.

6. 01 timecodes come originally from tape 01, and 02 timecodes from tape 02, and so on, except for 10 o'clock timecodes, which are my cut and edited versions.

7. Make the 'Tape' heading visible in your bin headings. As yet this column remains blank, because the original tape (or reel) numbers have not been imported when you imported the MOV

files. For my timelines to work as sequences, you now have to reallocate tape numbers to all these imported clips. This is not as bad as it sounds. Keep with it!

8. Let's begin with those clips that start with 01 timecodes. These will need a tape number of 01. This is best done in Media Composer by highlighting all the 01 start timecodes and selecting 'Clip' from the top menu, then 'Modify' and 'Set Source'. Click 'New' and enter 01 and click 'OK'.

9. Next, give the clips that start with 02 timecodes a tape number of 02, and so on. Remember, to click 'New' in the 'Set Source' window each time you do this.

10. Repeat this for all the clips except those that start with 10 o'clock timecode, as these are my cut sequences and not source clips.

11. Once you have allocated a tape number to all the source clips, you are ready to relink them to my timelines.

12. Keep the 'Imported Clips' bin open and reopen the bin you created earlier (called 'Exercises Timelines') which contains the timeline sequences as yet without media.

13. Highlight all the sequences in this bin, then right-click and select 'Relink'.

14. Make sure the following is set in the 'Relink' window:
    a. 'Media on Drive' is highlighted and the correct drive is selected and pointing to where your imported media is located.
    b. 'Relink Only to Media from Current Project' is ticked.
    c. 'Start Timecode and Tape' is selected as the relink method.
    d. 'Match Case when Comparing . . .' is selected.
    e. 'Video format of the Current Project Only' is selected.
    f. 'Create New Sequence' is ticked.

15. Hit 'OK', turn around three times, say the magic word, and with any luck you'll have created new sequence timelines, all alive with media.

With all this work done, remember these sequences are the 'answers' to the questions the exercises pose, so don't look at these sequences in detail yet, as you should really have a go at producing your own versions of the exercises before looking at my humble offerings.

The advantage of all this effort is that you will be able to adjust my sequence timelines and closely examine the moments which you like and modify ones you don't.

### Final Analysis—Getting the Media into FCP

Now, for you lot driving FCP, getting my timelines into FCP has to be via an EDL. This method of importation certainly worked on versions 6 and 7, but EDLs can't now directly import into version X (progress?); instead it only uses Apple's XML interchange format. The good news is that there are utilities around which enable you to convert between EDL and XML. Alternatively, import the EDL into FCP 7 as detailed below and export this as an XML.

Again, I am assuming you have copied the MOV files to a local drive and that you also have the bunch of EDLs created from my sequences in a known location on your computer. If not, locate them now.

1. Set up a new project in FCP—'DV PAL 48 kHz Anamorphic' seemed to work fine.

2. With the 'Browser' open, select 'Import' and navigate to 'EDL'.

3. Select 'Import for Reconnect' with 00.00 Handle Size and *don't* tick 'Make File Names Unique'.

4. Click 'OK'.

5. Find the EDL you wish to import and hit 'Choose'. This will create, first, a folder in your Browser called 'Master Clips for

xxx' (xxx being the EDL name) and, second, a sequence with the same EDL name.

6. Double-clicking that sequence will put the sequence into the timeline but as yet with no media.
7. Open the recently created 'Master Clips' folder and you'll see the clips that were used in the sequence but with a red line through each of them, indicating the media is offline.
8. Highlight all the clips, right-click, and select 'Reconnect Media'.
9. Search in the folder in your computer in which you placed the exercise MOV files. Now with luck, it will find the files it wants; if so, hit 'Choose'.
10. You'll probably get a 'File Attribute Warning' about start and end timecodes and reel numbers, but this can be ignored and you can hit 'Continue'.
11. Back in the 'Reconnect Files' window, the files will drop down to the 'Files Located' area and you can hit 'Connect'.
12. This should have connected the media and brought the timeline to life.

Sadly, the procedure has to be repeated for all the EDLs separately, unless you can find a better batch import method.

Given the fairly crude nature of an EDL import, some of the fine tuning I did to the sequences, like level adjustment and some effects work, will not have been imported. But, remember you have my final versions as separate 'cut' MOV files with fully mixed sound and vision for viewing.

If you got all the media and timelines into your software, you'll be able to fiddle with the sequences and examine them more closely. You can admire the moments you like and modify the ones you don't.

### ◾ *Première*—Getting the Media into Premiere Pro

Now for Adobe Premiere Pro. This method imports the sequences via an EDL in a similar way to FCP. Again, I am assuming you have copied the MOV files to a local drive and that you also have the bunch of EDLs created from my sequences in a known location on your computer. If not, locate them now.

1. Open a new project in Premiere Pro with capture format 'DV'.
2. With the 'Project Window' open, select 'Import' either by right-clicking the window or from the 'File' menu.
3. Navigate to the EDL of your choice (this can be several at once). Click 'OK'.
4. In the 'EDL Information' window select 'PAL'.
5. In the 'New Sequence Window' select '48kHz'.
6. This process will generate a folder in the project window, one for each EDL that was imported, and within each folder are the shots, currently with no media, and a sequence which can be loaded into the timeline window.
7. Highlight all the clips in the folders that need media. Right-click and select 'Link Media', or get this from the 'File' menu.
8. In the 'Link Media' window, tick 'File Name' and 'File Extension' and 'Use Media Browser to Locate Files'. Also it might help to tick 'Link Others Automatically'.
9. Hit 'Locate' and navigate to the folder in your computer in which you placed the exercise MOV files.
10. Click on the file image it finds and hit 'OK'. This will relink this (and other shots) to the sequence in the timeline, which should now play okay.

If successful, your project window should look not unlike the illustration on the next page.

| Name ∨ | | Media Start | Media End | Media Durati | Tape | Frame Rate | Audio Info |
|---|---|---|---|---|---|---|---|
| ▢ ▾ 📁 BTH EXE1 SEQNO BREATH | | | | | | | |
| ▢ | BTH EXE1 SEQ-NO BREATH | 10:00:00:00 | 10:00:06:22 | 00:00:06:23 | | 25.00 fps | 48000 Hz - |
| ▢ | BTH EXE1 2 MCU H (07).MOV | 07:35:45:01 | 07:35:49:22 | 00:00:04:22 | 07 | 25.00 fps | 48000 Hz - |
| ▢ | BTH EXE1 1 MLS H (07).MOV | 07:36:59:24 | 07:37:03:12 | 00:00:03:14 | 07 | 25.00 fps | 48000 Hz - |
| ▢ ▾ 📁 BTH EXE1 SEQBREATH ON WS | | | | | | | |
| ▢ | BTH EXE1 SEQ-BREATH ON WS | 10:00:00:00 | 10:00:07:12 | 00:00:07:13 | | 25.00 fps | 48000 Hz - |
| ▢ | BTH EXE1 2 MCU H (07).MOV | 07:35:45:01 | 07:35:49:22 | 00:00:04:22 | 07 | 25.00 fps | 48000 Hz - |
| ▢ | BTH EXE1 1 MLS H (07).MOV | 07:36:59:24 | 07:37:03:12 | 00:00:03:14 | 07 | 25.00 fps | 48000 Hz - |
| ▢ ▾ 📁 BTH EXE1 SEQBREATH AFTER | | | | | | | |
| ▢ | BTH EXE1 SEQ-BREATH AFTER | 10:00:00:00 | 10:00:07:10 | 00:00:07:11 | | 25.00 fps | 48000 Hz - |
| ▢ | BTH EXE1 2 MCU H (07).MOV | 07:35:45:01 | 07:35:49:22 | 00:00:04:22 | 07 | 25.00 fps | 48000 Hz - |
| ▢ | BTH EXE1 1 MLS H (07).MOV | 07:36:59:24 | 07:37:03:12 | 00:00:03:14 | 07 | 25.00 fps | 48000 Hz - |
| ▢ ACT SEQ1 Seq.mov | | 10:00:00:00 | 10:00:10:20 | 00:00:10:21 | | 25.00 fps | 48000 Hz - |
| ▢ ▾ 📁 ACT SEQ1 SEQ | | | | | | | |
| ▢ | ACT SEQ1 SEQ | 10:00:00:00 | 10:00:07:24 | 00:00:08:00 | | 25.00 fps | 48000 Hz - |
| ▢ | ACT SEQ1 8 MG RL TK2 (01) | 01:34:50:22 | 01:34:52:15 | 00:00:01:19 | 01 | 25.00 fps | |
| ▢ | ACT SEQ1 8 MG RL TK1 (01).M | 01:34:48:23 | 01:34:55:11 | 00:00:06:14 | 01 | 25.00 fps | 48000 Hz - |
| ▢ | ACT SEQ1 8 MG RL TK1 (01).M | 01:34:48:23 | 01:34:55:11 | 00:00:06:14 | 01 | 25.00 fps | 48000 Hz - |
| ▢ | ACT SEQ1 4 WS MG-TREE2 (01) | 01:16:49:24 | 01:16:51:08 | 00:00:01:10 | 01 | 25.00 fps | |
| ▢ | ACT SEQ1 3 MOBILE FALLS(01) | 01:30:39:01 | 01:30:46:00 | 00:00:07:00 | 01 | 25.00 fps | 48000 Hz - |
| ▢ | ACT SEQ1 2 MCU J (01).MOV | 01:28:50:21 | 01:28:57:12 | 00:00:06:17 | 01 | 25.00 fps | 48000 Hz - |
| ▢ | ACT SEQ1 2 MCU J (01).MOV | 01:28:50:21 | 01:28:57:12 | 00:00:06:17 | 01 | 25.00 fps | 48000 Hz - |
| ▢ | ACT SEQ1 2 MCU J (01).MOV | 01:28:50:21 | 01:28:57:12 | 00:00:06:17 | 01 | 25.00 fps | 48000 Hz - |
| ▢ | ACT SEQ1 1 MCU C (01).MOV | 01:21:21:06 | 01:21:29:24 | 00:00:08:19 | 01 | 25.00 fps | 48000 Hz - |
| ▢ | ACT SEQ1 1 MCU C (01).MOV | 01:21:21:06 | 01:21:29:24 | 00:00:08:19 | 01 | 25.00 fps | 48000 Hz - |
| ▢ | ACT SEQ1 1 MCU C (01).MOV | 01:21:21:06 | 01:21:29:24 | 00:00:08:19 | 01 | 25.00 fps | 48000 Hz - |
| ▢ | ACT SEQ1 1 MCU C (01).MOV | 01:21:21:06 | 01:21:29:24 | 00:00:08:19 | 01 | 25.00 fps | 48000 Hz - |

ADOBE PREMIERE'S PROJECT WINDOW.

Once again, given the fairly crude nature of an EDL import, some of the fine tuning I did to the sequences, like level adjustment and some effects work, will not have been imported. But, remember you have my final 'cut' versions as separate MOV files with fully mixed sound and vision for viewing.

If you got all the media and timelines into your software, you'll be able to fiddle with the sequences and examine them more closely. You can admire the moments you like and modify the ones you don't.

# Appendix 2
# A List of the Exercises

**Chapter 1. What Is This All About?**

Exercise 1: Inserting a Shot

**Chapter 2. Shots, Our Building Blocks**

Exercise 2: Shot Names

Exercise 3: Reaction Shots

Exercise 4: Cutaways 1

Exercise 5: Cutaways 2

Exercise 6: Locked-Off Shots

**Chapter 3. Joining Shots Together**

Exercise 7: Crossing the Line Examples 1–4

Exercise 8: Crossing the Line

Exercise 9: Screen Direction Example

Exercise 10: Repeated Action

Exercise 11: Movement 1

Exercise 12: Movement 2

Exercise 13: Eye Contact 1

Exercise 14: Eye Contact 2

Exercise 15: Split Edits 1

Exercise 16: Split Edits 2

Exercise 17: Split Edits 3

Exercise 18: Expressions 1

Exercise 19: Expressions 2

**Chapter 4. Dealing with Dialogue**

Exercise 20: Editing Dialogue Sounds

Exercise 21: Breaths

Exercise 22: Dialogue Rhythm

Exercise 23: Dialogue Repair

**Chapter 5. Creating Sequences**

Exercise 24: Keep It Moving

Exercise 25: Pauses

Exercise 26: Continuity

Exercise 27: Healing Sound

Exercise 28: Dialogue Removal

Exercise 29: Damage Limitation 1

Exercise 30: Damage Limitation 2

Exercise 31: Noddies

Exercise 32: Shorten Time

Exercise 33: Tighten Action

**Chapter 6. Scene Construction**

Exercise 34: Out Wide 1

Exercise 35: Out Wide 2

Exercise 36: Out Wide 3

Exercise 37: Underlaying Dialogue

Exercise 38: Cutting In 1

Exercise 39: Cutting In 2
Exercise 40: Vary Shot Sizes

## Chapter 7. Joining Scenes Together

Exercise 41: Scene Join 1
Exercise 42: Scene Join 2
Exercise 43: Scene Join 3
Exercise 44: Action Seq

## Chapter 8. Different Programme Styles

Exercise 45: Stretching Time

## Chapter 9. Sound Matters

Exercise 46: Mixing Sound Fx

## Chapter 10. Music, Music, Music

Exercise 47: Editing Music 1
Exercise 48: Editing Music 2

## Chapter 11. Scenes of Style

Exercise 49: Dream Seqs
Exercise 50: Montage 1
Exercise 51: Montage 2

## Chapter 12. Video Manipulation

Exercise 52: Chroma Key

### *The Hit List*—All the MOV Files

There now follows a complete list of the MOV clips that are downloadable with this publication. All those with 'cut' in the file name are my versions of the exercises as cut sequences.

| Name | Subtitle |
| --- | --- |
| Ex 01-1 MCU M (12).mov | Chapter 1 Inserting a Shot |
| Ex 01-2 MCU P (12).mov | Chapter 1 Inserting a Shot |
| Ex 01-CUT BAD.mov | Chapter 1 Inserting a Shot |
| Ex 01-CUT GOOD.mov | Chapter 1 Inserting a Shot |
| Ex 02-Example 1.mov | Chapter 2 Shot Names |
| Ex 02-Example 2.mov | Chapter 2 Shot Names |
| Ex 02-Example 3.mov | Chapter 2 Shot Names |
| Ex 02-Example 4.mov | Chapter 2 Shot Names |
| Ex 03-1 MCU T (04).mov | Chapter 2 Reaction Shots |
| Ex 03-2 MCU H (04).mov | Chapter 2 Reaction Shots |
| Ex 03-CUT BAD.mov | Chapter 2 Reaction Shots |
| Ex 03-CUT GOOD.mov | Chapter 2 Reaction Shots |
| Ex 04-1 WS 2S (12).mov | Chapter 2 Cutaways 1 |
| Ex 04-2 Trophies (12).mov | Chapter 2 Cutaways 1 |
| Ex 04-CUT BAD Early.mov | Chapter 2 Cutaways 1 |
| Ex 04-CUT BAD Late.mov | Chapter 2 Cutaways 1 |
| Ex 04-CUT GOOD.mov | Chapter 2 Cutaways 1 |
| Ex 05-1 M2S T & H (04).mov | Chapter 2 Cutaways 2 |
| Ex 05-2 Laptop LS (05).mov | Chapter 2 Cutaways 2 |
| Ex 05-3 Radio SW (05).mov | Chapter 2 Cutaways 2 |
| Ex 05-4 Cursor (05).mov | Chapter 2 Cutaways 2 |
| Ex 05-5 CU Play (05).mov | Chapter 2 Cutaways 2 |
| Ex 05-6 Listen (05).mov | Chapter 2 Cutaways 2 |
| Ex 05-7 Radio VO (16).mov | Chapter 2 Cutaways 2 |
| Ex 05-CUT.mov | Chapter 2 Cutaways 2 |
| Ex 06-1 WS H (02).mov | Chapter 2 Locked Off Shots |
| Ex 06-CUT.mov | Chapter 2 Locked Off Shots |
| Ex 07-1 Correct.mov | Chapter 3 Crossing the Line Examples |
| Ex 07-1 Incorrect.mov | Chapter 3 Crossing the Line Examples |
| Ex 07-2 Correct.mov | Chapter 3 Crossing the Line Examples |
| Ex 07-2 Incorrect.mov | Chapter 3 Crossing the Line Examples |
| Ex 07-3 Correct.mov | Chapter 3 Crossing the Line Examples |
| Ex 07-3 Incorrect.mov | Chapter 3 Crossing the Line Examples |
| Ex 07-4 Correct.mov | Chapter 3 Crossing the Line Examples |
| Ex 07-4 Incorrect.mov | Chapter 3 Crossing the Line Examples |
| Ex 08-1 MCU H (02).mov | Chapter 3 Crossing the Line Examples |
| Ex 08-2 MCU C Flop (03).mov | Chapter 3 Crossing the Line Examples |
| Ex 08-3 MCU C Norm (03).mov | Chapter 3 Crossing the Line Examples |
| Ex 08-4 MS H OS C (02).mov | Chapter 3 Crossing the Line Examples |
| Ex 08-5 MCU H OS C (02).mov | Chapter 3 Crossing the Line Examples |
| Ex 08-CUT BAD.mov | Chapter 3 Crossing the Line Examples |
| Ex 08-CUT GOOD.mov | Chapter 3 Crossing the Line Examples |

| Name | Subtitle |
| --- | --- |
| Ex 09-BAD.mov | Chapter 3 Screen Direction Examples |
| Ex 09-GOOD.mov | Chapter 3 Screen Direction Examples |
| Ex 10-1 The Photo (12).mov | Chapter 3 Repeated Action |
| Ex 10-2 M & Photo (13).mov | Chapter 3 Repeated Action |
| Ex 10-3 MCU P (12).mov | Chapter 3 Repeated Action |
| Ex 10-4 MCU M (13).mov | Chapter 3 Repeated Action |
| Ex 10-CUT BAD.mov | Chapter 3 Repeated Actio |
| Ex 10-CUT GOOD.mov | Chapter 3 Repeated Actio |
| Ex 10-CUT WORSE.mov | Chapter 3 Repeated Actio |
| Ex 11-1 M & Photo (13).mov | Chapter 3 Movement 1 |
| Ex 11-2 Sq 2S Sofa (12).mov | Chapter 3 Movement 1 |
| Ex 11-3 W2S P up (13).mov | Chapter 3 Movement 1 |
| Ex 11-CUT BAD Early.mov | Chapter 3 Movement 1 |
| Ex 11-CUT BAD Late.mov | Chapter 3 Movement 1 |
| Ex 11-CUT GOOD.mov | Chapter 3 Movement 1 |
| Ex 12-1 H & C exit (02).mov | Chapter 3 Movement 2 |
| Ex 12-2 H OS C (02).mov | Chapter 3 Movement 2 |
| Ex 12-3 MCU C (03).mov | Chapter 3 Movement 2 |
| Ex 12-CUT BAD.mov | Chapter 3 Movement 2 |
| Ex 12-CUT GOOD.mov | Chapter 3 Movement 2 |
| Ex 13-1 Tk1 MCU M (12).mov | Chapter 3 Eye Contact 1 |
| Ex 13-2 Tk2 MCU M (13).mov | Chapter 3 Eye Contact 1 |
| Ex 13-3 MCU P (12).mov | Chapter 3 Eye Contact 1 |
| Ex 13-CUT BAD.mov | Chapter 3 Eye Contact 1 |
| Ex 13-CUT GOOD.mov | Chapter 3 Eye Contact 1 |
| Ex 14-1 CU H (02).mov | Chapter 3 Eye Contact 2 |
| Ex 14-2 MCU C (03).mov | Chapter 3 Eye Contact 2 |
| Ex 14-CUT BAD.mov | Chapter 3 Eye Contact 2 |
| Ex 14-CUT GOOD.mov | Chapter 3 Eye Contact 2 |
| Ex 15-1 MCU P (12).mov | Chapter 3 Split Edits 1 |
| Ex 15-2 MCU M (12).mov | Chapter 3 Split Edits 1 |
| Ex 15-CUT BAD.mov | Chapter 3 Split Edits 1 |
| Ex 15-CUT GOOD.mov | Chapter 3 Split Edits 1 |
| Ex 16-1 MCU M (12).mov | Chapter 3 Split Edits 2 |
| Ex 16-2 MCU P Tk 1 (12).mov | Chapter 3 Split Edits 2 |
| Ex 16-3 MCU P Tk 2 (12).mov | Chapter 3 Split Edits 2 |
| Ex 16-CUT BAD.mov | Chapter 3 Split Edits 2 |
| Ex 16-CUT GOOD.mov | Chapter 3 Split Edits 2 |
| Ex 17-1 MCU H (04).mov | Chapter 3 Split Edits 3 |
| Ex 17-2 MCU Tim (04).mov | Chapter 3 Split Edits 3 |
| Ex 17-CUT BAD NO SPLITS.mov | Chapter 3 Split Edits 3 |
| Ex 17-CUT GOOD.mov | Chapter 3 Split Edits 3 |
| Ex 18-1 MLS H (05).mov | Chapter 3 Expressions 1 |
| Ex 18-2 MCU H (05).mov | Chapter 3 Expressions 1 |
| Ex 18-3 Play & Pan (05).mov | Chapter 3 Expressions 1 |
| Ex 18-4 CU Play (05).mov | Chapter 3 Expressions 1 |
| Ex 18-5 Laptop (05).mov | Chapter 3 Expressions 1 |
| Ex 18-6 Radio VO (16).mov | Chapter 3 Expressions 1 |
| Ex 18-CUT.mov | Chapter 3 Expressions 1 |
| Ex 19-1 MCU T (08).mov | Chapter 3 Expressions 2 |
| Ex 19-2 MCU H (08).mov | Chapter 3 Expressions 2 |
| Ex 19-CUT BAD.mov | Chapter 3 Expressions 2 |
| Ex 19-CUT GOOD.mov | Chapter 3 Expressions 2 |
| Ex 20-1 MCU T (04).mov | Chapter 4 Editing Dialogue Sounds |
| Ex 20-2 Sq 2S T & H (04).mov | Chapter 4 Editing Dialogue Sounds |
| Ex 20-CUT BAD.mov | Chapter 4 Editing Dialogue Sounds |
| Ex 20-CUT GOOD.mov | Chapter 4 Editing Dialogue Sounds |
| Ex 21-1 MLS H (07).mov | Chapter 4 Breaths |
| Ex 21-2 MCU H (07).mov | Chapter 4 Breaths |
| Ex 21-CUT-breath after.mov | Chapter 4 Breaths |
| Ex 21-CUT-breath on WS.mov | Chapter 4 Breaths |
| Ex 21-CUT-no breath.mov | Chapter 4 Breaths |
| Ex 22-1 CU H (06).mov | Chapter 4 Dialogue Rhythm |
| Ex 22-2 MCU H (06).mov | Chapter 4 Dialogue Rhythm |
| Ex 22-3 MCU H (06).mov | Chapter 4 Dialogue Rhythm |
| Ex 22-4 MCU T (06).mov | Chapter 4 Dialogue Rhythm |
| Ex 22-5 W2S T & H (05).mov | Chapter 4 Dialogue Rhythm |
| Ex 22-CUT Long Vers.mov | Chapter 4 Dialogue Rhythm |
| Ex 22-CUT Short Vers.mov | Chapter 4 Dialogue Rhythm |
| Ex 23-1 2S T&H Tk 1 (04).mov | Chapter 4 Dialogue Repair |
| Ex 23-2 2S T&H Tk 2 (04).mov | Chapter 4 Dialogue Repair |
| Ex 23-CUT.mov | Chapter 4 Dialogue Repair |
| Ex 24-1 MCU H (08).mov | Chapter 5 Keep it Moving |
| Ex 24-2 MCU T (08).mov | Chapter 5 Keep it Moving |
| Ex 24-CUT Correct.mov | Chapter 5 Keep it Moving |
| Ex 24-CUT Too Loose.mov | Chapter 5 Keep it Moving |
| Ex 24-CUT Too Tight.mov | Chapter 5 Keep it Moving |
| Ex 25-1 MS P Tk 1 (13).mov | Chapter 5 Pauses |
| Ex 25-2 MS P Tk 2 (13).mov | Chapter 5 Pauses |
| Ex 25-3 MS M & Sofa (13).mov | Chapter 5 Pauses |
| Ex 25-CUT GOOD.mov | Chapter 5 Pauses |
| Ex 25-CUT Too Loose.mov | Chapter 5 Pauses |
| Ex 25-CUT Too Tight.mov | Chapter 5 Pauses |

| Name | Subtitle |
|---|---|
| Ex 26-1 WS T & H (04).mov | Chapter 5 Continuity |
| Ex 26-2 MCU T (04).mov | Chapter 5 Continuity |
| Ex 26-3 MCU H (04).mov | Chapter 5 Continuity |
| Ex 26-CUT BAD.mov | Chapter 5 Continuity |
| Ex 26-CUT GOOD.mov | Chapter 5 Continuity |
| Ex 27-1 WS 2S (12).mov | Chapter 5 Healing Sound |
| Ex 27-2 Sq 2S (12).mov | Chapter 5 Healing Sound |
| Ex 27-3 Sitting Fx (13).mov | Chapter 5 Healing Sound |
| Ex 27-4 Clock (16).mov | Chapter 5 Healing Sound |
| Ex 27-CUT.mov | Chapter 5 Healing Sound |
| Ex 28-1 MCU H (08).mov | Chapter 5 Dialogue Removal |
| Ex 28-2 MCU T (08).mov | Chapter 5 Dialogue Removal |
| Ex 28-CUT Long Vers.mov | Chapter 5 Dialogue Removal |
| Ex 28-CUT Short Vers.mov | Chapter 5 Dialogue Removal |
| Ex 29-1 MCU P (12).mov | Chapter 5 Damage Limitation 1 |
| Ex 29-2 MCU M (12).mov | Chapter 5 Damage Limitation 1 |
| Ex 29-CUT BAD.mov | Chapter 5 Damage Limitation 1 |
| Ex 29-CUT GOOD.mov | Chapter 5 Damage Limitation 1 |
| Ex 30-1 MS M & Mag (13).mov | Chapter 5 Damage Limitation 2 |
| Ex 30-2 MCU P (12).mov | Chapter 5 Damage Limitation 2 |
| Ex 30-3 MCU M (12).mov | Chapter 5 Damage Limitation 2 |
| Ex 30-CUT BAD.mov | Chapter 5 Damage Limitation 2 |
| Ex 30-CUT GOOD.mov | Chapter 5 Damage Limitation 2 |
| Ex 31-1 Sq 2S (12).mov | Chapter 5 Noddies |
| Ex 31-2 MCU P (12).mov | Chapter 5 Noddies |
| Ex 31-3 CU M (12).mov | Chapter 5 Noddies |
| Ex 31-CUT.mov | Chapter 5 Noddies |
| Ex 32-1 WS H's (03).mov | Chapter 5 Shorten Time |
| Ex 32-2 T at corner (03).mov | Chapter 5 Shorten Time |
| Ex 32-3 T at gate (03).mov | Chapter 5 Shorten Time |
| Ex 32-4 T Taps (03).mov | Chapter 5 Shorten Time |
| Ex 32-5 Aircraft (16).mov | Chapter 5 Shorten Time |
| Ex 32-CUT BAD.mov | Chapter 5 Shorten Time |
| Ex 32-CUT GOOD.mov | Chapter 5 Shorten Time |
| Ex 32-CUT SHORT.mov | Chapter 5 Shorten Time |
| Ex 33-1 MCU M (12).mov | Chapter 5 Tighten Action |
| Ex 33-2 MCU P (12).mov | Chapter 5 Tighten Action |
| Ex 33-CUT BAD.mov | Chapter 5 Tighten Action |
| Ex 33-CUT GOOD.mov | Chapter 5 Tighten Action |

| Name | Subtitle |
|---|---|
| Ex 34-1 W2S to Desk (05).mov | Chapter 6 Out Wide 1 |
| Ex 34-2 OS Fav H (05).mov | Chapter 6 Out Wide 1 |
| Ex 34-3 MCU T (05).mov | Chapter 6 Out Wide 1 |
| Ex 34-CUT V1 BAD Early.mov | Chapter 6 Out Wide 1 |
| Ex 34-CUT V1 BAD Late.mov | Chapter 6 Out Wide 1 |
| Ex 34-CUT V1 GOOD.mov | Chapter 6 Out Wide 1 |
| Ex 34-CUT V2 BAD Late.mov | Chapter 6 Out Wide 1 |
| Ex 34-CUT V2 GOOD .mov | Chapter 6 Out Wide 1 |
| Ex 35-1 WS & Laptop (06).mov | Chapter 6 Out Wide 2 |
| Ex 35-2 2S OS Laptop (07).mov | Chapter 6 Out Wide 2 |
| Ex 35-CUT BAD Early.mov | Chapter 6 Out Wide 2 |
| Ex 35-CUT BAD Late.mov | Chapter 6 Out Wide 2 |
| Ex 35-CUT GOOD.mov | Chapter 6 Out Wide 2 |
| Ex 36-1 MCU H (06).mov | Chapter 6 Out Wide 3 |
| Ex 36-2 MCU T (06).mov | Chapter 6 Out Wide 3 |
| Ex 36-3 W2S T & H (05).mov | Chapter 6 Out Wide 3 |
| Ex 36-CUT BAD.mov | Chapter 6 Out Wide 3 |
| Ex 36-CUT GOOD.mov | Chapter 6 Out Wide 3 |
| Ex 37-1 MCU H (08).mov | Chapter 6 Underlaying Dialogue |
| Ex 37-2 MCU T (08).mov | Chapter 6 Underlaying Dialogue |
| Ex 37-CUT BAD.mov | Chapter 6 Underlaying Dialogue |
| Ex 37-CUT GOOD.mov | Chapter 6 Underlaying Dialogue |
| Ex 38-1 CU H (07).mov | Chapter 6 Cutting In 1 |
| Ex 38-2 LS H & T (07).mov | Chapter 6 Cutting In 1 |
| Ex 38-CUT BAD.mov | Chapter 6 Cutting In 1 |
| Ex 38-CUT GOOD.mov | Chapter 6 Cutting In 1 |
| Ex 39-1 Sq 2S (13).mov | Chapter 6 Cutting In 2 |
| Ex 39-2 MCU M (13).mov | Chapter 6 Cutting In 2 |
| Ex 39-CUT BAD.mov | Chapter 6 Cutting In 2 |
| Ex 39-CUT GOOD.mov | Chapter 6 Cutting In 2 |
| Ex 40-1 M & Photo (13).mov | Chapter 6 Vary Shot Sizes |
| Ex 40-2 Sq 2S (12).mov | Chapter 6 Vary Shot Sizes |
| Ex 40-3 MCU M (13).mov | Chapter 6 Vary Shot Sizes |
| Ex 40-CUT BAD.mov | Chapter 6 Vary Shot Sizes |
| Ex 40-CUT GOOD.mov | Chapter 6 Vary Shot Sizes |

| Name | Subtitle |
|---|---|
| Ex 41-1 L2S H (02).mov | Chapter 7 Scene Join 1 |
| Ex 41-2 CU H (02).mov | Chapter 7 Scene Join 1 |
| Ex 41-3 WS H's (03).mov | Chapter 7 Scene Join 1 |
| Ex 41-4 W2S T & H (05).mov | Chapter 7 Scene Join 1 |
| Ex 41-5 MCU H (06).mov | Chapter 7 Scene Join 1 |
| Ex 41-6 MCU T (06).mov | Chapter 7 Scene Join 1 |
| Ex 41-7 Bell (16).mov | Chapter 7 Scene Join 1 |
| Ex 41-CUT BAD.mov | Chapter 7 Scene Join 1 |
| Ex 41-CUT GOOD.mov | Chapter 7 Scene Join 1 |
| Ex 42-1 MCU P (13).mov | Chapter 7 Scene Join 2 |
| Ex 42-2 W2S Exit (13).mov | Chapter 7 Scene Join 2 |
| Ex 42-3 MCU M (13).mov | Chapter 7 Scene Join 2 |
| Ex 42-4 WS River (12).mov | Chapter 7 Scene Join 2 |
| Ex 42-5 WS P & M (11).mov | Chapter 7 Scene Join 2 |
| Ex 42-6 Music (16).mov | Chapter 7 Scene Join 2 |
| Ex 42-CUT.mov | Chapter 7 Scene Join 2 |
| Ex 43-1 MCU M (12).mov | Chapter 7 Scene Join 3 |
| Ex 43-2 Sq 2S Bench (11).mov | Chapter 7 Scene Join 3 |
| Ex 43-3 WS get up (12).mov | Chapter 7 Scene Join 3 |
| Ex 43-4 WS Enter (13).mov | Chapter 7 Scene Join 3 |
| Ex 43-5 Music (16).mov | Chapter 7 Scene Join 3 |
| Ex 43-CUT.mov | Chapter 7 Scene Join 3 |
| Ex 44-1 MCU C (01).mov | Chapter 7 Action Sequence |
| Ex 44-2 MCU J (01).mov | Chapter 7 Action Sequence |
| Ex 44-3 Mobile falls(01).mov | Chapter 7 Action Sequence |
| Ex 44-4 WS MG-Tree (01).mov | Chapter 7 Action Sequence |
| Ex 44-4 WS MG-Tree2 (01).mov | Chapter 7 Action Sequence |
| Ex 44-5 Wheel Stops (01).mov | Chapter 7 Action Sequence |
| Ex 44-6 Bonnet (02).mov | Chapter 7 Action Sequence |
| Ex 44-7 Headlight (01).mov | Chapter 7 Action Sequence |
| Ex 44-8 MG RL Tk1 (01).mov | Chapter 7 Action Sequence |
| Ex 44-8 MG RL Tk2 (01).mov | Chapter 7 Action Sequence |
| Ex 44-9 Crash Fx (16).mov | Chapter 7 Action Sequence |
| Ex 44-10 Skid Fx (16).mov | Chapter 7 Action Sequence |
| Ex 44-11 Horn (01).mov | Chapter 7 Action Sequence |
| Ex 44-12 Int Car (01).mov | Chapter 7 Action Sequence |
| Ex 44-CUT.mov | Chapter 7 Action Sequence |
| Ex 45-1 CU H (06).mov | Chapter 8 Stretching Time |
| Ex 45-2 CU T (06).mov | Chapter 8 Stretching Time |
| Ex 45-3 2S & Laptop (06).mov | Chapter 8 Stretching Time |
| Ex 45-CUT BAD.mov | Chapter 8 Stretching Time |
| Ex 45-CUT GOOD.mov | Chapter 8 Stretching Time |
| Ex 46-1 WS P & M (13).mov | Chapter 9 Mixing Sound Effects |
| Ex 46-2 MCU M (13).mov | Chapter 9 Mixing Sound Effects |
| Ex 46-3 MCU M (13).mov | Chapter 9 Mixing Sound Effects |
| Ex 46-4 MS P & door (13).mov | Chapter 9 Mixing Sound Effects |
| Ex 46-5 MS P & door (13).mov | Chapter 9 Mixing Sound Effects |
| Ex 46-6 TV 1 (14).mov | Chapter 9 Mixing Sound Effects |
| Ex 46-7 TV 2 (14).mov | Chapter 9 Mixing Sound Effects |
| Ex 46-8 TV 3 (14).mov | Chapter 9 Mixing Sound Effects |
| Ex 46-9 TV 4 (14).mov | Chapter 9 Mixing Sound Effects |
| Ex 46-10 Clock (16).mov | Chapter 9 Mixing Sound Effects |
| Ex 46-11 Tea Fx (16).mov | Chapter 9 Mixing Sound Effects |
| Ex 46-12 P's Feet Fx(13).mov | Chapter 9 Mixing Sound Effects |
| Ex 46-13 Plane (16).mov | Chapter 9 Mixing Sound Effects |
| Ex 46-14 Proj Fx (16).mov | Chapter 9 Mixing Sound Effects |
| Ex 46-15 VHS Bleep (16).mov | Chapter 9 Mixing Sound Effects |
| Ex 46-CUT.mov | Chapter 9 Mixing Sound Effects |
| Ex 47-1 Holidays (16).mov | Chapter 10 Editing Music 1 |
| Ex 47-2 Mermaid (16).mov | Chapter 10 Editing Music 1 |
| Ex 47-3 Death (16).mov | Chapter 10 Editing Music 1 |
| Ex 47-4 Burial (16).mov | Chapter 10 Editing Music 1 |
| Ex 47-5 Rejection (16).mov | Chapter 10 Editing Music 1 |
| Ex 47-CUT 1 Holidays.mov | Chapter 10 Editing Music 1 |
| Ex 47-CUT 2 Mermaid.mov | Chapter 10 Editing Music 1 |
| Ex 47-CUT 3 Death.mov | Chapter 10 Editing Music 1 |
| Ex 47-CUT 4 Burial.mov | Chapter 10 Editing Music 1 |
| Ex 47-CUT 5 Rejection.mov | Chapter 10 Editing Music 1 |
| Ex 48-CUT All 5 Pieces.mov | Chapter 10 Editing Music 2 |
| Ex 49-1 MCU M (13).mov | Chapter 11 Dream Sequences |
| Ex 49-2 TV Shots (14).mov | Chapter 11 Dream Sequences |
| Ex 49-3 Rough Sea (14).mov | Chapter 11 Dream Sequences |
| Ex 49-4 Rough Sea (14).mov | Chapter 11 Dream Sequences |
| Ex 49-5 Rough Sea (14).mov | Chapter 11 Dream Sequences |
| Ex 49-6 Rough Sea (14).mov | Chapter 11 Dream Sequences |
| Ex 49-7 Rough Sea (14).mov | Chapter 11 Dream Sequences |
| Ex 49-8 WT Boys (16).mov | Chapter 11 Dream Sequences |
| Ex 49-CUT.mov | Chapter 11 Dream Sequences |

| Name | Subtitle |
|---|---|
| Ex 50-1 MCU P Sits (13).mov | Chapter 11 Montage 1 |
| Ex 50-2 WS M exit (13).mov | Chapter 11 Montage 1 |
| Ex 50-3 TV & Cups(14).mov | Chapter 11 Montage 1 |
| Ex 50-4 TV Clips (14).mov | Chapter 11 Montage 1 |
| Ex 50-5 Film clips (15).mov | Chapter 11 Montage 1 |
| Ex 50-6 Proj Fx (16).mov | Chapter 11 Montage 1 |
| Ex 50-7 Music (16).mov | Chapter 11 Montage 1 |
| Ex 50-CUT.mov | Chapter 11 Montage 1 |
| Ex 51-1 WS Car (01).mov | Chapter 11 Montage 2 |
| Ex 51-2 CU Bonnet (01).mov | Chapter 11 Montage 2 |
| Ex 51-3 LS Bonnet (01).mov | Chapter 11 Montage 2 |
| Ex 51-4 Wash Car (01).mov | Chapter 11 Montage 2 |
| Ex 51-5 Dog (01).mov | Chapter 11 Montage 2 |
| Ex 51-6 WS Cyclist (01).mov | Chapter 11 Montage 2 |
| Ex 51-7 MS Cyclist (01).mov | Chapter 11 Montage 2 |
| Ex 51-8 Wheels (01).mov | Chapter 11 Montage 2 |
| Ex 51-9 MLS Runner (01).mov | Chapter 11 Montage 2 |
| Ex 51-10 MLS Runner (01).mov | Chapter 11 Montage 2 |
| Ex 51-11 MLS Runner (01).mov | Chapter 11 Montage 2 |
| Ex 51-12 Lady & Dog (01).mov | Chapter 11 Montage 2 |
| Ex 51-13 Lady & Dog (01).mov | Chapter 11 Montage 2 |
| Ex 51-14 Feet & Dog (01).mov | Chapter 11 Montage 2 |
| Ex 51-15 CU Radio (01).mov | Chapter 11 Montage 2 |
| Ex 51-16 CU Saw (01).mov | Chapter 11 Montage 2 |
| Ex 51-17 WS Sawing (01).mov | Chapter 11 Montage 2 |
| Ex 51-18 MS Weeding (01).mov | Chapter 11 Montage 2 |
| Ex 51-19 H Reading (03).mov | Chapter 11 Montage 2 |
| Ex 51-20 Birds Fx (16).mov | Chapter 11 Montage 2 |
| Ex 51-21 Radio VO (16).mov | Chapter 11 Montage 2 |
| Ex 51-22 Radio VO (16).mov | Chapter 11 Montage 2 |
| Ex 51-CUT.mov | Chapter 11 Montage 2 |
| Ex 52-1 WS 2S (12).mov | Chapter 12 Chroma Key |
| Ex 52-2 WS H's (03).mov | Chapter 12 Chroma Key |
| Ex 52-3 W2S rise (12).mov | Chapter 12 Chroma Key |
| Ex 52-4 Green TVs (16).mov | Chapter 12 Chroma Key |
| Ex 52-CUT.mov | Chapter 12 Chroma Key |

# Appendix 3
# My CV

### 🎬 *The Media Show*—My Back Catalogue

As Edina said in *Ab Fab*, 'Names, names, names. . . .'

*Only Fools and Horses* (right from the start); *Blackadder* (Series 2–4); *Absolutely Fabulous* (Series 1–3); *Bottom; One Foot in the Grave; Parkinson; Saturday* and *Sunday Night Clive; Yes, Prime Minister; As Time Goes By; KYTV; 'Allo 'Allo!; French and Saunders; Alas Smith and Jones; Just Good Friends; Hi-de-Hi!; Not the 9 O'Clock News; Joking Apart; So Haunt Me; May to December; Butterflies; Terry and June; Open All Hours; A Kick up the Eighties; Dear John; Agony Again; The Magnificent Evans; Heartburn Hotel; In Sickness and in Health; The Brittas Empire; Clarence; Tonight at 8:30; Goodnight Sweetheart; Fist of Fun, Ever Decreasing Circles; Mulberry; Brush Strokes; 2.4 Children; Goodness Gracious Me; Waiting for God; Next of Kin; Bread; The Vicar of Dibley* (Series 2); *The Val Doonican Music Show*; a couple of *Royal Variety Shows*, and numerous other music specials with the likes of Stéphane Grappelli, Karl Richter, James Galway, Kiri Te Kanawa, Yehudi Menuhin, and Nana Mouskouri.

### 🎬 *On the Dark Side*—It Wasn't All Comedy

Amongst the laughs were other programmes like a drama series called *Maggie* and the coverage of the Advent Service from Salisbury Cathedral called *From Darkness to Light.* In addition, there was lots of sport and current affairs, with a sprinkling of Albert Hall Promenade concerts thrown in for good measure.

### 🎬 *The Roads to Freedom*—Working outside the BBC

I left the BBC in 1998 to go solo. The production world was changing with the formation of many independent production companies, such as Alomo, Watchmaker, Tiger Aspect, DLT Entertainment, Hat Trick, and many others. Some BBC shows like *Saturday Night Clive* moved to ITV, so you had, for the first time, an ITV show made by a mostly BBC team.

The BBC itself started to become more of a commissioner of programmes, so it made more sense for me to go freelance. The series happily kept on coming in my direction, such as *High Stakes*

and *Teenage Kicks* for ITV, *Time Gentlemen Please* for Sky, and back to the BBC for *My Family*; *Roger, Roger*; *Dad*; *Lee Evans*; and *My Hero*.

In more recent years, I have worked on five series of *Parkinson* for ITV, four series of *The Green, Green Grass*, three series of *The Catherine Tate Show*; two series of *The Old Guys*; a John Sullivan comedy drama called *Rock n' Chips,* two series of *Mount Pleasant* for Sky, along with *The Apprentice—You're Fired* for the BBC.

More recently still I have worked on *Count Arthur Strong* for the BBC, *Vicious* for ITV, and most recently *Birds of a Feather* and *Still Open All Hours.* Those last two sound slightly familiar, don't you think?

At the time of writing I have just finished a series called *Mountain Goats* for BBC Scotland.

# Appendix 4
# Abbreviations

I know how annoying abbreviations can be if you are not so familiar with the terminology. Here is a list of the ones I have used in this book but for which I may not have alluded to their meaning every time.

**¼″**—Analogue audio tape format

**2S**—Two-shot

**2S FAV X or Y**—Two-shot favouring X or Y

**3S**—Three-shot

**AAF**—Advanced authoring format

**ADR**—Additional dialogue recording

**atmos**—Atmospheric sound backgrounds

**AV**—A simultaneous sound and vision cut

**BAFTA**—British Academy of Film and Television Arts

**BBC**—British Broadcasting Corporation

**CGI**—Computer-generated imagery

**CRT**—Cathode ray tube

**CU**—Close-up

**dB**—Decibel (level of sound measurement)

**DOP**—Director of photography

**DSP**—Digital signal processing

**ECU**—Extreme close-up

**EDL**—Edit decision list

**EQ**—Equalisation

**FCP**—Final Cut Pro

**FPS**—Frames per second

**FX**—Effects

**GV**—General view

**HA**—High angle

**HD**—High definition

**ident clock**—A countdown clock inserted before the start of the programme, containing details of that programme, like episode and duration.

**ISO**—Isolated camera or recording, as distinct from the main cut coverage

**ITV**—Independent Television (UK)

**LA**—Low angle

**LS**—Long shot

**LS**—Loudspeaker

**MCU**—Medium close-up

**MS**—Mid shot

**OMF**—Open media format

**OS**—Over shoulder

**POV**—Point of view

**PPM**—Peak programme meter

**PRE-RX**—Preliminary recording

**QAR**—Quality assessment review

**RAID**—Originally Redundant Array of Inexpensive Disks; now commonly Redundant Array of Independent Disks

**RGB**—Red, green, and blue

**RRF**—Recording report form  
**RX**—Recording  
**SC**—Scene  
**SD**—Standard definition  
**SPL**—Sound pressure level  
**TC**—Timecode  
**TK**—Take  
**TX**—Transmission  

**VFX**—Video or visual effects  
**VO**—Voiceover  
**VT**—Video tape  
**VTR**—Video tape recorder  
**WMA**—Windows media audio  
**WS**—Wide shot  
**WT**—Wild track  
**XCU**—Extreme close-up

# Index